CHINESE PAINTING

CHINESE PAINTING

BY WILLIAM COHN

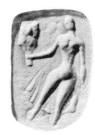

Hacker Art Books New York 1978

First published London, 1948.
Reissued 1978 by
Hacker Art Books, New York

Library of Congress Catalogue Card Number 76-6320
International Standard Book Number 0-87817-203-3

This reprint is published with the agreement of the Phaidon Press, London.

Printed in the United States of America.

TO MY WIFE,
MY UNFAILING HELPMATE

CONTENTS

ERRATA

IN THE INDEX

For p. 58 read p. 57 in each case. Binyon: for 76 read 77; David: for 53 read 52; Fu Shêng: for 50 read 51; Gray: for 76 read 77; Hedin: for 41 read 28; Hsüan Wu: for 37 read 39; Hui Tsung: for 34 read 33; Kung, Prince: for 53 read 52; Pi Hua: for 14 read 13; Tun Huang: for 53 read 52; Wu School: for 80 read 88; Wên Jên Hua: for 91 read 92.

IN THE LIST OF PLATES

Plates 26-27: for 1153 read 1135; Plate 98: read Hsia Kuei (active c. A.D. 1180-1230); Plates 169-172: for 3rd century B.C. read 4th century B.C.

PREFACE

WHATEVER merit this brief survey of Chinese painting may have is due to the fact that it is the work of a lover of art. It is concerned primarily with the paintings themselves, their artistic qualities, and their stylistic changes, less with the criteria of authorship, with the literary sources and the inscriptions, and least with religion, philosophy and history, the domain of Sinology. Not, of course, that these are wholly neglected, for, obviously, they are of vital importance for a full understanding of the development of art, which is inseparably linked up with the spiritual attitude of the different periods. Our method of approach is perhaps not inappropriate to showing the subject in a somewhat new light, more especially since previous works, valuable and praiseworthy as they are, have often accorded first place to the old literature and to the cultural background. Whoever is interested in the careers of the painters and in the charming yet sometimes rather stereotyped anecdotes which surround their lives, may turn to the series of excellent publications named in the Bibliography.

A deep affection for the Chinese spirit in general, and particularly for the Chinese language of the brush, has encouraged the present writer to make this venture—and a venture any account of Chinese painting cannot but be. Affection has its roots in experience, and such experience as the writer may claim he has had in a long and serious study of the treasures of Chinese pictorial art in many of the private and museum collections of China, Japan, the United States and Europe; to say nothing of the special exhibitions in Peking, Tōkyō, Kyōto, Berlin, Stockholm and London.

As for the translations and interpretations of the Chinese texts, the present writer, fully sensible of his incompetence in this field, would hesitate to encroach upon the achievements of the recognized scholars of Sinology; and so he has again and again turned to them for information and guidance. Controversies among Sinologues, though very frequent, only seldom affect the sphere of interest of the art historian. Whenever misunderstandings concerning art problems arise, they may as a rule be settled without serious difficulty.

Although painting, the most refined realization of Chinese creative power, is more closely integrated with the life of the Chinese people than it is in the Western world, the history of artists and art literature has been surprisingly similar to our own. China, with Japan—which has been largely dependent on China in the province of art—is the only non-European country where this parallel is to be found. Thus she offers a fruitful field for comparative studies, which are in all circumstances profitable for an understanding of art and art history. Such questions are only occasionally touched upon here. It is to be hoped that students of art will devote more attention to this task than they have hitherto done.

According to Chinese custom, painters use not one name only but several. Here, usually, those names are given by which they are most widely known. In the case of private collections, we seldom take account of the collectors, as art treasures change their owners very often, and more than ever in these days.

To many readers the text may seem to be somewhat overloaded with Chinese names and words. It must, however, be borne in mind that we are dealing with the art development of

two thousand-odd years in one of the largest countries of the world, and with a people who all through their long history have been noted for their cultivation of the various branches of the arts. The fact is, the names we mention are mostly so well known that identification is generally possible without the addition of Chinese characters. A table of the Chinese dynasties will be found on page 111.

In the plates and text figures the main lines of the development of Chinese painting over a period of two thousand years can be followed, and this in spite of the fact that it was not always possible to show works of the highest artistic quality, let alone exclusively genuine ones. Things being as they are, it has been found necessary on several occasions to fall back upon copies and paraphrases. The aim, in any case, was to represent the different stages of Chinese painting and its most characteristic subjects by selected specimens. The difficulties of the war and post-war periods must be held responsible for the omission of other illustrations which would else have been included. Nor must it be forgotten that there was a limit to the number of plates.

The absence of coloured plates may be regretted by many. But it is rarely possible to reproduce satisfactorily the subtle colours of Chinese pictures and, in particular, the patina of the paint ground, whether paper or silk. Actually a tendency exists to exaggerate the part which colour plays in Chinese painting. The majority of the works published here hold like the originals to black and white tones.

I should like to express my gratitude to Mr. Adrian Allinson for the help he has given me in preparing the manuscript in English. My deepest thanks are due to my friend, Mr. W. C. Morris, for his indefatigable assistance in the same work.

I also wish to express my gratitude to all who have kindly permitted the reproduction of paintings in their possession and put photographs at my disposal.

Oxford, 1945. W. C.

LIST OF TEXT ILLUSTRATIONS

1. Bronze vessel (*Hu*) with *Hunting Scenes*. H. of the Hu 38 cm. 5th-3rd century B.C. Chinese Government. Cf. pl. 1.

2. Basket with paintings in lacquer colour. H. of the basket 22 cm. L. 39 cm. W. 18 cm. 2nd or 3rd century A.D. Museum, Seoul. Cf. pl. 6-10.

3. Attributed to Ku K'ai-chih (4th century A.D.). *The Admonitions of the Imperial Preceptress*. Part of a hand scroll. *Mountain Landscape*. Ink and colour on silk. H. 19.5 cm. L. 347 cm. British Museum, London. Cf. pl. 13-15.

4. Bronze mirror with representations of the *Animals of the Four Cardinal Points and the Zodiac* in relief. D. 12 cm. 6th century A.D. Cf. pl. 11 and 12.

5. *Ingwakyō. The Temptation of the Buddha*. Part of a hand scroll. Colour on paper. H. 27 cm. 8th century A.D. Sambōin, Kyōto.

6. Relief of the Pin Yang caves, Lung Mên. *Female Donors*. Detail. H. c. 200 cm. Early 6th century A.D.

7-8. Sides of a stone sarcophagus with incised representations of *Stories of Filial Piety*. H. 62 cm. W. 234 cm. Early 6th century A.D. William Rockhill Nelson Gallery of Art, Kansas City.

9. Attributed to Yen Li-pên (d. A.D. 673). *Portraits of the Emperors*. First part of the hand scroll. Colour on silk. H. 51 cm. Museum of Fine Arts, Boston. Cf. pl. 18 and 19.

10. Attributed to Li Ssǔ-hsün (A.D. 651-716). *Palace*. Colour on paper. H. 36 cm. W. 30 cm. Museum of Fine Arts, Boston.

11. After Li Chao-tao (c. A.D. 670-730). The *Lo Yang Mansion*. Colour on silk. H. 37 cm. W. 39 cm. Chinese Government.

12. After Wu Tao-tzǔ (8th century A.D.). *Confucius and his Disciples*. Engraving on stone, dated A.D. 1025.

13. After Wu Tao-tzǔ (8th century A.D.). *Kuanyin*. Stone rubbing. Louvre, Paris.

14. After Wu Tao-tzǔ (8th century A.D.). *Tortoise coupled with Serpent*. Stone rubbing. H. 39 cm. W. 21 cm. British Museum, London.

15. Attributed to Wang Wei (A.D. 698-759). *Mountains in Snow*. Colour on silk. H. 69 cm. W. 36 cm. Chinese Government.

16. After Wang Wei (A.D. 698-759). The *Wang Ch'uan T'u*. Part of a hand scroll. Stone rubbing.

17. Paraphrase of the *Wang Ch'uan T'u* by Wang Wei (A.D. 698-759), attributed to Chao Mêng-fu (A.D. 1254-1322). Part of a hand scroll. Colour on silk. H. 41 cm. L. c. 500 cm. British Museum, London.

18. After Han Kan (c. A.D. 720-780). *Horses led by Grooms*. Part of a hand scroll. Colour on silk. H. 31 cm. L. 192 cm. Freer Gallery, Washington.

19. Attributed to Tai Sung (8th-9th century A.D.). *Fighting Water Buffaloes*. Ink on paper. H. c. 20 cm. W. c. 18 cm. Chinese Government.

20. Attributed to Chou Fang (active c. A.D. 780-816). *Palace Lady playing Ch'in and Listeners*. Hand scroll. Colour on silk. H. 28 cm. W. 73 cm. William Rockhill Nelson Gallery of Art, Kansas City.

21-22. After Kuan-hsiu (A.D. 832-912). Eight of a series of *Sixteen Lohans*. Rubbings from the stone engravings in the Shêng Yin Ssǔ near Hangchou. Cf. pl. 29 and 30.

23. *O-mi-t'o (Amitābha) as Ruler of the Paradise of the West*. Fresco. Cave 139a. 8th or 9th century A.D. Tun Huang.

24. *Monk in Rage*. From Turfan (Central Asia). Colour on silk. W. 45 cm. Fragment. T'ang Dynasty. Museum, Berlin.

25. *Official and Attendant on Horseback*. From Tun Huang. Colour on paper. H. 15 cm. W. 23 cm. Fragment. 8th century A.D. Louvre, Paris.

26. Li Ch'êng (late 10th century A.D.). *Rider with Attendant in front of an inscribed Slab*. Ink and slight colour on silk. H. 126 cm. W. 105 cm. Private Collection, Japan.

27-28. Attributed to Huang Ch'üan (d. A.D. 965). *An Assembly of Birds on a Willow Bank*. Parts of a hand scroll. Colour on silk. H. 23 cm. L. 182 cm. Mrs. Ada Small Moore, New York.

29. Attributed to the Emperor Hui Tsung (A.D. 1082-1135). *An Autumn Evening by a Lake*. Part of a hand scroll. Ink on paper. H. 33 cm. L. 234 cm. Chinese Government.

30. Attributed to Li T'ang (A.D. 1049-c. 1130). *Buffalo and Piping Herd-Boy*. Ink and slight colour on silk. H. 51 cm. W. 130 cm. British Museum, London.

31. Chao Mêng-chien (13th century A.D.). *Narcissuses*. Slight colour on paper. H. c. 25 cm. W. c. 55 cm. Private Collection, China.

32. Attributed to Liu Sung-nien (active c. A.D. 1190-1230). *The Three Incarnations of Yüan-tse*. Hand scroll. Ink and slight colour on silk. H. 24 cm. L. 99 cm. British Museum, London.

33. Ch'ien Hsüan (A.D. 1235-c. 1290). *Insects and Lotus*. Hand scroll. Ink and colour on paper. H. 26 cm. L. 120 cm. Detroit Institute of Arts, Detroit. Cf. pl. 128 and 129.

34. Wu Chên (A.D. 1280-1354). *Bamboo in Wind*. Ink on paper. H. 75 cm. W. 50 cm. Museum of Fine Arts, Boston.

35. Shuai Wêng (13th-14th century A.D.). *The Chinese Founder of the Ch'an Sect Hui-nêng*. Ink on paper. H. c. 80 cm. W. c. 30 cm. Private Collection, Japan.

36. *Chên Wu, the Prince of the North Pole, the Seven Deities of the Northern Dipper and other Taoist Deities and Attendants*. Fresco in colour. H. 341 cm. 13th or 14th century A.D. Royal Ontario Museum, Toronto. Cf. pl. 165.

37. *Jih T'ien* (Deity of the Sun). Fragment of a fresco in colour. H. 145 cm. W. 61 cm. 15th century A.D. University Museum, Philadelphia.

38. Yao Shou (A.D. 1425-1495). *Myna in Winter*. Ink and colour on paper. H. 116 cm. W. 30 cm. Chinese Government.

39. Ch'ien Ku (A.D. 1508-1572). *A Magpie on the Branch of an Apricot Tree*. Ink and colour on paper. H. 116 cm. W. 34 cm. Dated 1569. Chinese Government.

40. Wên Chêng-ming (A.D. 1470-1567?). *Bamboo*. Ink on paper. Private Collection, China.

41-42. Hsiang Shêng-mo (A.D. 1597-1658). *River Landscape*. Parts of a hand scroll. Ink and slight colour on paper. H. c. 30 cm.

43-44. Giuseppe Castiglione S.J. (Lang Shih-ning, A.D. 1698-1766). *Kazak Kirghis Envoys presenting Horses to the Emperor Ch'ien Lung*. Parts of a hand scroll. Colour on paper. H. 30 cm. Musée Guimet, Paris.

45. Lêng Mei (18th century A.D.). *Lady with Children and Servants on a Terrace*. Colour on silk. H. 116 cm. W. 59 cm. Museum of Fine Arts, Boston.

46. Huang Shên (18th century A.D.). *Portrait of Ning Yü-ch'uan in the Guise of his Ancestor Ning Ch'i*. Ink and slight colour on silk. H. 128 cm. W. 49 cm. British Museum, London.

I. OUR KNOWLEDGE OF CHINESE PAINTING

LITERARY sources and the works of art themselves, with their accompanying inscriptions—the two points of departure in Art History—are, where China is concerned, only just beginning to be examined more seriously. This much seems to be firmly established to-day: our knowledge of early painting, not unlike that of Western classical painting, is chiefly dependent upon copies, paraphrases and literary documents. It is doubtful whether there will be any substantial change in this respect. Confronted with the later painting of China, the Western student is in the same position as his forerunner was a century ago regarding his own art—if this comparison is not too optimistic and we can safely go back to, say, Sandrart, who published his large and comprehensive work in the second half of the seventeenth century.[1] At any rate no scientific criticism, whether of the paintings themselves or of the literary sources, has been seriously undertaken. An important difference may, however, be said to exist: to-day we are at least aware of our ignorance. We do know that we have barely begun to employ on Chinese art the critical methods which in the meantime have been developed in other realms of art history. Above all, there are practically no monographs on either individual painters or local schools, and only very few dealing with particular aspects of Chinese painting.[2] The investigation of Chinese art still entails a number of unique difficulties. It is simply not possible to rely entirely upon Western experience and Western methods. Research must be adapted to the particular exigencies of Eastern art. On certain questions, mainly those regarding the authenticity and attribution of pictures, it is obvious that we have to leave final decisions in the hands of Eastern specialists. Their traditions, going back many hundreds of years, are still vital to-day, and give them a start and an advantage with which we can never compete—an advantage, moreover, that has every prospect of increasing, the more intimately their profound connoisseurship becomes linked up with Western methods.[3]

Decisive questions, such as that regarding the date of a picture and its genuineness as the work of the master whose signature it bears, or that again of its traditional attribution, are by no means easily determined, even within the realms of Western art history. One need only consider the uncertainty of Rembrandt's *œuvre*. Such problems are naturally more complicated in the case of China. It has been frequently alleged that the eternal mutability of things, ever responsible for the bringing forth of new styles, as we know it in the West, is not to be found in China. Consequently dating and attribution based upon style are supposed to be practically impossible.[4] This is manifestly absurd,[5] although, to be sure, the peculiar characteristics of Chinese painting, with its subtle technique, doubtless render clear distinctions, for the beginner at all events, more difficult to grasp. And up to a certain point, the Westerner must remain a tyro all his life. Furthermore, the development of Eastern art does

[1] Joachim von Sandrart, *Teutsche Academie*, Nürnberg, 1675-1679. I quote this work because it is indeed the first comprehensive one on the subject. It embodies the whole knowledge of the art of its time and even contains a chapter on East Asiatic painting, perhaps the first European treatment of it. [2] Of course there are articles on certain painters and certain special subjects of Chinese painting spread over different Chinese, Japanese and Western journals, but they are mostly far from being real monographs. [3] This refers especially to all epigraphical questions. [4] John C. Ferguson, for instance, writes in his *Chinese Painting*, p. 26: 'It is idle folly to assert that the paintings of a particular period, such as that of the T'ang or the Sung or the Yüan, have certain definite characteristics which are sufficient to guide a collector in determining the age in which a particular painting was produced, or in suggesting that a painting must have been the work of such and such an artist.' [5] The present writer has tried to show that Chinese art has had a similar development to Western art. Cf. *Chinese Art in the Light of Comparative Study*, The Burlington Magazine, July, August, 1941.

not exhibit the tempestuous tempo of the restless West. The fetters of tradition bind it more strongly. No greater praise can be bestowed upon a Chinese painter than to say of him that, his manner of painting being indistinguishable from his master's, he had become the master's equal. Thus copies and paraphrases made of the important works of their predecessors, or even of their contemporaries, play no small part in the *œuvre* of most artists. Often indeed they are not marked as such; on the contrary, the numerous inscriptions and seals[6] of the original are also included in the copy, and all this for the purpose not so much of forgery as of paying respectful tribute to the model or of making a faithful duplicate. Naturally there have been many intentional forgeries. All the world over, wherever Art for Art's sake is practised, these will not be missing. Certain works, whose intention it is to paraphrase the style of a given old master, form a class of their own.[7] Here we are concerned only with reminiscences of an original; the hand of the actual painter remains more or less recognizable. If the intention, as often happens, is expressly stated in an annotation, all is plain sailing. If not, as the style of the different masters is not yet sufficiently known, certain difficulties may arise.

It seems very unlikely that paintings of the pre-Sung, or even of the pre-Ming, period have survived in any considerable numbers. The Chinese house, with its framework of wood, does not offer works of art favourable protection. Nearly all the frescoes, for instance, done in the hey-day of fresco painting have perished. Countless internal and external wars have brought frightful devastation in their train; and although the Emperors and high officials continued to collect paintings, it was precisely this concentration of art treasures in the hands of a few that formed one of the chief causes of their decimation, to say nothing of the many other accidents to which the particularly sensitive pictures were exposed. With the frequent change of dynasties and the numerous rebellions, the palaces, with all their content of hoarded treasures, went up in flames.[8] The famous painters and connoisseurs of the Sung dynasty, Su Tung-p'o (A.D. 1036-1101) and Mi Fei (A.D. 1051-1107), concur in stating that they had seen only two or, at most, four originals by Wu Tao-tzŭ (8th century A.D.), one of the greatest masters of Chinese painting. Tung Ch'i-ch'ang (A.D. 1555-1636), highly prized both as painter and art critic, was by this time unacquainted with a single work from the hand of Wu Tao-tzŭ;[9] and Chang Ch'ou, a contemporary of Tung's, who also complained about the rarity of pictures preserved from olden times, includes the Sung period in his scepticism. Furthermore, he adds: 'What the amateurs see are mostly copies.' It must always be borne in mind that the more famous the name or seal found on a work, the more doubtful the work will be. Even on the paintings executed in the manner of certain esteemed masters, the signatures are often added, as though to confirm the success of the effort. Right up to our own day, all inscriptions, including the seals, must be held suspect. The work itself, first its style, then the material and state of preservation, and then again the inscriptions, must be the point of departure for any sound research. Knowledge and comparison of as many works as

[6]See R. Saitō, *Dictionary of Signatures and Seals of Chinese Painters*, Tōkyō, 1906. (In Japanese.) How little we can trust the painter's seals is shown by Werner Speiser in his monograph on T'ang Yin (A.D. 1470-1523). He says that we know of twenty-two different seals of T'ang Yin, but that he could not discover any identical seals on the paintings. Moreover, there is the possibility that genuine seals are found on fakes or paraphrases whereas spurious seals may be found on genuine pictures. Ostasiatische Zeitschrift XI (XXI), 1/2, p. 9, and 13 ff. Kisaku Tanaka comes to similar conclusions in an article: *Artist's Seals on Old Paintings*, Bijutsu Kenkyū, Jan. 1939. Cf. also Soame Jenyns, *A Background to Chinese Painting*, 1935, p. 13 ff. [7]They are so frequent that they were given a special designation, namely *Fang* in contrast to real copies, which are called *Mu* or *Lin*. [8]More information on this subject is to be found in the following articles: Arthur Waley, *The Rarity of Ancient Chinese Paintings*, The Burlington Magazine, Vol. XXX, 1917, p. 209 ff; Osvald Sirén, *A History of Early Chinese Painting*, 1933, I, p. 26 f; W. Perceval Yetts, *Some Buddhist Frescoes from China*, The Burlington Magazine, Vol. LI, 1927, p. 121; William Cohn, *Chinese Wall-Paintings*, The Burlington Magazine, July, 1943. [9]'The masters of antiquity are far from us. Ts'ao Pu-hsing and Wu Tao-tzŭ are of a period that is closer to us, but nevertheless one never sees a picture by either of them.' Cf. Osvald Sirén, *The Chinese on the Art of Painting*, 1936, p. 144. Chang Ch'ou's complaint is to be found in it. *A History of Early Chinese Painting*, 1933, II, p. 140.

possible exhibiting similarities in style and subject will take the explorer farthest. Fortunately, a few safe pointers for the start are not missing.

What then, it may be asked, about the literary sources? Corresponding to the important role painting plays in her culture, China has produced an enormous art-literature. Excluding Western publications of the last hundred years, nowhere else perhaps does there exist one of so wide a scope. How far back do these documents go? Illuminating passages on painting, extracted from the writings said to be by the outstanding painter Ku K'ai-chih (c. A.D. 344-406), are well known. To be sure, it is doubtful whether the three treatises ascribed to the master are really by him, but they seem to be of a very early date. Here is proof positive that even before his day the nature and technique of painting was being thought of and written about. It is permissible to go back as far as the Han period, that is to say the beginning of the Christian era.[10] The *Ku Hua P'in Lu*, by Hsieh Ho, written at the end of the 5th century A.D., is still to-day fundamental and vital to a proper understanding of Chinese painting. The author himself emphasizes, however, that he has merely summed up those principles which formed the basis of painting from ancient times.[11] Catalogues of collections, with their biographical and critical notes coming down to us from of old, offer a wealth of information. The earliest known of these is a catalogue compiled under the T'ang Emperor T'ai Tsung (A.D. 627-649), who inherited the art collection of his predecessors, the rulers of the short-lived, art-loving Sui dynasty.[12] But vague records of galleries of paintings as far back as of the Han period are known to have been handed down.[13]

Thus, it is possible to say that the basis of Chinese art-literature was laid in the first half-millennium of the Christian era. Since then, and in ever growing numbers, essays, encyclopedias, biographies, theoretical, critical and technical discourses, historical statements, catalogues of collections, and colophons dealing with painting and its masters, have been produced. The most important of these writings were collected and reprinted from the sixteenth century onwards, a peculiarly Chinese activity, which has continued right into our own time. This lively literary interest shows how vital and indispensable to the Chinese is their occupation with painting and its sister-art calligraphy. Early Eastern and Western writers have had in common a lack of all scruple in the way they embodied in their own elaborations the views and formulations of their forerunners, and the credulity with which they accepted whatever those cared to state. But in the West, for a hundred years now, or, if you prefer, since Winckelmann (1717-68), a systematic and scientific attitude has been adopted, not only towards art itself, but also to its sources, subjecting both to critical investigation. The statements made by earlier writers on art, like Vasari, van Mander, Sandrart and others have been placed, so to speak, under the magnifying lens. Examination of periods and schools has caused artists and their works to be classified anew in the order of art development. Reports on the prominent painters and their *œuvre* have again and again been tested in biographies. Similar endeavours have only recently been made in China and Japan; they signify no more than a beginning.[14]

Despite this state of affairs, repeated efforts have been undertaken to give the West access, if only in extracts, to the theoretical and historical expositions, the anecdotes and

[10]Indeed, the official historical records of the two Han dynasties already contain a lot of information on painting. [11]Cf. Shio Sakanishi, *The Spirit of the Brush*, The Wisdom of the East Series, 1939, p. 46 ff. [12]This catalogue, the *Chêng Kuan Kung Ssŭ Hua Shih*, compiled by P'ei Hsiao Yüan, contains a list of 293 paintings of various collections and mentions 47 temples with frescoes by well-known artists. [13]Cf. Herbert A. Giles, *An Introduction to the History of Chinese Pictorial Art*, 1918, p. 10 f. [14]A critical examination, for instance, of the present conditions of the most important work on early Chinese painting, the *Li Tai Ming Hua Chi* by Chang Yen-yüan, completed in A.D. 845, yielded the following results: the original manuscript has been lost; the earliest printed edition is only from the late Ming period; there are numerous omissions and insertions as well as much general disorder. Kenyū Dōtani, *Study of Li-Tai-Ming-Hua-Chi*, Bijutsu Kenkyū, June, 1939. Cf. also Arthur Waley, *Chinese Temple Paintings*, The Burlington Magazine, XLI, 1922, p. 228, and Seiichi Taki, *On the Books of theoretical and historical Studies of Painting published in the Sung Period*, Kokka, No. 394, 396, 397.

judgments, of the ancient Chinese art literature. A wealth of indispensable, interesting and illuminating material thereby came to light.[15] But how tentative it all is! Much too often we are not yet clear about the meaning of Chinese art-terms. How far can we trust the sources from which both the ancient and modern Chinese authors have drawn? We come repeatedly across similar anecdotes and characterizations in the 'lives' of painters, and we find frequently in the discussions upon their achievements that the major weight is laid upon teachers and models. How much of such accounts is convention and how much is fact? If Chinese art-critics of previous days continually stress the heritage the masters owe to the past, it is for us just as important, if not more important, to determine what new solutions and formulations the individual artist has added to the realm of art. This point of view, so obvious in Europe, is almost entirely lacking in the old Chinese art literature. Thus it would seem that the position held by the individual masters within the hierarchy of art, particularly since the Ming period, must be considerably revised. Just imagine European art still being seen through the eyes of a Vasari, a Sandrart or a Walpole! A large percentage of the masters whom they honoured in the highest degree mean to us little or nothing. Can matters be any different in China? The Westerner cannot take over Chinese valuations of the past without application of his own critical judgment. Add to this: the majority of Chinese painters were not professionals, even up to the nineteenth century. They were high officials, military dignitaries, poets, philosophers or scholars, and they were at least as much esteemed for their calligraphy as for their painting. The Chinese obviously puts a higher value upon the total personality than upon specifically artistic achievement. Also in this matter, we cannot just blindly fall into line with the Chinese. For us, the significance of the painter, as painter, must first be determined. A knowledge of his character, and of his activities and interests apart from his art, can only serve to bring him closer to us as a man; but for the evaluation of his artistic competence, this is a secondary consideration.

[15]Books and articles by Giles, Hirth, Ku Têng, Omura, Sirén, Ferguson, Waley, and the great Chinese and Japanese publications—named in the general Bibliography—abound in quotations which are frequently identical, being drawn as they are from the old Chinese literary sources. But one should never forget the late Paul Pelliot's warning: '. . . à quelles erreurs invraisamblables les meilleurs connaisseurs chinois de la fin des Ming et des débuts des Ts'ing pouvaient se laisser entrainer.' *Notes sur quelques Artistes des Six Dynasties et des T'ang*, T'oung Pao, XXII, 1923, p. 224.

II. TECHNIQUE AND FORM

ART is one: vision and thought, technique and form make an indissolubly blended whole. Chinese painting exemplifies this with particular clarity. It is possible, up to a certain point, to elucidate the nature of Chinese painting by a study of its technique and form. Its most ancient form was wall painting *(Pi Hua)*; in it various techniques were developed, especially those of fresco and secco painting. Wall painting is the only field in which Eastern and Western practices coincide. Since the Han Dynasty *(c.* 200 B.C.-A.D. 200) at least, temples and halls of every kind have been scattered throughout China and decorated with religious, didactic or historical representations. The significant traits of monumental mural painting are the accentuation of the background as a two-dimensional plane, the independent expressiveness of the lines or contours and, generally, the maintenance and stressing of the decorative element. In China, not only the frescoes, but painting in all its branches—as long as it remained true to its genius—has always exhibited these features; not, of course, without inexhaustible variations.

The oldest form of movable painting seems to have been the hand scroll *(Shou Chüan,* the Japanese name is *Makimono),* which, being laid upon floor or table, is unrolled from right to left for perusal and contemplation. The scroll, made of silk or paper, is also the oldest setting of the book in China.[16] Thus we can note in the Far East a phenomenon which has its exact counterpart in classical Antiquity. In both cases, wall and scroll are the principal vehicles of the art of the brush. We can do no more than hint at such a parallel here. There were probably paintings on scrolls in the Han period, if not earlier. In the beginning they may have been mostly illustrative, accompanying a text. But the scroll seems to have become an independent art-form at a very early date. While in the West it has entirely disappeared since the early Middle Ages, it has, even to-day, not lost its significance and popularity in China. It is indeed, when employed to represent landscapes or narrative subjects, a most characteristic expression of Eastern art. As the scenes are unrolled and pass before the eye, the beholder finds space- and time-concepts bound together in a fascinating unity. Thus, painting is enriched by elements which, in the West, are peculiar to the arts of music and the dance.

The easel picture of Antiquity and the Renaissance corresponds to the hanging scroll *(Chou,* called by the Japanese *Kakemono)* in China. Both forms grew out of the desire to create movable pictures for walls. In Europe, oil-technique and the frame came into use with the easel picture. The West steered towards illusionism, while the East tended towards a kind of expressionism bound by calligraphic ties.

It is not exactly known when the hanging picture was evolved in China. Probably painted or inscribed banners serving some festive purpose formed the earliest stage. Perhaps religious representations—particularly Buddhist—of deities and priests were at first mounted as hanging pictures. This could not have happened much before the T'ang period (A.D. 618-906). The full development of its mounting seems to have gone hand-in-hand with the appearance of the independent animal, flower, and landscape picture. It would be rash to mention even approximate dates for this development. We may, however, say that the pro-

[16]Cf. A. W. Hummel, *The Development of the Book in China,* Journal of the American Oriental Society, vol. 61, no. 2, June, 1941.

cess, the details of which are so far unknown to us, is likely to have been perfected towards the end of the 10th century.[17]

Let us examine more closely the setting of a hanging picture and attempt to understand its meaning. Every period had a special method of mounting and chose special materials for this purpose. Yet the basic elements remained essentially the same. In this respect, things are not much different from those of the West. The materials employed give us here, as there, hints as to the date of a work. But, here as there, the greatest care must be taken; the pitfalls are many. The paintings were frequently remounted. Whether silk or paper serves as paint ground is quite irrelevant to a consideration of the artistic value. The fabric forming the setting possesses the same function as the border of a fresco or of a tapestry. It is meant to heighten the decorative character of the picture, not, as with the plastic frame, to isolate and cut it off from the surroundings. Intimately associated with the peculiarity of Chinese painting is the fact that the accent of the mounting does not lie below, where we might expect to find it, but above. Thus the picture is, like the script, to be read from above downwards and, as far as spatial effects are aimed at, from back to front. In addition, the upper part of the picture surface is often covered with all kinds of inscriptions and seals. In this way the eye of the beholder is attracted to the top, and at the same time, the non-illusionistic intention—itself already stressed by the calligraphic character of the painting—is further underlined. One might perhaps think that the vertical strips *(Fêng Tai)*, which either hang free or are pasted flat at the top of the hanging scroll, serve the same purpose. This is of course possible. But they seem rather to have a practical intent, such as holding the rolled-up picture together or keeping away insects. In order to roll the picture smoothly and quickly and to give it a certain rigidity when hanging on the wall, a massive rod, whose protruding ends are often made of some precious material, is affixed to the bottom edge of the fabric. An Eastern painting is, as is well known, not meant as a lasting wall decoration. The movability of the picture, for whose outer borders noble brocades or silk damasks are used instead of a heavy frame, the fine texture of the paper or silk on which it is painted, and the easy fluid limpidity of the medium employed, are among the dominant features of Chinese and Japanese art of the brush.

It may be taken as in keeping with the character of Chinese painting that the arts of engraving, so popular in the West, where they were intended to serve as easily acquired and handy works of art, have not been much developed. Though the woodcut was known in China about seven hundred years earlier than in Europe, it did not there participate in the evolution of painting to anything like the same degree. It appears always to have remained a pure handicraft, despite the fine colour-prints which it brought forth since the Wan Li period (A.D. 1573-1620).[18] Other branches of graphic art, such as etching, copper-engraving, lithography, etc., which flourished so vigorously in the West, have remained practically unknown. In fact, the need for those easily produced and handled art forms was less felt in China, where popular paintings on paper or silk were executed in any quantity, and found their way into even the poorest dwelling. Both material and time have always been cheap in China. Furthermore, two forms of painting existed which, up to a certain point, satisfied a want similar to that which was met by the arts of engraving in Europe: paintings on fans

[17]There is still another form of painting which is peculiar to the Far East: I mean the folding screen, a kind of movable fresco *(I Tung Pi Hua)*. It may be that it is even older than the hanging scroll. Although it was in vogue in all periods, as we learn from the literary sources and from representations on pictures, actual screens of older times are very seldom preserved, if at all. Cf. Chiang Yee, *The Chinese Eye*, 1935, p. 226 f. [18]Cf. Laurence Binyon, *A Catalogue of Japanese and Chinese Woodcuts in the British Museum*, 1916; Werner Speiser, *T'ang Yin*, Ostasiatische Zeitschrift XI (XXI) 3/4, 1935, p. 115; Fritz Rumpf, *Die Anfänge des Farbenholzschnittes in China und Japan*, Ostasiatische Zeitschrift VII (XVII), 1931, and the summary of Genji Kuroda's lecture, *Der chinesische Holzschnitt*, Ostasiatische Zeitschrift VIII (XVIII), 1933, p. 129; finally again R. Petrucci, *Encyclopédie de la Peinture Chinoise*, 1918, which is an annotated translation of the *Chieh Tzǔ Yüan Hua Chuan*.

(Shan) and those on square or rectangular leaves, single *(Tou Fang)* or collected in albums *(Ts'ê Yeh)*. Plain silk or paper fans had been from of old staple articles. These would be decorated with calligraphies or drawings by more or less famous artists and made to serve as presents. To the master, they would be mere *'pièces d'occasion.'* The same holds good for album leaves. Like drawings or prints in Europe, they were often bound together in series, under special titles; the themes most frequently treated being landscapes, above all the four seasons, and certain symbolic plants, such as bamboo, plum-blossom and orchid. But before all else come paraphrases in the style of the old masters *(Fang)*.

The drawing, in the Western sense, seems never to have become an object of special appreciation in China. Naturally, that is no mere accident. All Far-Eastern painting is, indeed, drawing, and in its very essence more closely related to Western drawing than to oil painting. With us, usually, a drawing is the preparatory study for a picture.[19] Such studies, as we repeatedly learn from literary sources, were made by a Chinese to at least the same extent. He considered them as an exercise, but not finished enough to allow them out of his hand. If an East-Asiatic painting seems to us no more than a sketch, this signifies only that we have not quite understood it. The work is always the culmination of numerous preparatory studies which the master did not regard as being worth preserving.

A similar misunderstanding is involved in looking upon Far Eastern art as being impressionistic. It is true there are traits common to both European impressionism and certain currents of Chinese painting; for example, the pleasure in atmospheric phenomena, the persistence of a lively brushwork, the dissolution of forms and of composition. Yet, in its very nature, Chinese painting mostly exemplifies diametrically opposed tendencies. Not the almost scientific rendering of reality filled with light and air[20] is its aim, but the concentration on the essentials achieved through the maximum expressiveness of a more or less limited calligraphically defined brushwork. Consequently the Chinese painter, a sharp and eager observer of Nature in all her moods, very rarely worked directly from life. The general character of his art prohibited it. This does not exclude the fact, frequently recorded, that on his wanderings through the land he would make numerous studies for future reference. To steep himself in nature was, of course, an indispensable preliminary to his artistic creations.

[19]This is the definition of a drawing by Joseph Meder in his well-known work, *Die Handzeichnung*, 1919. [20]'What the Impressionists were anxious to catch was the momentary "look" of the scene they were painting.' Eric Newton, *British Painting*, 1945, p. 31.

III. PAINTING AND CALLIGRAPHY

AS we have seen, form and mounting throw a flood of light upon the aims of Chinese painting. The Chinese themselves have never discussed this interdependence. It was also far from their thoughts to draw comparisons with Western practice. All the more did they occupy themselves with the relationship of painting to calligraphy.[21] It is not enough to underline the pictographical nature of Chinese script. We have to go deeper. In the evolution of the characters, a similar trend towards stylization, abstraction and rhythmic expression can be recognized as in painting. It must be assumed that in remote antiquity script and painting were almost identical. The same ideograph is employed for the words 'painting' and 'writing,' a fact of even greater significance than the use of the same word for both activities among the Greeks. The decisive factor for the close connexion is that the same brush and ink used in writing also served for painting. The entire evolution of Chinese painting would certainly have taken quite another course, if the quill pen or some other instrument had been the medium for writing. Calligraphy would not have exerted, on the one hand, so remarkable an influence upon the development of the sister art, nor would it, on the other, have been likely to rise to the importance to which it has indeed risen. If the Chinese painter sprang up mainly among the most cultivated circles of the land, this is largely due to the fact that the craft of writing was practised only by the educated. Whoever did not study it with particular assiduity and master it could not become a painter; neither, for that matter, could he become an official or a scholar.

When we, in the West, speak of a painter's 'handwriting', as exemplified in some painting or drawing, we are dealing with a conception similar to that which is general in China. But usually this expression is meant by us only in a figurative sense, and no-one thinks of actual writing. In China it is possible to say, in the real sense of the word, that the artist writes his pictures and the calligraphist paints his ideographs.[22] Calligraphic texts often serve the same decorative purposes as paintings and are similarly mounted. Not only that; they frequently have the same contents, expressing in words what those symbolize objectively. By virtue of the pictographical basis of the Chinese script, the educated still see in many characters the prototypes abstracted from reality, and sometimes a bit of the past comes to life again for them. The qualities the Chinese appreciate most highly in individual handwriting, and because of which certain calligraphists became famous, also supply to a certain extent a measure for the value of paintings. Thus spirit and harmony, suppleness and firmness, in other words *Ch'i Yün Shêng Tung* (rhythm and vitality[23]), the first of the *Six Principles of Painting*—formulated by Hsieh Ho towards the end of the 5th century A.D.—have always been, and still are, the chief criterion of both Chinese calligraphy and painting. Balance in the structure of individual characters, as well as in the arrangement of them in a group, has its equivalent in painting too.

The most significant consequence of the calligraphic nature of Chinese painting is, on the one hand, the maintenance of the picture-plane as such, and on the other, the lack of an

[21]Most of the Chinese essays on art, old and new, are full of references to this relationship. Cf. Chiang Yee, *Chinese Calligraphy*, 1938, especially the chapter Painting and Calligraphy, p. 207 ff.; John C. Ferguson, *Outlines of Chinese Art*, 1918. Lecture IV, Calligraphy and Painting, p. 134 ff.; Soame Jenyns, *A Background to Chinese Painting*, 1935, III, The Relation to Calligraphy, p. 89 ff. Cf. also Yang Yü-hsun, *La Calligraphie Chinoise depuis les Han*, 1933. [22]Chiang Yee quotes a saying of Chao Mêng-fu, the famous Yüan painter: 'Painting and writing are fundamentally the same; to paint a rock is to write in the Fei-Pei style; to paint a tree is to write in the Chou style. If you want to write Bamboos you ought to be familiar with the Eight Styles of Calligraphy.' *The Chinese Eye*, 1935, p.52. [23]Cf. Sakanishi, *The Spirit of the Brush*, 1939, p. 46 ff.

accentuated modelling of figures and objects by means of light and shade, and of a linear perspective. Painting, for the Far Eastern, is language of the brush. Everything is concentrated upon giving the clearest possible expression to this language. Plasticity and linear perspective would obscure the life and rhythm of the brushstroke. All the same, a more or less keen interest in spatial relations is not lacking. At a very early date front- or profile-views of figures which exhibit the ductus of line were left behind, and the artist went on, as in the West, to foreshortenings and overlaps. Soon more striking spatial effects were introduced. Not only so; for when in the China of the 8th or 9th century A.D. a pure landscape painting arose in the world for the first time—that is, a landscape created as an end in itself, no longer serving only as a background to something else—spatial effects gradually became one of the determining factors. Not the reproduction of an isolated, in some way restricted and, so to say, tangible space was here sought for and eventually achieved, but the insertion of a scene in a floating, boundless and immeasurable universe. The conception of this mysterious infinity is not transmitted through the adherence to a fixed viewpoint and a perspective in the Western manner. It is brought about by changing the viewpoint, by gradations of brush-tone and by including the more or less untouched picture surface to add to the impression of the painting. Furthermore, if we take into account the atmospheric phenomena such as mist, fog, moonlight and clouds, and also the characterizations of morning and evening, wind and storm, snow or rain, in which the Chinese masters excel, it often seems as if here particularly the Far East, with its limpid inks and watercolours, has been more successful than Europe with its viscous oil. To be sure, sharp contrasts of sunlight and shade, cast shadows, and the garish effects of artificial light, remain outside the intentions of Eastern painting. The roots of all these peculiarities, not to be traced to the specific means of painting alone, lie in the deep conviction governing the thought of the East from India to Japan, that our material world is merely an illusion.

The close relationship between painting and calligraphy has occasionally been denied by Western writers.[24] They affirmed, for example, that ink and brush were already being used for writing in the late Shang period (?1766-?1122 B.C.), more than a millennium earlier than the witness borne by any surviving painting. They go on to say that pure ink painting first appeared not earlier than the late T'ang period (A.D. 618-906), and this is not always calligraphic in character, as the *P'o Mo* style (spilled ink), for instance, stresses the interior forms only and not the outlines. Moreover painting with colours and simple outlines has no bearing on calligraphy. To all these objections the reply must be made: the notion of calligraphy, with its many styles, should not be understood too narrowly. What is meant is not only the method of writing with increasing and diminishing brushstrokes, but also with evenly flowing lines. The cursive script *(Ts'ao Shu)*, we do well to remember, is capable of endless variations.[25] The *P'o Mo* style, which does not use outlines, can be derived from the cursive script without any great stretch of imagination. On the other hand, the writing in the Small Seal style *(Hsiao Chüan)* breathes exactly the same spirit as the Pure Outline drawing *(Pai Miao)*. The fact that paintings in pure outlines are often covered with colours does not in the least deprive them of their fundamentally linear and calligraphic character. In art literature the close relationship between calligraphy and painting was already axiomatic for Chang Yen-yüan in his *Li Tai Ming Hua Chi*, completed in A.D. 847.[26]

The closeness of the tie varied from time to time. It was particularly strong at the end of the T'ang period, when pure ink painting first appeared, and it reached its apotheosis in the

[24]Cf., for instance, Ludwig Bachhofer, *Chinesische Landschaftsmalerei vom X. bis XIII. Jahrhundert*, Sinica, 1935, p. 9 ff. [25]Chiang Yee, *Chinese Calligraphy*, 1938, p. 93 ff. [26]'It may consequently be said that, although writing and painting have different names, they are the same thing.' See Osvald Sirén's translation of the first chapter of the first section of Chang Yen-yüan's *Li Tai Ming Hua Chi* in *The Chinese on the Art of Painting*, 1936, p. 225.

Sung era. Certain aspects in the development of painting since the middle of the Ming period also cannot be understood if the calligraphic element is not taken into consideration. There arose a sort of syntax or grammar of painting, tabulating not only the more or less rigid pattern of natural forms, such as rocks, waterfalls, trees, plants, birds, animals and human figures with the draperies of their garments, but also of houses, bridges and boats of all kinds.[27] Copybooks appeared laying down rules which show how, by following set models, all things on earth were to be painted. The most famous of these, to name only two that were published in the seventeenth century, are the *Shih Chu Chai Shu Hua P'u (Album of the Ten Bamboo Hall*, first edition A.D. 1630) and the *Chieh Tzŭ Yüan Hua Chuan (Mustard Seed Garden Compendium*, since 1689). All who were occupied with the painter's craft could—and still can—find the various patterns for specified objects, much as one could pick out the different modes of script for letters in the copybooks devoted to writing. Admittedly this is a final stage, almost, one might say, a mechanization of art. Since the Baroque, we are familiar with Western text-books that display a similar character. Indeed, it is also Chinese 'Baroque' that brought about the ossification; but there, as here, a softening-up was again and again being effected by really creative artists. The degree of dependence upon such copybooks offers a certain criterion for the age and quality of works of later Chinese painting.[28]

This is not the place to make a detailed examination of the origins of script and painting, which is a most controversial question, far from being solved. What is sure is: the oldest paintings we know—they are of the Han period—clearly betray calligraphic brushwork, and the mastery of the means employed proves they must have had a long history behind them. But it is just here we grope in the dark. May it not be with China, as with so many peoples, that abstract but significant ornament was the prelude to both script and painting?

Besides the inner relationship, a number of outer ties also exist between painting and calligraphy. By this is meant primarily the inscriptions of various kinds to be found upon the picture surface and on the mounting. In the case of hanging pictures we are dealing with a later development, and this step signifies a further underlining both of the decorative and calligraphic element. The beginning was tentative and limited to the signatures of the masters; but since the 14th century A.D. the practice became more and more intentional, until by the 18th it seemed almost to have gained the upper hand. The inscriptions were then conceived as an integral part of the picture and, for the Chinese at all events, they enhance its artistic significance. As they are often added at a later date, the picture surface undergoes intentional changes in the course of centuries, a procedure which to our Western ideas is quite intolerable. Their actual content is a secondary matter, the decisive factor being their calligraphic beauty and the manner in which they harmonize with the rest of the painting. Nevertheless the inscriptions are occasionally of literary value, and of great help in determining the date and giving a fuller understanding of the work. But, on the other hand, the scribes often expend themselves in empty conventional jingle. It would lead us too far to go into particulars here. The variety of the inscriptions is too great. Yet there are some points to which we may refer. At least since the late Sung period the master often includes one or other of his various names, and one or more of his many seals *(Yin Chang)* in coral-red. So does the collector. Then there are annotations, particularly expository *(T'i Pa)*

[27]Several Western writers have dealt with this subject; for instance, R. Petrucci, *Encyclopédie de la Peinture Chinoise*, 1918; Otto Fischer, *Achtzehn Stilarten der Chinesischen Figurenmalerei*, Ostasiatische Zeitschrift, Vol. VIII, 1919/20; Benjamin March, *Some Technical Terms of Chinese Painting*, 1935; Victor Rienaecker, *Chinese Art*, a series of articles published in the art journal Apollo since December 1943; Victoria Contag, *Das Mallehrbuch für Personen-Malerei des Chieh Tzŭ Yüan*, T'oung Pao XXXIII, 1937. Cf. also n. 18. [28]Of course, it is quite wrong to use this grammar of painting to interpret the methods of pre-Ming painting, although the trend to classify the brush strokes is apparent before Ming. Otto Fischer (op. cit. p. 85) stresses the same point, saying that the theoretical codification probably took place at the moment when Chinese painting had reached the end of its creative power.

牡丹一本同榦二花其紅深淺不同名品矣而兩種也一曰疊羅紅一曰勝雲紅艷麗尊榮皆冠一時之妙造化密移如此褒賞之餘因成口占

異品殊芳共翠柯嫩紅拂拂醉金荷春羅幾疊戀朝雲繡重縈洛絳河至鑑和鳴鸞對舞寶枝連理錦成裹束君造化勝前歲吟繞清香故琢磨

Poem written by the Emperor Hui Tsung (A.D. 1100-1125). Chinese Government.

and laudatory *(T'i Shih)*. The former—and that is the most favourable case—are often written by the master himself; the latter, always by another hand, are, as it were, expert opinions. Poems play a large role among the inscriptions. They may be either verses that inspired the master to produce his work, or they may be expressly meant to praise him.[29]

Thus a Chinese picture is a manifold of intimately interwoven elements, a wonderful harmony in which each of the components—painting, calligraphy, poetry and prose—serves to complement and heighten the others; in which, too, each constituent demands a special critical approach. But, alas, how often does it happen that just where the greatest riches seem to lie, much or all is nothing but imitation, paraphrase or even forgery. The Western investigator should, first and foremost, concentrate upon the painting itself. The Chinese appreciation of calligraphic inscriptions cannot be fully shared by him. As already suggested, in many cases the content of the script is not worth the trouble its translation entails. Incidentally, it is often not too difficult to determine with some certainty, and without having to decipher them, whether the inscriptions and seals are contemporaneous with the painting or have been added to it at a later date. In the latter case they will be found not to have sunk so deeply into the silk or paper as the painting itself.

[29]Useful information regarding inscriptions is to be found in numerous annotated catalogues of picture collections, where they are dealt with very completely, although the paintings themselves are often rather dubious.

IV. WHAT PAINTING MEANS TO THE CHINESE

THE 'Six Arts' (*Liu I*) of the ancient Chinese are Ritual, Music, Archery, Charioteering, Calligraphy and Calculation. Another and later grouping enumerates the 'Four Accomplishments of the Scholar,' namely Music, Chess, Calligraphy and Painting (*Ch'in Ch'i Shu Hua*). In the first classification painting, it will be noted, is not expressly stressed, calligraphy being considered to include both. Thus, of the fine arts as understood in the West, only painting is looked upon as an art; sculpture, architecture and the crafts are not mentioned at all. These were regarded as mere artisan work. Western classical Antiquity thought likewise, although in later times the attempt has been made to annul the distinction between 'high' and 'applied' art. Obviously it was the close relationship in China of calligraphy to painting that gave the latter such overwhelming significance. It is, like script, rooted in magic, as are so many other things all over the world, even in the West of to-day. In the Occident, it is not painting but rather music that has attained to a similarly commanding position in the realm of the arts.

How did this predominance of painting and calligraphy express itself in the life of the people? One or two pointers must here suffice; preparatory works for a sociology of art are still lacking in China. In very early days aspirants to official callings had to pass literary examinations, and only those among them came to rank and honour who had been successful. This institution gradually became more and more influential. We see it fully developed by the time of the Sung period (A.D. 960-1279). Since then the examination system has formed in China the focal point of all intellectual life, and it lost this position not earlier than in the twentieth century.[30] From of old it was difficult to distinguish between the functionary and the scholar; even military officials were scholars. In this respect China is unique. Sages, philosophers and men of letters constituted the leaders of the nation. Calligraphy and painting, as a part of their training, was a *conditio sine qua non* for them all. The rulers and the members of the Court, far from lagging behind, set the example. How often did it happen that the Emperors themselves were more or less prominent calligraphers and painters. One of the first of them we know to have been a notable painter was Ming Ti (A.D. 324-326), an Emperor of the Tsin dynasty. Many others followed. It is not easy to judge to what extent sycophancy added to the fame of princely and highly-placed painters. The fact that they were valued as such is eloquent enough. We in the West should say a flourishing dilettantism prevailed, much as with music in nineteenth-century Europe, or with watercolour painting in present-day England. The comparison is, however, not wholly apt, the situation being a little different in the East. For the famous painters whose praises are justly celebrated in the records often sprang from the upper classes. They were wont to collect their incomes as Generals, provincial Governors, or officials in the Ministries of Justice or Education, or as members of the Board of Excise or Salt Monopoly. Thus we are confronted with a sociology of the artist entirely different from that in the West. In the Western Middle Ages, the painter was a craftsman belonging to a guild and began as an apprentice and grinder of colours. After a certain time he was allowed to become independent. Not till the days of Leonardo and Michelangelo was any change made. The painter of the Renaissance no longer wished to be considered a mere craftsman, but a man of culture, a gentleman, nay, even a

[30]Regarding the examination system, see Edouard Biot, *Essay sur l'Histoire de l'Instruction publique en Chine et de la Corporation des Lettrés*, 1847.

scholar. The same conditions that had obtained in China from ancient times were then being approached. In Europe, also, many cases arose of artists who practised their activity as a side-line. Think of Holland of the seventeenth and eighteenth centuries. But here, what we see are little men plying a trade; there, an intellectual aristocracy to whom calligraphy, and therefore painting, was as their daily bread. The fact that priests were frequently painters is common to East and West.

How the activities of the painter in China worked out in detail, and how he acquired his reputation as a master, are questions still rather obscure. We may be sure that officials did not have to overwork themselves. Their posts are often likely to have been mere sinecures. Sometimes they gave up their positions at an early date in order to devote themselves entirely to painting, calligraphy, poetry or literature. On the other hand, there were masters who never accepted office, and it may be that these were the really creative spirits. Naturally, professionals, as well as official Court painters, as in Europe since the days of the Baroque, were not lacking. It is not clear how far the gentleman-painter derived an income from his artistic activity. What is certain is that after their death the works of famous masters fetched, according to valuation and rarity, prices as high as, if not higher than, those in the West. Common to both West and East are Painting Academies (Hua Yüan). Whilst these did not arise or really flourish in Europe till the 17th century, in China they go perhaps as far back as the T'ang period,[31] and reach their acme in Sung times, under the Emperor Hui Tsung (A.D. 1100-1125). Quite a number of more or less stereotyped stories are recorded concerning the influence of the rulers over the Academies and the dryness of the instruction given. But, in general, it can hardly be said that they had an unfavourable effect, as it is so often asserted with regard to similar Western institutions. How illuminating it would be to make a detailed comparison between both the Academies and the social status of the artist here and there.

It is easily understandable, from the part played by painting in the life of the entire people, that the habit of collecting set in at an early date and was cultivated to a high degree. Already Han accounts speak, though vaguely, of the princely interest in pictures. Concerning the collection of the Liang ruler Yüan Ti (A.D. 552-55) we know he brought together about 240,000 paintings and calligraphies. It is recorded that, foreseeing the end of his reign, he burnt the whole of his huge collection.[32] Most of the Chinese Emperors have, since the Sui and T'ang dynasties, looked upon it as a *nobile officium* to build up in their palaces vast collections of paintings and calligraphies. Parenthetically, in the course of their annual airing, the treasure houses were not infrequently opened to the public, as is still the occasional practice in the East. The example set by the Emperors was followed by officials and scholars. When respectable middle classes in China grew up, particularly in the Ming period, they did not lag behind.[33] The fact that this passion for collecting encouraged the activities of the forger has already been mentioned. Abundant information on this matter is to be found in literature, and the study of the composition of famous collections is most revealing. A series of catalogues, instructive but often unreliable, has been preserved. We also know of a large number of painters who made names for themselves as connoisseurs. Their expert opinions, frequently set down on the picture surface itself, were highly appreciated, though they often appear no less dubious than those of their Western counterparts.[34]

[31]Cf. Nikolaus Pevsner, *Academies of Art, Past and Present*, 1940, p. 34; S. Taki, *Origin and Growth of the Academy in China*, Kokka, No. 274, 1915. Yoshio Yonezawa states in an article in the Kokka, No. 554, that the Hua Yüan originated in the middle of the T'ang dynasty (A.D. 618-906) and not, as often supposed in the Southern T'ang dynasty, one of the usurper dynasties (middle of the 10th century A.D.). Cf. also n. 146. [32]Cf. Arthur Waley, *The Rarity of Ancient Chinese Paintings*, Burlington Magazine, No. 171. [33]Cf. John C. Ferguson, *Chinese Painting*, 1927, p. 14 ff. [34]The more famous the names of the collectors or experts on the paintings, the more doubtful they are. The seals or signatures of the Emperors Hui Tsung, K'ang Hsi or Ch'ien Lung, of the experts Hsiang Yüan-pien or Tung Ch'i-ch'ang, supply perhaps corroborative, but certainly not conclusive, evidence for the authenticity of the picture.

V. THE SUBJECTS

ALL the world over, art has first had to serve religious, mythological and historical ends which are not easily kept sharply asunder. So it was in China, where the themes were provided by the current conceptions of Ancestor Worship, Confucianism and Taoism. We hear of mural decorations in ceremonial halls of different kinds, with representations of remarkable figures and scenes from mythology and history, as early as the days of Confucius. Soon the walls of palaces were being covered with paintings too.[35] With the introduction of Buddhism in the early centuries of the Christian era, numerous temples arose that offered the fresco painter a new wealth of opportunity for his activities. In the beginning the hand scroll seems to have had a mainly illustrative character, being actually identical with the book scroll. Later on, the text more and more receded into the background. By the end of the T'ang period the movable hanging picture competed with the fresco and the hand scroll for first place. Hereupon hieratic mural painting fell in a measure to the level of a handicraft. The hanging picture treated the same subjects as the mural and the hand scroll: religious, historical and courtly topics, genre and portraiture in all their variations. But the centre of interest now became the landscape, to which must be added plants and animals, as well as the strange figures from the world of Taoism and Ch'an Buddhism. These last being hermits, moved mostly within the frame of the landscape. With this special range of subjects, predominant for practically the last millennium, Chinese painting acquired that characteristic which has been peculiar to it, and differentiates it so much from European conceptions. The artists cut themselves off from the commonplace and material things, devoting themselves to the contemplation of those of deeper meaning. And even this restriction often did not suffice. For not every type of landscape was painted, but only the mountain scenes enlivened with waterfalls, rivers or lakes. *Shan Shui*, the word for landscape, signifies 'mountain-water.' Neither were all animals and birds included, but chiefly those pregnant with timeless symbolic ideas. So we meet again and again Dragons, Apes, Tigers and Buffaloes, and above all, birds such as the Phœnix, the Heron, the Crane, the Quail and the wild Goose. In the vegetable world pre-eminence was given to the '*Three Friends*,' i.e. the Bamboo, the Plum-Blossom and the Pine, to which may be added the Orchid, the Peony and the Lotus. This stern limitation of themes naturally has both its drawbacks and its advantages. On the one hand, there is the danger of uniformity and mere virtuosity; on the other, the attention of the spectator to the subject with which he has long been familiar is not so fully engaged, and thus he is enabled to concentrate more on the purely artistic values. To enter into a detailed examination of the symbolism and the meaning of all the subjects occurring in Chinese painting would lead us too far—would lead us, in fact, to a study of the whole body of civilization in China.

Linked up with the symbolic character of so many topics is the fact that painting is knit into the life of the people in a much deeper manner than we are accustomed to in Europe. A very definite demand for pictures has developed in the course of centuries. The different rooms in the house of the well-to-do Chinese call for different kinds of picture. The reception room is decorated with other subjects than the study, the bedroom or the nursery. In this respect the West differs only in a slight degree. Over and above this, the Chinese are in the habit of exchanging the pictures, as their easy movability permits. The various seasons

[35]See A. Conrady's contribution in O. Münsterberg's *Chinesische Kunstgeschichte*, I, 1910, p. 80 ff, and chapter VI of this book.

of the year call for appropriate paintings, as well as special occasions like birth, marriage, death or anniversaries, the passing of examinations, New Year's Day—in fact all days of celebration. Up to this very time, no house is so poverty-stricken as not to own a few pictures, even if they are kept only to ward off evil spirits or bring luck to the family. They also served as presents, and thus the demand for them attained astonishing dimensions. A plethora of painting set in, to the extent of which the immense quantities in China herself and in Western museums and collections bear eloquent witness. To satisfy the insistent requirements of the people, works of all qualities and all prices were produced. Not only the highly honoured masters, but also the more or less dexterous craftsmen in factory-like workshops laboured to this end. Every mode of production was exploited; from important and unique originals, thence on to school works, duplicates and paraphrases of famous models, and finally copies and forgeries, and all these of the most varied quality. After the invention of block-printing in the 6th or 7th century A.D., woodcuts were also made. But the latter, as already remarked, played no great part. A simply mounted painting from any suburban workshop was not much more costly than a woodcut print. In the case of an accredited master of the past or present, and particularly when the picture was additionally enriched by the inscriptions of connoisseurs or collectors, the intending purchaser had to dip deep, sometimes very deep, into his purse. And thus it has remained right up to the present time. At any rate, the great majority of Chinese pictures that fill the art markets and collections of East and West are mass-produced.

Recapitulating briefly, we may say that a comparison of the range of subjects of Chinese and Western painting shows many surprising parallels. Mythological, religious and historical themes have, in both, never ceased to attract the artists. Genre painting of all descriptions, too, was as much at home in the East as in the West. This holds good even for still-life. It is often said that portraiture seemed to be of little or no significance in Chinese painting. This is far from being true. Actually, it was highly favoured from the earliest time and its style changed in harmony with the general development.[36] The most striking difference between the two arts is that landscape, flower and animal subjects were more predominant in China and emerged at an earlier stage than in Europe.

[36]Cf. S. Elisséev, *Notes sur le Portrait en Extrême-Orient*, Études d'Orientalisme publiées par le Musée Guimet, 1922; William Cohn, *Ostasiatische Portraitmalerei*, 1923.

VI. FORMATIVE PERIOD

FROM THE EARLIEST TIMES TO THE HAN DYNASTY (206 B.C. TO A.D. 220)

IF every activity employing the use of colours and brushes (or some brush-like instrument) is to be called painting, we know hardly a people to whom it is not indigenous. In this sense the subject may engage not only the student of pre-history and of anthropology, but the art historian as well. Here, however, painting is to be considered in so far as its products have acquired a representational character and a value in their own right. At what particular time this happened in China is just as difficult to determine as with any other people. Chinese writers (the earlier and the later) attribute the legendary invention of painting, like that of all other cultural achievements, to certain 'Culture-Heroes'; the Greeks, as everybody knows, did much the same in Western Antiquity. Various names are mentioned in China, but the godfathers of painting are difficult to distinguish from those of calligraphy. The credit for having invented painting is usually given to Shih Huang, a minister of Huang Ti, the Yellow Emperor (conventional date 2697-2597 B.C.).[37]

An examination of the oldest surviving monuments adorned with subjects taken from the world of animals and men, as, for instance, the ritual bronze vessels, suggests that the representation of human beings in action did not appear until a relatively late date in Chinese art. In its earliest days, i.e. from the Shang period (?1766-?1122 B.C.) till the end of the Western Chou period (c. 722 B.C.), art seems to have been essentially zoomorphic and highly symbolic. What can literary sources bring to bear upon the earliest development of painting? The greatest part of the oldest Chinese literature has been, as we shall see later, largely altered by interpolation and is therefore not reliable. This much is likely: painting as an independent art existed in the 6th or, at the latest, 5th century of the pre-Christian era. Its earliest efforts may go back still further, having their origin in that zoomorphic art already mentioned. The references to painted portraits in Confucian books or in writings by Chuang Tzŭ (4th to 3rd century B.C.) are not quite trustworthy. But with Ch'ü Yüan (332-295 B.C.) we seem to stand on firmer ground. In his *T'ien Wên*, that is the third part of the *Elegies*

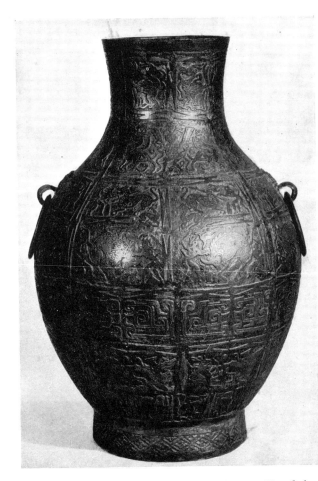

1. Bronze vessel (*Hu*) with *Hunting Scenes*. H. of the Hu 38 cm. 5th-3rd century B.C. Chinese Government. Cf. pl. 1.

[37] Cf. Friedrich Hirth, *Die Malerei in China. Entstehung und Ursprungslegenden*, 1900. It is said that the general Mêng T'ien invented the brush in the 3rd century B.C. But, in fact, Mêng T'ien can only have contributed to the improvement of the brush, which existed already in the Shang period (2nd millennium B.C.), as certain remnants of brush-writing on oracle bones prove. Cf. Herlee Glessner Creel, *The Birth of China*, 1936, p. 172 f.

of Ch'u, he deals with figures of mythology and history, and we are disposed to conclude that he really describes mural paintings.[38] Later on, Han Fei Tzŭ (d.233 B.C.), Huai Nan Tzŭ (d.122 B.C.) and, more especially, Wang Yen-shou (middle of the 2nd century A.D.) speak of painting as of an old established practice. In his famous poem, *The Ling Kuang Palace* (excellently translated into English by Arthur Waley), Wang Yen-shou depicts the frescoes of that palace (erected about the middle of the 2nd century B.C.) in detail. The subjects named by these writers are portraits of heroes, rulers and ministers, historical and religious scenes (mythological, legendary and didactic, as we should call them). The scanty remnants of the oldest paintings that have survived probably belong to the Han period. Of the painting of the centuries preceding Han times an echo is to be found in other branches of art. There are low reliefs on globular bronze vases (Fig. 1), believed to have been produced about the *Pl. 1* period of the *Warring States* (c.481-221 B.C.), a study of which would prove very illuminating.[39] The subjects are hunting scenes. But we find, too, some figures whose meaning is not yet clear. Perhaps they represent some sort of exorcist with animal mask, such as used to play an important part in the life of those days. Thus no ordinary scenes of the chase seem to be intended here, particularly as the animals introduced are often of a supernatural order. The clear and expressive silhouettes of the representations almost suggest shadow-pictures. All the figures appear in profile and if occasionally a head is turned more or less full-face, the body usually retains its side-on aspect. The preference is for symmetrical arrangements, be it a face-to-face or back-to-back view, probably the result of Western (Iranian) influences. The treatment is purely in terms of flat-surface and the depth of space has been converted into two dimensions. We find no suggestion of surrounding scene. Men and animals show strong movement and produce a surprisingly life-like effect.

The *Warring States* period was one of transition. The Chou dynasty (?1122-221 B.C.) had lost practically all its political power. China had crumpled into numerous petty princedoms. The feudal system, once a magnificent organization, broke down; wars between the different feudal states were unceasing. This time of political unrest and confusion, as can also be observed in the life of other peoples under similar conditions, saw rich spiritual production. Ideas and conceptions, decisive for the entire later development of China, came to light. This was the age of the *Hundred Schools* of philosophy. The pupils of Confucius (K'ung Fu Tzŭ, 551-478 B.C.) set out to interpret his world of thought. Taoism, the doctrines of which were said to have emanated from the rather vague figure of Lao Tzŭ (traditional date b.604 B.C.), took a more definite shape. Its first historically documented exponent, Chuang Tzŭ, was not active, however, till the 4th century B.C. Besides, mention must be made of Mo Tzŭ (5th to 4th century B.C.), the proclaimer of universal love for mankind, and Mêng Tzŭ (b.372 B.C.), who interpreted and still further developed the philosophy of Confucius, both significant representatives of the spiritual life of the epoch. Yet the actual course of events was determined by quite other thinkers: by Hsün Tzŭ (3rd century B.C.) and, above all, by Kung-sun Yang (Lord of Shang, 4th century B.C.). In opposition to Mêng Tzŭ, the former believed in the innate wickedness of human nature; the latter, were he alive to-day, would almost certainly be regarded as a kind of fascist.[40] Apparently their teachings inspired the 'First Emperor' (Shih Huang Ti, 221-209 B.C.) with leading principles for his revolutionary

[38]Cf. A. Conrady, E. Erkes, *Das älteste Dokument zur Chinesischen Kunstgeschichte*, T'ien-Wên, 1931. [39]Such vases occur in several collections all over the world; for example, in the Freer Gallery, in the Chinese Government's collections, in the Stoclet collection, Brussels, and in the Imperial Museum, Tōkyō. Cf. also N. Viandier, *Note sur un Vase Chinois du Musée du Louvre*, Revue des Arts Asiatiques, XII, 4, and Bernard Karlgreen, *The Date of the Early Dong-so'n Culture*. Bulletin Museum of Far Eastern Antiquities, Stockholm, 1942. [40]H. H. Dubs, *Hsüntze, The Moulder of Ancient Confucianism*, 1927; H. H. Dubs, *The Works of Hsüntze*, 1928. J. J. L. Duyvendak, *The Book of Lord Shang*, 1928, and E. R. Hughes, *Chinese Philosophy in Classical Times*, 1942.

measures. It is easy to comprehend that with the appearance of such critical and self-willed personalities, old established philosophical and religious conceptions should begin to totter. The profound change in the spirit of the age expressed itself in art most distinctly in the revolution undergone by the ritual bronzes. They lost their severe archaic forms, and with them the magic symbolism of their decoration. Their place was taken by simple and often almost elegant vessels adorned with new design, either ornamental or representational; and it was at this time that those vase reliefs, with their dynamic hunting scenes, appeared.

The epoch of the *Warring States* in many respects resembles that of Greek history before the Macedonian hegemony: political disintegration, the struggle of all against all, and an intense spiritual and mental awareness. The Macedonian state, considered by the Greeks as semi-barbarian, attained the upper hand by a concentration upon military development and a disregard of the accepted political usages. Something similar happened in China. Macedonia corresponded to the State of Ch'in, which lay beyond the Western boundaries of China proper of that day. Ch'in spread out more and more, one feudal state after another becoming its victim. The house of Chou lost its last possessions to Ch'in in the year 256 B.C., and soon after, all the remaining feudal states found themselves in the same plight. In 221 B.C., the King of Ch'in proclaimed himself Shih Huang Ti, the 'First Emperor' of China. The new spirit brewing for a long time in all fields of intellectual life now expressed itself in the whole outlook of the country. Numerous totalitarian laws and regulations were introduced. In 213 the Emperor agreed to the proposal of his mighty minister Li Ssŭ to burn all ancient philosophic and historical works, with the exception of those contained in the Imperial Library,[41] in order to paralyse both the adoration and influence of the past and the dissatisfaction with the present. Another proclamation ordered the unification of the system of measurements. To put an end, once and for all, to the depredations of the nomads, particularly to those of the Hsiung Nu (Huns), the Emperor caused the Great Wall to be built. Although such protective walls already existed in some feudal states, and even though the erections made in the time of Shih Huang Ti did not exhibit anything of the monumental grandeur of the still surviving wall (most of which was constructed in the Ming period), nevertheless the plan of these fortifications—over 2,500 miles in length—is surely to be reckoned among the mightiest the human mind has ever conceived. The 'First Emperor' wished, like all dictators, to be considered a great builder. Ssŭ-ma Ch'ien, the famous historian, who compiled his works a bare hundred years after Shih Huang Ti's death, becomes very eloquent over the numerous palaces erected by the Emperor. We hear much of their magnificence, and one may suppose they were embellished with frescoes; but nothing has survived. The rule of the Ch'in dynasty, for which its founder prophesied a duration of ten thousand years, was actually too short to produce an impress on art. To-day we have rightly given up speaking of a Ch'in style. Soon after the Emperor's death rebellion broke out; then attempts were made to reconstitute the feudal states, to be followed by violent struggles between the rival leaders. From these Liu Pang, a simple peasant, emerged the victor. He founded the epochal Han dynasty that was to determine the destinies of the Land of the Middle for four hundred years.

With the establishment of the Han dynasty (206 B.C.-A.D. 220) China stands in the full light of history. There still exist considerable gaps in our knowledge, and doubts there cannot but be; in its essentials, however, we now have a clear picture of her political, spiritual and artistic state. The country remained a centralized monarchy. But the Han Emperors not only permitted a new hierarchy of scholars to arise; they encouraged them, and even relied upon them. The introduction of literary examinations supported this develop-

[41]Not much later this library was also destroyed during the disturbances which accompanied the end of the Ch'in dynasty.

ment.[42] Thus, at this early date, a certain unification occurred between officialdom and the intellectual *élite*. Shih Huang Ti's ukase on books was officially revoked in 191 B.C. A lively activity set in to reconstruct, comment upon, and publish whatever ancient literature, particularly Confucian, had survived the holocaust. Opinion is still divided concerning the extent and dependability of these remains. In any case a remarkable spectacle is offered to us: at first the philosophic and historical writings were destroyed and then zealously reconstituted—naturally in the particular spirit of the emendators, which often means in accordance with the wishes of the ruling dynasty and in the sense of the prevailing beliefs. Finally—and this has been the task of Sinology, especially during the last century—, the effort was made to root out the glosses of the Han scholars and to extract the original text, on which the views of the scholars of both East and West are similarly at variance.

The blossoming of philology in the Han era brought forth further achievements. The first Chinese dictionary arranged according to a system of 'keys' was compiled. The most brilliant feat of the age was accomplished in the field of history. Ssŭ-ma T'an, and particularly his son Ssŭ-ma Ch'ien (*c*.136-85 B.C.), created the *Shih Chi,* the most important of earlier Chinese works on history, the prototype of countless later compilations, and our inexhaustible source for the old culture of China.[43] Mention might also be made of the *Ch'ien Han Shu,* from the pen of Pan Ku (d. 92 A.D.), the first official dynastic history to deal with early Han.

But the orientation of the period was far from being purely retrospective and conservative. It seems that Taoism was the most powerful force, penetrating all spheres of life, and it becomes more and more patent that it attained now almost as much importance as Confucianism. In the West, and occasionally by the Chinese themselves, Taoism was regarded as full of superstition and witchcraft. What religion is entirely free of such elements? Taoism is replete with profound ideas of an ever fructifying nature. The conception of Universalism, in its main implications a belief in the harmony subsisting between the phenomena of Heaven and Earth, belongs, in fact, to the sphere of Taoism. It was formulated in Han times, though its origins are to be traced still further back. Besides, that opposition to life as led at court and in the city, so strongly emphasized in poetry and painting, grew out of the world in which the Taoist *Wu Wei* (non-activity) set the ideal. The greatest thinkers of the age, such as Huai Nan Tzŭ, Han Fei Tzŭ and Wang Ch'ung, not to mention any of the monarchs, paid homage to Taoist wisdom.

A most significant trend of the Han era was its urge to discovery and expansion, an urge to manifest itself only once again with equal power half a millennium later, in the T'ang period. Linked with this was a new accessibility to impressions and stimuli from abroad. This brought in its train the introduction of Buddhism into China.[44] The foreign religion began to gain a following in the land of Confucius, though not in the least because many of its ideas were closely related to those of Taoism. Under the eminent Han ruler Wu Ti (140-87 B.C.), who occupied the throne more than fifty years, Chang Ch'ien, an explorer in the modern sense, made different expeditions leading him as far as Ferghana and Bactria. A man of similar mentality, Pan Ch'ao[45] (A.D. 32-102), resumed the work of Chang Ch'ien in the 1st century A.D., and on a larger scale. These were the first official contacts with Western civilization. Chinese armies reached Kashgar and Hami in the West, and Korea and Indo-

[42]It seems that the beginning of the official examinations can be traced to the Emperor Wu Ti (140-86 B.C.). Cf. Otto Franke, *Geschichte des Chinesischen Reiches*, 1930, I, p. 301. [43]E. Chavannes, *Les Mémoires Historiques de Se-ma Ts'ien,* 5 volumes, 1895-1905. [44]The date of the official introduction of Buddhism into China is A.D. 65, when the Han ruler Ming Ti had dreamt of a great deity in the West and sent an embassy to introduce his cult in China. This is, however, a legend put forth after the event. Actually Buddhism began to percolate into China at an earlier date. H. Maspero, *Le Songe et l'Ambassade de l'Empereur Ming,* Bulletin de l'École Française d'Extrême-Orient X, 1910; Otto Franke, *Die Ausbreitung des Buddhismus von Indien nach Turkestan und China,* Archiv für Religionswissenschaft XII. [45]Incidentally, Pan Ch'ao was the brother of the already mentioned historian Pan Ku and of Pan Chao, a well-known woman writer.

China in the East and South. The connexion with so many foreign countries left its mark in all spheres of life, not least in art. On the other hand, art productions of Han China such as textiles, bronzes and lacquer, found their way into South China (then still alien), into Korea, Mongolia, Afghanistan, Turkestan and Indo-China; surprising witnesses to the spread of Chinese culture and trade in this age. Whether, and how far, paintings participated in this exchange we are not able to determine.[46]

Painting—and, incidentally, architecture—is the least known art form of the Han era. According to the literary sources, we might expect to find frescoes and paintings on silk or paper[47] hand scrolls. The accounts mention the names of a few painters, some picture titles, and they recite a number of anecdotes.[48] Furthermore, we learn of some mural paintings, and of a series of imperial commissions, particularly portraits, referring to the entire period. In short, the literature is now replete with allusions to painting. Quite obviously art was a significant factor in the life of the day.

Which of the surviving works of Han art are best suited to furnish us with some clear idea? First and foremost, a series of slabs and tiles of funeral chambers decorated in low relief.[49] *Pl. 2, 3* They must be considered rather as documents of painting than of sculpture. Whatever technique may have been applied—and there are three or four different ones—, they were always kept almost entirely flat and recall the methods of painting, from which they probably derived. Naturally, the eloquence of the brush—the soul of Chinese painting—failed to find expression; nevertheless we can gain much enlightenment from these reliefs. The style is *Pl. 1* predominantly the same as in the décor of the bronze vessels of the *Warring States*, of which mention has been made. Here, as there, all expression lies in the vivid outlines and in the wealth of movement. Preference is given, as before, to more or less pure profiles, likewise the same arrangement of friezes or stripes is to be found, and the same fabulous animals disport themselves. But, in the Han era, the range of subject matter has considerably increased. All spheres of belief, of history, of manners and usages are touched upon. We have the opportunity of getting acquainted with the architecture of the time. Deities, heroes and rulers of Antiquity appear, as well as paragons of feminine propriety and filial piety. The aim is to teach and to exhort. We also witness battles, chases, banquets and receptions. Representations of jugglers are conspicuous; the same circus items are here reproduced which still form the repertory of Chinese variety artists to this day. It is often possible to date these low reliefs within reasonable limits by means of their accompanying inscriptions. They belong in the main to the Eastern Han dynasty, i.e. to the first two centuries after Christ. It

[46]In all these countries objects of art and craft, with the exception of paintings, have recently been excavated; among others, a silken fragment with inweaves of mountains, rocks, trees and birds. It was found in Noin Ula (Mongolia) and may be the earliest Chinese landscape representation we know. Cf. W. Perceval Yetts, *Discoveries of the Kozlóv Expedition*, The Burlington Magazine, April, 1926. To the Korean finds we shall refer later. [47]The traditional date of the Chinese invention of paper is A.D. 105. Paper manuscripts of the 2nd century A.D. have been found by Sir Aurel Stein and Sven Hedin in Central Asia. Cf. E. Chavannes, *Documents Chinois découverts par Aurel Stein dans les Sables du Turkestan Oriental*, 1913; A. Herrmann, *Lou-lan, China, Indien und Rom im Lichte der Ausgrabungen am Lobnor*, 1931. The quality of the paper used for painting was of greatest variety and was gradually improved. The same is true of silk, the invention of which seems to go back to prehistoric times. Cf. John C. Ferguson, *Chinese Painting*, p. 37 ff. [48]At least the names of Mao Yen-shou, Ts'ai Ying, Chao Ch'i and Liu Pao may be quoted, because they occur not infrequently in art literature. Connected with Mao Yen-shou is the popular story of Chao Chün, a palace lady. When he painted her for the Han Emperor Yüan (48-32 B.C.), she refused to bribe him. Consequently he made her portrait less attractive than those of the other palace ladies. Later on, Chao Chün was sent away to be the wife of a Hsiung Nu chief. Before she departed, the Emperor saw her and realized that in fact her beauty surpassed that of all the other ladies. This anecdote is a favoured subject of Chinese painting. But cf. Paul Pelliot, *Notes sur quelques Artistes des Six Dynasties et des T'ang*, T'oung Pao XXII, 1923, where Pelliot points out that the Chinese literary sources, especially regarding the early painters, are often full of errors and considers the story of the princess Chao Chün to be a later invention. Cf. also Friedrich Hirth, op. cit., p. 18 ff. [49]A great part of them was first published by E. Chavannes, *Mission Archéologique dans la Chine Septentrionale*, 1909-15. Later on, they were discussed in almost all publications on Chinese art. Cf. also William Charles White, *Tomb Tile Pictures of Ancient China*, Toronto, 1939; Olov Jansé, *Briques et Objets Ceramiques Funéraires de l'Epoque des Han appartenant à C. T. Loo et Cie*, Paris, 1936.

may be inferred from the dates that we are not yet able to draw a clear line of development. We are obviously dealing with sporadic examples of handicraft products. The nature of the problems, however, with which art was beginning to wrestle emerges quite plainly. Advancing from stripe arrangement and single scenes, an effort towards more elaborate interdependence is being made. Unified balanced compositions of wider scope are sought after. Pure two-dimensionalism no longer satisfies; the endeavour to acquire spatiality and figural plasticity has begun. The profile view tends more and more to be discarded in favour of overlaps and foreshortenings. The figures, indeed, begin to take on an individual appearance. Observe that, according to the sources, it was portraiture which formed one of the principal tasks of Han art. Thus, what the stone slabs have to tell us is by no means little, even though it be only what we can read from rather crude reproductions.

This becomes at once evident as soon as we are confronted with works of the time in which the brush itself, and not the stonemason's chisel, is allowed to speak. Unfortunately, such examples have survived only in small numbers, and even then, where they serve as subsidiary ornamentation. Doubtless they are originals, but it is unlikely that artists of the first rank were engaged upon them. The two most outstanding works will receive attention here: decorations on a basket and on hollow tiles. The basket (Fig. 2), excavated in a Korean

2. Basket with paintings in lacquer colour. H. of the basket 22 cm. L. 39 cm. W. 18 cm. 2nd or 3rd century A.D. Museum, Seoul. Cf. pl. 6-10.

grave, shows paintings in lacquer, perfectly preserved.[50] We see figures, erect and seated, each one with an inscription. They are persons who have distinguished themselves in filial piety. Their vitality is surprising; so, too, the expressiveness of gesture and certainty of characterization. The figures are seen from all angles, pure profile, front view, three-quarter, and from the back. Draperies are delineated with vigorous strokes, while the master has treated the faces with the point of the brush. No attempt is made to suggest a setting, but space can be felt between the various persons engaged in animated discussion, whose relation to one another is stressed by the directions of their glance and turn of the bodies. The colours are the usual ones employed in lacquer painting; the flesh of the males being reddish, of the females cream, a differentiation similarly to be met with in Indian painting—in fact, the women wear make-up!

Pl. 6-10

[50]See *The Tomb of the Painted Basket of Lo-lang, I*, Keijō, 1934.

Whereas the ornament on the basket is carried out in viscous lacquer colours, that on the hollow tiles is in a medium similar to that of Chinese painting. It is, however, doubtful whether it can compare in artistic value with the paintings on the walls of temples and palaces extolled in the sources. Several decorated hollow tiles are preserved, the most important being excavated from a tomb in the neighbourhood of Lo Yang (now in the Boston Museum). An animal fight and spectators seem to be the subject. We see the brush-stroke with all its calligraphic crescendo and diminuendo. The conception is more subtle, the gestures are more finely articulated, the spatial relations between the various figures have become more distinct than in any representation described so far. The fact that no hint at a setting is offered is, in China, by no means a sign of some specific stage of style; rather it reveals a mode of expression which has never entirely been given up.[51]

Pl. 4, 5

Altogether, despite the paucity of the material, we can say that the Han era developed the main features of Chinese painting. We dare not say more, we can hardly say less. But it would fit well within the framework of so creative an epoch if we could ascribe to it a major share in the evolution of China's language of the brush.

[51]It is, of course, possible that these and the lacquer paintings are somewhat later than the Han era. Cf. K. Tomita, *Portfolio of Chinese Paintings in the Museum of Fine Arts*, Boston, 1933. There exist bronze containers, earthenware vases and other hollow tiles decorated in a similar way. Cf. Otto Fischer, *Die Chinesische Malerei der Han-Dynastie*, 1931; Hamada Kōsaku, *On Chinese Painting in the Han Period* (in Japanese), Kokka No. 508, 509.

VII. FIRST DEVELOPMENTS

THE SIX DYNASTIES (A.D. 220-589)

PALACE revolutions, rebellions and the influence of the eunuchs caused the downfall of the Han dynasty. It was followed by another epoch of nearly four hundred years which has been labelled, as was the early medieval age of Europe, the 'Dark Ages'. In fact, a whole series of allied phenomena can be traced in both. Consider, for instance, the rise of new states in conjunction with the invasion of so-called barbarian peoples and the introduction and spread of a new religion from foreign countries. But the term 'Dark Ages' is just as much out of place here as it was in Europe; for in both cases those centuries were replete with creative powers in all realms of the spirit.

After the overthrow of the Han, China disintegrated into numerous and, very often, mutually hostile states. Particularly at the outset of this period, the country had to endure repeated invasions by nomadic tribes of the North, who, however, were not only quickly assimilated, but were soon transformed into bearers of Chinese culture. New states under short-lived dynasties proceeded to emerge. The *Five Hu* (foreign invaders) founded no less than 'Sixteen Kingdoms'. Countless monuments of art suffered destruction in the course of these disorders. The capitals Lo Yang and Ch'ang An were plundered and devastated several times. In his famous *Li Tai Ming Hua Chi*, completed in the year 847, Chang Yen-yüan gives a moving account of the fate of the various imperial art collections.[52] In spite of all this, neither spiritual nor artistic life came to a standstill. The South at all events was barely touched by invasions and thus it gradually gained a cultural superiority. Here, with Nanking as their brilliant capital, six different dynasties who gave the period its name followed one another between the years 220 and 589.[53] A subdivision of the period is known by the title *The Three Kingdoms* (*San Kuo*, 221-280), another by the title *Period of Northern and Southern Dynasties* (*Nan Pei Ch'ao*, 386-589), because the Wei dynasty, an alien one, was step by step consolidating itself in the North. The Northern Wei (386-535) and the Southern Liang dynasty (502-557) were the two that, of all others, did most to continue the cultural tradition of China.

The short initial period, *The Three Kingdoms*, owes, it is true, its fame to a warlike prowess, a fame unique in the annals of Chinese history. The most famous historical Chinese novel is dedicated to the glorification of this era.[54] Its heroes are even to-day among the best beloved figures of the stage and are frequently depicted in art. One of its generals, Kuan Yü, was exalted to the rank of a War God, with the name Kuan Ti, and as such is still honoured. Yet at the same time, the group of the *Seven Sages of the Bamboo Grove* emerged,[55] and in their circles the attempt was made to harmonize Taoist and Buddhist ideas. Here, we meet those hermits who withdrew from the artificialities of the world, to lead, in communion with nature, a contemplative life. This signified opposition to the dictates of Confucianism. It is small wonder that art soon included them in its subject matter. In the 4th century Wang Hsi-chih (321-379) and his almost equally gifted son, who are both among the most highly prized masters of calligraphy, lived and worked. Not much later T'ao Ch'ien (Yüan-ming, 365-427), the great poet, composed his memorable poems. Anthologies of verse and prose (among which the Wên Hsüan was the first) were compiled in the 6th century.

[52]Cf. O Sirén, *A History of Early Chinese Painting*, 1933, I, p. 26 f. [53]It is worth mentioning that China was united for a short time in those days, i.e. under the Emperor Wu of the Chin dynasty (A.D. 265-290). [54]That is the *San Kuo Chih Yen I*, in its present form a work of the 16th century. Translation by C. H. Brewitt-Tailor, Shanghai, 1925. [55]Cf. L. Wieger, *Histoire des Croyances religieuses*, 1927, p. 333 f.; C. P. Fitzgerald, *China, a Short Cultural History*, 1935, p. 262 ft.

The fact that the country was in such a state of political unrest may be one of the reasons why religious teachings found so many willing ears. Without doubt, the epoch of the 'Six Dynasties' must have been the most devout in China's history. The Buddhist cave temples of Yün Kang and Lung Mên, with their richly carved ornament, bear eloquent witness to the fact. Buddhism gained more and more adherents; Taoism began to develop into a religion with rites, temples and priests. A decisive point was reached when the Taoists were granted a religious head under T'ai Wu Ti (424-452), their temple being visited by the Emperor in person. Buddhism and Taoism alike, with their contempt for worldly concerns and their speculations regarding the Beyond, progressively proved themselves indispensable complements to Confucianism, with its secular orientation. Although the seeds of this development were already sown in the Han period, they were only now beginning to shoot.

Whereas Taoism was associated with China's earliest metaphysical conceptions, Buddhism made its appearance as a completely new religion imported from abroad. Taoism certainly paved the way, only in its turn to incorporate Buddhist elements. The first centuries of the Christian era saw, in India and Central Asia, the rise of Mahāyāna, the Great Vehicle, which bears a similar relationship to early Buddhism as mature Catholicism does to early Christianity. It was primarily in the form of Mahāyāna that Buddhism entered China. The cult soon became firmly established, and with it grew up a flourishing Chinese-Buddhist art. Artists never wearied of portraying Mi-lo (Maitreya), the Buddha of the future world period, as well as the historical Buddha and O-mi-t'o (Amitābha), or the Bodhisattva Kuanyin (Avalokitesvara), to mention only the favourite figures. A multitude of translations, especially of the momentous Mahāyāna Sūtras were published. Kumarajiva, the most prolific of the translators, came from India to China in 405. He was responsible for the first translations of the *Saddharma-pundarīka Sūtra*, the *Vimalakīrti* and the *Amitābha Sūtras*.[56] Chinese pilgrims journeyed to India, the holy land of Buddhism, in order to visit those spots where the Enlightened One had lived and preached. Accounts of these travels appeared; the first of them, still worth reading to-day, being by Fa Hsien, who stayed in India from 399 to 414.[57] Indian priests also came to China, among others Bodhidharma (Ta-mo), who landed during the reign of Liang Wu Ti (502-549). Chinese Buddhist sects developed. The first to become established in China seems to have been the Ching T'u sect, in which the Buddha O-mi-t'o and his Western paradise formed the centre. Bodhidharma is reputed to have founded the Ch'an sect,[58] which practised a remarkable blend of Buddhism and Taoism. Perhaps no other Buddhist sect had such far-reaching significance for the whole of Chinese art than these two.[59]

What remained of the art of the time is scanty. Its sculptures, executed in durable materials such as stone or bronze, had some chance of withstanding the depredations of time and of man's destructive hands; but even here the gaps are large, particularly in the first centuries of the age. Works in wood and dry lacquer mostly perished with the temples in which they stood. The plight of painting was the most unfortunate of all. It may be recalled how in the year 554 the Liang ruler Yüan Ti consigned his vast collection of pictures and book scrolls to the flames. That is only one case among many.

There seem to have been two streams, broadly, in the painting of the time which enriched one another. On the one hand, the realistic Han tradition continued, and on the other a new Buddhist painting grew up, in the development of which Indian, Central Asiatic and Iranian influences participated. The number of recorded masters is much greater than in

[56]Buddhist art was deeply inspired by these three Sūtras. [57]Cf. James Legge, *A Record of Buddhistic Kingdoms*, 1886. [58]The proper founder of the Ch'an sect seems to have been the Chinese priest Hui-nêng (d. 713), cf. fig. 35. In fact, the Ch'an doctrine is rather a Chinese version of Buddhism. Cf. Hu Shih, *Development of Zen Buddhism in China*. The Chinese Social and Political Science Review, Vol. 15, 1932. [59]The T'ien T'ai sect, too, was founded in the 6th century. The Saddharma-pundarīka Sūtra is its principal scripture.

the past. Let us glance at a few of them. They are repeatedly extolled in ancient literature and mean something more to us than mere names.[60] We know, for instance, that they were chiefly high officials and scholars. The subject matter of their pictures is tabulated. Occasionally some remark is even made which can give us the key to their method of painting. But most of the accounts are later inventions, cock-and-bull stories, and not of much help. In the stormy years of the *Three Kingdoms* (3rd century), we have Ts'ao Pu-hsing, who appears to have been the earliest painter of dragons to achieve fame. He is the first of whom a specific work is noted down in the catalogue the Emperor Hui Tsung (1082-1135) caused to be issued nearly a thousand years later. This monarch also claimed to have possessed among his collection original works by Wei Hsieh (4th century), whose themes were of the didactic order which found acceptance in those days.[61]

The most significant painter of the whole epoch was indubitably Ku K'ai-chih (?350-412); If all that has been recounted and written about him were to be collected it would fill volumes. Western writters have made their contribution too.[62] There are even a few paintings ascribed to him in Western collections, and some critics go so far as to take them for originals. The topics of about sixty of his pictures have been handed down to us. Ku was one of the earliest painters to treat Buddhist themes; he is said to have adorned the walls of temples with frescoes. His landscapes are among the first to be spoken of, and his portraits received high praise. Several short treatises on painting have been attributed to him.[63] Lastly, we know some facts about his life. And what of the works that pass under his name? Here the outlook is not very bright.[64] Only the famous hand scroll in the British Museum, *Admonitions of the Imperial Preceptress (Nü Shih Chên)*, is worthy of confidence, if not as an original, at least as a dependable copy, perhaps of early Sung times.[65] The style of the work stands just midway between Han and Sui. Emphasis is laid on the outlines as in Han painting, while several of the details appear similar to those in the low reliefs of the Han slabs. New and personal contributions are to be found in the harmonious grouping of the figures and in the realization of the individuals. Here, Ku K'ai-chih seems to stand out from among his compeers and to look over and beyond them. Where the masters of the Han tiles used calligraphic accents, Ku availed himself of even, flowing lines. It may be assumed that both methods had already been developed in Han painting, and they proceeded side by side. The treatment of the landscape in the scroll (Fig. 3) is somewhat surprising. The compact and massive mountain scenery is strikingly reminiscent of the lids of certain hill-shaped vessels (hill jars, *Po Shan Lu*) of the Han period.[66] Besides, men and animals, sun and moon, are thoroughly out of propor-

Pl. 13, 15

[60]The copies after works of these and other early painters which are attributed to the Emperor Hui Tsung are of no documentary value, being only free paraphrases. Some illustrations in John C. Ferguson, *Chinese Painting*, 1927, p. 42 ff. [61]The great calligraphists Wang Hsi-chih and his son Wang Hsien-chih, who were active in the 4th century, were, of course, also respectable painters. The painting attributed to Wang Hsi-chih, published by Mrs. Agnes E. Meyer, shows once again that even the most imposing pedigree furnished by the inscriptions is not to be taken as a proof for the genuineness of a work. Cf. Agnes E. Meyer, *A Chinese Primitive*. Hirth Anniversary Volume, 1923. [62]Cf., for instance, Laurence Binyon, *A Chinese Painting of the Fourth Century*, The Burlington Magazine, 1904; Edouard Chavannes, *Ku K'ai-tsche*, T'oung Pao, 1904; id. *Notes sur la Peinture de Ku K'ai-tsche conservée au British Museum*, T'oung Pao, v, 1909. In the former article Chavannes gives Ku's biography; in the latter, a translation of the text to the scroll in the British Museum by Chang Hua. Arthur Waley has devoted a chapter of 22 pages to Ku K'ai-chih in his *Introduction to the Study of Chinese Painting*, 1923; John Ferguson wrote 10 pages on Ku in his *Chinese Painting*, 1927. Laurence Binyon, again, added a booklet to the publication of the hand scroll in the British Museum, *Admonitions of the Imperial Preceptress*, in colour-woodcut, published by the Trustees of the British Museum in 1912. [63]Cf. Shio Sakanishi, *The Spirit of the Brush*, 1939, p. 23 ff. Ku's writings (if they are in fact by him) are impregnated with Taoist ideas. [64]The scroll of the Freer Gallery, Washington, *The Lady of the Lo River*, and the landscape scroll in the Metropolitan Museum, New York, attributed to Ku K'ai-chih, are certainly later than the 4th century A.D. The former is reproduced in the *Pageant of Chinese Painting*, pl. 5, and Sirén, *Chinese Paintings in American Collections*, pl. 1. There are also some stone engravings, especially in the Confucian Temple in Ch'ü Fou, which are said to have been executed after works by Ku K'ai-chih. Yet their style does not appear to have anything to do with the master. [65]The opinions on the genuineness or the date of the scroll widely differ. Cf. also Paul Pelliot, *Le plus ancien Possesseur connu du 'Kou K'ai-tsche' du British Museum*, T'oung Pao, xxx, 1933. [66]Cf., for example, the hill jar of the Victoria and Albert Museum, London, illustrated in Leigh Ashton and Basil Gray, *Chinese Art*, 1925, Fig. 20 a.

tion, most markedly so the kneeling huntsman with his cross-bow aimed at the animals in the mountains. The lack of proportion in this scene is at variance with the more highly developed spatial relations of the remainder; it would appear as though the master were experimenting. We certainly have before us one of the earliest attempts in Chinese painting at representing a real landscape. The tentative nature of this effort should go to prove that other works as well as the writings ascribed to Ku are only loosely connected with him, if at

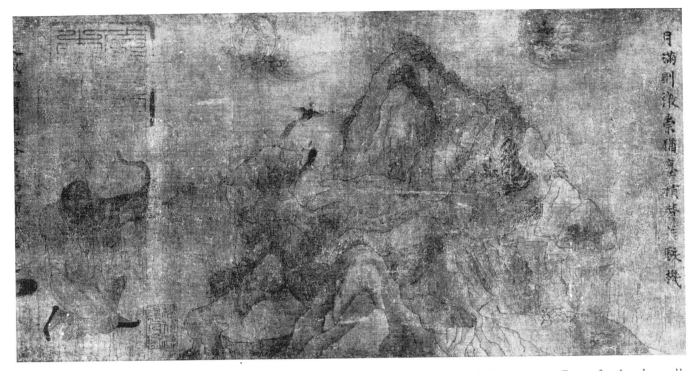

3. Attributed to Ku K'ai-chih (4th century A.D.). *The Admonitions of the Imperial Preceptress*. Part of a hand scroll. *Mountain Landscape*. Ink and colour on silk. H. 19·5 cm. L. 347 cm. British Museum, London. Cf. pl. 13-15.

all. To sum up: The greatest charm of this unique scroll lies in the noble accord of the contours, in the restrained dignity of the figures and in their exalted expression. The scroll contains illustrations to a text by the poet Chang Hua (A.D. 232-300); the model actions of women in the past are being depicted—the aim being their emulation by future generations.

In the following centuries, it is the Southern dynasties that gave a powerful impetus to painting. Lu T'an-wei, who was active in Nanking in the 5th century, is considered in the literary accounts to rank almost as high as Ku K'ai-chih. He painted mostly Buddhist subjects. More remarkable is it that a portrait of the great calligrapher Wang Hsien-chih was among his works. This may be no mere accident; for in his art he seems to have stressed the calligraphic element. His contemporary, Hsieh Ho, owes his reputation not to his art, but to an essay on painting, the best known and most frequently quoted work in all Chinese art literature. Hsieh Ho's expositions are to a certain extent valid even to-day, although Chinese painting of his time had only begun to face up to its problems. In his *Ku Hua P'in Lu* (Notes concerning the Classification of old Painting) he established six principles (*Liu Fa*) which were intended to serve as standards for the evaluation of a picture.[67] The last four canons are

[67] The *Liu Fa* are discussed in most Western books on Chinese painting. Of course, the translations vary considerably from each other. Cf. Shio Sakanishi, *The Spirit of the Brush*, 1939, p. 46 ff. Soame Jenyns (op. cit.) has juxtaposed the translations of the *Liu Fa* by Waley, Taki and Hirth respectively. To these may be added those of Giles, Sirén and Ku Têng. The *Liu Fa* have, in fact, mainly theoretical value. The old and new Chinese experts do seldom agree how far this canon is realized in the different paintings.

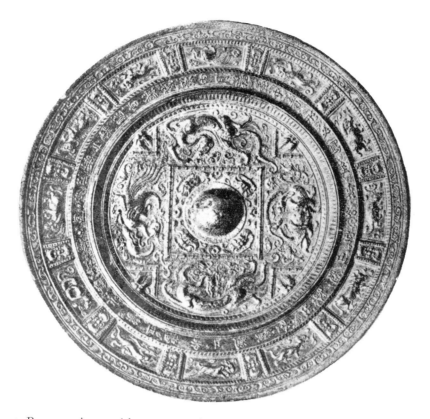

4. Bronze mirror with representations of *the Animals of the Four Cardinal Points and the Zodiac* in relief. D. 12 cm. 6th century A.D. Cf. pl. 11 and 12.

not much more than statements of the obvious, and could just as well apply to Western painting, viz., realistic form, right colour, good composition and the study of good models. But at the head of his rules he puts *Ch'i Yün Shêng Tung,* rhythm and vitality. This is the ideal towards which Chinese painting has always striven. It is an ideal attainable, according to canon number two, through *Ku Fa Yung Pi,* significant brushwork, which ranks second only to number one. It is noteworthy that verisimilitude takes only the third and fourth place.

Easily the most brilliant among the rulers of these days was Wu Ti (502-549), a member of the Southern Liang dynasty residing in Nanking. He proved to be an enthusiastic follower of Buddhism. It is not without reason that Bodhidharma, the alleged founder of the Ch'an sect, is said to have visited his Court; and it is not by mere chance that Chang Sêng-yu, whose works abound with Buddhist subjects, was in his service. Chang's paintings, *The Brushing of the Elephant,* and *The Drunken Priest,* Buddhist themes, are repeatedly referred to and praised in literary sources. Numerous copies and paraphrases are in existence. None of them would appear to be close enough to the original to give us a really lively conception of the master's art, and the same holds good for the landscapes that are linked with his name.

Chang Sêng-yu also painted numerous temple frescoes, as most of his contemporary colleagues did.[68] The strong religious impulse found expression in a widespread architectural activity; Buddhists and Taoists zealously competed with each other in the erection of temples. Besides, palaces, ceremonial halls and funeral chambers were built. In China proper, nothing has been preserved of the buildings and the frescoes that decorated their walls. Only in Tun Huang, in the far West, the last halting place of caravans before their entry into the Central

[68]Among the murals mentioned in the *Chêng Kuan Kung Ssŭ Hua Shih* (7th century A.D.) are several executed by Ku K'ai-chih and Chang Sêng-yu. Cf. n. 12.

5. *Ingwakyō.　The Temptation of the Buddha.*　Part of a hand scroll.　Colour on paper.　H. 27 cm. 8th century A.D.
Sambōin, Kyōto.

Asiatic desert, in Korea, as well as in Central Asia itself, certain favourable conditions have enabled a few remains to survive.[69] Created outside the vital art centres, these hardly exhibit all the possibilities of which the art of the time was capable. Any attempt at exact dating is risky, as we are too badly informed of all that concerns painting and painters of the pre-Tʻang centuries. The murals of the burial chambers of U-hyön-ni (Gukenri, Korea), for instance, from the point of view of style and according to the present state of our knowledge, could just as easily be the product of the 4th or 5th century as of the 6th, in which they actually appear to have been executed. A comparison with the mirror reliefs of the 6th century (Fig. 4) speaks even in favour of the earlier date.[70] The frescoes in U-hyön-ni show representations of the animal deities of the *Four Cardinal Points*, the Phœnix, the Tortoise in the coils of the Snake, the Dragon and the Tiger (*Ssŭ Shên*), a popular motif in art to be met with from the close of the Chou period (4th to 3rd century B.C.) right up to the Tʻang epoch (618-906). Each of the walls is adorned with one of the four animals in majestic proportions. The contours are markedly expressive, and only few colours appear. These Korean works lead us to regret still more the loss involved in the destruction of the non-Buddhist mural painting of ancient China. The earliest murals in the caves of Tun Huang (especially cave 110 and 135)[71] may have been executed in the same centuries. The fact that the com-

Pl. 11, 12

[69]We know nothing about the masters who executed the Tun Huang frescoes; neither where they came from, nor what their training was. The sculptures in the different caves of Tun Huang—about early sculpture we are much better informed than about early painting—do not suffice to date the latter, since they are not necessarily coeval with the paintings. Cf. Paul Pelliot, *Les Grottes de Touen-houang*, 1914-24, six volumes; Eiichi Matsumoto, *Tonkō-ga no Kenkyū*, Tōkyō, 1937; Ludwig Bachhofer, *Die Raumdarstellung in der Chinesischen Malerei des Ersten Jahrtausends*, Münchener Jahrbuch der Bildenden Kunst VIII, 3, 1931. Bachhofer has with great acumen shown the logical development of the painting in Tun Huang. Whether the real chronology corresponds to it is, however, doubtful. The excavation of the caves began in A.D. 366.　[70]Cf. William Cohn, *The Deities of the Four Cardinal Points in Chinese Art*, Transactions Oriental Ceramic Society, 1943. The mirror reliefs of the 6th century often exhibit the same subjects as the chambers of U-hyön-ni, but in a style which is near Tʻang, whereas the Korean murals are rather near Han style. See, for instance, pl. 13.　[71]Paul Pelliot, op. cit., pl. 189 and 284.

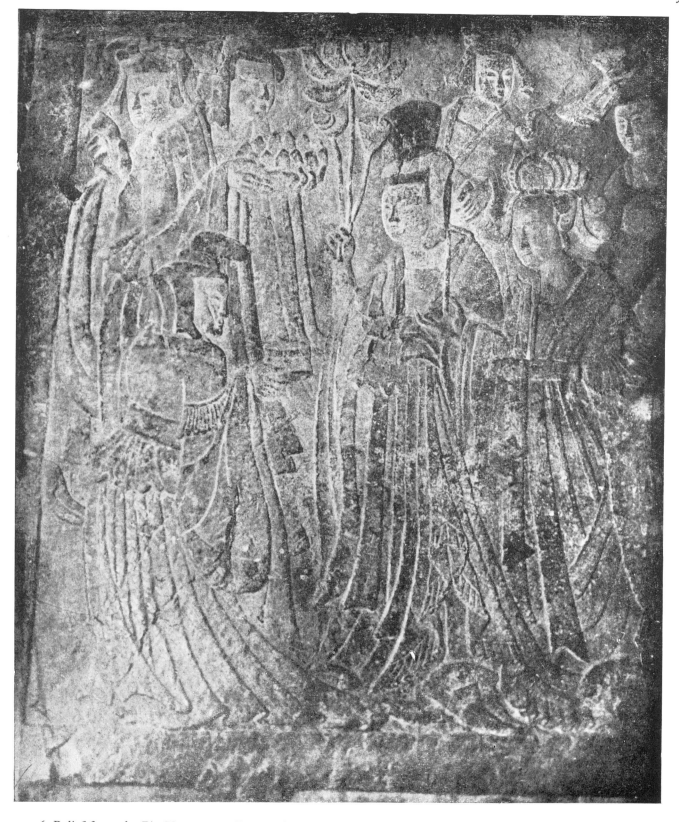

6. Relief from the Pin Yang caves, Lung Mên. *Female Donors*. Detail. H. c. 200 cm. Early 6th century A.D.

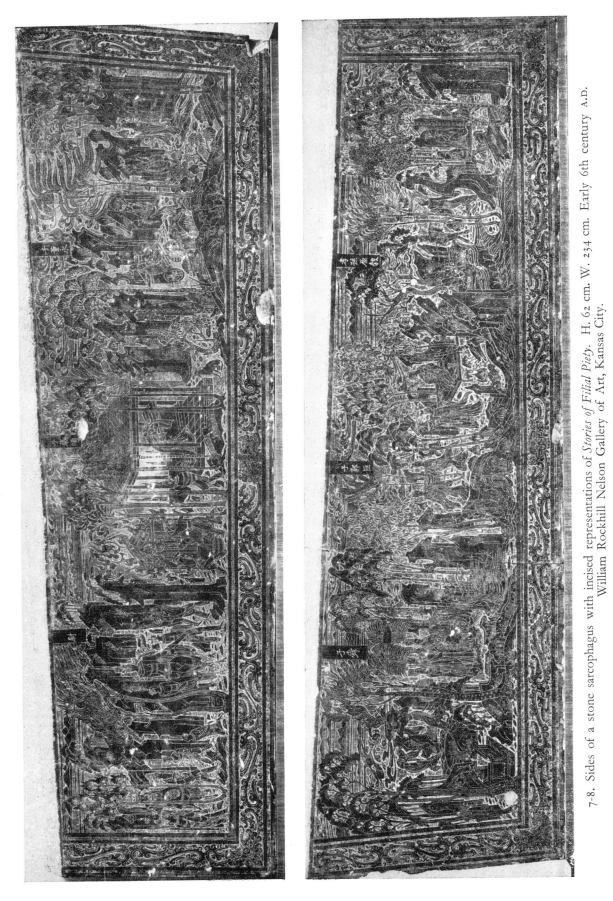

7-8. Sides of a stone sarcophagus with incised representations of *Stories of Filial Piety*. H. 62 cm. W. 234 cm. Early 6th century A.D. William Rockhill Nelson Gallery of Art, Kansas City.

position here often employed is an arrangement in tiers may be attributed to old tradition. It is true the narration of the Buddha's earlier incarnations *(Jātaka)* is very much suited to such treatment. But we also find tentative efforts being made at solving the problem of larger unified compositions. Many of the figures portrayed in waving garments give the impression of floating about like incorporeal beings, much as we have seen with Ku K'ai-chih. Isolated landscape elements provide the settings.[72]

Artistically much more important and informative regarding the state of painting in the 6th century would appear to be a series of designs incised upon the stone walls of sacrificial halls and sarcophagi, and on steles which, often by the aid of the accompanying inscriptions, can be attributed to the early half and middle of the century.[73] Here, figures, houses, trees and even mountains, are intimately interwoven. Besides, the various trees are more distinctly characterized. It is evident that the landscape, China's favourite subject, has begun its triumphal career.[74]

If we want to form a notion of what pure figure painting in this century was able to achieve, we cannot do better than turn our attention to the well-known low reliefs of the Pin Yang caves in Lung Mên,[75] which in their pronounced flatness make the impression of paintings. There passes before our eyes a solemn procession of male and female princely donors (Fig. 6). Observe the slight individualization of the heads of the majestically-striding figures, as well as the manifold descending lines of the drapery folds. Conceptions of this kind prove to be the direct harbingers of the figural compositions by a Wu Tao-tzǔ or Yen Li-pên, the prominent masters of the following period.

[72]The *Lo Shên* scroll of the Freer Gallery and the *Ingwakyō* scrolls (Fig. 5) in different Japanese collections (representations of the life of Buddha, past and present) also show the style of about the middle of the 6th century. To be sure, the Ingwakyō is a Japanese copy after a Chinese model executed in or about A.D. 735. [73]The finest stone engravings we know are those of the Sacrificial Stone House of the Boston Museum, completed A.D. 529, published in the Bulletin of the Museum of Fine Arts, Boston, No. 242, December 1942, and those of a Stone Sarcophagus in the William Rockhill Nelson Gallery of Art, Kansas City (Fig. 7-8). In both cases *Paragons of Filial Piety* are mainly illustrated. [74]Alexander C. Soper, *Early Chinese Landscape Painting*, Art Bulletin, June 1941. [75]The Pin Yang caves are the foundation of the Wei Emperor Hsüan Wu (A.D. 500-516) and were completed in A.D. 523. See Tōyō Bijutsu Taikwan XIII and E. Chavannes, *Mission Archéologique dans la Chine Septentrionale*, 1909-15, pl. 293, 296.

VIII. RELIGIOUS AND COURT PAINTING

THE SUI DYNASTY (A.D. 581-618) AND THE T'ANG DYNASTY (A.D. 618-906)

BACKGROUND

SUI and T'ang times are so closely integrated as to form a historical unity. The Sui epoch may be considered the opening scene to that colourful and exciting drama in which the history and culture of China unfolds under the T'ang. Though the early T'ang rulers firmly and successfully followed an imperialistic policy enabling China to become the most powerful empire in the world, the significance of the epoch as a whole can equally be traced in the realms of spiritual and artistic life.

Yang Chien, general and minister under the Northern Chou dynasty, which had already made an end, in 557, of the great empire of the Wei, usurped the throne of his grandson (a minor) in 581, and in quick succession reduced the remaining states. Thus, ending a four-hundred year era of dissension, anarchy and warfare, he brought about the reunion of China. To his dynasty he gave the name of Sui. The personality of his son, Yang Ti, has been very variously interpreted by posterity. Be that as it may, he must, together with the Emperors Ming Huang (T'ang) and Hui Tsung (Sung), be regarded as among the most ardent patrons of Chinese art and literature. Palaces, ships and voyages were no less his passion. The deed that has made him memorable is the planning and construction of a part of the canal by which China acquired a unique means of communication between North and South. Its importance as a contribution to the unity of the country, even up to modern times, is not to be underestimated. Later historians, however, maintain that the canal was built solely to enable the Emperor to indulge his predilection for travel by water and to reach with ease the most beautiful regions of the country. A picture of a Southern Chinese landscape which hung in his palace is supposed to have inspired him to build the canal. We do not know how far these stories are based on facts, but they fit in well with the disposition of the ruler. The canal, nearly a thousand miles long, is just as grandiose a work as the Great Wall of Shih Huang Ti, costing as many hecatombs of human lives and arousing as much indignation. Along the banks Yang Ti caused palaces to be erected and parks to be laid out, whose splendour and beauty later writers, particularly the historian Ssŭ-ma Kuang (1019-1086), never wearied of telling. His pleasure in brilliant festivities is supposed to have reached a peak in the celebrations at the opening of the waterway—assuming, of course, that the description be not a later invention. Hundreds of many-tiered barques transported the entire Court to the South; cavalry with waving pennons accompanied the vast procession of ships along the tree-lined banks. It is easily understandable that a man with such tastes should have been an enthusiastic supporter of all the various branches of the arts. Yang Ti is said to have erected two tower-like buildings in his capital Lo Yang, one as a storehouse for book scrolls, the other for picture scrolls and art treasures of different kinds. Furthermore, we learn of the destiny of his picture collection: twice it came to grief during its transport by water after the fall of the Sui. Only three hundred paintings were saved, and these passed into the collection of the first T'ang Emperor.[76]

No more than a short life was granted to the Sui dynasty. Yang Ti's enormous expenditure upon his favourite hobbies, combined with an unsuccessful war with Korea (611-614),

[76]Otto Franke, *Geschichte des Chinesischen Reiches* II, 1936, p. 321 ff. Cf. also L. Wieger *Textes Historiques*, 3 vols., Hien-hien, 1905, p. 1,506 ff. and Tsui Chi, *A Short History of Chinese Civilization*, 1942, p. 122 ff. Cf. n. 12.

soon led to rebellions. The Sui period played a similar part in Chinese history to that of Ch'in. Both did much to prepare the way for a long-enduring united China; both live in the mind of posterity through the creation of mighty edifices. To attribute a definite art style to either of them would be risky. When mention is made of Sui mirrors or Sui sculptures, this does not mean that their style was evolved during the short decades of that particular period; what is implied points to a transition between the Six Dynasties and T'ang.

The leader of the rebellion against the Sui was the governor of a Northern prefecture, but it was his son, Li Shih-min, whose genius supplied the moving force.[77] Whereas the former founded the T'ang dynasty in 618, the latter directed the destinies of the country. Ten years later Li Shih-min followed his father upon the throne. Under the posthumous name of T'ai Tsung we find him entered in the annals of Chinese history as one of its most celebrated and successful personages.

In the early days of the T'ang period a reaction first set in against Yang Ti's extravagance and enthusiasm for art. T'ai Tsung primarily distinguished himself as a military leader and organizer. He waged victorious wars and enlarged the boundaries of the empire, even beyond those it had in Han times. China was reorganized into ten provinces. The system of examinations to which earlier Emperors had already given much consideration underwent further development. The examinations served, as of old, to buttress Confucianism, the subjects set being entirely Confucian. Yet we should not measure the times by Confucianism alone; the masses, even the members of the Court, were more inclined towards Buddhism and Taoism.

The stability of the early T'ang dynasty can be gauged by the long reigns of its rulers. T'ai Tsung's lasted twenty-two years (627-649); his son, Kao Tsung, reigned for as many as thirty-four (649-683). This was, however, a mere shadow-government. In reality, one of his wives, the famous Empress Wu, held the reins and maintained her power after her husband's death till 705. The verdict of history concerning her cannot be considered favourable. But it must not be forgotten that the historians were always ardent Confucianists who had every reason for being prejudiced against a woman—a woman, besides, known to be a passionate follower of Buddhism. Anyway hers must have been a colourful personality, and it is a fact that the land was firmly governed during her long rule, and that she knew how to restrict unrest and warlike disturbances to a minimum.

In these days the preparatory stages of Buddhism had already been left behind. Its numerous sects, founded in the past, had organized themselves and new ones were in the process of formation. The Indian faith took on Chinese colouring to such a degree that the foreign origin is often scarcely recognizable. Taoism flourished by its side. Moreover, other religions, seeking an entrance, met with no serious obstacles placed in their path. The adherents of Mazdaism, Manichæism, Nestorian Christianity, Judaism and Islam, were permitted not only to practise their faiths, but even to erect their own centres of worship.

Already under Emperor T'ai Tsung Buddhism had gained the sympathies of the Court. When the priest Hsüan Tsang returned from his pilgrimage to India (629-645) he was received in Ch'ang An with high honours; and I Ching, who had sojourned in India from 671 to 695, enjoyed the protection of the Empress Wu.[78] The O-mi-t'o (Amitābha) sects were greatly in vogue. Their most influential champion, Shên Tao, died in 681. As regards the Ch'an sects, their sixth patriarch, Hui-nêng (637-713) may be considered as their real founder.[79] In the year 719 the Indians Vajrabodhi (Chin-kang-chih) and Amoghavajra

[77]C. P. Fitzgerald, *Son of Heaven . . . Li Shih-min*, 1933. [78]Samuel Beal, *Si-Yu-Ki. Buddhist Records of the Western World.* Translated from the Chinese of Hiuen Tsiang (A.D. 629), 2 vols., 1906; René Grousset, *In the Footsteps of the Buddha*, 1932; E. Chavannes, *Mémoire Composé à l'Epoque de la Grande Dynastie T'ang sur les Religieux Eminents qui allèrent chercher la Loi dans les Pays d'Occident par I-tsing*, 1894. [79]Hu Shih, *Development of Zen Buddhism in China.* The Chinese Social and Political Science Review, Jan. 1932; *The Sutra of Wei Lang (or Hui Nêng).* Translated from the Chinese by Wong Mou-lan, 1944. Cf. n. 58, cf. also Fig. 35.

Pl. 121

(Pu-k'ung) introduced the Chên Yen sect (also called Mi Tsung), which favoured the worship of the Buddha P'i-lu-fo (Vairocana),[80] who now became a popular subject in Buddhist art. It is true that, already in 676, the Empress Wu and her husband had endowed a rock temple in Lung Mên with a gigantic effigy of Vairocana. Being a fervent believer in Buddhism, she manifestly was far in advance of her time. How many temples embellished with Buddhist frescoes may have owed their existence to her initiative! Two of the most famous Chinese painters, Yen Li-pên and Li Ssŭ-hsün, were active in her days, both holding high governmental posts. It is expressly stated that the Empress knew how to draw the finest talent in the land into her service.

With the reign of Hsüan Tsung, known under the name of Ming Huang, who of all the rulers of the dynasty sat longest upon the throne (712-756), the T'ang period attained its zenith. Poets, such as Li Po and his younger contemporary Tu Fu,[81] painters like Wu Tao-tzŭ, Wang Wei and Han Kan, set the standard. Politically, the Emperor lived in the reflected glory of his predecessors; these had provided so well for the future that in the beginning he had been able to dispense with warlike undertakings. For posterity, Ming Huang's name is inseparably associated with the story of his tragic love for the beautiful Yang Kuei Fei. The life story of a woman—her incredible rise to favour as the consort of two Emperors, father and son, her days of happiness and fortune and her fearful end—has seldom been so often celebrated by poets, painters and writers, and not in East Asia alone, as was that of Ming Huang's mistress. Not only was she the cause of one of the most frightful rebellions, but she even contributed to the very downfall of the entire dynasty.

The rebellion was fomented by An Lu-shan, a man of the lowest birth. Starting his career as a slave, then becoming the minion and step-son of Yang Kuei Fei, rising to the position of governor of a province and general of the guards, and, finally, playing the part of a successful rebel, he strikes one as being no less unusual and dramatic than the Empress herself. The battles caused by this insurrection (755-766) were so destructive and the consequences so far-reaching, that they really signify the beginning of the end of the T'ang dynasty. Revolts of provincial governors and generals never ceased. Wars with neighbouring peoples, particularly with Tibetans and Uighurs, brought further difficulties in their train. When we consider that about a century later an even more terrible revolt under Huang Ch'ao raged throughout the land and that Buddhism then began to be harshly persecuted, we can form some idea of the number of art treasures of every sort that perished during the last hundred and fifty years of the T'ang era. In China herself, little more than stone sculptures and objects secreted in graves were able to survive the vicissitudes of those times.

The decaying T'ang dynasty was no longer able to maintain the spiritual life of the country at its previous height. Thus the stream of great names turns into a trickle. Po Chü-i, the poet (772-846), considered by many to be the equal of Li Po and Tu Fu, is one of the few outstanding figures. The man who seems to have been most characteristic of the time was Han Yü (768-824), scholar, prose-writer and politician. His memorial against Buddhism is a masterpiece of noble prose; though he fell into disgrace and was banished, it had far-reaching effects. The Emperor had caused a Buddha relic to be transferred with great pomp from a temple to the Imperial palace in Ch'ang An for a three-day exhibition (819). This infuriated the Confucianists, and Han Yü used the occasion to protest against the faith in relics and the new religion. When the Emperor Wu Tsung later issued an edict (845) ordering the suppression of Buddhism and the destruction of thousands of monasteries and temples, as well as the secularization of hundreds of thousands of monks and nuns, Han

[80]According to the doctrine of the Chên Yen sect, all Buddhas are emanations of the central Buddha P'i-lu-fo (Vairocana).
[81]Florence Ayscough, *Tu Fu, The Autobiography of a Chinese Poet*, Boston, 1929; Shigeyoshi Obata, *The Works of Li Po*, New York, 1922.

Yü's impressive document had attained its end.[82] This persecution is said to have been the heaviest blow Buddhism has ever had to suffer. There is no doubt that numerous buildings containing frescoes and sculptures by master hands perished; yet how far the measure was really enforced it is difficult to say. The fact remains that the edict was countermanded by Wu Tsung's successor in 852. These attacks upon Buddhism were obviously unable to affect its vitality or do it any lasting harm. The various sects continued to flourish, and it was even then that Ch'an Buddhism first began to percolate into the life and art of China.

DEVELOPMENT

Cosmopolitanism on a large scale was among the characteristic traits of T'ang culture, and this manifested itself as much in art as in religion. Like Paris in the Middle Ages, Ch'ang An, the capital of the T'ang, was a centre of spiritual activity. Indians, Arabs, Persians, Uighurs, Tocharese, Koreans and Japanese, congregated here in order to enlarge their knowledge and to exchange their wares for the products of China.

The Sui and T'ang art, in most of its branches, stands fairly clearly outlined before our eyes; though surviving monuments are a minute and accidental fragment of the total sum. As usual, painting suffers most. The number of the masters mentioned in the sources, however, is considerable, among them being a few more individual than those of earlier times. There are even some original works from China herself, to which may be added copies or paraphrases of T'ang models of later origin and, supplementing these, a group of Buddhist paintings from the outer provinces of China, as well as, for the first time, from Japan. Seventh and eighth-century Japan must be considered to have been culturally a province of China. Architectural activities were enormous. Literary accounts give the actual number of temples built or destroyed. For instance, the few decades of the Sui period saw the erection of no less than 3,792 temples, many embellished with frescoes.

In fact the most eminent Sui painters, such as Chêng Fa-shih and Wei-ch'ih Po-chih-na,[83] are especially known for their frescoes. It is worth noting that the latter came from Khotan and that at this time three Indian painters arrived in China. Doubtless, Chinese Buddhist art was continually being affected by Indian and Central Asiatic influences. The more marked three-dimensionality in the sculpture and the greater plasticity of the figures in the painting of the Sui and the following period may be traced to them. The murals in the Kondō of the Hōryūji (Japan) are probably the best suited to give us an idea of Buddhist painting about 600, even though they may have been actually produced at a later date.[84] The figures here do not yet possess the firmness and energy of T'ang style at its ripest; they are more spiritually conceived, and the flow of line reveals a delicacy which seems later to have been lost. In the main, four Buddhas are represented, one for each quarter of the globe, each flanked by two Bodhisattvas and other attendants, each in his respective Paradise (*Pien Hsiang,* as it was called)—in other words, Trinities such as dominated the religious painting of the entire period. One of the Trinities shows the Buddha O-mi-t'o, the ruler of the Western Paradise, between the Bodhisattvas Kuanyin (Avalokitesvara) and Ta-shih-chê (Mahāsthāmaprāpta). *Pl. 16*

[82]It is recorded that about 5,000 large and 40,000 smaller temples were destroyed and approximately 250,000 monks and nuns were compelled to return to secular life. But this is certainly exaggerated. L. Wieger, *Textes Historiques,* III, p. 1,743. [83]His son I-sêng was a well-known painter too. Cf. Herbert Mueller, *Der Devaraja des Wei-ch'ih I-sêng,* Ostasiatische Zeitschrift VIII, p. 300 ff. [84]The date of the Hōryūji frescoes is the subject of controversy. They have been attributed either to the early 7th, to the later 7th or to the early 8th century. Cf. *Kondō Hekiga,* Tōkyō, 1918-1921; *Hōryūji Hekiga no Kenkyū* (Studies of the Wall-paintings of the Hōryūji), Nara, 1932. See also Jeannine Auboyer, *Les Influences et les Reminiscences Etrangères au Kondō du Hōryūji,* Paris, 1941, and Naitō Tōichirō, *The Wall-paintings of Hōryūji.* Translated and edited by Acker and Rowland, Baltimore, 1943. Most of the writers assume that the Hōryūji has been rebuilt after a conflagration in the 8th century. But we, in accordance with A. C. Soper (*The Evolution of Buddhist Architecture in Japan,* Princetown, 1942) and Yukio Yashiro (*The Fresco Paintings of the Hōryūji,* Nara, 1936) believe the earliest part of the Hōryūji to be a work of the first half of the 7th century.

Here we are confronted with the most favoured Buddhist theme, in the creation of which the painter Ts'ao Chung-ta, who was already active before the rise of the Sui, may have participated.[85] The development of this imposing subject from a hieratic gravity and a simple juxtaposition of the figures into a composition of majestic pomp, in the course of the T'ang era, can be traced in the wall paintings of Tun Huang.[86]

The secular painting of the time was devoted to historical subjects, primarily to Court life. The fact that women played a role at Court as never before found its reflection in art. Also the manifold tributary gifts offered to China from all parts of the world inspired the masters. Altogether, one can speak of a kind of genre painting, and this is perhaps the most representative category of T'ang art. A new joy was discovered in the daily scene. If some of the painters are described as having specialized in carriages and horses, others in every type of architecture, the reference is to a closely related sphere. Though these themes were not unknown in the past, they had now come to the fore. Stylistically, the compositions gain more unity, the figures move with greater freedom and details begin to receive more attention. Besides, landscape attains an ever greater importance. Here Chan Tzŭ-ch'ien (c. 600), the 'Father' of T'ang painting obviously has given the initiative. Colourful and fantastic sceneries, with magnificent buildings in resplendent settings, were being executed. Occasionally we find even a visual experience of nature. The literary accounts suggest that lyrical and pure landscape painting, too, had already taken shape by the first half of the 8th century; but this could only have been rudimentary and tentative.

The two outstanding masters of the early T'ang era, Yen Li-pên (d.673) and Li Ssŭ-hsün (651-716) seem to have been pioneers in all fields of painting and are both heralded in art literature as innovators. Yen Li-pên chiefly painted historical and Buddhist subjects.[87] We see men of flesh and blood whose gestures are full of life, instead of the unreal figures of the past, which almost resemble marionettes. Everything speaks in favour of the hand scroll in *Pl. 18, 19* the Boston Museum, with its images of thirteen Emperors (from Han to Sui dynasty) and their followers, being closely allied to his work or being partly by his hand.[88] The rulers, up to a point individually characterized, stride pompously with powerful movements and gestures, or sit majestically enthroned upon a low dais with legs tucked in. Superb colouring and richness in detail give the scroll a festive character. The emptiness of the stage upon which the figures move is to be found in all phases of Chinese painting, but the isolation of the individual groups produces an archaic effect.

There is less justification for linking the second hand scroll in the Boston Museum, *Pl. 20, 21* *Scholars of the Northern Ch'i Dynasty collating Classic Texts,*[89] with Yen Li-pên's name, though there are details which remind us of the Emperor Scroll. If it really has something to do with Yen, it can only be in the nature of a fine paraphrase from the brush of a master

[85]The four Buddhas are: (1) The historical Buddha; (2) Amitābha (O-mi-t'o); (3) Bhaishajyaguru (Yo-shih-wang), the Medicine Buddha; (4) Maitreya (Mi-lo), the Buddha of the Future. In the narrow panels between the Buddha pictures single Bodhisattvas are represented. The Maitreya group in Tun Huang, cave 77, which Bachhofer attributes to the first half of the 7th century A.D., exhibits a style similar to that of the Hōryūji frescoes. Cf. Paul Pelliot, *Notes sur quelques Artistes des Six Dynasties et des T'ang*, T'oung Pao, XXII, 1923; id. *Les Grottes de Touen-houang*, 1914-1921; Ludwig Bachhofer, *Die Raumdarstellung in der Chinesischen Malerei des Ersten Jahrtausends nach Christi*, Münchener Jahrbuch der Bildenden Kunst, 1931; William Cohn, *Amida Bilder in der Ostasiatischen Kunstsammlung*, Berliner Museen LIV, 1933; Seiichi Taki, *On the Taima-Mandara*, Kokka XXI; Sir Aurel Stein, *Serindia*, 5 vols., 1906 et seq., especially III, Appendix E, Essays on Buddhist Paintings from the Caves of the Thousand Buddhas, Tun-huang by Raphael Petrucci and Laurence Binyon; id. *The Thousand Buddhas, Ancient Buddhist Paintings from the Cave Temples on the Western Frontier of China*, 1921; A. Waley, *A Catalogue of Paintings Recovered from Tun Huang by Sir Aurel Stein*, 1931. Noritake Tsuda, *A Study of Iconographic Representations of Buddha Amitābha and his Paradise* (Abstract from an essay in Japanese, Tōkyō, 1937). [86]The caves 104 (Pelliot, pl. 187); 146 (pl. 318); 70 (pl. 119-121); 31 (pl. 66 and 67); 139a (pl. 303); 46 (pl. 78-81), and 14 (pl. 39) show the different stages. See Bachhofer, op. cit. [87]The titles of a great number of his paintings are recorded. [88]Kojiro Tomita, *Portraits of the Emperors attributed to Yen Li-pên* (d. 673), Bulletin of the Museum of Fine Arts, Boston, XXX, Feb. 1932. According to the author, the first six groups (Fig. 9) are later than the other seven, which actually could be originals by Yen. [89]Kojiro Tomita, *Scholars of the Northern Ch'i Dynasty collating Classic Texts*, Bulletin of the Museum of Fine Arts, Boston, XXIX, Aug. 1931.

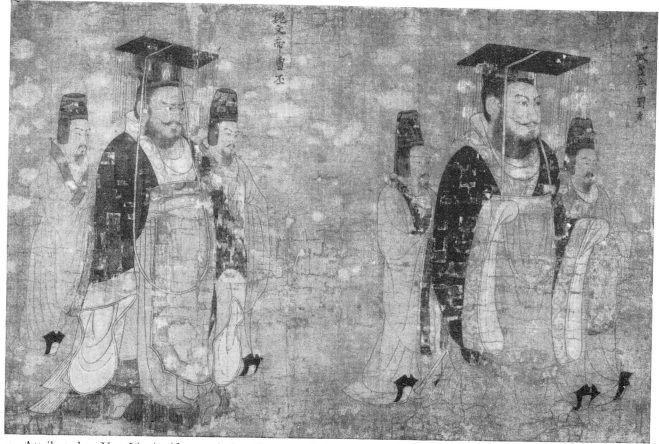

9. Attributed to Yen Li-pên (d. A.D. 673). *Portraits of the Emperors*. First part of the hand scroll. Colour on silk. H. 51 cm. Museum of Fine Arts, Boston. Cf. pl. 18 and 19.

several centuries later.[90] The work in its present form breathes an entirely different life from that which might be expected from Yen Li-pên and his time. The figures with their spiritualized faces recall those hermits whom we find in the subsequent Sung painting. It is equally doubtful whether so refined and balanced a composition, so complete a mastery of the spatial relations and such restraint in regard to bright colour treatment, can have lain within Yen's power or intention. The fact that women are present at the serious pursuit of the scholars fits in quite well, on the other hand, with the friendly disposition of the T'ang period towards women.

A motif frequently treated by Yen Li-pên was the *Tribute Bearers (Chih Kung T'u)*. In Hui Tsung's catalogue, four scrolls on this theme find mention among forty-two of Yen's work. A number of representations of this kind are preserved; the best known example was frequently exhibited in the Palace Museum, Peking. All of them seem to derive from Yen; but in the main they are arid performances, remarkable solely for their subject. The Chinese master showed the same pleasure in rare and strange men, animals and things from remote countries, as did Leonardo or Rembrandt in Europe.[91]

Li Ssǔ-hsün, Yen Li-pên's younger contemporary, a relation of the Imperial house and a general in the Imperial guard, was, before all, a landscapist, and his creations must have

[90]But it is certainly not later than early Sung time. [91]A painting by Yen Li-pên named *Hsi Yü T'u* (Types from Western Frontiers), which is recorded in the *Hsüan Ho Hua P'u*, must have belonged to this category. There were several painters who treated similar subjects in T'ang times; for example, Hu Huan and Chou Fang. Werner Speiser and Osvald Sirén mention further works by Yen Li-pên, namely *The Tea Drinkers* and *The Drunken Monk*, and show the persistence of these subjects in Chinese painting. Cf. Werner Speiser, *Studien zu chinesischen Bildern I. Die Teetrinker von Yên Li-pên*, Ostasiatische Zeitschrift VII (XVII), 1931, p. 208 ff. and Osvald Sirén, *An Early Chinese Painting*, Parnassus, 1939.

10. Attributed to Li Ssǔ-hsün (A.D. 651-716). *Palace*. Colour on paper. H. 36 cm. W. 30 cm. Museum of Fine Arts, Boston.

been epoch-making in this field. As we shall see later, he was even proclaimed the founder of a particular school, the so-called *Northern School*. Numerous works are to be found under his name or that of his son, Li Chao-tao, who obviously trod in his father's footsteps. But their compositions are not landscapes in the common sense of the word. The two Li seem to have inaugurated that branch of Chinese painting in which romantic architecture takes

11. After Li Chao-tao (c. A.D. 670-730). *The Lo Yang Mansion.* Colour on silk. H.37 cm. W. 39 cm.
Chinese Government.

the dominant part. It is true, their pictures consist of mountains and oddly-shaped rocks, of trees of all kinds, of rivers, lakes and waterfalls, but for the most part of bridges, terraces, pavilions and sumptuous palaces; all in lively colours, especially green and blue, and including gold. Coulisse follows upon coulisse, not yet conceived in real spatial relationship. Details of every sort are worked out with great care. Although it certainly must be regarded as a copy, the Palace landscape in the Boston Museum (Fig. 10) can perhaps best give us an adequate idea of the style of the Li, father or son. Here the composition, no less than the spacing, has an archaic aspect; the struggle to arrive at new solutions, however, is evident.[92]

Just as the twin stars Yen Li-pên and Li Ssŭ-hsün illuminated the early T'ang period with their lustre, so the two names (known to every Chinese) Wu Tao-tzŭ (Tao-yüan, c. 700-760) and Wang Wei (698-759) shed glory on mid-T'ang. The former was, as it

[92]These landscapes are often called *Ch'ing Lü Shan Shui* or *Chin Pi Shan Shui*. See Benjamin March, *Some Technical Terms of Chinese Painting*, 1935. The painting of a similar theme attributed to Li Chao-tao (Fig. 11) in the possession of the Chinese Government, is rather a paraphrase of a time not earlier than the Sung period. There is much more depth, there are complicated overlappings; the influence of the developed style of Sung landscape painting makes itself felt.

were, the Raphael or Dürer of China, the latter the more esoteric idol of the man of high culture. Of them, more fascinating stories are told than of any other Chinese

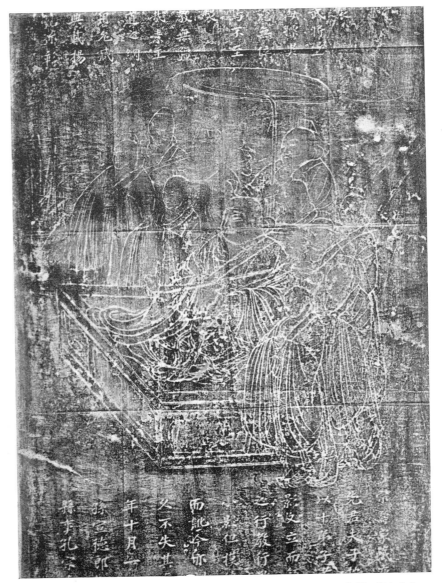

12. After Wu Tao-tzŭ (8th century A.D.). *Confucius and his Disciples.*
Engraving on stone, dated A.D. 1025.

painters. Many stone engravings after their works are still extant, clearer witnesses of their style than the numerous paintings which claim to have preserved their manner.[93] Wu Tao-tzŭ appears to have been the earliest eminent professional among painters. We do not hear that he ever indulged in the activities of the writer or the scholar, and the small office he held did not come to him till late in life.[94] He is supposed to have executed no less than three hundred frescoes (in the capital cities Ch'ang An and Lo Yang), besides many pictures of every description; and the people were filled with wonder as they watched him paint. Wang Wei, on the other hand, was a celebrated poet, and as famous for his calligraphy and music as for his painting; it was this combination of gifts which the Chinese of later centuries considered essential to the personality of a great artist.[95] In the figural paintings of Wu Tao-tzŭ, sweeping and harmonious outlining is conspicuous; but in fact the early 6th century already showed similar features.[96] The master seems to have made space and depth decisive factors and to have given more modelling to his figures. The sources extol these achievements again and again, and the engravings after his paintings

[93]The most important stone engravings of alleged works by Wu are the following: 1. *Confucius with Disciples* in the Confucian Temple in Ch'ü Fou; 2. *Flying Devils* in the Tung Yüeh Miao (Chü Yang Hsien in Hopei); 3. *Tortoise with Snake* in Ch'êng Tu (Szechuan); 4. Some pieces in the Pei Lin in Sianfu. The best known paintings ascribed to Wu are the *Buddha Trinity* of the Tōfukuji, Nara; the *Nirvana* of the Manjūji, Kyōto; the hand scroll, *The Birth of the Buddha*, in a Japanese private collection and the two landscapes of the Daitokuji, Kyōto. In addition there are several Kuanyin representations which, at the least, may be traced back to Wu. None of these works is older than the Sung period. Illustrations are to be found in most of the well-known Japanese publications. [94]It is also remarkable that Wu is not mentioned in the official history of the T'ang, and that his dates are not known. [95]A. von Herder, *Wang Wei, der Maler der T'ang Zeit*, Sinica, 1930. The essay on landscape painting said to be by Wang Wei is certainly of a later time. Translations by Shio Sakanishi, *The Spirit of the Brush;* by Jonny Hefter, *Abhandlung über die Landschaftsmalerei von Wang Wei*, Ostasiatische Zeitschrift VII (XVII), and by Sirén. Cf. also S. Elisséev, *La Révélation des Secrets de la Peinture par Wang-wei*, Revue des Arts Asiatiques, 1927, IV, 4. [96]See, for instance, the procession reliefs of the Pin Yang caves of A.D. 523, Fig. 6.

make this patent. The group of *Confucius surrounded by his Pupils* (Fig. 12), for instance, displays in its complete command of all the means employed the sovereignty of an artist of genius. Equally impressive is the majesty of his Kuanyin conceptions (Fig. 13), whatever type they show. The mastery of Wu Tao-tzŭ is revealed perhaps nowhere more distinctly than in the representation of one of the *Four Animals of the Cardinal Points,* the *Tortoise coupled with Serpent* (Fig. 14), a work in which the old Chinese idea of Yin and Yang has found a monumental embodiment, executed with a vigour which even a poor rubbing is able to disclose. But, on the whole, the rubbings and stone engravings, likewise the existing copies and adaptations, leave us only to guess at the scope of the master's power, the range of his subjects and the development of his style. Moreover, the reports on his method of painting contradict one another too frequently.

Wang Wei, like Wu Tao-tzŭ, was active in figure, landscape and fresco work; for posterity he remains the eminent landscape painter. It is probable that he began as a follower of the Li, rendering richly coloured architectural sceneries, more or less inventions of his fancy. Then he discovered the poetry in nature and started to paint winter landscapes (Fig. 15), those stirring symbols of loneliness and calm.[97] Finally he took a new step. He proceeded to paint a particular country spot to which he was attached; to wit, his own estate, also celebrated in verse by him. It is the famous *Wang Ch'uan scroll,* of which a series of stone engravings (Fig. 16) and paraphrases (Fig. 17) have survived, insufficient, of course, to convey a real idea of the original.[98] The composition has still a

[97]Our present knowledge is too slender to enable us to determine how much of the original is retained in several winter landscapes associated with Wang's name. In any case it is obvious that they are much later works (for example, the pieces in the possession of the Chinese Government (Fig. 15), and in Japanese possession), although the T'ang elements are clearly recognizable. [98]Cf. Berthold Laufer, *A Landscape by Wang Wei,* Ostasiatische Zeitschrift I, 1912; John C. Ferguson, *Wang Ch'uan,* Ostasiatische Zeitschrift III; Herbert Franke, *Wang-ch'uan chi,* Ostasiatische Zeitschrift XIII (XXIII), 1/2, 1937. In the last article a complete translation of Wang Wei's and P'ei Ti's poem is given. The stone engravings (Fig 16) differ from each other. The hand scroll in the British Museum (Fig. 17) signed Tzŭ-ang (Chao Mêng-fu) and dated 1309 claims only to be in the style of Wang Wei. Cf. n. 175.

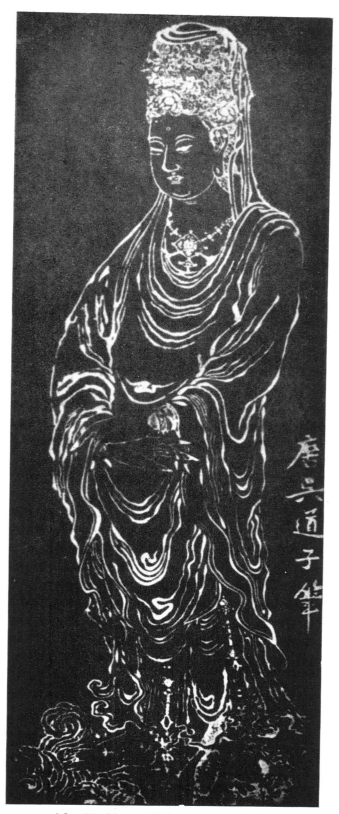

13. After Wu Tao-tzŭ (8th century A.D.). *Kuanyin.* Stone rubbing. Louvre, Paris.

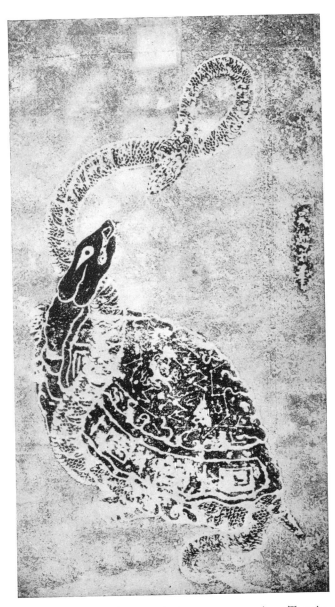

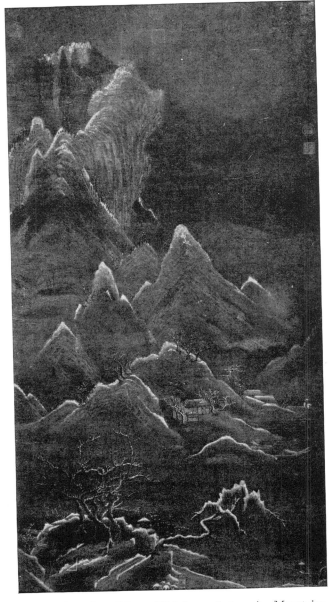

14. After Wu Tao-tzŭ (8th century A.D.). *Tortoise coupled with Serpent*. Stone rubbing. H. 39 cm. W. 21 cm. British Museum, London.

15. Attributed to Wang Wei (A.D. 698-759). *Mountains in Snow*. Colour on silk. H. 69 cm. W. 36 cm. Chinese Government.

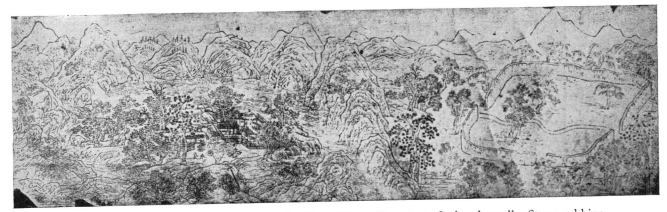

16. After Wang Wei (A.D. 698-759). *The Wang Ch'uan T'u*. Part of a hand scroll. Stone rubbing.

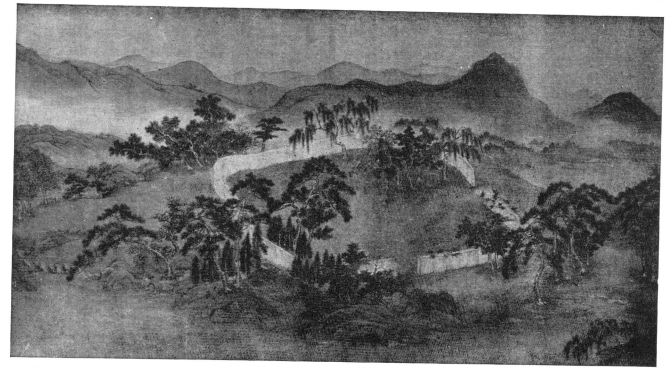

17. Paraphrase of the *Wang Ch'uan T'u* by Wang Wei (A.D. 698-759), attributed to Chao Mêng-fu (A.D. 1254-1322). Part of a hand scroll. Colour on silk. H. 41 cm. L.c. 500 cm. British Museum, London.

map-like aspect, although it may not be exclusively topographical, being transformed by his imagination. At any rate, the *Wang Ch'uan T'u* seems to be the earliest hand scroll in which a specific section of landscape unfolds itself before the eyes of the beholder. The range of landscape painting was thus decisively widened. The assertion of later critics that Wang was the first to refrain occasionally from using any colour whatever and to paint in black ink *(P'o Mo)*, poses a problem.[99] There is no evidence to confirm this, and his colourful verses certainly do not suggest anything of the sort. All information concerning the master should be examined with special care, as it may be held to be suspect of propaganda. Posthumously Wang Wei was ranked as the 'Father' of the highly valued *Southern School*, a position in accordance with which certain traits, inspired by wish rather than derived from fact, were bestowed on him.[100] To-day there is one work alone which possibly shows Wang Wei's hand: the spiritualized portrait of the aged scholar Fu Shêng (3rd century B.C.) in a Japanese private collection.[101] This painting seems to be identical with one noted down in the Emperor Hui Tsung's catalogue. The lay-out of the picture, the even flow of the contours and the manner in which the emaciated figure bending *Pl. 22* over the table is spaced, support the attribution to mid-T'ang. Unusual are the pronounced verisimilitude and the strange pose of the sage. The work can only be credited to a revolutionary master of the first rank, such as Wang Wei was known to be. An allied theme which

[99]There are in the main three possibilities of using black ink in Chinese painting: (1) as pure outline (Pai Miao) ; (2) in a calligraphic and modelling way (P'o Mo); (3) without any outline, in splashes (P'o Mo). (Although the word P'o is used for (2) and (3), it is differently written and has a different meaning; Mo means ink.) The first method has occasionally been employed from very old time, and probably also by Wang Wei. The third seems to have been invented by a later painter named Wang Hsia (d. A.D. 804), and not by Wang Wei, as is often asserted. The famous *Waterfall* in ink of the Chishakuin, Kyōto, wonderful in conception as it is, has certainly nothing whatever to do with Wang. It is, in fact, a not quite convincing work and is not earlier than the Southern Sung period. Cf. Seiichi Taki, *Ink Drawing in the T'ang Dynasty*, Kokka, No. 386, 1922. [100]On the Northern and Southern School see below. [101]Cf. Seiichi Taki, *Fu-chêng granting a new Text of the Shu-ching*, Kokka, No. 588, Nov. 1939. Taki is rather sceptical in attributing the work to Wang Wei. In his opinion it was painted at the end of the T'ang or in the early Sung period.

Pl. 25

Pl. 24

Pl. 33

he painted several times is the image of the Buddhist saint Wei Mo-ch'i (Vimalakīrti).[102]

Here is the place to insert a small anonymous picture in the possession of the Chinese Government. Whether an original or a copy, it represents the style of the time between the incised 6th-century slabs and the great landscapists of the 10th century. The affinity to the manner of the Li is obvious, but without sharing their predilection for romantic architecture. A genre subject is taken: travellers on horseback, who are hastening towards, or have already arrived at, a resting place. What, however, the master really strives after is the delineation of mountain scenery in all its manifold variety and as true to nature as possible. We behold towering masses of mountains, steep paths, torrents and bridges; a break in the mountain walls enables us to glimpse the far distance. The incident of the travellers takes place in the foreground and the effort to bring men and landscape into a natural connexion to one another is plainly discernible. Everything is sharply and clearly worked out, even the sense of space, though real depth is still lacking; the colours are primarily blues and greens.[103]

There were two artists at the Court of the T'ang Emperor Ming Huang who might be considered the fashionable artists of their day, Han Kan (?720-780), the painter of horses,[104] and Chang Hsüan (early 8th century), the painter of women. It is difficult to determine whether works from their hands are still extant; the popularity of their subjects can at least be documented by means of contemporary originals from another province of art. I refer to the lively figures in burnt clay which have been unearthed from tombs, among which the representations of graceful women and of all kinds of horses predominate—life in this world seeking to find its continuation in the next! Possibly we may one day succeed in tracing the development of Han Kan's style with greater exactness, for which purpose the large number of copies and paraphrases of his pictures, often covered with seals and inscriptions, will serve as basis. It would appear that in his earlier works he had not yet broken with the severe style of the past, but that later he acquired an ever greater freedom and even virtuosity. This much is sure, as a portraitist of horses he possessed a marvellous sureness of eye. We hear he often received commissions to paint remarkable horses offered as tribute. It may be that the hand scroll of the Freer Gallery, Washington (Fig. 18), with its magnificently saddled *Horses led by Grooms*, is a splendid old copy of such a work. Here, as usual, scenic elements are avoided. The more telling, therefore, appear the noble proportions of the animals, the saddles reproduced down to the finest details, and the grooms with their outlandish faces and clothes. A small painting, formerly in the possession of Prince Kung and now in the collection of Sir Percival David, makes at first sight, apart from the mass of seals it contains, a less imposing impression. It is, all the same, praised by many experts as an original work by Han Kan, and has a truly archaic flavour. The actual theme is the restlessness of a proud horse bound to a stake. If both paintings really are representative of the master's style, it would be justifiable to look upon the latter as an early work, and that in Washington as a late one.[105]

[102]Vimalakīrti was an eminent disciple of Buddha. He is the principal figure of the *Vimalakīrti Nirdesa Sūtra*, which played a great part in early Buddhism. The visit of the Buddha Manjusri to Vimalakīrti during the illness of the latter is the subject of many representations in painting and sculpture. An image of Vimalakīrti attributed to Li Lung-mien is illustrated on pl. 64. [103]Ludwig Bachhofer, *Chinese Landscape Painting in the Eighth Century*, The Burlington Magazine, LXVII, 1935. It is possible that the landscape in question has something to do with Li Chao-tao, Li Ssŭ-hsün's son. In the London Exhibition 1935/36 there was on view a landscape—the loan of the Chinese Government (No. 1015)—attributed to this master. The work is undoubtedly either a paraphrase of the painting illustrated here, or it shares a common model with it. We are thus given an opportunity of seeing how a design created by a great master becomes, in the hands of the mere artisan, desiccated and schematized. [104]The Emperor Ming Huang was extraordinarily fond of horses. He is said to have had 40,000 in his stables, amongst them chiefly horses from Ferghana. There were several painters who were called upon to paint them. Besides Han Kan, his contemporary or teacher, Ts'ao Pa, may be named. [105]The fragments from Tun Huang with representations of horses (in Delhi and in the Louvre, Fig. 25) appear to show reflections of the art of Han Kan.

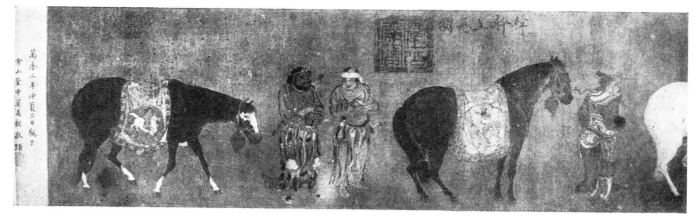

18. After Han Kan (c. A.D. 720-780). *Horses led by Grooms.* Part of a hand scroll. Colour on silk. H. 31 cm. L. 192 cm.
Freer Gallery, Washington.

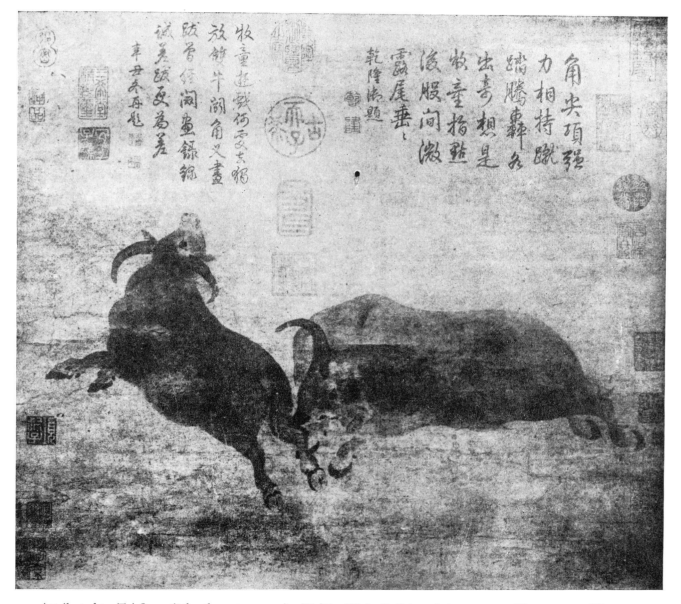

19. Attributed to Tai Sung (8th-9th century A.D.). *Fighting Water Buffaloes.* Ink on paper. H. c. 20 cm. W. c. 18 cm.
Chinese Government.

The horse was used in China rather by the upper and well-to-do classes and, of course, by the warriors. The all-purposes animal of the common people and of the peasants, however, was the buffalo, which appears almost as frequently among the tomb figures as the horse. The pre-eminent painter of buffaloes of this time was Tai Sung, who lived somewhat later than Han Kan. The *Fighting Buffaloes* (Fig. 19) ascribed to him—although certainly a later adaptation—clearly reveal T'ang spirit. In Sung times the buffaloes were conceived as symbols of the peaceful life on the land, while our painting shows vigorous animals of exuberant vitality.

Regarding Chang Hsüan, there is a picture, considered (according to an inscription) to be a copy by the Emperor Hui Tsung (1082-1135), of a hand scroll by this master;[106] and it really seems to be true to the original. It is a genre scene at Court. Some of the ladies are

Pl. 26-27 engaged in giving finishing touches to rolls of raw silk. This was one of the duties of their rank, for it may be remembered that this costly material was produced within the confines of the Imperial Palace, and that rolls of silk had served from of old as Imperial presents. The incident takes place in the immediate foreground, some furniture being included by way of *mise en scène*. The figures are bound together in a unified composition. Surprising is the variety of the poses and the certainty of characterization of the complicated procedure in the working of the silk. The slender women, with their delicate hands, are the same we know from the burial gifts. What we do not find in the latter is the splendid colour of the robes and, above all, the individual and intense expression of the faces—this being perhaps Chang Hsüan's particular *forte*.

The high T'ang period is, as we have seen, less remarkable for an impetuous striving than for a quiet consolidation and balance. A harvest was being garnered which the preceding centuries had sown; and this is why the painters of the 8th century are revered as the classics of their art. The closing T'ang age depended in the main upon the blessings of this time of fruition. Only here and there can one trace the beginnings of unrest and a fumbling after new solutions—precursors of the revolution which, in the 10th and 11th centuries, was so greatly to change the face of life and art.

Thus Chou Fang (active *c.*780-816), a painter chiefly of secular subjects, travelled upon well-worn paths. Chang Hsüan served as his model. The most we can conclude from a study of the works supposed to be his is that he developed still further the psychological features in his figural paintings. Both in the *Lady playing Ch'in* (Museum, Kansas City, Fig. 20) and in the *Ladies Sewing* (Moore Collection, New York), the activities, as such, are of a secondary importance to the expressions of listening and of relaxation. If the stage is enlivened with landscape elements, the idea is to stress the spatial illusion.[107]

There is a special reason for making mention here of Li Chên, Chou Fang's contem-

Pl. 23 porary. He is the only master of the entire T'ang period referred to in the sources of whom authentic originals exist. For they were commissioned of him by the Japanese priest Kōbō Daishi, and taken to Japan in the year A.D. 806, where they are to be seen to this very day. There are few accounts of Li Chên, and the little we know does not suggest that he should go down to posterity as the creator of statuesque portraits of priests. We learn that his subjects were, like those of Chang Hsüan and Chou Fang, beautiful women, but none of these has been preserved. His patriarchs of the Chên Yen sects belong to the same category as the imperial portraits of Yen Li-pên. What grips us here is the vital power of the original

[106]In fact, a painting of this title is mentioned in the *Hsüan Ho Hua P'u*, the catalogue of Hui Tsung's collection. [107]Cf. Louise Wallace Hackney and Yau Chang-Foo, *A Study of Chinese Painting in the Collection of Ada Small Moore*, 1940, p. 69 ff, No. XXI, where a complete illustration and a detail of the *Ladies Sewing* in colour is given. Here the work is attributed to the Sung dynasty. It is certainly not earlier, but seems to go back to an original by Chou Fang. Copies and paraphrases after Chou Fang are abundant. The master is considered the originator of erotic pictures, which are as frequent in China as in other countries. See A. Waley, *An Introduction to the Study of Chinese Painting*, 1923, p. 158. According to the sources Chou Fang also painted Buddhist subjects.

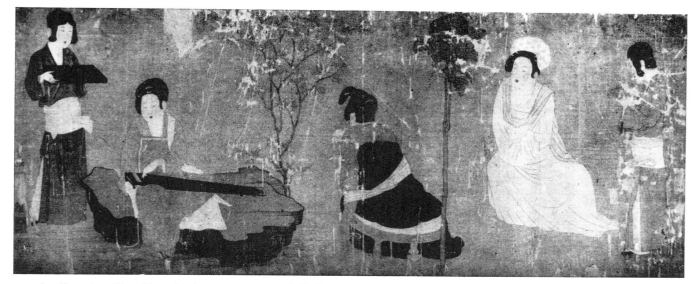

20. Attributed to Chou Fang (active c. A.D. 780-816). *Palace Lady playing Ch'in and Listeners.* Hand scroll. Colour on silk. H. 28 cm. W. 73 cm. William Rockhill Nelson Gallery of Art, Kansas City.

work. The impressive physiognomies of the saints are rendered with a minimum of means. Truth to life is combined with a certain solemnity, this being the aspiration of art in the high and late T'ang period.

The Chinese ideal of a mighty spiritualized personality was created by Kuan-hsiu (832-912), possibly the only supreme talent of the declining age, whose activity continued at the Court of one of the usurpers of the following period. The *Lohans*,[108] alleged to be his, with their faces 'stamped by the seal of self-inflicted misery and lined with never-ending toil of the spirit', served as one of the models of its kind for future generations. As in modern expressionism, the master turned to violent distortions in order to attain his goal. Kuan-hsiu was a priest of the Ch'an sects, and Lohan images belong pre-eminently to their ritual. The ultimate effects of the influence of these revolutionary sects made themselves felt in painting only a hundred-odd years later, but they touched Lohan representations least of all. Here, the relation with Kuan-hsiu's vital and monumental apostles (with whom the Lohans could be compared), has never entirely ceased to inspire the artists.[109]

The Buddhist frescoes by Kuan-hsiu, as well as those of the many other T'ang painters, have all perished, and once again we must have recourse to Central Asia, in order to get an idea what they looked like. The representations of the Paradise of O-mi-t'o (Amitābha) found now their most sumptuous expression. Centralized compositions are united with a sense of vast space. Extended groups of buildings form the background. Figures to any number are assembled in festive and balanced arrangement. One could almost forget that a religious scene is meant. In fact, what we observe is the splendour of the Imperial Court, translated into a world of bliss. Caves 31, 34, 120g and 139a (Fig. 23) in Tun Huang contain probably the most remarkable examples of this sort executed at the pinnacle of the era (8th till 9th century). The 9th-century mural paintings in the chapel of Wan Fo-hsia, also in Tun Huang, are in a specially good state of preservation.[110] Here the deities of the Chên Yen

Pl. 29-30

Pl. 32

[108]See. S. Ōmura, *Zengetsu Daishi Jūroku Rakan*, Tōkyō, 1909, where the whole series, partly in colour, is illustrated. There are stone engravings of a series of Lohans ascribed to Kuan-hsiu in the Shêng Yin Ssŭ near Hangchou (Fig. 21-22). [109]See M. W. de Visser, *The Arhats in China and Japan*, Berlin, 1923, where the origin of the motif, the single figures, the different groups, and most of the series known to-day are dealt with. See also, especially on Kuan-hsiu, Silvain Lévi et Edouard Chavannes *Les Seize Arhat, Protecteurs de la Loi*, Journal Asiatique, 1916, Appendix II, p. 298 ff. It is doubtful whether any originals by Kuan-hsiu have survived. [110]Langdon Warner, *Buddhist Wall-Painting, A Study of a Ninth-Century Grotto at Wan Fo Hsia*, Cambridge, Mass., 1938. Cf. also n. 85 and 86.

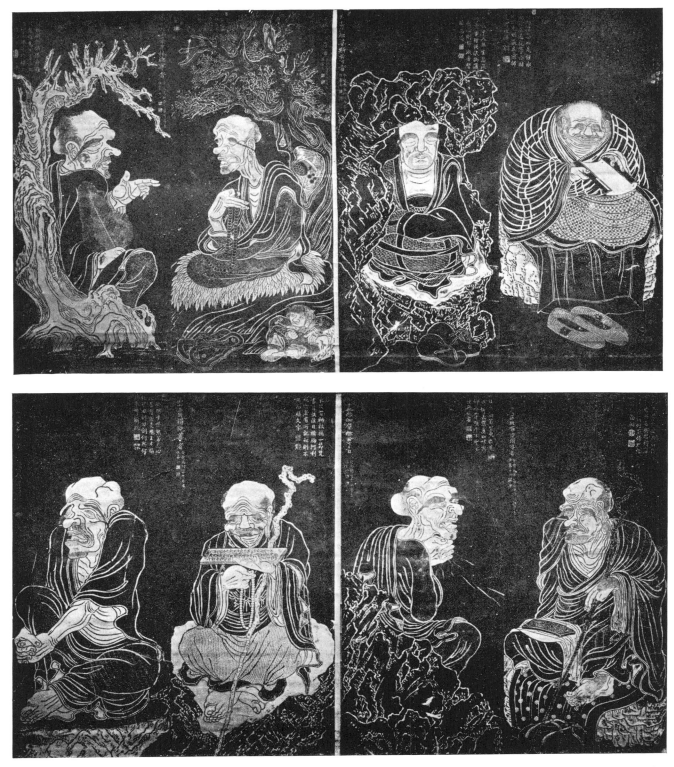

21-22. After Kuan-hsiu (A.D. 832-912). Eight of a series of *Sixteen Lohans*. Rubbings from the stone engravings in the Shêng Yin Ssŭ near Hangchou. Cf. pl. 29 and 30.

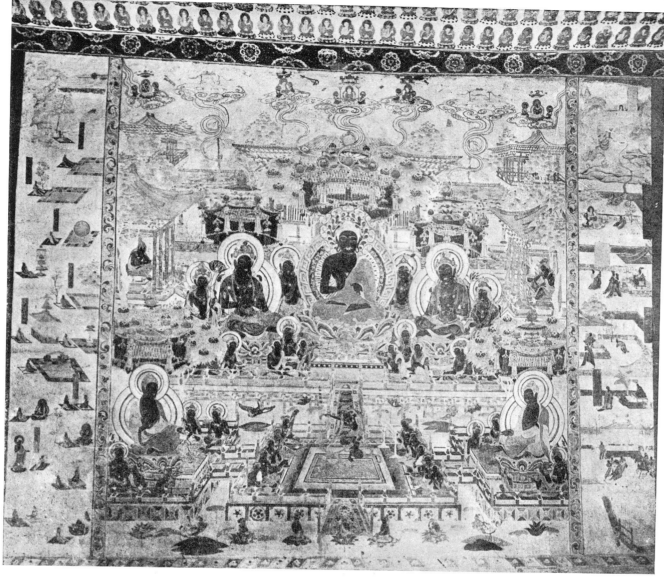

23. *O-mi-t'o (Amitābha) as Ruler of the Paradise of the West*. Fresco. Cave 139a. 8th or 9th century A.D. Tun Huang.

sect—which at that time was at its very height—look down upon the spectator and move him to devotion. Once again we have a centralized composition with P'i-lu-fo (Vairocana) in the middle, flanked by Wên-shu (Manjusri) seated upon a lion, and P'u-hsien (Samantabhadra) upon an elephant. The transcendental calm and remoteness of the Buddha is intensified by the diagonal position of the followers and the vigorous movement of the animals' grooms, which recall similar representations by Yen Li-pên and Han Kan. The figures are plastically conceived, all dimensional fumblings being now a thing of the past.

The frescoes from Turfan (Museum, Berlin) mostly have their origin in the same period.[111] As Turfan lies still farther away than Tun Huang from the centre of Chinese art life, they exhibit, as far as they have come to light, a much more provincial character than their counterparts in Tun Huang. How dry is the treatment of the figures and how shallow is the spacing on the central composition of the Pranidhi scenes from Bäzäklik (Turfan).[112] *Pl.* 17

[111]A. v. Le Coq, *Chotscho*, 1913; id. Die buddhistische Spätantike in Mittelasien, 7 vols., 1922-26; Ernst Waldschmidt, *Gandhāra, Kutscha, Turfan*, 1925; A. Wachsberger, *Stilkritische Studien zur Kunst Chinesisch Turkestans*, Ostasiatische Zeitschrift, III, IV, 1914-16. [112]The Dīpankara Buddha is one of the predecessors of the historical Buddha. Pranidhi-scenes means scenes of worship.

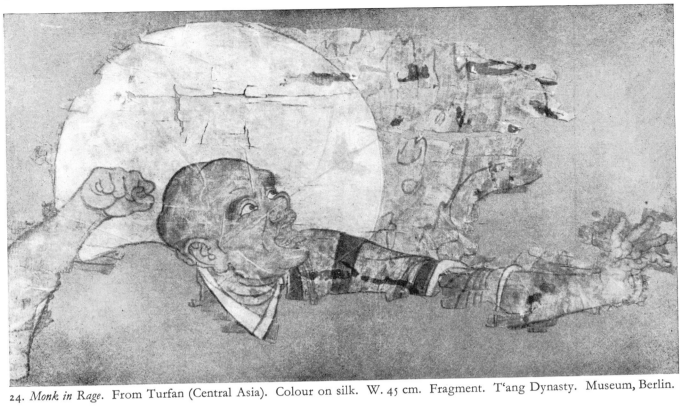

24. *Monk in Rage*. From Turfan (Central Asia). Colour on silk. W. 45 cm. Fragment. T'ang Dynasty. Museum, Berlin.

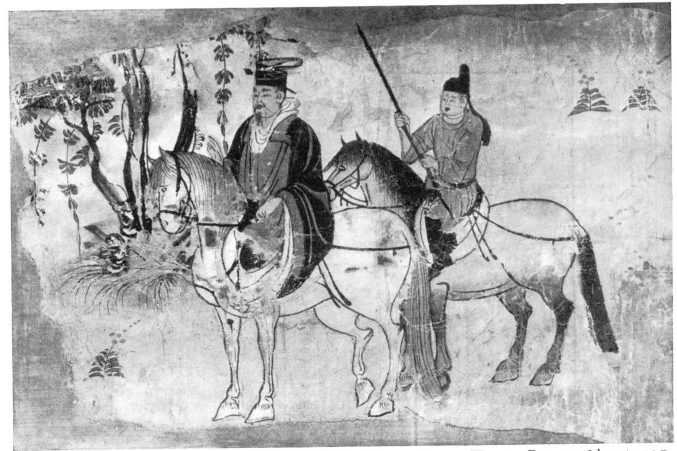

25. *Official and Attendant on Horseback*. From Tun Huang. Colour on paper. H. 15 cm. W. 23 cm. Fragment. 8th century A.D.
Louvre, Paris.

However, the grandeur of T'ang conception does not fail to impress even here. In Turfan, as in Tun Huang, not only frescoes, but also a number of independent paintings on silk and paper have been found. The head of a Bodhisattva with a richly ornamented head-dress, *Pl. 28* from Turfan, is a noble example of Buddhist painting of the high T'ang period. And the fragment of a *Monk* (Fig. 24) exhibiting greatest exaltation (also from there) betrays an unusual inner power. In comparison with it the silk painting from Tun Huang, with the Bodhisattva Ti-tsang (Kshitigarbha) in the centre and the *Ten Infernal Tribunals* in the background (dated 983), in so far as it exhausts itself in conventional Buddhist iconography, *Pl. 31* seems to be a distinctly poor performance.[113] The donor, a beautifully dressed woman, with attendants at the foot of the picture, is certainly not by the same hand as the rest. Here we are face to face with a fine expression of 10th-century secular art in China. The *Horsemen* (Fig. 25) and the *Horses* from Tun Huang excel in liveliness and vigour. They offer *Pl. 33* perhaps a better idea of the art of Han Kan than most of the pictures that go under his name.[114]

[113]Ti-tsang is at one and the same time the Lord of Hell and the Saviour from Hell; the Ten Kings of Hell are subject to him. They are accordingly represented in company with him. Cf. *Asiatic Mythology*, 1932, p. 375 ff; M W. de Visser, *The Bodhisattva Ti-tsang in China and Japan*, Ostasiatische Zeitschrift 11, 1913, p. 266 ff. The Museum of Fine Arts, Boston, and the Daitokuji, Kyōto, own noble sets of 13th or 14th century representations of the *Ten Kings of Hell*. [114]Most of the collections of Chinese art all over the world own paintings which are ascribed to, or connected with, T'ang and pre-T'ang masters. It would be worth while to submit them to a more thorough examination in order to make out how far they can be used to enlarge our knowledge.

IX. MATURITY AND BALANCE

THE FIVE DYNASTIES (A.D. 907-960) AND THE SUNG DYNASTY (A.D. 960-1279)

BACKGROUND

AFTER the fall of the Han, it took China nearly four centuries to become united; after the T'ang dynasty collapsed, only a few decades. The urge towards consolidation and, at the same time, isolation had grown more intensive. It is, in fact, impossible to speak of a sovereign Chinese culture embracing all parts of the country before the Sung epoch. Up till then many unifying elements doubtless existed, but centrifugal forces were still very powerful. The T'ang people were ever ready to absorb foreign religions and the influence of foreign races, whereas the culture of Sung was sufficient unto itself. It either rejected outside influences or thoroughly assimilated them. Even trade with the outer world was gradually allowed to pass into the hands of Arab merchants.[115] If we compare T'ang and Sung mentalities, we see certain fundamental differences. There prevails in the former a lively pleasure in, and a keen enjoyment of, the colourfulness of this world; in the latter, spiritual self-discipline is the keynote, a striving to grasp the innermost content of all being, together with a deep reverence for Antiquity. Then again, there is, in the one, a relish for the good things of this life; in the other, a flight into the silences of nature; even some of the rulers indulged this propensity and resigned their thrones before their time. Finally, whereas the T'ang had been of a warlike complexion, now the soldier, never overrated in China, lost all esteem. The philosopher and the man of letters were reputed to be the real leaders. It is no accident that the academic life and the examination system reached their peak under the Sung, that printed books were produced for the first time in the world, and that far-reaching reforms were being attempted. It would appear as though the Sung monarchs occupied themselves above all else with the maintenance of peace and the encouragement of art, philosophy and poetry. The fact that threats by neighbouring states continually caused unrest, and the political situation had rarely been more unsatisfactory, does not diminish the grandeur of this attitude.

After the rebellion of Huang Ch'ao (876-884) and the extermination of the house of T'ang and all its dependants by Chu Wên, China fell into a condition of chaos. Official records inform us that within fifty-four years (907-960) five dynasties, with thirteen emperors of eight different families, followed one another. In reality, not only the five dynasties after which the period is named, but a much larger number succeeded each other on the throne. Governors and generals not infrequently proclaimed themselves masters of their provinces and founded independent states.[116] Often the power of the rulers did not spread much beyond the confines of their capitals. Southern China, as usual, was less touched by political unrest than the North, and thus she had greater possibilities of strengthening her share in the cultural development of the land.

This prelude to the Sung period lasted only half a century. China was ripe for unity, which in fact, from now on, hardly again suffered any lasting setback. Nevertheless, the new empire of the Sung lay under an unfavourable political constellation from the very beginning. Three neighbouring peoples, originally of nomad stock, incessantly threatened her: the

[115]'Chou K'ü-fei, writing 1178 . . . shows conclusively that this trade in his time was in the hands of the Arabs and other foreigners. . . .' Cf. F. Hirth and W. W. Rockhill, *Chau Ju-kua: His Work on the Chinese and Arab Trade in the Twelfth and Thirteenth Centuries, entitled Chu-fan-chi* (St. Petersburg, 1912), p. 22. [116]There were above all three usurper kingdoms: Liao in the North (capital Yen Ching, that is, Peking); Shu in the West (Szechuan, capital Ch'êng Tu); Southern T'ang in the South-East (capital Nanking).

Turkish Khitan from the North, the Chin ('Golden Horde'), the ancestors of the Manchus from the North-East, and, finally, the Mongols, who were later to conquer not only China but half the world. The Hsia, although less dangerous, may be added to the list; they founded a mighty empire in the North-West of China during the first centuries of the Sung period.[117] But the significance of these threats and troubles, however fatal they were eventually to become, must not be exaggerated. The wars often merely consisted of short frontier incidents, and the government, by dint of clever negotiation, usually found a peaceful way out. Such a procedure may be condemned from the standpoint of national policy; and in the long run, the empire did indeed fall, bit by bit, into the hands of the aggressors. But it should be remembered that nationalism in our modern sense was then non-existent. The aggressive peoples were very strongly influenced by Chinese culture. On the other hand, the collections of the Sung rulers, for instance, contained pictures by painters from the enemy states. Despite all confusions, the dynasty succeeded in cultivating over a long period the finest blooms of the various arts of peace. Its founder, a general of the *Five Dynasties* (*Wu Tai*), who was posthumously named T'ai Tsu (960-976), was still entirely occupied with the pacification and organization of the newly united state. But his successor, the Emperor T'ai Tsung (976-997), already found the leisure to devote himself to cultural tasks. He commissioned the compilation of the first encyclopedia of really comprehensive scope,[118] and enlarged the imperial collection of paintings, of which he caused a catalogue to be drawn up. A series of painters who had distinguished themselves in the reigns of his predecessors continued their activities in K'ai Fêng Fu, the new capital. Sung culture now developed its own specific character under the Emperors Jên Tsung (1023-63), Shên Tsung (1068-85) and Chê Tsung (1086-1100). At the same time the statesman Wang An-shih (1021-86) endeavoured to carry through his surprisingly modern reforms. It is true, they were strongly opposed and finally wrecked during his lifetime, but the ideas behind them did not cease to germinate. The work of his political opponent, Ssŭ-ma Kuang, the great historian, is almost as fundamental as that of his precursor of the same family name of a thousand years earlier. The state examinations acquired that form which they have kept up, without any considerable alteration, to the days of the Republic. Ch'an Buddhism exerted the deepest influence. Philosophy took a new start. A synthesis of the many controversial ideas of the past was its aim; metaphysical problems came to the front. A series of eminent thinkers were at work, the forerunners of Chu Hsi, the Chinese Aristotle.[119] In literature Ou-yang Hsiu (1007-72) and Su Tung-p'o (1036-1101)[120] appeared, the former a poet and historian, the latter a creative genius in all spheres, including that of painting. An intimate friendship united him with artists such as Li Lung-mien, Mi Fei and Wên T'ung—all of them revered names for the Chinese lover of art.

The last emperor of the Northern Sung dynasty, Hui Tsung (1100-25), was considered a great painter and profound connoisseur of art. The Academy of Painting enjoyed his special protection. He brought the cataloguing of the much enlarged Imperial collection of pictures and bronzes[121] to a conclusion. These catalogues are far more than a mere registration of objects; they contain biographies, archæological information and even illustrations. Despite all this, neither the painting nor the other spiritual activities of Hui Tsung's time

[117]The Hsia were Tanguts, the Khitan and Chin Tungus. The Khitan rulers called themselves Liao. The Chin were called Juhchên by the Chinese. [118]The *T'ai P'ing Yü Lan* published from 977 to 983, surpassed all previous encyclopedias (*Lei Shu*) in volume. [119]Cf. A. Forke *Geschichte der neueren Chinesischen Philosophie*. The author observes that philosophy, too, reached a higher peak than ever before: 'Mir scheint, als ob doch der Sung-Zeit die Palme gebührt, und dass sie höher steht als die Tschou-Epoche', p. 7. The forerunners of Chu Hsi are known as the *Five Philosophers*. [120]Clara Candlin, *The Herald Wind*, Translations of Sung Dynasty Poems, Lyrics and Songs. With an Introduction by L. Cranmer-Byng, 1933. See n. 136, 137. [121]That is the *Hsüan Ho Hua P'u* (*Hsüan Ho Collection of Painting*) and the *Hsüan Ho Po Ku T'u Lu*. The former was begun in A.D. 990 and later on enlarged. It contains 6,396 paintings. Cf. Soames Jenyns, *A Background to Chinese Painting*, 1935, p. 107 f.

attained to quite the height of the immediate past. The Emperor's personal destiny is known to have been peculiarly tragic. Both he and his son, as well as the members of the entire Imperial Court, were made prisoners by the Chin in 1126, when the latter crossed the frozen Hoangho and conquered K'ai Fêng Fu. No member of the Sung house was killed on this occasion; but this fact is not surprising, if we take into account that the Chin had become thoroughly Chinese and that the person of the Chinese Emperor possessed for them an element of holiness. They made all haste to transport the captured library and picture collection to their own capital, Yen Ching (Peking).[122] They even permitted a son of Hui Tsung, after a short lapse of time, to be proclaimed Emperor, and thus to become the founder of the Southern Sung dynasty which now controlled only the south of the land.

Despite the enormous reduction of the empire, the hundred and fifty years (1127-1279) given to the Southern Sung dynasty proved to be one of the most memorable art epochs of China. The capital, Hangchou (since 1138), quickly developed into one of the most brilliant cities of the world. The vital arteries of Chinese art and philosophy, so far from being weakened and debilitated, as one might have expected, now actually teemed with fresh blood. In the realm of philosophy Chu Hsi (1131-1200)[123] effected the culmination of the rationalistic Neo-Confucian system, the overpowering significance of which was not, however, felt till after his death. Taoism and Ch'an Buddhism still held men in thrall. Both religions preached the insubstantiality of this world, and the ideal of the man of culture was, in fact, a life far removed from the vanities and pettinesses of the day. It is significant that three consecutive Emperors, in order to be able to withdraw into monastic solitude, abdicated in favour of their sons. There was, in fact, also sufficient political justification for dissatisfaction with this world. The Chin never ceased upsetting the land; and even more fateful events were already casting their shadows before. The Mongol storm was gathering. In 1189 Genghis Khan had become leader of the Mongols and began his triumphal march through Asia to Europe. Later on, he thrust his way into the empire of Chin (1211), and soon his horsemen stood at the frontiers of China. A succession of horrors now ensued. After K'ai Fêng Fu, the capital of Chin, had fallen, the last Chin monarch committed suicide. The Sung, not having recognized the danger, failed to come to his help. The Mongols started their attack upon China in 1251. In 1260 Kublai Khan was appointed Grand Khan of all the Mongols, with Peking as his capital. Hangchou capitulated in 1276. Two years later, the last scion of the Sung house (a child) was drowned during flight. The Mongols (Yüan) were masters of all China.

DEVELOPMENT

Since the 10th century it is Ch'an Buddhism,[124] imbued with Taoist thought, which has produced the most profound change in painting, and it was in its shadow that *Mo Hua* (painting in Indian ink) arose. Ch'an Buddhism taught that the divine exists everywhere, both in nature and in man. Thus it may easily be understood that landscape and, besides, animal and plant should move into the foreground. Once it is accepted that everything of this world is mere illusion, it seems equally comprehensible that the painters turn away from the accidentals of being—from the superficiality of colour, the accentuation of detail, and from all themes lacking inner significance—in order the better to probe into the very essence of

[122]It is certainly untrue that Hui Tsung's collection was completely destroyed, as is sometimes reported; but it is no less certainly true that only few of the works bearing the seal of Hui Tsung's collections are entitled to it. [123]J. P. Bruce, *Chu Hsi and His Masters*, 1923. [124]On the influence of Ch'an Buddhism on art cf. Arthur Waley, *Zen Buddhism and its Relation to Art*, 1922, and Osvald Sirén in *The Chinese on the Art of Painting*, Peiping, 1936. On Ch'an Buddhism itself: D.T. Suzuki, *Essays in Zen Buddhism*, 3 vols., 1927 ff; Hu Shih, *Development of Zen Buddhism in China*. The Chinese Social and Political Science Review, vol. xv, 1932; Alan W. Watts, *The Spirit of Zen*, 1936; Heinrich Dumoulin, *Entwicklung des Chinesischen Ch'an Buddhismus nach Hui-nêng*, Monumenta Serica, VI, 1941; Ōkakura Kakuzō, *The Book of Tea*, 1919.

reality. In landscape, space and depth become the most important elements. Sūnyatā, the doctrine of the great Emptiness, one of the fundamental doctrines of Ch'an, appears to have found symbolic reflection. When, as frequently happens, means are reduced to an absolute minimum and the painting seems to have been made in a flash of plenary inspiration, this process may correspond to Intuition, another characteristic trait of Ch'an. Naturally, also many figures taken from the world of Ch'an enrich the subject matter of Sung painting.

Residing in Nanking, around the middle of the 10th century, was Li Yü (d.978), the last ruler of the Southern T'ang dynasty (one of the usurper dynasties), in many respects a precursor of the Sung who were to annex his kingdom. Famed both as a poet and a painter, he was above all a Mæcenas of art. He founded in his capital K'ai Fêng Fu an Academy in which painting also was fostered. Well-known names, such as Hsü Hsi, Chou Wên-chü, Tung Yüan, Chü-jan and Ku Hung-chung are linked up with it.[125] The Emperor laid great stress on the refining of painting utensils and materials. Brushes, rubbing stones, paper and mounts of his time were later considered by Sung painters as unequalled models and were eagerly sought after. It also appears to have been in the 10th century that the use of the hanging picture, with its special kind of mounting, became more general than that of the hand scroll; and it is more than likely that Li Yü participated in this development.

Another cultural centre of the same epoch was Ch'êng Tu (I Chou) in Shu (modern Szechuan), situated in the far West of the empire. Many a painter fled from the capital, Ch'ang An, to I Chou during the unrest which accompanied the fall of T'ang.[126] But the fame of I Chou is not localized within the confines of Chinese art; over and above this, it can lay claim to world-wide significance. It would appear that the first books (block-books) ever to be produced were printed here.[127] And the first edition of the *Nine Classics,* the publication of which (at the instigation of the versatile minister Fêng Tao) covered the years 932 to 953, may possibly have issued from I Chou.

In Ch'êng Tu worked the painter Shih K'o, whose name is connected with the earliest surviving figure paintings in pure ink. If he really was the one who painted the images of two priests absorbed in meditation (Lohan or Ch'an patriarchs) with such a freedom of the brush, he must have been a revolutionary indeed. His brush stroke is instinct with expression and calligraphic dynamism. Gone is the preference for detail and colour of T'ang art—ink painting has found its own language. *Pl. 34-35*

The landscapists of the period of the *Five Dynasties* are cited in all Chinese writings on art as pioneers and their works have been looked upon by many generations as the ideal models to follow.[128] Their main theme is still the magnificence of the mountain world, as it was in T'ang times. Mighty formations of jagged mountains, enlivened by waterfalls, trees and shrubs, often covering the entire picture surface, tower immediately before the beholder's eyes. The human element almost disappears in the richness of the setting. But now monochromic treatment in black ink prevails. Clouds, mist, or layers of fog, in short, atmospheric effects, clearly begin to attract the attention of the masters. The mystery of boundless space has become a problem to be solved. And the insignificance of the creature, in comparison with the majesty of nature, is a thought which deeply absorbed them.

It is hardly possible to give a detailed description of the different landscape painters of the time. How little do we know of their lives and their *œuvre!* But a few pointers will be at-

[125]Wang Ch'i-han and Ku Tê-ch'ien should be mentioned too. [126]We happen to be specially well informed about the art life in Shu. In A.D. 1005 Huang Hsiu-fu published his *I Chou Ming Hua Lu,* which deals with 58 artists of Shu in those days; among them besides Shih K'o and Kuan-hsiu, whom we mentioned already, Huang Ch'üan, to whom we shall refer later; Li Shêng, Chao Chung-i, Tiao Kuang-yin, the teacher of Huang Ch'üan, and P'u Shih-hsün are also named. Wall painting, in particular, Buddhist as well as secular, was flowering in Shu; among the latter there were landscapes. [127]T. F. Carter, *The Invention of Printing in China and its Spread Westward,* New York, 1931, p. 47ff. Cf. also A. W. Hummel, *The Development of the Book in China,* Journal of the American Oriental Society, vol. 61, No. 2, June 1941. [128]Ludwig Bachhofer, *Chinesische Landschaftsmalerei vom X-XIII. Jahrhundert,* Sinica x, 1/2.

Pl. 36

Pl. 37-39

Pl. 40-42

Pl. 43

Pl. 44

Pl. 46-48

Pl. 45

tempted. At the beginning there is Ching Hao,[129] whose scenery is among the most fantastic. His compositions are rather overcrowded and his feeling for space is still groping. In the case of his pupil and supposed rival Kuan T'ung—both of them were active during the first half of the 10th century—, the scenery has become more simplified. Li Ch'êng (late 10th century) is considered by posterity to be one of the most gifted and influential landscape painters, not only of the period, but of all times. He no longer carries the mountains to the upper edge of the surface, the horizon tends to become lower, and valleys draw the eye into the depth. His trees are clearly characterized and breathe an inner life (Fig. 26).[130] His pupils, Fan K'uan (Chung-chêng) and Hsü Tao-ning seem to be more old-fashioned than he, but the aerial phenomena are more strongly stressed in their paintings. The works attributed to Tung Yüan make a remarkable stride in the direction of a lyrical landscape art. If the Boston scroll really is by his hand, he must have been far in advance of his time. Here the motif has become more simple and unpretentious, but haze and mist endow it with a mysterious power, covering the space as with a veil and simultaneously widening it. Closely related to Tung Yüan is Chü-jan, reputed to be his pupil. Both were already at work under Li Yü, the art-loving ruler of the Southern T'ang dynasty, and both continued their activities under the Sung. The conquest of space is hardly any longer a problem for Chü-jan. Over and above this, his landscapes are more tense in structure and closer to nature than anything preceding them. The hand scroll of the Freer Gallery ascribed to him still seems to contain something cartographic. The slight pedantry unmistakably shown here may have its origin in this factor. Nevertheless, it remains a unique work and is of uncommon quality. The banks of the Yangtze move past before us like a strip of film. A river landscape with its woods, pinnacled mountains, soft hills, and deep valleys is transformed into a dream vision by haze and mist.

All the evidence goes to show that despite the growing popularity of the landscape, the genre drawn from Court life did not cease to attract wide circles. To what extent has the new spirit left a mark on it? The question can be answered, for instance, by Ku Hung-chung's *Cock Fight before the Emperor*, Ku being one of the painters at the Court of the Southern T'ang. Here, there is as yet little in the way of spatial elements to be felt; but with what a light touch the grouping of the Emperor on horseback, surrounded by his attendants, is composed! And how lively appears the expression of tense interest on the part of the on-lookers.[131] Regarding the hand scrolls attributed to Chou Wên-chü (one in the British Museum, the other partly in the collections of Sir Percival David, Professor Bernard Berenson and the University Museum, Philadelphia),[132] which are probably early copies or excellent paraphrases of originals by the master, the aristocratic restraint of the women, as portrayed in older pictures of similar type, has been converted into graceful and even relaxed ease. The whole composition, although of a more haphazard aspect, is rather consciously balanced. Observe how cleverly the eye is led from group to group. Children play an important part. A work linked up with Chou Wên-chü's contemporary Huang Ch'üan (d.965), *An Assembly of Birds on a Willow Bank*, in the Moore Collection, New York (Figs.

[129]An essay on landscape painting is attributed to Ching Hao: *Pi Fa Chi* (*Notes on Brush Work*), also called *Hua Shan Shui Lu* (*Essay on Landscape Painting*). Although his authorship is doubtful, the essay gives us the atmosphere of 10th-century painting. See Shio Sakanishi, *The Spirit of the Brush*, 1939. [130]Li Ch'êng offers a specially characteristic example of the uncertainty of our knowledge of Chinese painting. Mi Fei (1051-1107) saw c. 300 paintings ascribed to Li, but considered only two authentic. Hui Tsung's catalogue enumerates 149 items by Li. Cf. Shio Sakanishi, op. cit. p. 97 f. [131]There is a six-fold screen in the Tōji, Kyōto, with genre-like representations which have certain similarities to Ku Hung-chung's *Cock Fight*. Although executed in Japan, it contributes, with its continuous landscape background, to our knowledge of Chinese 10th-century landscape painting. Further, it enables us to form some idea of early Chinese screens, none of which has survived. (Reproductions in most of the great Japanese publications.) The Tun Huang fresco (cave 70) where the famous episode outside Kusinagara is depicted may also belong to the same period. [132]Cf. Helen E. Fernald, *Ladies of the Court. An Early Chinese Scroll painting*, The Museum Journal (XIX, No. 4, 1928), where parts of the scrolls belonging to the University Museum, Philadelphia, and to Prof. Berenson are illustrated. See also Yukio Yashirō, *A Sung Copy of the Scroll 'Ladies of the Court' by Chou Wên-chü* (in Japanese), Bijutsu Kenkyū, Jan., 1934.

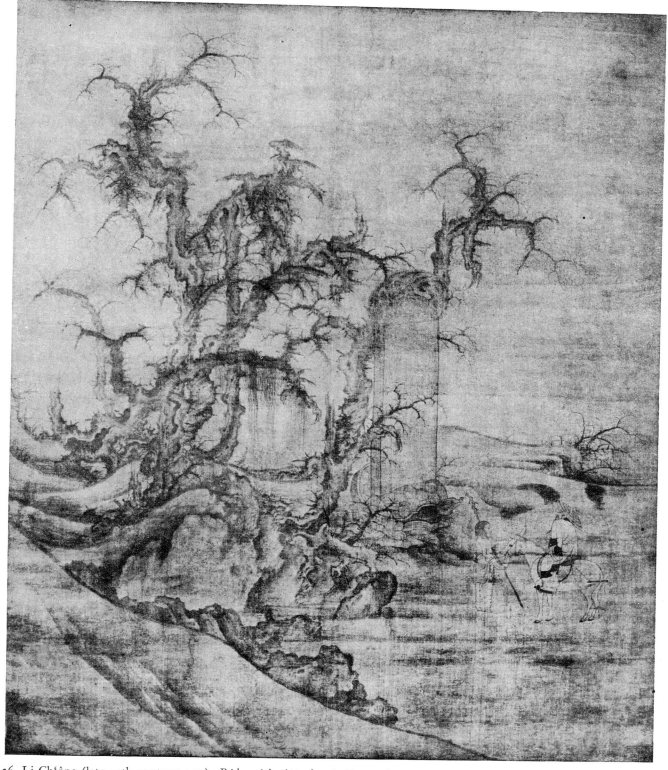

26. Li Ch'êng (late 10th century A.D.). *Rider with Attendant in Front of an inscribed Slab.* Ink and slight colour on silk. H. 126 cm. W. 105 cm. Private Collection, Japan.

27, 28), exhibits a similar character, though it deals with a quite different subject. It may be the earliest surviving hand scroll in which flowers and birds of all kinds are gracefully and rhythmically distributed within the framework of a long narrow picture surface; a unified landscape forms the background, and rich colours are employed. Huang Ch'üan must have

27. Attributed to Huang Ch'üan (d. A.D. 965). *An Assembly of Birds on a Willow Bank.* Part of a hand scroll. Colour on silk. H. 23 cm. L. 182 cm. Mrs. Ada Small Moore, New York.

been a highly prized master, for his name occurs innumerable times in art literature. The catalogue of Hui Tsung's collection counts no less than three hundred and forty-two works by his hand, many of them taken over from the Emperor's victorious predecessors, when they conquered the Shu state, where Huang's career had begun. Another contemporary flower specialist, Hsü Hsi, seems also to have enjoyed great popularity. But the two impressive hanging pictures with lotus and heron that have been attributed to him from of old do not suffice to give us an adequate idea of his art. The lotus is the Buddhist symbol for the purity of the soul; thus we are actually dealing with ritual pictures. This may explain their severely monumental conception, which is not necessarily characteristic of Hsü Hsi; it was probably formed as early as the T'ang period and remained traditional.

Pl. 52

Several of the masters who had won their laurels during the Five Dynasties carried on under the Sung. But new stars soon appeared in the firmament. Under the Emperor Shên Tsung we see Kuo Hsi (1020-1090) step into the foreground. He is said to have been commissioned to execute murals with landscapes for the Imperial Palace. Yet only a series of bulky hanging pictures which can be plausibly ascribed to him have survived. They are compositions of particular grandeur and well suited to reveal what the master's wall paintings may have looked like. Buildings, bridges and men have become important elements in landscape. Whereas the accent formerly lay upon the middle ground, here it is shifted more to the foreground. These features also find expression in the hand scrolls of the Toledo Museum and the Freer Gallery. The observation of atmospheric phenomena has undergone further refinement. Kuo Hsi's fame rests not only upon his paintings, but also upon a sensitive essay entitled *Lin Ch'üan Kao Chih (The Great Message of Forests and Streams)*.[133] It was published by his son, but actually inspired by the father. How many landscapists have kindled at this slender book treating of mountains and water, and the magic that mist and fog lend to things! For the first time we recognize the influence of Ch'an spirit upon art literature.

Pl. 49-51

Kuo Hsi was a member of the Academy, which now began with ever-growing determination to take art and artist under its wing. The first director, Huang Chü-ts'ai, a son of Huang Ch'üan, devoted himself chiefly, as did his father, to bird and flower painting. It is perhaps due to his influence that the painters called to the Academy favoured this branch of Chinese painting. The pattern for it was set by such masters as Chao Ch'ang (act. *c.*1000)[134] and Ts'ui

Pl. 35

[133]Kuo Hsi, *An Essay on Landscape Painting*, translated from the Chinese into English by Shio Sakanishi, 1935. [134]A contemporary of Chao Ch'ang was I Yüan-chi whose picture, *A Hundred Gibbons*, is often mentioned in literature. Kuo Jo-hsü's *T'u Hua Chien Wên Chih* (published A.D. 1074) gives ample information on the painting of the 10th and 11th centuries.

28. Attributed to Huang Ch'üan (d. A.D. 965). *An Assembly of Birds on a Willow Bank.* Part of a hand scroll. Colour on silk. H. 23 cm. L. 182 cm. Mrs. Ada Small Moore, New York.

Po (second half of 11th century). A brilliant decoration was achieved, harmonious in arrangement, unsurpassed in observation, bringing to life the splendour of nature in blossom. It served as a model for thousands of works of similar kind, which, it is true, were sometimes almost mass-produced. When we learn that the collection of Emperor Hui Tsung contained, besides the previously mentioned three hundred and forty-two pictures by Huang Ch'üan and two hundred and forty-nine by Hsü Hsi, another hundred and fifty-four by Chao Ch'ang and two hundred and forty-one by Ts'ui Po—mainly paintings of women, flowers and birds—, we can conclude that this production in bulk set in very early.

The art and life of the second half of the 11th century attained a climax of fervour and intensity that bids fair to rival the Golden Age of the T'ang Emperor Ming Huang. But obviously a more conscious and more introspective spirit prevailed. Not until now did the Chinese ideal of the Wên Jên (*literati*) to be at home in all provinces of culture, begin to materialize. To this must be added the factor of a specific æstheticism, without the knowledge of which the entire art of the Sung era cannot be understood. Witness the solemn tea ceremonies where the assembly, surrounded with selected paintings and other choice objects, entertained themselves with æsthetic discussions. Simplicity was the keynote, yet not to the exclusion of precious material and artistic accomplishment.[135]

In the centre of the intellectual life of the time stood the universal genius of Su Shih (Tung-p'o, 1036-1101).[136] His circle contained not only the painters Mi Fei, Wên T'ung and Li Lung-mien, but also such personalities as the great statesman Wang An-shih. Everything

[135]We know of the tea-ceremony and the æstheticism connected with it mainly from Japan. But it is pretty sure that there were Chinese antecedents. In the poem, *Making Tea in the Examination Hall*, written by Su Tung-p'o in A.D. 1072, for instance, several points are touched upon which are significant for the performance of the tea-ceremony. The first part of the poem reads:

> The 'crab's eyes' have passed away and the 'fishes eyes' begin;
> Sou, sou, it begins to make a pine-tree wind song.
> Scitter, scatter down from the grinding fine pearls fall;
> In blinding dance round the pot flying snow whirls.
> To pour the water into a silver urn and praise this second step
> Is to ignore the water-boiling theories of the men of old.
> For see you not
> That long ago Master Li, who loved his guests, boiled the water with his own hand;
> His pride was that a living flame met water fresh from the spring.
> And see you not
> That in these days the Duke of Lu boils his tea like the people of Western Shu.
> Drinks in patterned porcelain of Ting-chou or carven red jade.

Translation by Arthur Waley. See The Year Book of Oriental Art and Culture, 1924-25, edited by Arthur Waley.

[136]Ku Têng, *Su Tung-p'o als Kunstkritiker*, Ostasiatische Zeitschrift, 1932; Cyril Drummond Le Gros Clark, *The Prose-Poetry of Su Tung P'o*, 1935. See especially 'His Philosophy of Art', p. 10 ff.; id. *Selections from the work of Su Tung P'o*, 1932; Clara Candlin, *The Herald Wind*, Translations of Sung Dynasty Poems, Lyrics and Songs. With an Introduction by L. Cranmer-Byng, 1933.

that was sacred to the Sung man here found its realization. Su Shih's poems, highly charac-
teristic of Sung feeling and thought, are well suited to compete with the famous creations of
the T'ang poets. As a painter, he worked only in ink and confined himself primarily to the
subject of bamboo, now the accepted symbol of the Chinese gentleman in all situations of
life. Su Shih's friend, Mi Fei, was a keen collector of paintings and calligraphies; his enthu-
siasm was unbounded. Specially concerned with the careful preservation of his treasures, he
devised a number of rules and regulations for visitors who wished to admire them, so that the
precious things should not be damaged in the showing, and were looked upon only by
worthy eyes. In short, we find here all the formalities that are to be observed to this day by
the visitor to Far Eastern art collections.

Pl. 54 Su Shih proclaimed the prematurely deceased Wên T'ung (d. 1079) as the greatest
bamboo painter of all time and as his unattainable ideal. Representations of bamboo from
now on belonged to the repertory of most Sung and many later artists. It perhaps goes
beyond the capacity of the spoken word to analyse the fine shades by which the bamboo
pictures differ from one another; some short remarks may suffice. The general aim was to
capture stem and leaves with a few concentrated brush strokes—which, according to the
master's intention or ability, would vary from the utmost tenderness to extreme boldness—
and to dispose them harmoniously, or capriciously, over the picture surface. Bamboo, in its
simple pregnant structure resembling an ideograph, is a perfect object for ink painting.
Its different appearances in wind, storm, rain or moonlight offer the opportunity
for infinitely subtle nuances of ink tones, its flexibility giving scope for ample variation
of linear rhythm. It is doubtful whether any original work by Wên T'ung has survived;
and authentic pictures or calligraphies by Su Shih are also to be numbered among the rarest
of treasures.[137]

Pl. 56-57 Although Mi Fei (1051-1107) held a series of official positions and, like Su Shih, indulged
in literary activities, he seems to have occupied himself more zealously with painting than his
great colleague. In fact, he has left behind him a special essay on painting.[138] Both masters had
Pl. 55, 58-59 sons who were painters of repute. Mi Yu-jên and Su Kuo held closely to their fathers' style,
without attaining to the same dramatic vigour and spirituality. The works, which to-day are
linked with the name of Mi Fei, exhibit only one side of his genius, namely, his peculiar brush
technique. He almost entirely eliminated line and contour and built up his landscapes out of
splashes. Ink painting has here become purely pictorial. In all other respects his vertically
arranged sceneries remain the offspring of the preceding century. The hanging pictures in the
possession of the Chinese Government, of the Freer Gallery in Washington, and in Japanese
private possession, probably deserve, among many similar examples, to be accepted as the
most likely ones to be authentic.

Pl. 60-61 It has perhaps fallen to Chao Ta-nien (Ling-jang, act. *c.* 1080-1100) to remove the last
impediments to a landscape painting which has no other ambitions than to express a certain
mood of the soul. His works are often entirely free of hills and mountains—a rare occurrence
in Chinese landscape painting—and immediately before us flat country, intersected by
waterways, unfolds itself. All attention is given to the cultivation of the space. Details just
emerge from the mist. No earlier painter dared to present so unobtrusive and intimate a
view of the landscape. The master liked to work with splashes of ink, but his brush stroke is
devoid of all tension and strikes rather a more lyrical note. Chao's significance in the further

[137]Su Shih quotes Wên T'ung's (Yü-k'o) ideas on bamboo painting in his Fu (poem in prose), *Bending Bamboos of Yün-tang Valley*: 'If you wish to paint bamboo, you must first visualize it in your mind's eye. With brush in hand, study for a long time your subject. Directly you see what you want to paint, quickly follow it up with strokes of the brush. Thus, by close pursuit you reach out after your conception. Just as when a hare rises, the falcon stoops; the slightest hesitation, and it has disappeared.' Cf. C. D. Le Gros Clark, *Selections from the Work of Su Tung P'o*, 1932, p. 77. [138]The *Hua Shih*. Cf. Osvald Sirén, *Mi Fei, En Kinesisk Malare, Samlare ock Kritiker*, Nationalmusei Arsbook, 1932.

development of landscape painting, including his role as teacher to the Emperor Hui Tsung, cannot be overestimated.

Besides these pioneers of a new spiritual orientation nourished by Ch'an thought, there were, of course, more conservative masters. At the head of these stood Li Kung-lin (Lung-mien, 1040-1106).[139] As near as we can form a notion of his art, he must have looked upon T'ang painting as the model of perfection.[140] Nevertheless, he apparently knew how to impress every one of his works with the stamp of his individuality. Many of them are described in the older literature. Only a few of the great number[141] of surviving pictures attributed to him merit our confidence—most of all perhaps the hand scroll with the five horses and their *Pl. 66* grooms (formerly in Peking), in which the spirit of Han Kan is resuscitated; and then Vimalakīrti with follower (Japanese ownership), probably a part of a hand scroll, to which *Pl. 64* Wu Tao-tzŭ was godfather. But the elegance of the flow of line and the harmony of the composition which distinguish these works, surpass everything of their kind previously done.[142] The short hand scroll containing extended palace buildings (Freer Gallery, Washington) could hardly be credited to any other master than Li Lung-mien. Here we have an *Pl. 62-63* architectural landscape, a favourite theme of T'ang painting, but now without T'ang colours, drawn in black ink with a subtle brush. The splendid palace with its ample courtyards and delicate female figures is impregnated with something like wistfulness for times that have vanished for ever. Closely related to this hand scroll is another one, also in the Freer Gallery. Here, too, the main theme is one of noble architecture with a fantastic landscape background in T'ang style, but with supreme spatial and atmospheric effects—of its kind something quite new. There is the same air of unreality as in the palace scroll. As a matter of fact, we are dealing in this case with a fairy tale.[143] Most of the other works ascribed to Li Lung-mien— often most impressive ones—are less likely to be his, and this also holds good of the representations of Lohans, with which, according to the sources, he had much occupied himself. In this field he is said to have created new types, namely, more detached figures,[144] in contrast to the rather impetuous prophets by the 10th-century master Kuan-hsiu. Li *Pl. 29-30* Lung-mien enjoyed, as only few others, the highest possible appreciation, both from his own contemporaries and from posterity. Probably it was he that fused into a new unity the narrative style of T'ang painting with the latest achievements in the realm of landscape.[145]

Su Shih and his exalted circle were most of them just able to experience the beginning of the Emperor Hui Tsung's rule. But they were aged, and a new generation of artists congregated around the monarch—the painter on the throne. They stood in close relationship

[139] Agnes E. Meyer, *Chinese Painting as reflected in the Thought and Art of Li Lung-mien*, New York, 1923; V. Goloubew, *Un Peintre Chinois du XI Siècle, Li-Long-mien*, Gazette des Beaux Arts, 1914, I. [140] F. R. Martin, *Zeichnungen nach Wu Tao-tze*, 1904. Martin believes that the paintings published by him bearing the signature of Li Lung-mien were executed by Li after works by Wu Tao-tzŭ. Although they are obviously late paraphrases they may cast some light on the relation between the two masters. Li indubitably copied works of Wu. Incidentally, Goloubew (op. cit.) has uncovered remarkable similarities between the paintings published by Martin and the drawings of Botticelli for the *Divina Comedia*. [141] Hand scrolls attributed to Li Lung-mien are very frequent. In some cases even several replicas of the same work are extant. Cf. *La Légende de Koei Mou Chên, Peinture de Li Long-mien*, Annales du Musée Guimet; I. E. Chavannes, *La Légende de Koei Tseu-Mou Chên*, T'oung Pao, V, 1904; Karl Bone, *A Painting by Li Lung-mien*, T'oung Pao, VIII, 1907. [142] When we compare Li's Vimalakīrti with Wang Wei's *Pl. 22* Fu Shêng, we see a development in a measure similar to that from Gothic to Renaissance style. [143] Illustrated in Osvald Sirén's *Chinese Paintings in American Collections*, 1928, pl.30/31. [144] The set of a hundred paintings in the Daitokuji, Kyōto, and in Boston (dated 1178) representing the 500 Lohans may have originated in the shadow of Li Lung-mien. Of Chou Chi-ch'ang and Lin T'ing-kuei, who executed them, we know only from an inscription saying that they seem to have worked in Ningpo (Chekiang). Several other sets of 16 or 18 Lohans, now in Japan, belonging to the same period, come from *Pl. 86-87* Chekiang. Cf. Otto Kümmel, *Eine Lohan Folge der Sungzeit*, Jahrbuch der Asiatischen Kunst II, 1925. [145] The delicate painting *Pl. 65* of a *Woman in White* may be mentioned here. I am not quite sure whether it is meant to be a profane figure. Basket, fly-flap and the white garment indicate that Kuanyin may be represented, conceived as a human being. The work is said to be by Ho Ch'ung, a rather unknown painter. There are several figures of young women, ascribed to Li Lung-mien, which are considered incarnations of Kuanyin. Cf., for instance, Kokka, No. 233.

29. Attributed to the Emperor Hui Tsung (A.D. 1082-1135). *An Autumn Evening by a Lake.* Part of a hand scroll.
Ink on paper. H. 33 cm. L. 234 cm. Chinese Government.

to the Painting Academy (*T'u Hua Yüan*),[146] which now reached the peak of its influence. Two questions here arise: Was Hui Tsung really the outstanding painter of whom the sources are full? And what was the nature of the influence that he exerted upon the Academy? The first question may never be answered satisfactorily. The enormous number of daubs bearing the Emperor's signature—the many *White Falcons,* for instance—set no difficult problem. But there are, besides, numerous impressive paintings, signed, or merely attributed to him, which have survived. The variety of their style is startling. Among them are pictures of birds and flowers, either in colour or in ink (Fig. 29), executed with incredible delicacy;[147] but also others, thrown off, with a bolder brush stroke. Then, again, we see **Pl. 67-69** landscapes of surprising originality, others obviously reminiscent of Hui Tsung's teacher Chao Ta-nien, and not a few which may well derive from other contemporary painters. It is a difficult or almost impossible task to define the limits of his talents. Who, however, considering the Emperor's reputation, and while making full allowance for the obsequious eulogies paid to him,[148] can doubt that he had singular merits as an artist and far surpassed his princely forerunners? And yet, he may have been above all an inspirer and a Mæcenas of art.[149] Many of the works supposed to come from his hand may well have been productions by outstanding members of the Academy, which he signed with his name as a mark of his special appreciation. This would be fully in harmony with Chinese custom. The second question is closely connected with the first. The stories pointing to Hui Tsung's interference in the affairs of the Academy are too typical to be true.[150] This much is certain: the Academy in K'ai Fêng Fu, and later in Hangchou, can be compared with its Western counterparts at their height, e.g. with the one in Paris during the 17th and 18th centuries. It may be said the best talents of the time were associated with it. Comparisons with the 19th or 20th-century Academies in Europe would, on the other hand, lead us astray. Naturally, there were indivi-

[146]Cf. Seiichi Taki, *Art Encouragement under the Sung,* Kokka, No. 307/8, 1916; A. G. Wenley, *A Note on the so-called Sung-Academy of Painting,* Harvard Journal of Asiatic Studies, VI, 2, 1941. Têng Ch'un's *Hua Chi,* published 1167, is the most important Chinese work on this period. [147]See Kojiro Tomita, *The Five-coloured Parakeet by Hui Tsung* (1082-1135). Bulletin of the Museum of Fine Arts, Boston XXXI, Oct. 1933. [148]Are we really to believe Têng Ch'un's words (op. cit.): 'His expert knowledge was complete and thorough, his brushwork divine; he mastered every kind of subject and combined all the *Six Principles of Painting,* but specialized in feathers and furs' (birds and animals). It may be that only the last words are to be taken seriously. Cf. O. Sirén, *The Chinese on the Art of Painting,* 1936, p. 70. [149]There is still the question regarding the authenticity of the pictures in Hui Tsung's enormous collection. We find strange discrepancies between the great number of paintings by famous masters named in the catalogue, and the experiences of well-known, almost contemporary, experts. The *Hsüan Ho Hua P'u* enumerates ninety-three Wu Tao-tzŭ's; Mi Fei knew only four, Su Shih only one or two. The *Hsüan Ho Hua P'u* enumerates a hundred and fifty-nine Li Ch'êng's; Mi Fei saw three hundred imitations, but not more than two originals. Cf. A. Waley, *Introduction to the Study of Chinese Painting,* 1923, p. 113 f. [150]When we come across the following regulation issued in the first year of Hui Tsung's reign: 'Painters are not to imitate their predecessors but to depict objects as they exist, true to colour and form. Simplicity and nobility is to be their aim', we must recognize that this sounds by no means 'academic.' See A. Waley, *Introduction to the Study of Chinese Painting,* 1923, p. 178.

dual masters in China who held aloof from both Court and Academy. Such independent natures were always numerous in a land where life in solitude, far removed from the hurly-burly of the great city, set the fashion. In any case, the circle around Hui Tsung and his Academy seems to have been substantial enough. Perhaps the very outstanding innovators were missing, but the majority were fine artists.

Among them Li T'ang (1049-c. 1130) possessed an unusual versatility. The records testify to this, and several works that appear genuinely his, lend their corroboration. His landscapes, in their main characteristics, are rooted in the heroic conceptions of the 10th century; they are, however, more intimate and less pretentious. The real strength of Li T'ang probably lay in animal and figure painting, in which the landscape element was never absent. In his buffaloes—his peculiar speciality—the deep significance these animals have for the Chinese is expressed. These representations rise far above the level of mere well-observed animal studies. The *Buffalo* painting of the British Museum (Fig. 30), signed Li T'ang, can hardly be by him; the signature is obviously added later. Yet it may have some connexion with the master. With the very drastic *Village Doctor* and *The Return from a Festival*, Li *Pl.* 70-72 T'ang introduced genre into ink painting. A probable contemporary of Li Lung-mien was Ma Fên, the ancestor of the influential artist family of the Ma. We know little about him. If the remarkable scroll with the *Hundred Geese* (Museum, Honolulu) is correctly attributed *Pl.* 73-76 to him, and is not of later date, he was one of the first ink painters to make a study of birds in flight. Far Eastern painting reached unsurpassed heights in this power of grasping suspended movement. For the full development of the artistic significance of this motif, ink technique is particularly well suited. A century earlier, I Yüan-chi had already attempted to present a large number of animals of the same species, each in a different pose, within the framework of a landscape. In his case, they were apes who disported themselves on slopes

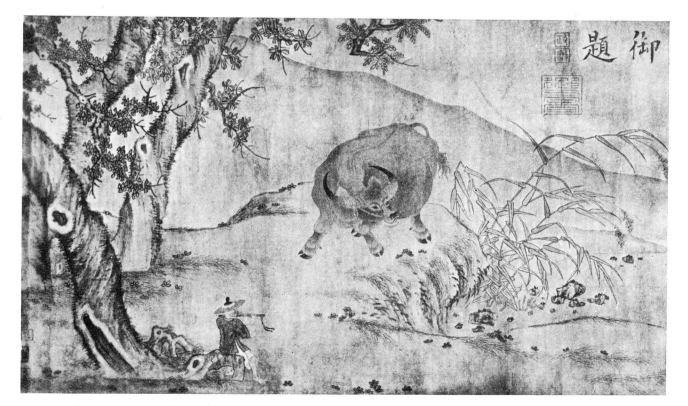

30. Attributed to Li T'ang (A.D. 1049-c. 1130). *Buffalo and Piping Herd-Boy.* Ink and slight colour on silk. H. 51 cm. W. 130 cm. British Museum, London.

and trees. What was then depicted by the aid of a pointed brush and with much detail, Ma Fên renders with broad washes, concentrating on the essentials.[151]

Pl. 77, 79 When we turn to those masters of the last decades of the Northern Sung who were more strongly attached to tradition (and traditionalists were always the majority in Chinese art), we meet at first with Su Han-ch'ên, who created colourful genre scenes with children as their main theme.[152] It may be that the enchanting *Toilette Scene* of the Boston Museum is by his brush. When we compare it with an 18th-century Dutch picture of a similar subject, or
Pl. 15 with an eight-hundred-years older Chinese version (Ku K'ai-chih), we realize that feminine vanity, with the means for gratifying it, is everywhere and at all times the same. All the more does the artistic conception testify to deep spiritual differences. Then there is Chao
Pl. 78 Po-chü, who places fairy-like palaces in a romantic mountain world, much as Li Ssŭ-hsün did before him. In his Boston hand scroll, with its narration of the *Entry of the First Han
Pl. 82-83 Emperor into the Capital of the Ch'in*, the real theme is palaces, terraces, mountains and bridges. But the surprising variation of the vistas and the brilliant disposition of the armies with the daring overlaps could only succeed in a time which had behind it a long experience in the realm of landscape painting.[153] Kung Su-jan, on the other hand, was a master apparently not unaffected by contemporary events. Strikingly realistic is the conception in one of his hand scrolls of a troop of warriors accompanied by dogs, presumably the representation of
Pl. 81 one or other of the border peoples then threatening China.[154] We have a model for the war-like scenes in contemporary and later Japanese hand scrolls in this work, which can thoroughly compete with them in its power of characterization and skill of composition.[155]

The loss of seven provinces, that is to say, of the whole Northern part of China, the capture of the Emperor Hui Tsung in 1126, the moving of the capital to Hangchou and the continual heavy battles with the Chin, did not produce any noticeable hiatus in the course of art development. After ten years, the Painting Academy flourished again in Hangchou, under the Emperor Kao Tsung, and included many celebrities who had participated in the move. At their head were the above-mentioned masters, Su Han-ch'ên, Li T'ang and Chao Po-chü. The younger generation still lay under their influence and was satisfied to continue working along well-established lines. Thus we have Li Ti (act. *c.* 1130-1180), who gave Li T'ang's style a lyrical sentimental twist. Very much is made in literature of Ma Ho-chih. But the works which pass under his name do not throw sufficient light upon his art. Chiang Ts'an is supposed to be the creator of a scroll in which the genre of the Hundred Animals is tried out
Pl. 80 on a new species. In his painting in New York (Metropolitan Museum), countless water buffaloes, in most varied movement, rove about in a wide undulating landscape, rendered in a pictorial style which avoids every sharp outline. Sovereign among animal painters were
Pl. 85 also Li An-chung and Mao I. *The Dog* (Boston Museum), attributed to the latter, is perhaps not anatomically satisfactory, but the manner in which the animal appears trotting out of the mist produces an incomparable impression of the creature's dereliction.

Around the turn of the 12th century, under the Emperors Ning Tsung (1194-1224) and Li Tsung (1224-1265), Sung China pulled all her strength together for a last mighty effort

[151]Several papers have been published on this beautiful scroll and different opinions have been given about its date. Cf. Yukyo Yashirō, *The Hundred Wild Geese*, Bijutsu Kenkyū, April 1937; E. P. Farrington, *The Hundred Wild Geese*, Bulletin of the Honolulu Academy of Arts, vol. 3; Edgar C. Schenk, *The Hundred Wild Geese*, The Honolulu Academy of Arts Annual Bulletin, vol. 1, 1939; George Rowley, *A Chinese Scroll of the Ming Dynasty*, Worcester Museum Annual 11, p. 63. [152]See also Dita Neumann, *Une Peinture de Sou Han-tch'en dans un Musée de Moscou*, Revue des Arts Asiatiques XII. [153]Kojiro Tomita, *Entry of the First Emperor of the Han Dynasty into Kuan-chung by Chao Po-chü*, Bulletin of the Museum of Fine Arts, Boston, xxx, Oct. 1932. [154]Possibly a particular event is depicted here; perhaps an episode of the story of Wên Chi or that of Chao Chün, those two famous women who had to marry chiefs of nomads in remote countries. See Tsui Chi, *A Short History of Chinese Civilization*, 1942, p. 94. [155]The Japanese claim to have originated this genre in the so-called Yamato-ye. This is not true. What is true is that the war paintings of the Yamato-ye are much more dramatic but at the same time more cruel in conception than those of the Chinese.

and this at a time when threatening clouds were obscuring the sky more than ever; when, indeed, far-seeing minds already felt that the Mongol danger could not be averted. These were the same decades in which Chu Hsi's profound interpretation of Confucius' teachings received official recognition (1237), from now on to be defined for the whole of the Far East, and when Ch'an Buddhism was acquiring an ever greater following. Not a few painters were Ch'an priests, and it may be that it was they in particular who represented the decisive impulses in art. Though most of the outstanding artists were members of the Academy, as before, this in no way signifies an indifference to Ch'an influence.

It was now that the classic era of Chinese landscape painting set in. Although the imagery was limited, there seems to have been no limit to the range of vision. To say much with little means was the highest aim. The more unpretentious the motif the better. Only a faint breath of colour, if any, enriched the scale of black ink tones. The power of the brush stroke attained its final expression. The suggestiveness of empty space was discovered, and the imagination of the beholder forced into collaboration. Similar ends were sought after in figure, animal and plant as in landscape.

All these traits are united in Ma Yüan (act. *c.* 1190-1224) and Hsia Kuei (act. *c.* 1180-1230), both members of the Academy. Nature, instinct with mysterious life, is their *Pl. 92-98* real theme. In their landscapes the foreground is stressed and the eye is led from it into the distance, in which mountains, waterways, bridges and boats emerge from a veil of mist. A hermit wanders on his way or sits in a pavilion rapt in thought—a traveller in time, but a pilgrim of Eternity. Hsia Kuei revels in contrasting ink shades. His stroke is elegant and fluid, pure lines and contours seldom appear. Now and then, however, his brush seems to take fire: there is a storm landscape by him of amazing concentration. Every stroke is *Pl. 97* pregnant with elemental power. The greater part of the picture surface remains empty, but it is just this emptiness which enhances the suggestiveness.

Ma Yüan painted landscapes as well as figures and other subjects. In this, he did not *Pl. 88-92* differ from the rest of his artistically-minded family, of whom he was the most distinguished representative. Pure line is part and parcel of his art; figures, rocks, mountains and all details exhibit sharp contours. A characteristic feature of Ma Yüan's is his weather-beaten pines, which, more or less cut off by the frame, asymmetrically divide the picture surface. Occasionally he shows himself in a quite different light. Thus, in a minute picture, we see nothing but a *Pl. 92* lonely fisherman in a boat upon a stretch of water. Boat and figure are worked out, as is his manner, in fine detail; but all accessories are missing. It really is surprising how the master succeeds in conjuring up the wide water surface with a few faint touches.[156]

None of the Academicians working under the Emperor Ning Tsung stands so clearly before us as Liang K'ai (act. *c.* 1200). Both the information concerning him and the pictures preserved bear this out. We hear that in the beginning he painted Buddhist subjects and was *Pl. 100-106* an enthusiastic admirer of Wu Tao-tzŭ, and that after a short time, for some unknown reason, he left the Academy or was ejected from it. One could almost divide his *œuvre* into early and late work. His treatment of drapery folds and the detailed execution of the heads in some of the pictures do in fact remind one of Wu Tao-tzŭ; these may well be his early works. But here, too, the peculiarity of his style and the originality of his inspiration is quite unmistakable. The representation of the Buddha as an ascetic who, after long years of struggle in *Pl. 101* the wilderness, is about to attain the truth, may be one of the conceptions created by Liang K'ai. The long hand scroll, *The Sixteen Lohans,* appears to be another early work by the *Pl. 105-106* master. Later on his method obviously undergoes a metamorphosis, and, employing a more wilful and vehement brush stroke, he sweeps over the ground with calligraphic rhythm.

[156] Hsü Shih-chang, of whom we know little apart from the fine Landscape of the Freer Gallery, was obviously influenced by Ma *Pl. 99* Yüan. The accentuation of the genre motif makes it probable that the work is not earlier than the end of the 13th century A.D.

74

Pl. 103-104 Belonging to this phase are the *Two Patriarchs of the Ch'an Sect,* the one cutting bamboo, the other tearing a manuscript—actions symbolizing certain Ch'an ideals. Here, the intimate relationship between painting and calligraphy becomes specially clear. And then consider his *Li Po* (Li T'ai-po). Was ever the spiritual figure of a poet more convincingly and more succinctly portrayed? Just a few lines, vibrant and concentrated, and there he stands. And, finally, the master's *Winter Landscape,* one of the two pictures which form the wings of *The Buddha on the Way to the Bodhi Tree.* Is it possible to render solitude and the grimness of cold with more intensity and fewer means?

Pl. 102

Pl. 100

Pl. 107, 109-114 Whereas Liang K'ai appears essentially a dramatist, Mu-ch'i (Fa-ch'ang) is a sensitive lyricist. We know with certainty that he became a Ch'an priest; of Liang K'ai we are in doubt. The Chinese sources take but little notice of Mu-ch'i, perhaps because he did not belong to the Academy. In fact, his career has something enigmatical about it. It is remarkable that most of his known pictures are to be found in Japan, and this from quite early days. The situation is still more complicated: we hear of another Ch'an priest living at a later time (perhaps a Japanese), who is supposed to have imitated the master with such skill that their work has become indistinguishable.[157] However this may be, the most accomplished works associated with Mu-ch'i's name belong to the highest achievements in Chinese ink painting. The older Liang K'ai may have been among his teachers, but while he drew mostly in lines graphically accentuated, Mu-ch'i's brush stroke is in the main of a dissolving nature. His peculiar character lies in his visionary powers, in the subtlety with which he places the objects on the picture surface and in the rich tone of his inks. Landscapes and figures, whether the latter be divinities or men or animals, all belong to a mysterious world. In his flowers we seem to feel the innermost life of the plant. Despite his predilection for restraint, he succeeds in raising tigers and dragons to the level of mighty nature symbols. In the representation of Buddhist themes he obviously tries to give expression to the great Ch'an thought that the divine is to be found within man himself.[158]

Pl. 111, 112

Pl. 109, 114

Pl. 108 The most daring step in the formation of landscape, even transcending that which Hsia Kuei, Liang K'ai or Mu-ch'i had attempted, was made by another Ch'an priest who is supposed to have lived at this time. Ying Yü-chien's brush is tied to no nature forms whatever. With apparently quite accidentally dropped splashes he represents a few houses set amid the mountains; a bridge leads across a stream, men climb up a hillside. In fact, the bounds of what can be expressed in terms of pure brush-language have been reached. The painting is written down at a blow, and the Ch'an idea of intuition seems to be realized.[159]

Pl. 115-117 Liang K'ai and Mu-ch'i were masters of a wide range, as already exemplified by the variety of their themes. Ch'ên Jung (So-wêng, middle of the 13th century), whose activities fall within the reign of the Emperor Li Tsung, seems to have been a specialist. He is known to us as a painter of dragons and, as such, he was particularly valued. As in this he had many predecessors,[160] it must be assumed that he excelled them in his art. Perhaps he was the first to arrange the dragons upon narrow strips of hand scrolls and to interweave them closely

[157]This Ch'an priest seems to have received from the abbot of the Liu T'ung Ssŭ (near Hangchou), a temple founded by Mu-ch'i, two of Mu-ch'i's seals. See Arthur Waley, *Zen Buddhism and its Relation to Art,* 1922, p. 22 and 28. Bun Takagi gives in his book *A Study on the Transmission of the most noted Masterpieces of 'Karae' attributed either to Yü-Chien or Mu-Hsi* (1926), a pedigree of two of Mu-ch'i's most famous landscape scrolls, and besides, one of a picture by Ying Yü-chien. But the author records the vicissitudes of the three pictures only up to the art-loving Japanese Shōgun Ashikaga Yoshimasa (1435-1490), who was ruler of Japan about 200 years after Mu-ch'i. [158]The Kuanyin illustrated here is the middle piece of a set of three pictures. The other two represent a *Monkey Mother on a Tree* and a *Crane with Bamboos.* Kuanyin, clad in *Pl. 109* white, is actually the Goddess of the island of P'u T'o, where she is believed to have worked miracles. Li Lung-mien was perhaps one of the first to paint Kuanyin in a white garment. About a hundred paintings are attributed, with more or less justification, to Mu-ch'i. The number of works associated with Ma Yüan, Hsia Kuei and Liang K'ai is not inconsiderable either. So far, there has not been a thorough sifting of the evidence for these ascriptions. We illustrate only a few characteristic examples. [159]We have here the P'o Mo style at its boldest. See n. 99. [160]One of the most famous early painters of dragons was Chang Sêng-yu (6th century A.D.). Cf. also pl. 12.

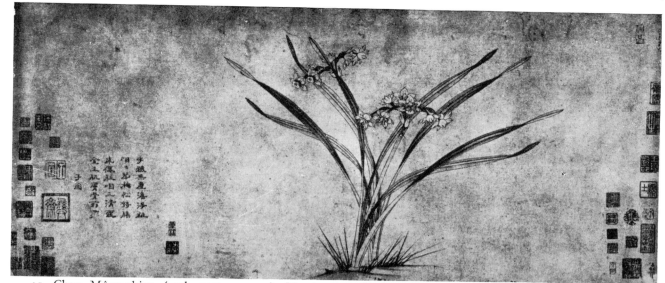

31. Chao Mêng-chien (13th century A.D.). *Narcissuses*. Slight colour on paper. H.c. 25 cm. W.c. 55 cm.
Private Collection, China.

with the elements of nature. We experience in his works the surge of rain and the power of thunder-storm, whose embodiment the dragon is. Its damp scaly body quivers amid menacing precipices and torrential waters. All the means of dramatic contrasts are employed.[161]

There can be no doubt that pure ink painting, born of the spirit of Ch'an Buddhism, as it developed during the Southern Sung dynasty, is the most glorious gift with which Chinese art has enriched mankind. How far it reigned supreme in its own day is another question. This much is certain, that we can by no means regard it as the only movement; others vied with it for the applause of art-lovers. The situation was no different in China from anywhere in the world. Here also, minutely executed paintings with gay colours and rich in detail, exercised the greatest attraction. Thus, pleasant flower pieces and animal representations, in all sizes, but preferably small, and of finest finish were produced. There were historical and genre-like pictures which vividly illustrated the life of the present[162] and the past, and portraits[163] opulent in colour. Finally, hieratic religious painting of more or less monumental

Pl. 84, 119

Pl. 121

Pl. 118

[161]I. E. L(odge), *Ch'ên Jung's Picture of Nine Dragons*, Museum of Fine Arts Bulletin, Boston, xv, Dec. 1917. Among other specialists of these days were Fan An-jên and Chao Mêng-chien. The former was well known as a painter of fish, the latter for his narcissuses (Fig. 31), his plum-blossoms, and for his essay on the plum tree (*Mei P'u*). Jih-kuan (Tzŭ-wên), the grapevine painter, is also worth mentioning. [162]Characteristic of that trend is, for example, Chang Tsê-tuan's *Going up the River for the Spring Festival*, a painting which the master executed at the command of the Emperor Hui Tsung; it is, actually, a colourful description of the life in Pien Liang (K'ai Fêng Fu), the capital of the Sung. The original seems to have been lost, but there are many copies of it all over the world, the British Museum included. Cf. Arthur Waley, *A Chinese Picture*, The Burlington Magazine, xxx. [163]The portrait published here is attributed to Chang Ssŭ-kung, a master known only from the Japanese booklet *Kundaikwan Sayūchōki*, in which he is said to have lived in the Sung period. Several Buddhist paintings are also connected with his name (cf. William Cohn, *Ein Chinesisches Kuanyin-Bild*, Berliner Museen xlix, 1928). He may well have been a contemporary of the great Sung philosopher Chu Hsi, whose short essay on portraiture is particularly suited to throw light upon the role portrait-painting played in Sung times. It reads: 'It has always been considered first-class work in portrait painting, even for the most skilful artist, when the result is a likeness, more or less exact, of the mere features. Such skill is now possessed by Kuo Kung-ch'ên; but what is still more marvellous, he catches the very expression, as it were, the inmost mind of his model. I had already heard much of him from a couple of friends; however, on my sending for him, he did not make his appearance until this year. Thereupon, a number of the gentlemen of the neighbourhood set themselves to test his skill. Sometimes the portrait would be perfect; sometimes perhaps a little less so; but in all cases a marked likeness was obtained, and in point of expression of individual character the artist showed powers of a very high order. I myself sat for two portraits, one large and the other small; and it was quite a joke to see how accurately he reproduced my coarse ugly face and my vulgar rustic turn of mind, so that even those who had only heard of but had never seen me, knew at once for whom the portraits were intended. I was just then about to start on my travels—eastwards, to the confines of Shantung; westwards to the quiet home of the old recluse T'ao Yüan-ming; after which I contemplated retirement from public life. And I thought how much I should like to bring back with me portraits of the various great and good, but unknown men, I might be fortunate enough to meet with on the way. But Kuo's parents were old, and he could not venture upon such a long journey, for which I felt very sorry. So at parting I gave him this document.' Cf. Herbert A. Giles, *Gems of Chinese Literature*, Shanghai, 1884; p. 218. See also n. 36.

dimensions, Buddhist or Taoist in inspiration, both mural[164] and movable, continued to be executed.

Pl. 126
Pl. 127
Pl. 86, 87

In religious painting, we find the same principal currents as in contemporary sculpture. The one tended to remain true to T'ang style, the other yielded to the latest development. In the first case, the grandeur of the past is still noticeable, but the figures are schematic and vapid; in the second, the composition has relaxed, and the deities are more human in appearance, exhibiting a more earthly charm. In fact, the old hieratic Buddhas seem to have lost much of their popularity. It was the Lohans (in groups of sixteen or five hundred) that attained highest favour. Numerous series have survived. What the artists worked out here was the realistic aspect of the Lohans as priests and, in addition, their activity as magicians and wonder-workers; but not so much their character as mighty heroes of belief, after the conception of Kuan-hsiu. Possibly Li Lung-mien showed the way. Significant is the fact that the Lohans are now mostly represented in a landscape setting.[165]

Even in narrative paintings, the landscape claims, if not first place, at least equal rights with the figure scene. From the masters working in this field, Liu Sung-nien (act. 1190-1230) and Li Sung (1166-1243) should be singled out. It is characteristic that both are said to have illustrated the whole practice of agriculture and the process of silk manufacture (*Kêng Chih T'u*).[166] Many existing pictures are attributed to Liu Sung-nien, but we do well to bear in mind that he is one of the most imitated Chinese masters. The hand scroll of the British Museum, *The Three Incarnations of Yüan-tse* (Fig. 32), although a doubtful attribution—the

32. Attributed to Liu Sung-nien (active c. A.D. 1190-1230). *The Three Incarnations of Yüan-tse.* Hand scroll. Ink and slight colour on silk. H. 24 cm. L. 99 cm. British Museum, London.

[164]We learn of several masters who painted murals in Sung times, for instance, Kuo Hsi, Su Han-ch'ên and Hsiao Chao. Fragments of murals from Chinese temples, showing religious and secular subjects in colour and ink, are spread over the art collections of the world. Some of them can possibly be attributed to the Sung period; most of them, however, belong to later times. More thorough investigations into that topic have just begun. The fragments published here are ascribed to the Sung, Yüan (Fig. 36), Ming (Fig. 37), and Ch'ing periods; but all these datings are only tentative. Cf. Laurence Binyon, *The George Eumorfopoulos Collection, Catalogue of the Chinese Frescoes*, 1927; W. Perceval Yetts, *Some Buddhist Frescoes from China*, The Burlington Magazine, 1927, LI, p. 120 ff.; id. *Chinese Frescoes for the Nation*, The Burlington Magazine, 1927, p. 322 f.; Paul Pelliot, *Les Fresques de Touen-houang et les Fresques de M. Eumorfopoulos*, 1928; Helen E. Fernald, *Chinese Frescoes of the T'ang Dynasty in the Museum*, The Museum Journal, 1926, XVII, No. 3; id. *Another Fresco from Moon Hill Monastery*, ibid., 1928, XIX, No. 2; id. *Two Sections of Chinese Fresco newly acquired*, ibid., 1929, XX, No. 2. The frescoes coming from the Moon Hill Monastery (Yüeh Shan Ssŭ) apparently show representations of the *Four Paradises*. It would be highly interesting to compare them with murals of the same subjects in the Hōryūji and in Turfan (cf. Ernst Waldschmidt, *Gandhāra, Kutscha, Turfan*, 1925, pl. 50). The present writer intends to devote a monograph to the fresco fragments preserved in the different museums and collections. See also L. Sickman, *Wall Paintings of the Yüan Period in the Kuang Shêng Ssŭ, Shansi*, Revue des Arts Asiatiques, June, 1937; id. *Notes on Later Chinese Buddhist Art*, Parnassus, April 1939; William Charles White, *Chinese Temple Frescoes, A Study of Three Wall-Paintings of the Thirteenth Century*, The University of Toronto Press, 1940; William Cohn, *Chinese Wall-Paintings*, The Burlington Magazine, July, 1943. See n. 84 and 111. [165]Cf. n. 144. [166]These illustrations by Liu Sung-nien and Li Sung have not come to light so far, but we gather that the subject was favoured in those days and has never lost its attraction. Cf. Otto Franke *Kêng tschi t'u. Ackerbau und Seidengewinnung*, Hamburg, 1913; id. *Zur Geschichte des Kêng Tschi T'u. Ein Beitrag zur chinesischen Kunstgeschichte und Kunstkritik*, Ostasiatische Zeitschrift III, 1913; Paul Pelliot, *A propos du Kêng Tsche t'ou*, Mémoires concernant l'Asie Orientale I, 1914; Fr. Jäger, *Der angebliche Steindruck des Kêng-tschi-t'u vom Jahre* 1210, Ostasiatische Zeitschrift IX (XIX), 1933.

landscape background is rather dry—may be representative of his style.[167] What is striking about the painting is the dramatic intensity of the expression and gesture of the figures, making clear the whole situation at a glance. We feel at once that there is something unusual about the boy; and the attitude of the man who recognizes in him the incarnation of his friend Yüan-tse, as well as the surprise of his companions, is convincingly worked out. *Pl.* 120

Of Li Sung a tiny fan picture of a boat with men aboard may serve as an example. What we see is not (as one might think) a mere presentation of landscape—the wide surging ocean lies outside its compass. It is a particular episode, perhaps the return of some illustrious personage or the like. Be that as it may, the original master succeeded in creating a singular and impressive work. Such scenes now appear more frequently, sometimes more related to Li Sung's manner, sometimes to that of Liu Sung-nien; and they are pointers to a new time in which the life and striving of the immediate present comes to the front, even when a historical event of the past serves as pretext. Thus a hand scroll in the Freer Gallery, Washington, illustrates a poem by T'ao Ch'ien (A.D. 365-427)[168]: *The Return into Private Life of a Retiring Official.* The incident has been adapted to contemporary conditions, a practice familiar to Western art. We behold the boat with the traveller approaching the banks. The whole family is prepared for his reception at the entrance to the house. Even more entertaining is *The Return of Wên Chi from Captivity in Mongolia.*[169] Wên Chi is one of the most famous and pathetic of figures among women of an earlier day (*c.* A.D. 200), who, being married to a Hsiung Nu (Hun) chief, was able in the end to come back to her husband. The spectacle we are offered is also one of contemporary life. We see a great encampment of tents in all its details in a desert-like region; and then, in dramatic contrast, a Chinese town with a crowded street in which is situated the noble mansion where Wên Chi is being received. What a wealth of types and characteristic scenes, and what vividness of description![170] The same spirit is at work as that which brought the theatre and the novel in this age to fruition. *Pl.* 122-123 *Pl.* 124-125

[167]See Basil Gray, *Paintings from the Eumorfopoulos Collection I, The Three Births of Yüan-tse,* The British Museum Quarterly, IX, 1934/35, p. 126 ff., and L. Binyon, *The Eumorfopoulos Collection of Chinese Paintings,* 1928, p. 12 ff. Here the story which provided the subject of the painting is told. [168]T'ao Ch'ien (Yüan-ming, A.D. 365-427) was the first great poet after Ch'ü Yüan (4th century B.C.). Cf. the translation of this poem in *Herbert A. Giles, Gems of Chinese Literature,* 1884, p. 105; German translation, Richard Wilhelm, *Die Chinesische Literatur,* 1926, p. 136. [169]Kojiro Tomita, *Wên-chi's Captivity in Mongolia and her Return to China,* Bulletin of the Museum of Fine Arts, Boston, XXVI, 1928. [170]The hand scroll by Chang Tsê-tuan, from c. 1125, mentioned in n. 162, exhibits similar features.

X. TRANSITION PERIOD
THE YÜAN DYNASTY (A.D. 1279-1368)

BACKGROUND

THE Yüan period lasted eighty-eight years. That is the official reckoning, which does not take into account the restless times of transition at its beginning and end. A people, fresh from the life of the steppes, of whose cruelty and rage for destruction the sources tell us again and again, controlled the Land of the Middle during a short interregnum. The conquest of China by the Mongols must not, however, be placed on a level with their other invasions. The empire of Chin (Kin), upon which they had fallen in 1210, was formerly Chinese territory, and already there the rough nomads had learnt to value the accomplishments of Chinese culture. It seems to have been the Khitan Yeh-lü Ch'u-ts'ai, the minister of Genghis Khan and Ogodai, who exercised a moderating influence on the policy of conquest. China was, it is true, harshly dealt with, but hardly more so than in other wars, and only in keeping with the method of warfare at that time. We must not forget that our knowledge largely comes from sources inimical to the Mongols. Kublai Khan's (Shih Tsu, 1260-1294) endeavour was at all events to be fair to the Chinese, to found a legitimate government, and to give the land the opportunity of enjoying all the blessings of peace.[171]

We know the appreciative descriptions Marco Polo gave of Yüan China.[172] Members of the most varied races lived and worked together in the capital Peking (Marco Polo's Cambaluc). Trade exchange took on tremendous proportions. Communications were improved. Even research work was not neglected. Kublai opened an Academy to which eminent Sung scholars were appointed. He favoured Buddhism in its Tibetan form, but without objecting to any other religion. Buddhism, Taoism, Christianity and Islam were free to practise undisturbed. The Franciscan Giovanni da Monte Corvino had great success, and was allowed to build a church. As the Khan wished to be a real Chinese emperor, he supported conservative Confucianism; indeed, the last stone making for the supremacy of this faith in China was laid in the Yüan period. We do not know what was his attitude to art. Marco Polo scarcely speaks of it. The fact is that various painters enjoyed the Emperor's protection; yet there was no longer an Academy of painting. Consequently the number of artists working independently was greater than ever. It would seem as if the *bourgeoisie* was beginning to grow stronger and also to play a role as art patron. Part of the same development was the consolidation of the novel and the drama in a special form of literature, the origins of which go, of course, farther back.[173] However, as already remarked, the period was extremely short. Whereas the older generation of artists had entered their career under the Sung rulers, the younger one lived out its old age in a liberated China under the Ming.

None of the Yüan emperors, apart from Kublai Khan, is worthy of special consideration. After him difficulties within the dynasty soon set in. It is significant that no less than nine emperors succeeded one another during the forty years following his death, of whom several fell a sacrifice to palace intrigues. If a long rule was granted to the last Yüan monarch, Shun Ti (1333-1368), he had the cruel, even senseless, anti-Chinese measures of his minister

[171]There was, in fact, the *Pax Tartarica*. In the 14th century it was possible to travel in perfect security from the Black Sea to China, an achievement perhaps unique in those days. See G. F. Hudson, *Europe and China*, 1931, p. 134. [172]H. Yule, *The Book of Ser Marco Polo*, 2 vols., 1921. [173] 85 playwrights are mentioned in the Yüan period and 563 plays are preserved. Cf. A. E. Zucker, *The Chinese Theatre*, 1925. Chang Tien-lin, *Chinesisches Drama und Chinesisches Theater*, Sinica (1938), XIII, 5, 6.

Bayan to thank for it. It was precisely these measures that finally led to the extinction of the dynasty, disturbances having begun to break out in the early years of the 14th century. The last Yüan emperor fled to the steppes (1368), from which his people had once come; but considerable time was to pass before the Mongols were completely driven out of China. A culture of the highest refinement does no harm to a people built up as strongly as were the Chinese upon family tradition, but it would tend to impair the original vigour of an unstable and nomad tribe.

DEVELOPMENT

Is it appropriate to devote a separate chapter to the painting of the Yüan period? In fact, it is often treated as an appendage of the Sung era. Yet this is not doing it justice. Art made considerable moves towards new solutions, and if Yüan painting most strongly impressed its stamp upon the ensuing development, it was because of the activities of a series of outstanding masters who distinguished themselves in those days. Chinese art found itself in a situation similar to the European around the end of the Renaissance. The Baroque style was in process of incubation. This becomes manifest in Chinese painting in a more unified vision and a more explicit stressing of the pictorial, as well as in a preference for larger sizes and richer colouring; finally, in a tendency towards realism. Colour and realism, both, here signified at the same time a retrogression to T'ang art. It often appears as though Yüan China had wearied of the lyricism of Sung painting. Hence the propensity for heroic landscape. Possibly, political issues and the taste of the invaders may have caused certain themes beloved of pre-Sung painting to come into favour again. People chose rather to dwell upon the greatest epoch of Chinese power than to be reminded of the unfortunate recent past. Apart from this, the influence of the conquerors is hardly noticeable. Stylistic changes came from within, just as the blossoming of the drama and the novel at that time was the result of an innate force.

The Sung painter Ch'ien Hsüan (Shun-chü b. 1235), at the onset of the Mongol cata- *Pl.* 128-130 strophe, had many years of successful activity behind him. As late as 1260 he had been given a rank in the Academy of the Southern Sung. Thus it is understandable that he declined to serve the new despots and retired into solitude. He was one of the most eminent painters of fine detail China has ever produced. When we have before our eyes the most convincing among the many works attributed to him, we can but admire his deep susceptibility to the varied beauties and lovelinesses of nature and the supreme ease and grace of his expression. The *Insect* scroll of the Art Institute, Detroit (Fig. 33), for example, is in its way a highlight. *Pl.* 128-129 Truth to life can go no farther: we seem to hear the humming of the insects amid the grasses and flowers; never has their flight and the delicacy of their bodily structure been brought out more perfectly. And yet the artist offers us much more than this. His brush stroke is vibrant

33. Ch'ien Hsüan (A.D. 1235-c. 1290). *Insects and Lotus.* Hand scroll. Ink and colour on paper. H. 26 cm. L. 120 cm. Detroit Institute of Arts, Detroit. Cf. pl. 128 and 129.

with inner tension, and the entire work shows wonderful rhythm. The rich interplay of colour tones is indeed surprising. As in a piece of music, the theme undergoes ever new variations. The insect scroll is not alone; there are other paintings of equal subtlety and refinement by Ch'ien. But in his figure representations we feel much less of his genius. Here he holds closely to Li Lung-mien and the T'ang tradition.[174]

In contrast to Ch'ien Hsüan, Chao Mêng-fu (Tzŭ-ang, 1254-1322) had no qualms about adapting himself to the new regime and was unreservedly at the service of Kublai Khan. He accepted the high office of a State Secretary of War. His friend Ch'ien Hsüan, twenty years his senior, reprimanded him, as is reported, for his faithlessness. Nevertheless Chao Mêng-fu was one of the most highly prized and revered Chinese painters. As far as we can judge to-day, it is difficult to accept without reservation this exuberant appreciation. He lay entirely under the spell of the great Li Lung-mien. We hear that he, like his teacher, made copies of well-known works of T'ang masters, for example, of Wang Wei, and possibly some of these or their copies have survived.[175] Chao, like Li Lung-mien and Han Kan, excelled in the representation of horses, a speciality which certainly suited the taste of the ruling dynasty. Yet when, in the work of the Freer Gallery, his horses wander about in a rich landscape, wade through a stream and quench their thirst in its waters, such a conception is not to be found among his precursors. In addition, the animals are less linear in treatment and finished in more detail. This is also apparent in another of his paintings, *A Sheep and a Goat*, in the
Pl. 134-136 same Museum, and in the *Two Horses* of the Stoclet collection (Brussels), if we can trust the inscription. Perhaps the realism then coming into vogue is partly to be put to Chao's credit—an achievement not without its drawbacks. The growth of realism in Chinese art often signifies a weakening of its inner strength. Chao Mêng-fu's conservatism becomes particularly clear in his figure pictures and landscapes.[176] It may be, as so frequently in later Chinese art criticism, that the recognition accorded to a master is the greater the more he reveals himself as a custodian of the past. If he then, as in the case of Chao Mêng-fu, also distinguished himself as a poet, calligrapher and scholar, there are no limits to the esteem in which he is held.

In the person of Chao Mêng-fu's wife, Kuan Tao-shêng, we make acquaintance with the first Chinese woman painter whose name is worthy of record. The hand scrolls with bamboo, one in the Fogg Museum and the other in the Moore collection (New York),[177] may be accepted as being from her brush. Here the bamboo does not appear as an isolated growth, as formerly, but in dense thickets within the frame of a continuous landscape. Its delicate and sensitive design suggests the touch of a woman. There exist some bamboo paintings which, according to the inscriptions, were executed by both Kuan Tao-shêng and her husband. In reality it seems that Chao Mêng-fu added his name only in order to testify his appreciation of his wife's skill, or to make the works more precious. At any rate it is hardly possible to distinguish different hands in them.

Although Chao Mêng-fu's fame outshone that of all his contemporaries, some of them must be considered at least equal to him in significance. It was in the main the heroic land-
Pl. 139 scape of the 10th century which they fostered and revived. Kao K'o-kung, first of all, took up this line. Apparently he was no less influenced by Mi Fei. It is instructive to compare the

[174]Ch'ien Hsüan's pupil Wang Yüan (Jo-shui, act. first half of the 14th century) is often not to be distinguished from his teacher. There are several anonymous paintings which could be attributed either to Ch'ien Hsüan or to Wang Yüan, or even to less known pupils of theirs. The *Young Sparrows in a Basket*, for instance, is ascribed to Sung Yu-shih, an almost
Pl. 132-133 unknown master. [175]Cf., for example, the paraphrase after Wang Wei's *Wang Ch'uan T'u* in the British Museum, signed Tzŭ-ang and dated 1309, which is, however, only a copy after Chao Mêng-fu (Fig. 17). See Laurence Binyon, *A Landscape by Chao Mêng-fu in the British Museum*, T'oung Pao, 1905. See n. 98. [176]The same character is revealed in his collected inscriptions and colophons, in which he seldom fails to extol the spirit of antiquity. Cf. Osvald Sirén, *The Chinese on the Art of Painting*, 1936, p. 109 ff. [177]Illustrated in Louise Wallace Hackney and Yau Chang-Foo, *A Study of Chinese Paintings in the Collection of Ada Small Moore*, 1940, pl. XXVIII.

landscapes of the two masters. Two hundred years of development have effected great changes in spacing, in composition, and in the sense of verisimilitude. How archaic and monumental appear Mi Fei's sceneries in comparison with Kao K'o-kung's pictorial visions! *Pl.* 139 In sharp contrast with Kao, as much in life as in art, was Kung K'ai. Whereas the former was an official, the latter kept well away from the Court. The fact that he was an eccentric can perhaps be gathered from his works, which were by no means confined to landscapes. His *Starving Horse* is of a shattering naturalism, hitherto unknown.[178] His hand scroll in the *Pl.* 137 Freer Gallery exhibits similarly dramatic features. The figure of Chung K'uei, the Demon-Exorciser and no less his attendants, is filled with an unheard-of intensity of life. Here the master is inspired by T'ang style. The *Sleeping Man in a Boat* leads us to the atmosphere of *Pl.* 138 Sung art. But with the chief motif moved to the foreground, as well as with the convincing characterization of the sleeper's expression and gesture, his original mind and the spirit of the time vigorously break through.

The predilection for verisimilitude comes to the fore ever more strongly in the 14th century. This attitude found its most marked representatives in Yen Hui and Jên Jên-fa. We *Pl.* 140-142 know little of Yen Hui's life and not much more of his *œuvre*. Several works ascribed to him are in their way something entirely new. In spite of the calligraphic treatment of the drapery folds, one could surmise Western influence, if it were not for the fact that such notably well modelled figures with their wealth of movement are unthinkable in the Europe of the 13th and 14th centuries. Chinese art was at an early date able to develop its own proper sense of realism, which has in fact different tendencies from Western realism. In Yen Hui's *Winter Landscape* also, the character of the season is clearly revealed: dark leafless trees stand *Pl.* 142 out from the snow-covered earth and background, a fence bends under its burden of snow. And yet, the general style of the work is that of 10th century romanticism. Yen Hui's contemporary Jên Jên-fa appears to have been a fervent admirer of Chao Mêng-fu. Like the *Pl.* 145-146 latter, he tried his brush at many themes, but was primarily a painter of horses. In the meticulous care with which he shaped and characterized his animals, and in the daring foreshortenings with which he obviously wished to impress, he surpassed even his model, and could easily have competed with his English colleagues of the 18th and 19th centuries. His picture in the Victoria and Albert Museum, in which horses are groomed and fed by their keepers, gives the theme, so popular with the Chinese, a new genre-like twist.[179]

When, in the past, the master's total personality was often taken as the yard-stick to his appreciation, this became still more the practice in the 14th century. Many of the most respected artists would withdraw into some romantic spot, where they devoted themselves to the study of philosophy, poetry, painting and calligraphy. They lived the life of solitaries and preferred to be regarded as scholarly amateurs than as professionals. Outwardly, also, their works stress more strongly the close relationship between painting and literature. Poems and eulogies pertaining to the representations of their pictures, composed and inscribed by them, were considered more than ever an integral part of the whole. Thus we have here the real ancestors of the *Wên Jên Hua,* the painting of the *literati,* so largely dominating the Ming and Ch'ing periods. Stylistically, they followed the masters of the 10th and early 11th century, like Chü-jan and Tung Yüan. The landscapes became once again richer in detail and nature forms were many and variegated. Man was almost entirely excluded, or was treated merely as a detail among others. The insistence upon the suggestiveness of empty space and the curtailing of the objects by the frame were abandoned. In the same way as

[178]The subject of the *Emaciated Horse* is frequently to be found in Yüan art. The posture of Kung K'ai's horse is very similar to that of the white one in Chao Mêng-fu's painting of the Stoclet collection. [179]The remarkable pictures attributed to Li Wei and Chu Jui may be included here. We know little of these masters, and what we do know is contradictory and doubtful. Anyway the works seem to be not older than the 13th century, as the treatment of the trees and the entire *Pl.* 143, 144 attitude to reality show.

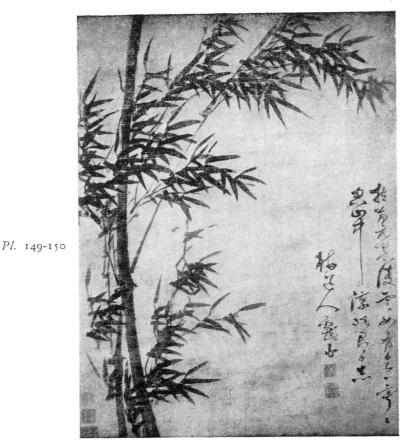

34. Wu Chên (A.D. 1280-1354). *Bamboo in Wind*. Ink on paper. H. 75 cm. W. 50 cm. Museum of Fine Arts, Boston.

Pl. 149-150

Pl. 151-152

Pl. 147-148

Pl. 153-154

three hundred years earlier, the landscape often covers the whole of the picture surface. The vertical factor is stressed. The germs of this conception are already to be found in a painter like Kao K'o-kung. Only the final decades of the Yüan period show the movement in its maturity.[180]

For the Chinese art lover, or, more appropriately, for the somewhat snobbish later art critics, the 14th century is first and foremost the epoch of the *Four Great Landscapists:* Huang Kung-wang (1269-1354), Wu Chên (1280-1354), Ni Tsan (1301-1374) and Wang Mêng (1308-1385). Even to-day their works are eagerly collected, being exchanged for gold, and consequently they have been frequently forged. The eldest, Huang Kung-wang, leant upon Chü-jan. He used to fill his sceneries with surging heights; anything in the nature of a foreground is hardly present. From the tenderness of the valleys and summits emerges the deep dark of upright but little differentiated trees. The *forte* of his colleague Wu Chên appears to have been bamboo painting (Fig. 34). In his works the contrast of ink tones and the verve of the brush have become intensified; Baroque, and with it virtuosity, is on the way. Wên T'ung and Su Tung-p'o, the worthies of bamboo painting, now belong to a bygone world. Wu Chên's landscapes also show an unusual dramatic air, evoked not only by the variation of black and white, but by their entire structure. At the same time they are nearer to nature than those of his brother painters. What is significant is the frequency of the poems and inscriptions with which he embellishes his paintings. Ni Tsan[181] is perhaps the most individual of the *Four Masters*. His scenery is intentionally simple, now and again almost bare; sometimes an axis is stressed, furnished by trees or waterfalls. Several of his landscapes give the impression of being flooded with dazzling sunlight. Hence the details are absorbed—not as formerly, in mist and vapour, but in light. Ni Tsan's trees are as slender as Huang Kung-wang's; they lead, however, a surprising life of their own, often dominating the whole picture. Being exceedingly sparing in his use of ink, the master takes all the more pain with its gradations. A cool restraint and a delicate reserve permeate his works: we feel a poet is speaking. The one to live farthest into the Ming period was Wang Mêng. Whereas Ni Tsan and Huang Kung-wang, in one way or another, followed their personal impulses, he and Wu Chên were most definitely taken back as far as the art of the 10th and 11th centuries. Wang Mêng's compositions are crammed with detail. His stroke has nearly dissolved itself into a sort of pointillism. Nevertheless his mountain formations betray more than usual massiveness. His particular concern is to come as close as possible to his models in the drawing of the 'wrinkles' of the rocks. The Baroque character of late Yüan painting becomes more striking here than elsewhere.

[180]Werner Speiser, *Die Yüan-Klassik der Landschaftsmalerei*, Ostasiatische Zeitschrift VII (XVII); id. *Landschafter der Yüan-Zeit* Sinica XI, 1936. [181]John C. Ferguson, *Ni Tsan*, Monumenta Serica V, 1940.

Of the numerous other painters active during the 14th century, some pursued similar aims to the above-mentioned, some continued the tradition of Southern Sung painting. Close to Wu Chên and Ni Tsan stood Ts'ao Chih-pai and Shêng Mou. In their landscapes, it is often a group of trees which, treated with meticulous care, first attracts the eye. But Ts'ao is a more energetic and imaginative personality than Shêng. His compositions are very simple; they show vigorous structure and poetic feeling. Fang Ts'ung-i's vistas, not unlike those of Mi Fei and Kao K'o-kung, are homogeneously built up out of spots and splashes. Fog and clouds veil all details. Over and above this, he is not satisfied with the old hackneyed topics and strives to arrive at new solutions. The Yüan masters seldom neglected bamboo painting, even if landscape was their proper domain; but some of them appear to have been specialists in this field. Thus Li K'an, who wrote an essay—Chu P'u—upon the methods of representing bamboos.[182] Ku An (first half of the 14th century) and K'o Chiu-ssŭ (1312-1365) must also be recorded here. It would seem as though this much beloved symbolic motif in Chinese art was being given a special aspect now. Since the bamboo was so often chosen to be rendered whipped by storm and rain, one thought perhaps of the man of culture suffering beneath the yoke of the brutal invader.

Following the example of their spiritual Sung predecessors, a series of artists withdrew into the monasteries of the Ch'an sect. As they held themselves remote from the main stream of life and art, we know all too little concerning their dates and destinies. Some of them went to Japan, where their works became difficult to distinguish from those of their Japanese monastic colleagues and pupils. Of their number, and related to one another in style, are the painters Liang-ch'üan, Shuai Wêng and Yin-t'o-lo (Indara).[183] In their figure pictures,

Pl. 155-157

Pl. 158

Pl. 159

[182]Osvald Sirén, *The Chinese on the Art of Painting*, 1936, p. 113f.
[183]Werner Speiser, *Liang-tsüan*, Sinica XIII, 5/6, p. 254 ff. The Japanese pronunciation of this name is Ryōsen. Paintings by Yin-t'o-lo and Liang ch'üan seem to be found only in Japan, and sometimes the latter is even considered a Japanese. The additional inscriptions on some of Yin-t'o-lo's paintings by priests of the 13th century seem to indicate that the master may have lived at this time.

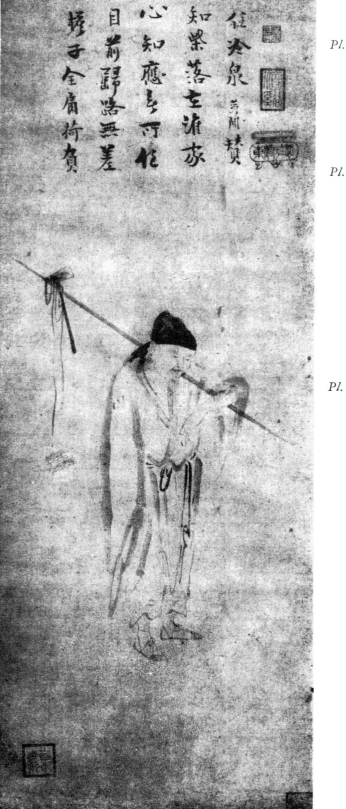

35. Shuai Wêng (13th-14th century A.D.). *The Chinese Founder of the Ch'an Sect Hui-nêng.* Ink on paper. H.c. 80 cm. W.c. 30 cm. Private Collection, Japan.

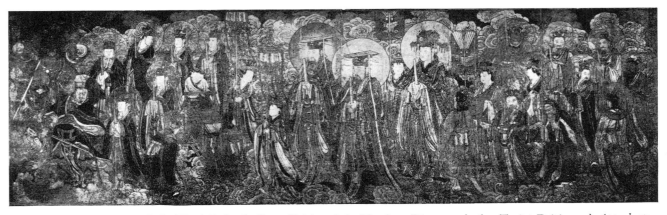

36. *Chên Wu, the Prince of the North Pole, the Seven Deities of the Northern Dipper and other Taoist Deities and Attendants.*
Fresco in colour. H. 341 cm. 13th or 14th century A.D. Royal Ontario Museum, Toronto. Cf. pl. 165.

inspired by Taoist-Buddhist ideas, they are influenced by Liang K'ai. But whereas the work of the latter reveals deepest intuition, that of the Yüan masters already smacks of virtuosity.

Pl. 163-164 All the same, Yin-t'o-lo's *Han-shan* and *Shih-tê*—we know several versions of this subject by him—are masterpieces of concentrated calligraphic power, and the simplicity and detachment of Shuai Wêng's ethereal portrait of *Hui-nêng* (Fig. 35) is admirable. We are also in the dark

Pl. 160-162 regarding the dates of Kao Jan-hui. Possibly he was a contemporary of Fang Ts'ung-i. In any case he is akin to him, surpassing his compeer in the sublimity of his visions and in the expressiveness of his drawing. Perhaps he was the last great Chinese landscape painter in whom the overwhelming experience of the one-ness of nature and soul found cogent realization.

We are no less in the dark regarding the wall painting of the time. Which of the fresco fragments scattered in many museums and collections could be ascribed to the 13th and

Pl. 165 14th centuries it is difficult to determine. It is not impossible that the two large Taoist frescoes in the Royal Ontario Museum, Toronto, originated in this period. Represented are the Lords of the North and South Pole with their suite of star-deities on clouds—a magnificent pageant (Fig. 36). It is a similar composition to that of the low reliefs of Lung Mên of the 6th century (Fig. 8), but now all is lucidly arranged. The painter has a special joy in showing the figures from all angles, even from the back. Whereas the reliefs of Lung Mên bear the mark of deep religious fervour, we are here reminded rather of a theatrical performance.

XI. PREDOMINANCE OF THE LITERATI
THE MING DYNASTY (A.D. 1368-1644)

BACKGROUND

THE collapse of the Yüan dynasty may be attributed not only to the enervating contact of Chinese culture and civilization with the once violent Mongol horsemen, but also, and no less, to the reawakened will of the Chinese people to freedom. Rebellions like that of the 'White Lotus Society' or that of the 'Red Turbans' had, to be sure, no more than a temporary success or none whatever. Not until the Buddhist monk, Chu Yüan-chang, the son of a poor peasant, appeared was the high aim accomplished. Before he could take steps towards the liberation of the land, he had to come to grips with other competing 'generals.' He succeeded with the aid of an army, which he had himself raised, in getting Nanking into his hands (1356). Having gained supremacy over his Chinese opponents, he turned his attention to the arch-enemy. The Mongol rulers had become so lackadaisical that they did not interfere with the battles of the generals. Chu Yüan-chang conquered Peking in the year 1368 and declared himself the first Emperor of the Ming dynasty (Hung Wu).[184] But many years were to elapse before the Mongols relinquished their claim to the throne. Hung Wu is another of the great Chinese rulers, as most of the founders of Chinese dynasties were. He wished to revive the glories of T'ang times. The pacifist and passive policy of the Sung was given up. China's expansive powers awoke again. Chinese armies, led by the Emperor, forced their way as far as Kublai Khan's ancient capital of Karakorum. At one time, Ming China exceeded in extent even the China of T'ang. Hung Wu organized the government of the land, and the division into provinces, according to the T'ang pattern. The capital was at first Nanking, from which his triumphal march had started. To this day, the mighty walls of the city are a witness to the will-to-power of the founder of the Ming dynasty.

Hung Wu had risen from simple peasant stock; but hardly was the throne made more or less secure, than art came into its own. Many of the artists were at once drawn to Court and into public service. The Emperor himself took up painting. The Imperial porcelain factory in Ching Tê Chên seems to have become only now (since 1369) the headquarters of porcelain production, a pre-eminence it retained up to recent times.

The Emperor Yung Lo (1403-1424), who ascended the throne after a short intermezzo, daringly moved the capital nearer the frontier to Peking, the former seat of the Yüan, in order the better to bid defiance to the ever-threatening Mongols. He carried out three great campaigns against them, till they renounced all claims. Most amazing are the expeditions his eunuch Chêng Ho (1405-1430)[185] made to Java, Sumatra, Cambodia and Siam—and going still farther afield, to Malacca, Ceylon, Africa and Persia. They were not really military enterprises, but mainly travels of enquiry for the purpose of creating trade relationships and to explore the countries. The Chinese distributed their home products to those Courts which they visited, and even took experts of all sorts with them. Thus celadon porcelain, for instance, reached the remotest regions. Under Yung Lo the foundations were laid for the great influence the Chinese dealer and craftsman still exerts all over Southern Asia. Like Hung Wu, Yung Lo was an ambitious builder. Peking of to-day—without doubt one of the most

[184]From now on we shall call the Emperors by the devices they gave to the period of their rule (*Nien Hao*). Hung Wu, Hsüan Tê, K'ang Hsi, etc., are not their names but their devices. [185]Cf. Paul Pelliot, *Les grands Voyages maritimes Chinois au Début du XVe Siècle*, T'oung Pao, 1933.

impressive cities of the world—and the Great Wall in its present condition, to mention only his most important deeds in this field, were accomplished by him. In the literary realm, the encyclopedia which was compiled under his auspices eclipsed all those of earlier times. Scholars to the number of 2,160 collaborated in the work of putting together the 22,937 volumes of the *Yung Lo Ta Tien*. But with such a gigantic compilation of knowledge the danger of an unqualified submission to the past became more potent than ever.

Ming China's great expansionist phase ended with Yung Lo. The energy of the ruling house began to slacken. As a matter of fact, from now on, the emperors became more and more tools in the hands of the eunuchs, who engrossed all power and had the first say at Court. Spiritual life did not suffer under these conditions, as long as it retained its resilience. The eunuchs evinced a lively interest in art, and the emperors, withdrawn from politics, filled in their leisure hours with æsthetic enjoyments. The short rule of Hsüan Tê (1426-1435),[186] the follower of Yung Lo, saw the beginning of an era in which high artistic aspirations flourished, no less in the province of painting than in that of the applied arts. Not only porcelain and lacquer, but also the bronzes of the 15th century, are still among the famous products of Chinese handicraft. This was the time when Wang Yang-ming (b. 1472), one of the last thinkers of really great calibre in China, dared to attack the doctrines of Chu Hsi, and therewith the official philosophy. It is perhaps symptomatic that Wang was almost ignored in his own country, but received all the more favour in Japan. Political reverses, however, soon set in, one to follow hard upon the other. Annam and other conquests were lost. The Mongols, who were again raising their heads, even managed to hold Hsüan Tê's successor prisoner for a time. This was merely an episode; China of the Ming was still a power. But the influence of the eunuchs and the women at the Court ate its way in deeper and deeper. Most notorious was the eunuch Liu Chin. He indulged his inclinations without let or hindrance under the Emperors Hung Chih (1488-1506) and Chêng Tê (1506-1522), until he was brought to a fall in the year 1510. We have information concerning the fabulous treasures of all kinds that he amassed during his career.

The last two important emperors of the Ming dynasty, Chia Ching (1522-1567) and Wan Li (1573-1620), incidentally contemporaries of Henry VIII and Elizabeth, enjoyed a long rule. Each of them remained at the helm for half a century. But the empire, though outwardly it appeared mighty and full of pomp and grandeur, was sapped of its inner strength. Nor did the rot show itself only in the realm of politics, it also appeared in art. Renewed attacks by the Mongols threatened the capital. The Japanese harassed the land by their continuous pirate onslaughts, which brought them as far as Nanking. In Wan Li's days regular Japanese armies landed in Korea, then under Chinese suzerainty, and caused long-lasting troubles. In addition, the disastrous depredations of the Manchus set in. Probably the weakness of the central government was responsible for the fact that, after a long interruption, European traders and missionaries were tolerated again in China. No one could have dreamt at that time how fraught with consequence this step was to prove. The Portuguese erected (since 1557) factories in China (Macao), and in the year 1601 Matteo Ricci settled in Peking as the first Jesuit missionary.[187] The decline of the Ming dynasty was nevertheless the result of internal unrest. A terrible famine broke out. Rebel leaders arose against the government while the external foe stood at the very frontier or had already crossed it. The last of the Ming emperors hanged himself from a tree on the Coal Hill in Peking; not because the Manchus, but one of the mightiest insurgents, threatened him. Now, as the result of being called upon for their aid by an adherent of the Ming, the Manchus made themselves lords of China. Once again an alien dynasty directed the destinies of the country.

[186]Before Hsüan Tê came to the throne, Yung Lo's son ruled China for a year or so. [187]Cf. E. R. Hughes, *The Invasion of China by the Western World*, 1937; Kenneth Scott Latourette, *A History of Christian Missions in China*, New York, 1929.

DEVELOPMENT

If we should venture to characterize in a few words the art of the Ming period, we should designate it as an art with growing Baroque tendencies, tendencies which had made themselves felt already in the days of Mongol rule. Classicist counter-currents were not missing, yet they do not seem to have been decisive. The Baroque spirit is to be found most distinctly in the applied arts. From now on, and in increasing measure, they changed into a display of colour and ornamentation. In painting, the most significant achievements were the pictorial method of vision and the unity of composition and space, surpassing all that was accomplished in previous times; and that, as we know, was by no means little. In the West the Baroque age is the great time of theoretical interest in painting. We see exactly the same in Ming China. Text-books appeared and laid down patterns, rules and principles.[188] Whereas in Europe all prescriptions soon fell into oblivion, China has cherished them almost till to-day. Besides, a flood of other art literature poured out. The Vasaris and the van Manders, the Belloris and the Sandrarts found their Chinese equivalents in abundance.[189] It is certainly in connexion with the same trends that the social status of painters underwent a change. Although the professionals still met with a certain contempt in some circles, the distinction between them and the amateurs was less rigidly drawn. When, finally, we mention the growing popularity of the theatre and the novel, we touch upon a further phenomenon common to Eastern and Western Baroque.

Until recently the attitude of the West has been (in contrast to that of China herself) summarily to brush aside the painting of the Ming period.[190] This standpoint surely called for revision. How should painting fail to show achievements in an age in which art in all its branches was the spiritual bread of both high and low! Were there not men who were in the top flight of Chinese painters? Now, in these latest days, the course has been entirely altered. Efforts have been made, on the Chinese pattern, to present an exhaustive survey and to introduce us to hundreds of painters and their innumerable works.[191] Have we not carried this procedure to excess? The last five hundred years of Chinese art development, with their enormous activity,[192] still show an almost impenetrable chaos. A mere beginning has been made in the critical attempt of sorting the tares from the wheat. And even when it is completed, the Westerner will not be able to approach the painting of the Ming and Ch'ing periods with the same sense of appraisal as the Chinese. The special interests of the Chinese and our own more general points of view must here be separated. Only the highlights actually deserve consideration. If this attitude is to be observed more strictly than it is (and it is our belief that it should be) in respect of European Baroque, with how much more force does the argument apply to the parallel epoch of an art standing so much farther from us.

In the Ming period the Chinese differentiated between a series of schools of painting,

[188]This point has already been discussed in the third chapter. It seems that such illustrated textbooks do not occur earlier than in the period Wan Li (1573-1619). But there are forerunners of these doctrinal tendencies in the Yüan period. Jao Tzŭ-jan's *Hui Tsung Shih Erh Chi*, and Hsia Wên-yen's *T'u Hui Pao Chien* published in 1365, the most important sources of our knowledge of Yüan painting, may be quoted here. Both enumerate pitfalls to warn the painters. Cf. Herbert A. Giles, *An Introduction to the History of Chinese Pictorial Art*, 1918, p. 170 ff.; Osvald Sirén, *The Chinese on the Art of Painting*, 1936, p. 114 ff. See n. 27. [189]Here, only Wang Shih-chêng (1526-1593), the compiler of the *Wang Shih Hua Yüan*, a thesaurus of many older writings on art, may be named. Other writers who were also esteemed as painters will be mentioned later on. [190]This is also valid for the Ch'ing period. Cf. A. Waley, *An Introduction to the Study of Chinese Painting*, 1923. [191]Cf. Osvald Sirén, *A History of Later Chinese Painting*, 1938. The Swedish scholar has dealt here with more than 260 Ming painters and with more than 400 of the last dynasty. In some cases he quotes more than 50 paintings by a single master. See also Victoria Contag and Wang Chi-chüan, *Maler- und Sammler-Stempel aus Ming und Ch'ing Zeit*, Shanghai, 1940. This elaborate book collects the seals of 430 Ming and Ch'ing painters. But the question arises: Is it necessary for Westerners to become familiar with such a large number of seals of, very often, second-class masters? Is it really useful to become familiar with 105 seals of Kao Fêng-han (1683-1743), with 149 of Hung Wu (late 18th century), or—most of all—with no less than 193 seals of the painter and collector Ch'ing Kao-tsung, to mention only some outstanding examples? [192]There are c. 1,200 names of Ming painters in the *P'ei Wên Chai Shu Hua P'u* (Imperial Encyclopedia of Calligraphy and Painting), published in 1708.

mainly the Northern and Southern Schools, and that of the *Wên Jên Hua (Painting of the Literati)*, which is almost identical with the Southern School. Geographical differences do not, as one might think, play any part in this classification, and even stylistic elements seem to be of secondary importance. We are dealing here rather with a sort of social cleavage. It was manifestly the difference between the professional and the amateur which was being stressed. This is not so simple as it sounds. It should not be forgotten that, from of old, the painter in China was seldom a professional in the true sense of the word. Since the Ming period, the tendency to choose painting as a profession had visibly grown. This went together, as we have already stated, with the marked rise of the bourgeoisie. The professional painter found himself opposed by the *Wên Jên*, for whom painting was one of the pursuits that belonged to true culture. Later art critics, particularly Mo Shih-lung (c.1550) and Tung Ch'i-ch'ang (1555-1636), formed two competing schools and called them the Northern and the Southern, on the analogy of the established division in Ch'an Buddhism. They also worked out a genealogical tree for them, tracing it back to Wang Wei and Li Ssŭ-hsün, the supreme landscape painters of the T'ang era.[193] This denomination and division has obtruded itself since then in many Chinese, Japanese and Western writings on art. In reality, not much is thereby gained, either in a historical or an artistic direction; most of the differentiations brought forward continually overlap. The best that can be said is that the so-called Southern School laid greater weight upon emotional expression and on the use of pure ink, and that in its case the influence of the four outstanding Yüan landscapists and their forerunners slightly predominates; whereas the Northern is more interested in colour, contour and detail, and is more inclined to lean upon the painting of the T'ang period. Moreover, the division holds good only for landscapes. These certainly played the major part during the Ming and the Ch'ing, but at the same time there was no lack of figure, animal and plant pictures. Actually, the masters of the last half-millennium of Chinese art development took their inspiration from the most varied sources, so that to speak of clear-cut differences of school is hardly possible. Besides the Northern and Southern, we meet in the Ming period, among others, two schools in particular which have received their names from the birthplaces of their leading masters—the *Chê School*, named after the province Chekiang, and the *Wu School*, deriving its name from the modern province Kiangsu (Wu). Their founders are reckoned to be Tai Chin (act. *c.* 1446) and Shên Chou (1427-1509). But neither of these two painters, nor their pupils, held themselves in any way to a definite style. For the rest, the Chê and Wu Schools overlap to a certain extent with the Northern and Southern ones. Once again we are back at our starting point—viz., the rather vague conception of schools in Chinese painting.[194]

Pl. 176 Of the Yüan masters who lived into the Ming era, Kao K'o-kung and Wang Mêng are already known to us. Somewhat younger are Wang Mien (1335-1407) and Tsou Fu-lei, famous primarily as painters of plum-blossoms.[195] With the bamboo, the pine and the narcissus, the plum-blossom belongs to those plants which have become profound symbols among the Chinese. It is the first harbinger of spring. Flowering on the bare wood in a surrounding still deep in snow, it inevitably provokes manifold reflections upon life and death. But in Yüan times, the motif, not unlike the bamboo, may also have associations with the political situation. Should the glad blossom of spring be an emblem of the longed-for

[193]Ku Têng, *Zur Bedeutung der Südschule in der Chinesischen Landschaftsmalerei*, Ostasiatische Zeitschrift VIII (XVIII); Victoria Contag, *Tung Ch'i-ch'ang's Hua Ch'an Shih Sui Pi und das Hua Shuo des Mo Shih-lung*, Ostasiatische Zeitschrift IX (XIX), 3/4, 1933; Ju Peon, *Die Entstehung der literarischen Richtung in der Chinesischen Malerei*, Sinica IX, 1934. [194]Hieratic religious Buddhist and Taoist painting of these days, being considered rather as applied art, was not affiliated to any school. It is seldom referred to in art literature, although paintings of remarkably fine rhythm and decorative charm were executed in *Pl.* 166-167 this field. Cf. n. 164, and pl. 166, 167. [195]We have already mentioned Chao Mêng-chien, one of the most highly extolled precursors of Tsou Fu-lei in plum-blossom painting. See Soame Jenyns, *A Background to Chinese Painting*, 1935, p. 197 f.

native-born ruler? As in the case of bamboo, so in the representation of the plum tree and its branches, the contrast between the firm stem and the delicate blooms swaying in the air, and their rhythmical disposition on the picture surface, is the joy of the master. Tsou Fu-lei chose the narrow strip of a hand scroll for his representation in the Freer Gallery. Although he employs only tones of black ink, the full glory of spring shines forth. Admirable the way in which the artist, broadly applying a half-dry brush, lays on a single daring stroke that diagonally cuts across the surface and, attenuating as it goes, fades out like a note in music. Wang Mien prefers the form of the hanging picture for his plum-blossoms (Japanese private possession), and thus gives away something of the esoteric character of the motif—perhaps a concession to the decorative aims of the time.

The majority of the paintings of early Ming are landscapes which in the main paraphrase the style of the *Four Great Yüan Landscapists*. Only the masters Hsü Pên and Wang Fu (1362-1416) may be singled out. The former is closely related to Wang Mêng, the latter to Ni Tsan. In both a stronger tonality is noticeable, and in their conceptions a greater intimacy which from now on is seldom absent. Their figures are often rendered in so small a size that they are hardly distinguishable. Wang Fu was not only a landscape painter, but is considered the most eminent portrayer of bamboo in Ming times, a judgment his surviving works do not sufficiently support.

About the same time the attractive scroll with illustrations to the *Nine Songs* of the poet and statesman Ch'ü Yüan (4th century B.C.) in the Boston Museum, must have been produced.[196] These songs repeatedly quickened the imagination of painters. We seem to be transported into a fairy world; some scenes are set in heaven, some on earth. The figures are exquisitely characterized; a brush full of elegance and flattering rhythms outlines the draperies and cloud formations. The master's method reminds us of Li Lung-mien and Liu Sung-nien (Sung). The landscape setting, however, is sketched with a more pictorial technique. Chang Wu, to whom the scroll is ascribed, shows himself also in other works to be a man who trims his sail in his own way.

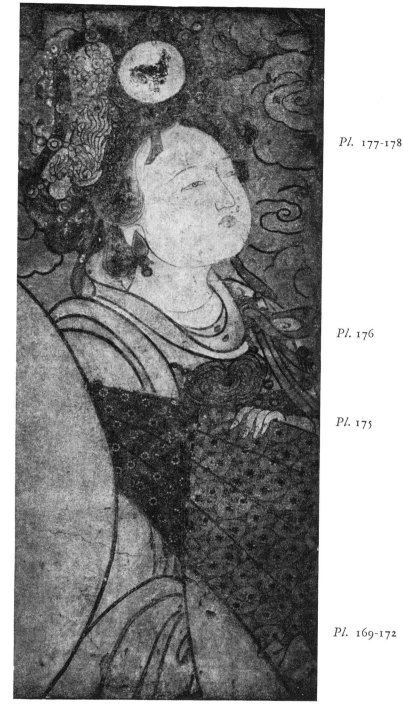

Pl. 177-178

Pl. 176

Pl. 175

Pl. 169-172

37. *Jih T'ien* (Deity of the Sun). Fragment of a fresco in colour. H. 145 cm. W. 61 cm. 15th century A.D. University Museum, Philadelphia.

[196]Kojiro Tomita, *Scroll of the Nine Songs of Ch'ü Yüan*, Bulletin of the Museum of Fine Arts, Boston, XXXV, 1937, p. 60 ff. Here, Tomita also gives translations of the texts which accompany the paintings on the hand scroll.

Pl. 173, 174, 183

A comparison between the already mentioned leaders of the Wu and Chê Schools, Shên Chou (Shih-t'ien) and Tai Chin (Wên-chin), who were active under the Emperor Hsüan Tê (himself a painter) and during the following decades, proves to be very enlightening. If the varying endeavours of the two schools, as well as their overlappings, are to be seen anywhere better than another, they are to be noticed in the output of these two artists. Both can be called virtuosi of the brush, both mostly use ink as their medium, and exhibit that firmer relation to reality which had been prepared for in the Yüan period. But then their ways part. Shên Chou excels in the wealth of ink shades. A profound poetry breathes through all his work, while Tai is rather a cool and objective observer. Eloquent of the masters is their different placing of the human element in landscape. Shên holds aloof from anything in the nature of genre. For a *Wên Jên* this is as it should be. In Tai's case some event or other usually seems to form the starting point. The landscape is—to say mere background would be an exaggeration, but it is at any rate no longer the dominant theme. The master seeks for new solutions and is generally more versatile than his esteemed colleague. The contrast of their personalities, emphasized by the Chinese, wholly comes to light when the masters' lives are examined. Shên Chou is a man after the heart of the *Wên Jên*, in whose hands art criticism lay, and so, the conditions for ultimate fame. He came from a family of scholars and is supposed to have been a child-prodigy—as is the legend of many of China's great men— and he attained mastery in all artistic fields. He lived reserved, refrained from accepting office, and declined to take payment for his pictures. A circle of congenial friends gathered round him. His kindness towards everyone, especially his mother, is praised. With Tai Chin it is quite otherwise. Whereas the accounts overflow with references to Shên, they are restrained in respect of Tai. During his lifetime he could seldom record a success. We hear nothing of his calligraphic gift or his erudition. He was evidently a professional. It is reported with something like satisfaction that he died poor. We should not even know the time of his activities had he not himself often supplied his works with dates. He did not receive fairer treatment till generations later. And yet, he is to be numbered among the few really eminent painters of the Ming era.

Pl. 185

Not a single one of the numerous painters of the late 15th and early 16th centuries (periods of Hung Chih, 1488-1505, and Chêng Tê, 1506-1521) can compare in stature with Shên Chou and Tai Chin. None the less there is, for instance, Liu Chün (act. *c.* 1500), who is a painter of some rank. He attempts to put new life into Yen Hui's powerful and realistic conceptions from the sphere of Taoism. In his *Three Sennin* merrily dancing around a toad, every line is infused with the rhythm of the dance. Detachment, serenity and closeness to nature, as they are taught by Taoism, are embodied here in a popular manner. Then we have

Pl. 179-182

Shih Chung (1437-1517), a solitary, according to the sources, a friend of Shên Chou's and temperamentally akin to him. His paintings are strongly emotional, to an extent, indeed, so far unknown. His snow landscape in Boston (dated 1504)[197] testifies to a master rich in fantasy. His flashing brush shows the utmost brilliance. Light and dark alternate in sharp contrasts. Snow-covered mountains, valleys and villages are conjured up by making free use of the blank ground. When we compare Shih Chung's winter landscape with that of Chu Tuan (active at about the same time), the spontaneity of the former becomes still more

Pl. 193
Pl. 186

evident. Chu Tuan lay too much under the spell of the 10th and 11th centuries. In addition, we have Wu Wei (1458-1508), who, when describing the life of peasants and fishermen, looks back to Tai Chin. In his representations of hermits contemplating nature, the landscape sometimes sinks to the level of a mere framework for the figures. Occasionally, as in the work

[197]Kojiro Tomita, *Snowscape by Shih Chung*, Bulletin of the Museum of Fine Arts, Boston, April, 1940; Werner Speiser and Herbert Franke, *Eine Winterlandschaft des Shih Chung* (1437-nach 1517), Ostasiatische Zeitschrift XII (XXII), 3-4, 1936. The painting described by the authors, dated 1506, is in the Cologne Museum.

owned by the Chinese Government, he also creates pure figural scenes devoid of any landscape background whatever. Whether he paints landscape or figure, his language is always of a noticeable vitality and freedom, even of originality. Lin Liang (at work *c.* 1500) is a specialist in the realm of bird and flower painting. His medium is pure ink. He succeeds in covering large surfaces with the greatest ease. As he loves lively movement and the sharpest contrasts of wash tones, all his works are instinct with a Baroque restlessness. Naturally, a great number of Ming painters occupied themselves with bird and flower motifs from a more decorative angle. Among the best known of these is Lü Chi (*c.* 1500), who continued the tradition of Pien Wên-chin, his senior by more than fifty years. One can understand that his richly coloured, painstaking and agreeably arranged decorations fitted in admirably with the splendour-loving Court of a Hung Chih and a Chêng Tê.

In a certain contrast to all these artists working about 1500 stands Hsü Lin. He was obviously an admirer of Sung lyricism, as expressed by the Ma family. None the less he too paid tribute to his time. In his remarkable series of four landscapes representing the *Four Seasons* (Japanese ownership),[198] lyricism has given place to sentimentality, and where before we had a sense of infinity, there is now a feeling of intimacy. The trees are no longer curtailed by the frame, rather they form the axis of the painting.[199]

When the Emperor Chia Ching (1522-1566) came to the throne, four masters of the highest repute were in their prime: Wên Chêng-ming (1470-1567?), T'ang Yin (1470-1523), Hsieh Shih-ch'ên (1488-1547) and Ch'iu Ying (act. *c.* 1522-1560). They dominated the first half of the 16th century. And just as the period Chia Ching still was able to produce works of nobility in the applied arts, with porcelain as the chief, so in painting there was still indisputable evidence of creative power. Even if Wên Chêng-ming does not deserve quite the prominence with which Chinese art-criticism credits him, certain it is that he stands well above the average. His being a pupil of Shên Chou and, like him, a genuine *Wên Jên*, already sufficed to overload him with praise. He seems, in contrast to his teacher, to have been very industrious, so

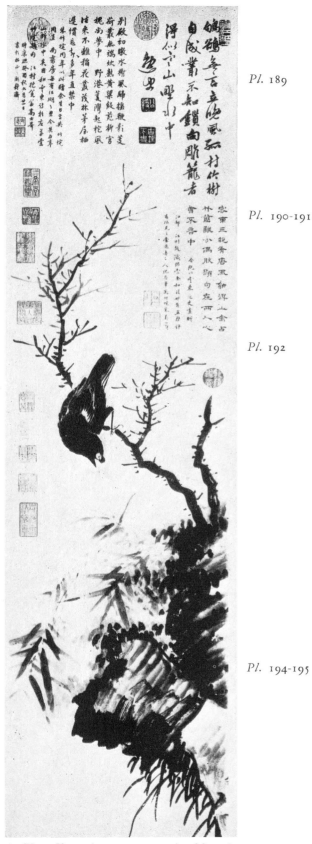

Pl. 189

Pl. 190-191

Pl. 192

Pl. 194-195

38. Yao Shou (A.D. 1425-1495). *Myna in Winter*. Ink and colour on paper. H. 116 cm. W. 30 cm. Chinese Government.

[198]Cf. Tōyō Bijutsu Taikwan, vol. x, pl. 190-192. [199]It may be instructive to include here two bird paintings which are well suited to illustrate two trends, highly esteemed in those days, and to show the change of style within a century. Both works are by popular masters. The one by Yao Shou (1425-1495, Fig. 38), on paper in pure ink, is a dramatic performance rich in tone and brilliant in brushwork; the other by Ch'ien Ku (1508-1572, Fig. 39), on silk in colour, is purely decorative and rather sentimental.

Pl. 197

Pl. 196, 210

Pl. 210

Pl. 198,
199, 204,
205, 207

39. Ch'ien Ku (A.D. 1508-1572). *A Magpie on
the Branch of an Apricot Tree.* Ink and colour
on paper. H. 116 cm. W. 34 cm. Dated 1569.
Chinese Government.

much so that many considered him the real head of the
school of the *Wên Jên Hua.* His activities have certainly
done much to enhance the prestige the *Wên Jên Hua*
enjoyed in days to come. He left behind him a large
output, in which landscapes and bamboo paintings
(Fig. 40) predominate. An artist of consummate ease,
he is less conventional than many of his colleagues.
On occasion he liberated himself from the tendency,
so characteristic of Ming times, to crowd the picture
surface with a superabundance of detail. In some of
his works, as in the Peking one, he goes so far as to
eliminate even mountains and water. Here the foliage
of the trees is translucent, as if the sun shone through
it. Above all, his bamboo pictures demonstrate in how
sovereign a manner he manipulates his brush. Wên
Chêng-ming's sons, not to forget his nephew, Wên
Po-jên, also well-known masters, continued his method.

T'ang Yin[200] and Ch'iu Ying have much in
common. Both artists are not entirely unfamiliar to
the West, and both owe this honour, be it said, to
rather indifferent and mellifluent representations of
women, which are, moreover, mostly paraphrases and
copies, and are to be found in innumerable quantities.
Both incline to tendencies of the *Chê School,* though
occasionally elements of the *Wu School* can be recog-
nized. Both are pupils of Chou Ch'ên, whose Boston
landscape, with its jagged rocks and joyous colour,
clearly betrays its descent from the ancestors of the
Chê School, Chao Po-chü and Li Ssŭ-hsün. Thus they
delight in the rendering of the multiplicity of moun-
tain forms and unexpected overlaps. Figures play a
prominent part. T'ang Yin, probably the elder—we do
not know Ch'iu Ying's exact dates—certainly deserves
the palm among the landscapists of the 16th century.
The hanging picture in Peking is not the most sig-
nificant example of his inventiveness and strong feel-
ing for space. There are a lot of other landscapes
which reveal these features more strongly. Authen-
tic figure pictures by him have seldom survived. In
Ch'iu Ying's case the situation is more favourable,
however difficult it often may be to come to a
definite conclusion.[201] Historical genre scenes in

[200]Werner Speiser, *T'ang Yin,* Ostasiatische Zeitschrift XI (XXI), 1935,
1/2, 3/4. This is one of the very few monographs on a Chinese painter;
it is, however, only a first attempt. [201]The difficulty of identifying works
of Ch'iu Ying is shown by Charles Fabens Kelley in his article, *A
Problem of Identification,* Ostasiatische Zeitschrift (XIX), 1933. The author
deals here with the well-known picture of a garden party attributed to
Ch'iu Ying, in the Chionin, Kyōto, and with paraphrases in the
Museums of Chicago and Boston.

which the past is glorified are the master's favourite themes. People make music, carouse, enjoy the beauties of nature, or watch cock-fights, as in the Boston scroll, which, if not actually by him, at least shows marked affinities with his style.[202] The fact that often distinct person-ages are portrayed has no particular meaning. Festive atmosphere, gay colours, details of im-plements, costumes and architecture, attract the master. He is extremely successful when depict-ing the spaciousness of architectural lay-out. As his whole family, with his daughter Tu-ling Nei-shih at the head, were actively engaged in painting, many a work attributed to him, e.g. the *Music in the Garden* (Chinese private owner-ship), may have been by his daughter or some other member of his studio. Incidentally, with-out the influence of T'ang Yin and Ch'iu Ying, the formation of the Japanese Ukiyoye and colour print is hardly imaginable.

With Hsieh Shih-ch'ên it becomes more evi-dent than with any of his predecessors to what great extent landscape, as such, has ceased to be sufficient to itself. However richly his composi-tions are provided with typical fantastically-formed mountains, with storm-smitten trees, with clouds and waterfalls, the master appears to be no less interested in describing how a beggar is given a drink, a woman in a house sits at a loom, a boat rushes down the rapids, or a girl with lamp in hand goes to the door to open to a late visit—the last perhaps one of the first examples of its kind, though omitting the effects of the light rays. For the rest, Hsieh Shih-ch'ên cultivates the same eclecticism as most of the Ming painters, with preference for the style of the Yüan landscapists.

The applied art of the closing Ming era, in particular that of the long Wan Li period (1573-1620), frequently gives pleasure by virtue of its freshness and *élan*, even if form, decoration and colour have grown coarser. But painting, from now on, seems to shut itself off from the main trend of art development. More than ever it subjects itself to the conservative spirit of

Pl. 204

Pl. 202

[202]The Boston scroll is obviously a paraphrase of Ku Hung-chung's treatment of the same subject (pl. 44). A comparison of the two conceptions reveals how, though the new age will have the new vision, the old design still survives, essentially unchanged.

40. Wên Chêng-ming (A.D. 1470-1567?). *Bamboo.* Ink on paper. Private Collection, China.

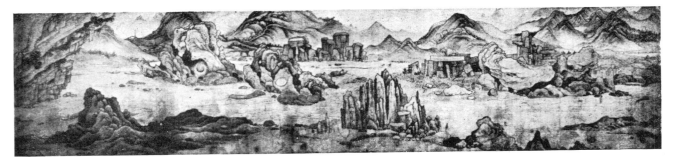

41. Hsiang Shêng-mo (A.D. 1597-1658). *River Landscape*. Part of a hand scroll. Ink and slight colour on paper.
H. c. 30 cm.

literature and philosophy, which, considering the almost unopposed domination of the
Wên Jên, is quite understandable. The artist rings the changes on old outworn themes and
dares not risk an independent idea. It is significant that now the leading masters, Hsiang
Yüan-pien (1525-1590), Mo Shih-lung, Tung Ch'i-ch'ang (1555-1636) and Ch'ên Chi-ju
Pl. 203 (1558-1639)[203] were essentially art critics and collectors. In fact, their theorizings and expert
opinions determine, more or less, even to-day, the general Chinese conception of art. Their
annotations are to be found upon countless older and contemporary pictures. It is an open
question how far their artistic activities will stand up to more modern criticism. How rarely
does a new outlook appear in their paintings, how little does one feel the breath of an authen-
tic personality! Their landscapes are too often rather dry, and their flower representations
mere *tours de force* of technical skill. And their expert opinions, are they always to be
accepted uncritically as the final word?[204] Whatever the answer, there are other painters who
seem to deserve much more to be set above the ruck of their time. There is, for example,
Pl. 209 Li Shih-ta (*c.* 1556-1620). He left behind him an essay on art, which has not survived; the
main points, however, are known.[205] Just as here the critic in a certain way seems to swim
against the stream, so in his paintings the artist strikes a personal note. Take his landscape
with the three lofty pine trees or his shady bamboo grove; in both, the figures are more
closely woven into their environment than is usual, and the scenery departs from all conven-
tionalities. Wang Ch'i (early 17th century), it is true, found his stimulus in Ni Tsan, but
Pl. 208 surpassed him in the economy of the means of expression. His Peking painting, with the
bridge and the empty hut, has the atmosphere of a still clear day in spring. The very un-
common pair of landscapes in the British Museum may have originated in the shadow of
Pl. 200-201 this master. Here we have the rare experience of beholding a dense wood, full of sylvan
poetry. A hermit, to whom a lad is bringing a book, is making himself comfortable at the
edge of a torrent, and above him hangs the foliage of realistically-seen trees. Ch'ên Hung-
Pl. 212 shou's (1599-1652) elongated female figures in curious costumes and head-dress, signifying
fairies or deities—however earthly their appearance may be—betray a self-willed hand in
expression, contour and drapery treatment. Are more characteristic examples of a Baroque
figural art to be imagined? It is interesting to observe how contemporary religious fresco
Pl. 213 painting, although more strongly bound to tradition, was occasionally quite near to such

[203]It would lead us too far to enumerate all their writings. Besides, it is often difficult to recognize what is by whom. Cf.
Victoria Contag, op. cit. The quintessence of Tung Ch'i-ch'ang's attitude to art is perhaps best expressed in the following
quotations: 'In calligraphy it is possible to create new styles, but in painting the familiar is essential.' 'It has been said that
in tree painting one is free to make one's own style. Nothing could be more untrue.' See Arthur Waley, *Introduction to the
Study of Chinese Painting*, 1923, p. 248. [204]It is not sufficient to repeat and translate their expert opinions; we must examine
them critically. Sir Percival David in his article, *Hsiang and his Album* (Transactions of the Oriental Ceramic Society,
1933/34), and Paul Pelliot in *Le prétendu Album de Porcelaines de Hiang Yüan-pien* (T'oung Pao XXXII, 1936) have set about
this task regarding porcelain. [205]Cf. Osvald Sirén, *History of Later Chinese Paintings*, vol. II, p. 19.

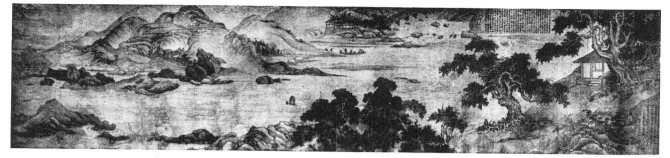

42. Hsiang Shêng-mo (A.D. 1597-1658). *River Landscape*. Part of a hand scroll. Ink and slight colour on paper.
H. c. 30 cm.

works.[206] Hsiang Shêng-mo (1597-1658) was a grandson of the above-mentioned Hsiang Yüan-pien. He has obviously more to say than his highly esteemed grandfather. The rock and mountain formations to which he devotes so much careful attention, are no mere products of the imagination. The picture illustrated here (Figs. 41-42) gives the effect of a journey by water through changing scenery which he must have made with keenly observant eyes.

[206]The fragment illustrated here may have been from a representation similar to that of the Royal Ontario Museum, Toronto, where the deities of *The Northern and Southern Dipper* are depicted (pl. 165 and Fig. 36), but it is obviously much later. Mark the gracefulness of the figures who look more like actors than deities.

XII. THE WESTERN IMPACT

THE CH'ING DYNASTY (A.D. 1644-1912)

BACKGROUND

IF the new invaders from the steppes, the Manchus, managed to occupy the throne of
China almost as long as the native T'ang, Sung or Ming dynasties, the explanation may be
found in the fact that the country's spiritual reserves of energy had been too heavily
drawn upon. Nevertheless the magic of Chinese culture proved itself strong enough to
subdue the aggressors in a very short time. The Manchus adapted themselves still more
thoroughly than the Mongols to everything Chinese, although, in the beginning, they treated
their new subjects by no means mildly. The important official positions were at once filled
by their own nationals; the obligation to wear a pigtail, after the model of the rulers, was
a harsh measure. A strict censorship was exercised upon all publications. Many books were
burned and many a malcontent had to pay for his subversive activities with his life. All the
same, it can be said that in their turn the Manchus gradually became more Chinese than the
Chinese themselves. But, as often occurs in history, those qualities of the subject peoples
which are most potentially dangerous, are the very ones to be fostered by their masters. In
China's case it was that unbounded veneration for the past which stifled all new life.

The Manchu prince Nurhachu (*c.* 1559-1626) had founded a state of considerable dimen-
sions, which, after lengthy wars, also embraced parts of Ming China. He made Mukden his
capital. The final conquest of all China did not follow as the result of any planned invasion.
The Manchus were called in by Wu San-kuei, a Chinese general of the Ming dynasty, to help
him against the rebel leader, Li Tzŭ-ch'êng, who already had several Chinese provinces,

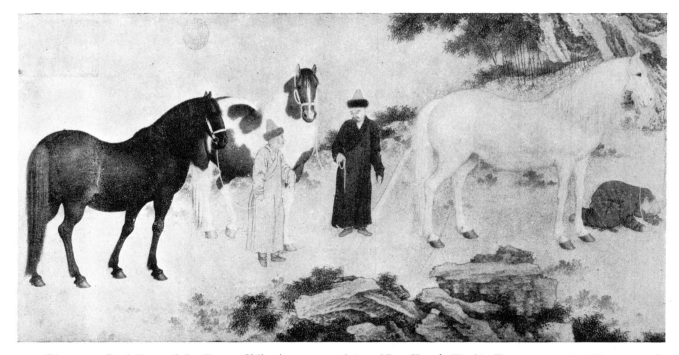

43. Giuseppe Castiglione S.J. (Lang Shih-ning, A.D. 1698-1766). *Kazak Kirghis Envoys presenting Horses to the
Emperor Ch'ien Lung.* Part of a hand scroll. Colour on paper. H. 30 cm. Musée Guimet, Paris.

including the capital Peking, in his grip. Li Tzŭ-ch'êng was defeated in 1644, but the Manchus remained in China from then on as masters of the land. At first, only the Northern and Western provinces fell to them. The new Manchu Emperor left the reduction of the South to Wu San-kuei and other former Ming adherents. Thus Chinese were in the service of the foreign despots from the very beginning. Even K'ang Hsi, the second of the Manchu Emperors, had severe battles to fight before the dynasty was firmly in the saddle; Wu San-kuei himself rose against him in the South. Manchu power did not cover all China until 1682. The rest of K'ang Hsi's sixty years of government (1662-1722) can, generally speaking, be considered happy. It may just be observed in passing that outstanding rulers like Louis XIV, Peter the Great, Charles II, and Charles XII of Sweden were contemporaries of K'ang Hsi, who himself belongs to the most remarkable figures on a throne. The Emperor worked untiringly at composing the differences between his own people and the Chinese. He offered sacrifices at the tombs of the Ming rulers—this, naturally, in order to underline the legitimacy of his dynasty. Confucianism was systematically patronized for the same reasons. It was under his auspices that compilations were called into being such as the world, perhaps, has never on a like scale seen again. It would take us too long to enumerate here the titles of all the works in question.[207] Among those devoted to art, the *Ch'in Ting P'ei Wên Chai Shu Hua P'u* (*Imperial Encyclopedia of Calligraphy and Painting*), in a hundred volumes, may be mentioned. At the same time the great scholars Ku Yen-wu (1613-1681), Yen Jo-chü (1636-1704) and many others, set out to subject the old classics to a critical analysis, thereby becoming the fathers of modern Sinology.

K'ang Hsi's son, Yung Chêng, reigned only thirteen years. He was followed by his son, Ch'ien Lung, who abdicated after a rule of sixty years because he did not wish to guide the destinies of his country for a longer period than his revered grandfather had done—an act

[207]The gigantic encyclopedia, *Ku Chin T'u Shu Chi Ch'êng*, completed only under K'ang Hsi's successor (1725), is indeed the most voluminous work ever published. There are 5,044 volumes, which give an exhaustive survey of the whole domain of Chinese knowledge.

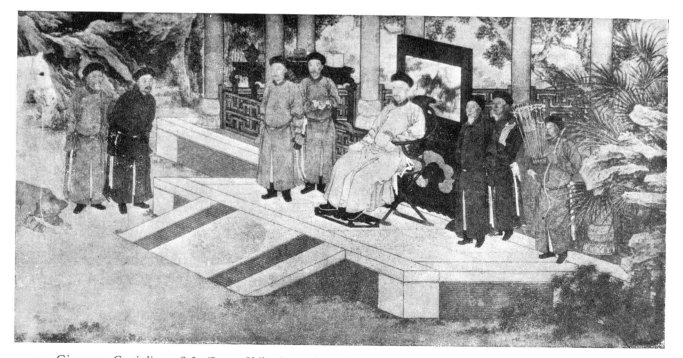

44. Giuseppe Castiglione S.J. (Lang Shih-ning, A.D. 1698-1766). *Kazak Kirghis Envoys presenting Horses to the Emperor Ch'ien Lung*. Part of a hand scroll. Colour on paper. H. 30 cm. Musée Guimet, Paris.

characteristic of the conservatism of the age. Under Ch'ien Lung the Manchus reached the pinnacle of their power. Never before had the frontiers of China been farther extended. Turkestan, Tibet, Burma and Nepal recognized her sovereign rights.

The first far-reaching conflict with the thought and might of the West started in the Manchu period. At the beginning the relationship was relatively frictionless. Europe regarded the Middle Kingdom with deference and esteem, and was, in fact, not inconsiderably influenced by Far Eastern ideas.[208] On the other hand, China was never more favourably disposed to the acceptance of Western teachings. As we already know, the Jesuit Matteo Ricci had received permission at the end of the Ming period to live and preach in Peking. Then the Germans, Adam Schall and Ferdinand Verbiest, came to China. Schall helped the Chinese to cast guns and to regulate their calendar. We hear that both Schall and Ricci brought images of Christian saints with them. The first treaty with a European country—Russia—was signed in 1689, and the first ambassador of a European power, the Englishman Lord Macartney, was received under Ch'ien Lung at Jehol. K'ang Hsi took instruction from Jesuit missionaries in the Western sciences, especially in astronomy, mathematics and anatomy. The Jesuit Giuseppe Castiglione settled in China in the year 1715, to be followed later by his colleague, Denis Attiret. Both of them were painters. Castiglione enjoyed, under the name of Lang Shih-ning, a remarkable reputation in the land of his choice. Many of his pictures are still extant. Although they obviously exhibit European features, their general effect is Chinese (Figs. 43, 44). Apparently he was urged to employ Chinese methods. He went so far as to sign his pictures with Chinese characters.[209]

With Chia Ch'ing's ascent to the throne (1796-1821) the political situation (both internal and external) underwent an entire change. Already in 1795, the Miaotzŭ, a South Chinese tribe, had revolted, and could only be pacified four years later. One rising succeeded another, secret societies created continual unrest. The oldest of these societies, the White Lotus (*Pai Lien Hui)*, after a long spell of inactivity, rose in 1796 and seriously endangered the rule of the Manchus. From 1850 till 1864 the T'ai P'ing rebellion raged throughout Central China. Then the Moslem revolted (1856); about forty years later, the Boxer upheaval followed. The European Powers exploited the country's weakness for their own ends. The Opium and Arrow wars (1839-1842 and 1857-1860), as well as other wars with the European States, broke out; as the result, China was forced to cede territory to the foreigners. A further calamity was the unhappy Sino-Japanese war (1894-1895). China became a republic in 1912, a sign that the Chinese were determined to start building a new world, which however by no means signifies a total abandonment of their old traditions.

DEVELOPMENT

*Pl.*211
Most of the rulers of the Ch'ing dynasty were great patrons of art and, of course, painters. Luxury and splendour reigned at their Courts; and not only there, but among the aristocracy and bourgeoisie as well.[210] It was to the crafts that the major tasks fell, and in them creative life still pulsed, even though their productions often did not exceed mere technical virtuosity

[208]Adolf Reichwein, *China and Europe, Intellectual and Artistic Contacts in the Eighteenth Century*, 1925. [209]There were quarrels between the Jesuits and the Dominicans in China which had the effect that their influence, and with it, Western influence, was considerably weakened during the last years of the period K'ang Hsi and the period Yung Chêng. Only under Ch'ien Lung were the Jesuits again restored to favour. The main point of the quarrels was the 'Rite Controversy.' The Jesuits yielded too much to Chinese rites—for example, ancestor worship and sacrifices to Confucius. The Dominicans denounced the Jesuits in Rome, whence a special legate was sent to inquire. K'ang Hsi considered this an unwarranted intervention and issued an edict against the missionaries. See E. R. Hughes, *The Invasion of China by the Western World*, 1937, p. 59f. [210]The resumption of the cataloguing of the immense imperial collections began under K'ang Hsi and was continued under Ch'ien Lung. The greatest private collectors about the end of Ming were Wang Shih-chêng and Tung Ch'i-ch'ang, and in the period K'ang Hsi, the Korean salt merchant An I-chou. These collectors were also active as writers on art. Cf. S. Jenyns, op. cit. p. 112f.

and elegance. Painting, on the other hand, was far more than in Ming times content to be enslaved to the past. Just as we maintained a critical attitude to the Ming masters and occasionally found ourselves in disagreement with the Chinese judgment about them, so now, but with even stronger emphasis, we consider it appropriate to approach the painters of the Ch'ing era with reserve. To lose oneself in the contemplation of some work or other has its charm; yet, taking them all in all, we find empty routine and rigid conventionalism is the rule. There were, naturally, exceptions, and more of these will possibly come to light when we shall be able to see the art of the last centuries in greater perspective. Most of the artists, however, differ only by a predilection for the style of one or the other of the four great Yüan landscapists, or by varying repetitions of Sung formulæ. In particular, the Yüan method of treating the fissures in mountain and rock formations, and trees and figures as well, now hardened into a series of set pattern. The *Shih Chu Chai Shu Hua P'u* (*Album of the Ten Bamboo Halls*), published about 1630, and the *Chieh Tzŭ Yüan Hua Chuan* (*Mustard Seed Garden Compendium*) which appeared since 1689, both of them textbooks illustrated with fine woodcuts, represent here milestones on the downward path, however attractive they are in themselves.[211] Thus the sources of Chinese creative genius, which had already in Ming times begun to flow rather sluggishly, dried up even more. On the other hand, Western influences were growing stronger. Indeed, there is every reason to believe that the most worthwhile achievements were reached in consequence of the willing acceptance of foreign impulses.

The leading masters of the early Ch'ing period,[212] the so-called 'Four Wang', were very definitely *Wên Jên*, with all the merits and shortcomings associated therewith. The first part of the life of the oldest of them, Wang Shih-min (1592-1680), still fell much in the time when the painter and art critic Tung Ch'i-ch'ang controlled the art life of the period. Wang Shih-min regarded him with veneration, and it was Tung who opened Wang Shih-min's eyes to the beauties of Yüan landscape painting. The hackneyed theme of mountain valleys in their seasonal phases, among whose threatening and rugged heights the human being and his habitation become all but invisible, keeps on reappearing in his pictures. It seems to have been his special pleasure to furnish them with as many interesting details as possible. His contemporary, Wang Chien (Yüan-chao, 1598-1677), is less broad in vision. On occasion he can be astonishingly simple. Here the influence of Ni Tsan is quite obvious. The other two members of the group, Wang Hui (Shih-ku, 1632-1720) and Wang Yüan-ch'i (1642-1715), *Pl. 214* worked mainly for the Emperor K'ang Hsi, that is a generation later. Wang Hui distinguishes himself by rich imagination. Romantically situated buildings and bridge structures supply the personal note in many of his landscapes. Spatial depth and atmosphere, with a temperamental brush stroke, help to give him a superior standing within the group. Wang Yüan-ch'i, as the editor of K'ang Hsi's great *Encyclopedia of Painting and Calligraphy*, was one of the outstanding personages of his day. Great attention was also paid to his own views *Pl. 215* upon painting.[213] It was only possible in the China of the 18th century for the editor of a compilation in a hundred volumes to be able at the same time to make a name for himself as a painter. To be sure, his output as a painter reveals his compiling activities to a certain degree. He is probably the most monotonous of the four namesakes. The landscape in the British Museum is not a characteristic specimen of his method; many of his other works give a more restless and overloaded impression. At any rate, in the London painting, the scheme that he repeatedly uses comes out quite well. A group of trees in the foreground, then the scene dips down into a valley with bridges and houses; in the background tower mountains that resemble woolly cloud formations rather than masses of cliff. Wang Yüan-ch'i's hand can be recognized at the first glance in this kind of fissure.

[211]Cf. chapters 3 and 11. [212]Victoria Contag, *Die sechs berühmten Maler der Ch'ing Dynastie*, 1940. [213]Osvald Sirén, *The Chinese on the Art of Painting*, 1936, p. 201 ff.

The 'Four Wang' represent the quintessence of the official taste in the K'ang Hsi period, but not that of the country as a whole. There were, of course, masters who had, up to a certain point, a personal word to say. The first to be named in this connexion is Yün Shou-p'ing (Nan-t'ien, 1633-1690).[214] He came of poor parents, passed no examination and, being a professional, held no office. Hence, his artistic career followed quite a different path from that of a *Wên Jên*. His talent lay in the fields of flower and plant painting, although typical landscapes are not entirely absent from his work. He was no superficial and slick technician, such as flourished in countless number at that time—the picture by Wang Wu (1632-1690) in the British Museum, dated 1662, is a characteristic example of their skill—; he gives us something more. When he employs ink, a lively brush stroke surprises; when colour, he shows a fine feeling for harmony. Being a strongly impressionable master, he was apparently among the first to take marked notice of Western methods. Thus, in his ink painting entitled *The Three Friends* (pine, bamboo, plum tree), we behold the moon's disc appearing behind a pine. Bamboo had been represented in moonlight as early as the Sung period, but the moon herself was never visible. Others of the master's flower pieces, with their painstaking exactitude and their stressing of shaded and unshaded passages, may have been influenced by Western botanical illustrations, and this without having lost their Eastern flavour. Most indicative of the growing significance of Western principles is that the Emperor K'ang Hsi, obviously not satisfied with the old illustrations of the famous work, *The Arts of Agriculture and Silk Manufacture (Kêng Chih T'u)*, ordered new ones to be executed, and entrusted the painter Chiao Ping-chên with this task. Chiao was Assistant at the Imperial Astronomical Observatory, where he had learned the Western manner of painting.

The most original painters of these decades, sometimes called the School of the Individualists, are to be found among Buddhist priests; they imparted new life to the tradition of Ch'an style. There is Chu Ta (Pa-ta Shan-jên, act. *c.* 1630-1650),[215] who is remarkable not so much for his landscapes (which are mostly quite conventional) as for his bird and flower paintings in ink. He knows how to concentrate on the essential and to express himself with as little means as possible. He also knows how the empty area of the picture surface can be made eloquent. And yet he does not rise above a brilliant and ingenious play, which frequently veils a certain wit and caprice. The priest Tao-chi (Shih-t'ao, act. *c.* 1660-1710) was not only an unusual painter but an outstanding writer as well.[216] He was one of the first to protest against the endless imitations of the old masters. His pictures show the same attitude. It is often difficult—a rare thing in late Chinese painting—to determine his models. His boldly conceived ink painting with orchids and bamboo, in which his friend Wang Yüan-chi, collaborated (the hand of the latter is easily recognizable in the treatment of the landscape background) is still reminiscent of the past. In other works, using a most dashing brush technique, he obviously gives form to immediate experience. Here he has the simplicity of the old masters, and yet his vision reveals quite a new spirit. His figures, although minute, are all expression and movement. Moreover, he discovers new atmospheric phenomena and unusual subjects, for example, a mountain lake surrounded by steep cliffs, with men bathing, or a still life with a flower vase.

A third priest painter, K'un Ts'an (Shih-ch'i, c. 1625-1700), gave Buddhist conceptions an entirely new aspect. In his *Buddha in the Wilderness*, the setting is a thick mountain


Pl. 219

Pl. 217

Pl. 220

Pl. 218

Pl. 222-223


[214]Cf. Arthur Waley, *Yün Shou-p'ing called 'Nan-t'ien'*, 1633-1690. The Year Book of Oriental Art and Culture, I, 1924-25. In this article one of the very few preserved Chinese screens, a work by Yün Shou-p'ing, is reproduced. [215]Cf. Werner Speiser, *Ba Da Shan Jên*. Sinica, 1933. [216]Sirén gives a translation of Shih-t'ao's highly interesting *Hua Yü Lu* (Notes on Painting). Here Shih-t'ao says: 'The method which consists in not following any method (of the ancients) is the perfect method.' 'I am always myself and must naturally be present (in my work). The beards and eyebrows of the old masters cannot grow on my own face. The lungs and bowels (thoughts and feelings) of the old masters cannot be transferred into my stomach (mind).' *The Chinese on the Art of Painting*, p. 187 and 188.

wood, drawn with vigorous touches; but the presence of the Enlightened One lends an air of mystery to the scene. We have another painting by him, of a Lohan in meditation, sitting like a bird in the branches of a tree. And again there is a landscape in which the painter himself lies on the ground, almost lost in the thicket.[217]

Of the masters whose activity continued under the Emperor Yung Chêng, Kao Ch'i-p'ei (d. 1734), Chiang T'ing-hsi (1669-1732) and Kao Fêng-han (1683-1743) excel. Kao Ch'i-p'ei is said to have made use of his fingers when painting—as Chang Tsao did of old—because the potentialities of his brush did not satisfy him. More important is his rare impetuosity, whether he is dealing with figures, landscapes or birds. His representation of the exorcizer Chung K'uei is particularly impressive in the powerful handling of the ink. A pictorial character, combined with unexpected ideas, distinguishes all his works. Chiang T'ing-hsi's *Pl. 216* art is very similar to that of Yün Shou-p'ing. Western influences are obvious, but not to the detriment of Eastern tradition. Kao Fêng-han seems to have been an admirer of the expressionistic manner of the priest K'un Ts'an.[218]

During Ch'ien Lung's long and politically so successful reign, an enormous art activity was being displayed. The Emperor himself was an indefatigable painter and calligrapher; his pictures, however, are either dry variations in contemporary style or not particularly bright experiments in European manner—for were not Castiglione and Attiret his protégés. In any case, the Western orientation was no longer confined to a few masters of adventurous imagination; it had become a fashionable gesture. The most eloquent proof of this is the erection of the Yüan Ming Yüan Palace after the Versailles model. The Emperor even commissioned Western painters to glorify his victories. Ch'ien Lung's real love was poetry. He immortalized himself on pictures of the past and the present, on porcelains and lacquers, in temples and in natural beauty spots, by means of poems and inscriptions which he himself had composed. He is said to have been the author of 30,000 poems. In his palace workshops, pieces of brilliant technique—and astonishing things were achieved in this respect—were appreciated above all else. Pictures were embroidered, lacquer was made to resemble pottery, porcelain to resemble bronze and lacquer; all techniques were combined, and every style of painting, including the European, was indulged in. What the art critic Chang Kêng (b. 1693) writes concerning the Emperor as a painter fits very well into the whole atmosphere of these days. Chang surpasses himself in exuberant hymns of praise.[219] They throw a dazzling light upon art criticism, as practised in China at that time, but, as is well known, China was not singular in this respect.

Obviously, Ch'ien Lung favoured those artists who in one way or another tried to come to terms with Western methods. The fact that they belonged to the most able of the epoch is only a proof of the Emperor's understanding of the existing artistic situation. These masters show at least their dissatisfaction with the prevailing stagnation in painting, and feel that something must be done in order to infuse new blood into it. Naturally, they are exceptions, the great majority remained faithful to the ancient, now trite manner, and in spite of, or rather, just because of that, many a lovely work came from their circles. But the most important problem facing the development of Chinese art during the last hundred and fifty years was unquestionably the endeavour to reach an agreement with the West.

Together with Castiglione and Attiret in the imperial workshops we find the master Tsou I-kuei (1686-1772). He learnt a lot from his alien compeers; in his written observations

[217]Many of the paintings of the *Four Wang*, of Yün Shou-p'ing and Pa-ta Shan-jên, of Shih-t'ao, Kung Hsien and others have been recently published in albums in China and Japan. [218]Here also Wu Li (1632-1718) may be mentioned, not indeed because he was anything more than a competent painter, but because, despite his being a Christian priest, he was little influenced by Western art. Cf. P. de Prunelé, S.J., *Notice sur le Père Acunha*, Ostasiatische Zeitschrift II, 1913/14, p. 319 ff, and Tschang and Prunelé, *Le Père A. Cunha, Shanghai*, 1914. [219]Chang Kêng says: 'His genius is a gift of Heaven, his intelligence is all-embracing, he has searched into the origin of life.' O. Sirén, *A History of Later Chinese Painting*, II, p. 199.

on painting, he even devoted a short section to European methods.[220] Nevertheless, the results of this contact with the West were not very happy. How much more arid appear his flower paintings than those of Yün Shou-p'ing, fifty years his senior. Hardly a breath of poetry has remained. The plants, like cut sprays, are pedantically correct, but spread over the surface without ease, whereas in earlier times they seem verily to grow up before our eyes and sway in the air. In fact, Tsou did not show much appreciation for Western methods in his writings on painting.

Pl. 221 Ch'ien Lung admired Tsou I-Kuei's paintings, as also those of Ching T'ing-piao, and this obviously for the same reason, namely, for their new approach to nature. In Ching T'ing-piao, however, we may have a personality who to a certain extent was able to overcome the new problems. His snow landscape with a fisherman in a boat, for instance—indeed a happy performance—must have startled the Chinese artists. The icy conditions of

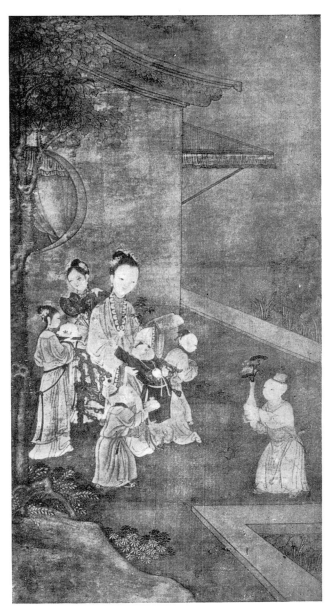

mountain, tree and shrub are brought out by means of large display of detail and the use of thick layers, when in the past a bare suggestion would have sufficed. With a convincing gesture the angler grasps for the fish dangling on the hook. The master looks out for unusual solutions in his ink paintings as well. To be sure, the vitality of the stroke is weakened and the wash tones incline to dullness, but there are compensations. With what certainty he captures the various movements of the peasants dredging mud from a waterway for the fertilizing of the rice fields. How charmingly the sails rise up out of the background and how clever is the treatment of the perspective, which shows full mastery of Western principles. Remarkable, too, are the careful foreshortenings of the figures as they recede into the depth. With Lêng Mei, a pupil of Chiao Ping-chên, the Western impact becomes still more evident. In many of his paintings there is a similar pleasure in perspective effects as in European paintings of the Quattrocento (Fig. 45). The master is generally known for his pictures of ladies of rank. The one in the Boston Museum is an attractive and typical example of his style. Lêng Mei's Western orientation, even if it does not enhance, certainly does not impair his ability to give a vivid expression of passing life.

When, finally, we consider Hua Yen (Hsin

[220]In his *Hsiao Shan Hua P'u* (*Remarks on Painting*) Tsou I-kuei writes: 'Westerners are fond of using the perspective plane in painting, with the result that the impression of depth and distance is very accurate.' 'Mural paintings of palaces and residences are often so real that one wants to walk straight into them.' John Ferguson, *Chinese Painting*, 1927, p. 182.

45. Lêng Mei (18th century A.D.). *Lady with Children and Servants on a Terrace*. Colour on silk. H. 116 cm. W. 59 cm. Museum of Fine Arts, Boston.

Lo Shan-jên, 1680-1755) and Chin Nung (Shou-mên, 1687-1774), we meet with masters who occasionally entirely abandoned the very idiom of Chinese art-language. Fortunately, they were creative talents, and were thus saved from degeneration into mere imitators. Both exercised a great influence on their brother painters and on those to follow. A word may be added on Shên Ch'üan (Nan-p'in) who worked in Nagasaki from 1731-1733. While usually a dry artist, he introduced the Western method of painting into Japan, where many of his works, mostly deer subjects, have survived. The well-known Maruyama School bears witness to his success in Japan.

In spite of the Western predilection of many of the artists, painting in general remained faithful to the old orthodox range of subjects. Landscapes peopled by sages were its principal concern; but Buddhist and Taoist figures, not to mention birds, flowers and bamboos, were not neglected either. It was still the *Wên Jên* ideal that held the masters in thrall.

Naturally, contemporary life in the town, in the streets as well as in the homes, and, last but not least, portraits of many varieties appeared in Ch'ing painting—now with more or less Western orientation. The well-known ancestor portraits are, it is true, mostly artisan work; there were, of course, also likenesses of artistic value. Let us discuss two probably coeval portraits which exhibit different tendencies. The painting by Huang Shên in the British Museum (Fig. 46), executed in ink (dated 1744), reflects the *Wên Jên* spirit. The master rendered, as the inscription tells us, a school friend in the character of one of his friend's ancestors, who was a simple peasant and rose to the rank of a minister. That is why he is represented with a buffalo. Although the brush stroke is weakened by too pronounced realistic effort, we have here the noble figure of a highly intellectual man with gentle features. According to *Wên Jên* tradition, the greatest part of the picture area is covered with beautifully written inscriptions. To a quite different sphere belongs the richly-coloured anonymous painting with a seated youth between two standing women in the Freer Gallery, Washington. It may be a portrait as

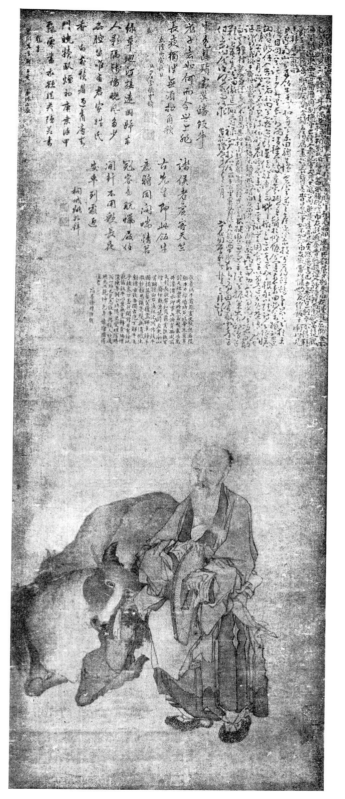

46. Huang Shên (18th century A.D.). *Portrait of Ning Yü-ch'uan in the Guise of his Ancestor Ning Ch'i*. Ink and slight colour on silk. H. 128 cm. W. 49 cm. British Museum, London.

Pl. 224 well, yet there is nothing of *Wên Jên* attitude about it; rather the bourgeois mentality of the 18th century, with its indulgence in wealth and luxury, is embodied. The interior of a room in an opulent house, depicted with great accuracy, forms the background. On the table and the shelves we see porcelain, bronzes and books. The vases are perhaps Yung Chêng imitations of Sung models. The disposal of the figures in the front against the obliquely receding interior is, for China, a new mode of vision.

From the 19th century onwards, right up to the present day, the struggle between ancient traditions and Western conceptions plays an increasing part in the whole culture of China. The Western impact upon painting grows stronger; even the medium of oil paint becomes more and more popular. On the other hand, let us not forget that the Eastern genius of painting has in its turn much enriched and stimulated the West. Although the Chinese master frequently works in both styles, and their reciprocal infiltration cannot be denied, indigenous and foreign orientations now stand in opposition to each other.[221] In a people as gifted as the Chinese, art, even in times of serious crisis, does not cease to thrive. Many excellent artists, well known also in the West—their paintings having been shown in Western exhibitions—are at work. The great question now arises: Will the Chinese painting of to-morrow be built up primarily upon Western foundations? Or will China be productive enough to march towards a new and decisive development of her own? At the moment it seems doubtful whether purely indigenous painting will, in the future, be more than an artificial prolongation of the past. All the evidence goes to show that a synthesis of Eastern and Western art methods has the greatest possible prospect of bringing about a new powerful Chinese painting. For the time being everything is in flux. It would be highly interesting to enter into a detailed examination of the art struggle of the last hundred and fifty years. We witness in China a process that has occurred *mutatis mutandis* so many times in the course of the some five-thousand-years-long evolution of world art. But these questions lie beyond the scope of the present survey.

[221] Liu Hai-su, himself a highly praised painter of our days, enumerates the currents of modern Chinese painting as follows, (1) The Archaizing Current, (2) The Current of the Middle Way [Synthesis of West and East], (3) The Southern Current, (4) The Literary Current. *Richtungen in der Modernen Malerei*, Sinica VI, 1931.

SELECTED BIBLIOGRAPHY

WORKS ON SPECIAL SUBJECTS ARE QUOTED IN THE FOOTNOTES, WHEREAS THE FOLLOWING BIBLIOGRAPHY LISTS GENERAL WORKS. IT IS ALMOST COMPLETE REGARDING IMPORTANT WESTERN PUBLICATIONS ON CHINESE PAINTING. AS TO FAR EASTERN BOOKS AND ARTICLES ON PAINTING AND WESTERN PUBLICATIONS ON HISTORY, PHILOSOPHY, RELIGION AND LITERATURE, ONLY A SMALL SELECTION IS GIVEN

GENERAL WORKS ON CHINA

Henri Cordier, *Bibliotheca Sinica. Dictionnaire Bibliographique des Ouvrages relatifs à l'Empire Chinois.* 5 vols. 1904/08. Supplement et Index, 1922.

Samuel Couling, *The Encyclopædia Sinica.* Shanghai, 1918.

E. Erkes, *China.* 1919.

H. A. Giles, *A Chinese Biographical Dictionary,* 1898.

A. Herrmann, *Atlas of China.* Harvard University Press, 1935.

G. F. Hudson, *Europe and China. Survey of their Relations from the Earliest Times to 1800.* 1931.

W. F. Mayers, *The Chinese Reader's Manual.* Shanghai, 1924.

Ssŭ-yü Têng and Knight Biggerstaff, *An Annotated Bibliography of Selected Chinese Reference Works.* Peiping, 1936.

S. H. Chen Zen (editor), *Symposium on Chinese Culture.* Shanghai, 1931.

HISTORY

Henri Cordier, *Histoire Générale de la Chine.* 4 vols., 1920/21.

C. P. Fitzgerald, *China, a short Cultural History.* 1935.

Otto Franke, *Geschichte des Chinesischen Reiches.* 3 vols., 1930 ff.

Marcel Granet, *La Civilisation Chinoise.* 1929.

René Grousset, *Histoire de l'Extrême Orient.* 2 vols., 1929.

Erich Hauer, *Chinas Werden im Spiegel der Geschichte.* 1928.

F. E. A. Krause, *Geschichte Ostasiens.* 2 vols., 1925.

Kenneth Scott Latourette, *The Chinese. Their History and Culture.* New York, 1943.

Li Ung Bing, *Outlines of Chinese History.* Shanghai, 1914.

Arthur Rosthorn, *Geschichte Chinas.* 1923.

Tsui Chi, *A Short History of Chinese Civilisation.* 1942.

L. Wieger, *Textes Historiques.* 3 vols. Hien-hien, 1905.

L. Wieger, *La Chine à travers les Âges.* Hien-hien, 1920.

Richard Wilhelm, *Ostasien, Werden und Wandel des Chinesischen Kulturkreises.* 1928.

Richard Wilhelm, *A Short History of Chinese Civilisation.* 1929.

PHILOSOPHY AND RELIGION

For the translations of the Chinese Classics and later Philosophers see the well-known works by S. Couvreur, H. H. Dubs, J. J. L. Duyvendak, Alfred Forke, Herbert and Lionel Giles, E. R. Hughes, James Legge, Victor Strauss, Arthur Waley, and Richard Wilhelm.

Sir Charles Eliot, *Hinduism and Buddhism.* 3 vols., 1921.

A. Forke, *The World-Conception of the Chinese.* 1925.

A. Forke, *Die Gedankenwelt des Chinesischen Kulturkreises.* 1927.

A. Forke, *Geschichte der Alten Chinesischen Philosophie.* 1927.

A. Forke, *Geschichte der Mittelalterlichen Chinesischen Philosophie.* 1934.

A. Forke, *Geschichte der Neueren Chinesischen Philosophie.* 1938.

J. J. M. de Groot, *The Religious System of China.* 6 vols. Leiden, 1892-1910.

J. J. M. de Groot, *Universismus.* 1918.

Heinrich Hackmann, *Chinesische Philosophie.* 1927.

F. E. A. Krause, *Ju-Tao-Fo. Die religiösen und philosophischen Systeme Ostasiens,* 1924.

Leon Wieger, *Buddhisme Chinois.* 2 vols., 1910.

Leon Wieger, *Taoisme.* 1911-13.

Leon Wieger, *A History of the Religious Beliefs and Philosophical Opinions in China.* Hsien-hsien, 1927.

Richard Wilhelm, *Chinesische Philosophie,* 1929.

LITERATURE

For the translation of Chinese poems, see the anthologies by W. Bynner, Alfred Forke, Herbert A. Giles, Soame Jenyns, Arthur Waley, Richard Wilhelm, and v. Zach.

Eduard Erkes, *Chinesische Literatur.* 1922.

H. A. Giles, *A History of Chinese Literature.* 1901.

H. A. Giles, *Gems of Chinese Literature.* Shanghai, 1922.

Wilhelm Grube, *Geschichte der Chinesischen Literatur,* 1902.

Sung-Nien Hsu, *Anthologie de la Litterature Chinoise des Origines à nos Jours.* 1933.

Richard Wilhelm, *Die Chinesische Literatur.* 1926.

A. Wylie, *Notes on Chinese Literature.* Shanghai, 1902.

FAR EASTERN ART

Allgemeines Lexikon der Bildenden Künstler (Thieme-Becker), 1907 ff. [Chinese Artists by Otto Kümmel.]

Leigh Ashton and Basil Gray, *Chinese Art.* 1935.

S. W. Bushell, *Chinese Art.* 2 vols., 1904-1906.

William Cohn, *Ostasiatische Portraitmalerei.* 1923.

William Cohn, *Vergleichende Studien zur Malerei Japans und Chinas.* Cicerone, xv, 1924.

William Cohn, *Chinese Art.* 1930.

Sir Percival David, *The Chinese Exhibition.* [Journal of the Royal Society of Arts, 1935.]

Serge Elisséev, *L'Art de la Chine* in *Histoire Universelle des Arts,* publiée sous la Direction de Louis Réau. Volume: Arts Musulmans, Extrême-Orient. 1939.

Serge Elisséev, *Notes sur le Portrait en Extrême-Orient.* Études d'Orientalisme, 1932.

E. F. Fenollosa, *Epochs of Chinese and Japanese Art.* 2 vols., 1912.

J. C. Ferguson, *Outlines of Chinese Art.* Chicago, 1918.

J. C. Ferguson, *Survey of Chinese Art.* Shanghai, 1939.

Otto Fischer, *Die Kunst Indiens, Chinas und Japans.* 1928.

Curt Glaser, *Die Kunst Ostasiens. Der Umkreis ihres Denkens und Gestaltens.* 1920.

René Grousset, *Les Civilisations de l'Orient.* Tome III: La Chine. 1930.

Grace Dunham Guest, *Annotated Outlines of the History of Chinese Arts.* Washington, 1945.

Otto Kümmel, *Die Kunst Chinas, Japans and Koreas.* Handbuch der Kunstwissenschaft, 1929.

George Soulié de Morant, *Histoire de l'Art Chinois de l'Antiquité à nos Jours.* 1928.

Oskar Münsterberg, *Chinesische Kunstgeschichte.* 2 vols., 1910.

S. Omura, *Chung Kuo Mei Shu Shih* [History of Chinese Art]. Shanghai, 1928.

Victor Rienaecker, *Chinese Art.* A series of articles in the journal Apollo since December, 1943.

Arnold Silcock, *Introduction to Chinese Art and History.* 1936.

HISTORY AND THEORY OF CHINESE PAINTING

Florence Ayscough, *The Connexion between Chinese Calligraphy, Poetry and Painting*. Wiener Beiträge VI, 1931.

Laurence Binyon, *The Flight of the Dragon.* 1911.

Laurence Binyon, *Painting in the Far East.* 1934.

Laurence Binyon, *Chinese Painters.* [Journal of the Royal Society of Arts, 1935.]

Chêng Ch'ang, *Chung Kuo Hua Hsüeh Ch'üan Shih* [History of Chinese Painting]. Shanghai, 1929.

Chiang Yee, *The Chinese Eye. An Interpretation of Chinese Painting.* 1935.

Ch'in Chung-wên, *Chung-kuo Hui Hua Hsüeh Shih* [History of Chinese Painting]. 1934.

Ch'in Tsu Yung, *Hua Hsüeh Hsin Yin* [Collection of Reprints on Painting). 1878.

William Cohn, *A Study of Chinese Painting.* [The Burlington Magazine, 1942.]

Fêng Chin-po, *Kuo Ch'ao Hua Shih* [Painters of the Last Dynasty], 1797.

John C. Ferguson, *Li Tai Chu Lu Hua Mu* [Index of recorded Paintings]. 6 vols. Nanking, 1933.

John C. Ferguson, *Chinese Painting.* Chicago, 1927.

John C. Ferguson, *Chinese Landscapists.* Asia Major, Hirth Anniversary Volume, 1923.

Otto Fischer, *Die Entwicklung der Baumdarstellung in der Chinesischen Kunst.* Ostasiatische Zeitschrift II, 1913/14.

Otto Fischer, *Chinesische Landschaftsmalerei.* 1921.

Herbert A. Giles, *An Introduction to the History of Chinese Pictorial Art.* 1918.

Basil Gray, *The Chinese Exhibition. Some Problems among the Paintings.* Apollo, 1936.

Ernst Grosse, *Die Ostasiatische Tuschmalerei.* 1923.

Louise Wallace Hackney, *Guide-Post to Chinese Painting.* Boston, 1927.

Friedrich Hirth, *Scraps from a Collector's Note-book.* Leiden, 1905.

Friedrich Hirth, *Native Sources for the Study of Chinese Pictorial Art.* New York, 1917.

Hsü Ch'in, *Ming Hua Lu* [Biographies of Ming Painters], 1817.

Ise Senichirō, *A History of Chinese Painting.* Tōkyō, 1923. In Japanese.

Ise Senichirō, *A History of Chinese Landscape Painting.* Kyōto, 1933. In Japanese.

Soame Jenyns, *A Background to Chinese Painting.* 1935.

Ku Têng, *Chinesische Malkunsttheorie in der T'ang- und Sungzeit.* Ostasiatische Zeitschrift X (XX), XI (XXI), 1934/35.

Ku Têng, *Einführung in die Geschichte der Malerei Chinas.* Sinica X, 1935.

Otto Kümmel, *Die Chinesische Malerei im Kundaikwan Sayūchōki.* Ostasiatische Zeitschrift I, 1912.

Otto Kümmel, *Chinesische Gemälde in China und Japan.* Ostasiatische Zeitschrift VII, 19.

Otto Kümmel, *Zur Chinesischen Künstlergeschichte.* Ostasiatische Zeitschrift XV, 1929.

Li Ê, *Nan Sung Yüan Hua Lu* [Record of Southern Sung Academy Painting], 1721.

Lu Tsun, *Sung Yüan I Lai Hua Jên Hsing Shih Lu* (Dictionary of Painters from the 11th to the 18th century). 1829.

Mao Chin, *Chin Tai Pi Shu.* [Collection of Reprints on Painting], c.1600.

Benjamin March, *Some Technical Terms of Chinese Painting.* Baltimore, 1935.

Benjamin March, *Linear Perspective in Chinese Painting.* [Eastern Art III.] Philadelphia, 1931.

P'ei Wên Chai Shu Hua P'u. [Encyclopedia of Writings and Paintings.] 1708.

P'êng Yün-ts'an, *Hua Shih Hui Chuan.* [Dictionary of c. 7500 Painters.]. 1825.

R. Petrucci, *La Philosophie de la Nature dans l'Art d'Extrême Orient,* 1911.

R. Petrucci, *Morceaux Choisis d'Esthétique Chinoise.* Ostasiatische Zeitschrift I, 1912/13.

R. Petrucci, *Les Peintres Chinois.* 1913. English translation, 1922.

R. Petrucci, *Encyclopédie de la Peinture Chinoise.* 1918.

A. v. Rosthorn, *Malerei und Kunstkritik in China.* Wiener Beiträge IV, 1930.

R. Saitō, *Biographical Dictionary of Chinese Painters.* 4 vols. Tōkyō, 1900. (In Japanese.)

A. Salmony, *Chinesische Landschaftsmalerei.* 1921.

Osvald Sirén, *Chinese Paintings in American Collections.* 1927/28.

Osvald Sirén, *A History of Early Chinese Painting.* 2 vols., 1933.

Osvald Sirén, *The Chinese on the Art of Painting. Translations and Comments.* Peiping, 1936.

Osvald Sirén, *A History of Later Chinese Painting.* 2 vols. 1938.

Osvald Sirén, *An Important Treatise of Painting from the Beginning of the 18th Century.* T'oung Pao, 1938.

Ssŭ T'ung Ku Chai Lun Hua Chi K'an [Collection of Reprints on Painting]. 1908.

Sun Ta-kung, *Chung Kuo Hua Chia Jên Ming Ta Tz'ŭ Tien* [Biographical Dictionary of Chinese Painters]. Shanghai, 1934.

Seiichi Taki, *Three Essays on Oriental Painting.* 1910.

Têng Shih, *Mei Shu Ts'ung Shu* [Collection of c. 200 Essays on Painting). Shanghai, 1910 ff.

K. Tomita, *Brush-strokes in Far Eastern Painting.* Eastern Art III. Philadelphia, 1931.

Arthur Waley, *Chinese Philosophy of Art.* [The Burlington Magazine XXXVII, XXXVIII, 1920/21.]

Arthur Waley, *An Index of Chinese Artists.* 1922. Additions of W. Speiser in Ostasiatische Zeitschrift, 1931 and 1938.

Arthur Waley, *An Introduction to the Study of Chinese Painting.* 1923.

Wang Fang-chuen, *Chinese Free-hand Flower Painting.* Peiping, 1936.

Wang Shih-chêng, *Wang Shih Hua Yüan* [Collection of Writings and Paintings of the Wang Family]. 1590.

Yukiō Yashirō, *Connoisseurship in Chinese Painting.* [The Journal of the Royal Society of Arts, 1936.]

Yü Shao-sung, *Shu Hua Shu Lu Chieh T'i* (Bibliography of Books on Painting and Calligraphy). 1931.

SUBJECTS OF CHINESE ART

Asiatic Mythology (Buddhist Mythology in Central Asia by J. Hackin; The Mythology of Modern China by Henri Maspero). 1932.

Henri F. Doré, *Recherches sur les Superstitions en Chine.* Shanghai, 1911-29.

Alice Getty, *The Gods of Northern Buddhism.* 1914.

Ferdinand Lessing, *Über die Symbolsprache in der Chinesischen Kunst.* Sinica, 1934/35.

R. Saitō, *Gwadai Jiten* (Dictionary of Subjects). Tōkyō, 1925. 5 vols.

V.-F. Weber, *Kō-ji-hō-ten.* Dictionnaire à l'Usage des Amateurs et Collectionneurs, 1923.

E. T. C. Werner, *A Dictionary of Chinese Mythology,* 1932.

E. T. C. Werner, *Myths and Legends of China.* 1922.

C. H. S. Williams, *Outlines of Chinese Symbolism.* Peiping, 1931.

BOOKS OF REPRODUCTIONS (cf.n.30)

M. Akiyama, *Sōgen Meigwa Shū* (Collection of Famous Paintings of the Sung and Yüan Dynasties). Tōkyō, 1930.

Bijutsu Kenkyū. Tōkyō, 1932 ff.

Bijutsu Shuei. 25 vols. Tōkyō, 1911 ff.

Laurence Binyon, *Chinese Paintings in English Collections*. Paris, 1927.

Chung Kuo Ming Hua Chi (Famous Chinese Paintings). Shanghai, 1909 ff.

Laurence Binyon, *The George Eumorfopoulos Collection, Catalogue of the Chinese, Corean and Siamese Paintings*. 1928.

E. Chavannes et R. Petrucci, *La Peinture Chinoise au Musée Cernuschi*. Ars Asiatica I, 1914.

The Chinese Exhibition. A Commemorative Catalogue of the International Exhibition of Chinese Art. Royal Academy of Arts, November 1935-March 1936.

Louise Wallace Hackney and Yau Chang-foo, *A Study of Chinese Painting in the Collection of Ada Small Moore*. 1940.

Illustrated Catalogue of Chinese Government Exhibits for the International Exhibition of Chinese Art in London. Vol. III. Painting and Calligraphy.

The Kokka (A monthly Journal of Oriental Art). Tōkyō, 1889 ff.

F. S. Kwen, *Descriptive Catalogue of Ancient and Genuine Chinese Paintings*. Privately printed by Lai-Yuan & Co., Shanghai.

Ku Kung (a Journal published by the Palace Museum, Peiping). 1929-1936.

Ku Kung Chou K'an (a Journal of Chinese Art). 1930-1936.

Ku Kung Shu Hua Chi (Collection of Calligraphies and Paintings in the Palace Museum). Vol. I-XLV. Peiping 1930 ff.

Kukwa Inshitsu Kwanzō Gwaraku (Collection of Mr. Kuwana). Kyōto, 1920.

Otto Kümmel, *Chinesische Kunst* (Ausstellung Chinesischer Kunst, Berlin, 1929). 1930.

B. Laufer, *T'ang, Sung and Yüan Paintings belonging to various Chinese Collections*. Paris, 1924.

Liang Chang-chü, *Illustrated Catalogue of Famous Paintings from the great Collection of the celebrated Connoisseur of Art Liang Chang-chü of Foochow*. Compiled in 1837. Translated into English in 1919.

Ming Jên Shu Hua (Paintings of famous Painters). No. 1-26. Shanghai, 1920-1925.

Nanjū Meigwaen (Southern School). 25 vols. Tōkyō, 1904 ff.

Shên Chou Kuo Kuang Chi (a Journal of Chinese Art). Shanghai, 1908 ff.

Shimbi Taikwan (Selected Relics of Japanese and Chinese Art). 20 vols. Kyōto, 1899 ff.

Shina Meigwa Hōkan (The Pageant of Chinese Painting). Tōkyō, 1936.

Shina Nangwa Taikwan (Southern School). Tōkyō, 1926.

Osvald Sirén, *Early Chinese Paintings from the A. W. Bahr Collection*. 1938.

Sōraikwan Kinshō (Catalogue of the Abe Collection). 3 vols. Ōsaka, 1930 ff.

E. A. Strehlneck, *Chinese Pictorial Art*. Shanghai, 1914.

K. Tomita, *Portfolio of Chinese Paintings in the Museum of Fine Arts* (Han to Sung periods). Boston, 1933.

Tōsō Gemmin Meigwa Taikwan (Exhibition of Chinese Painting, Tōkyō, 1928). 2 vols. Tōkyō, 1929.

Tōyō Bijutsu Taikwan (Masterpieces selected from the Fine Arts of the Far East). VII-XII. Tōkyō, 1908 ff.

Tschang Yi-Tchou et J. Hackin, *La Peinture Chinoise au Musée Guimet*. 1910.

E. A. Voretzsch, *Chinese Painting* (Shina Ga). 1932.

E. A. Voretzsch, *Führer durch eine Ausstellung Chinesischer Gemälde*. Kunst-Industrie Museum. Kristiania, 1919.

William Charles White, *An Album of Chinese Bamboos*. Toronto, 1939.

T. Yamamoto, *Chōkaidō Shōga Mōkuroku* (Catalogue of Paintings and Calligraphies in the Collection of the Editor). 12 vols., 1937.

Yuchikusai Zō Shinroku Taikagwafu (Collection of Mr. R. Ueno). Ōsaka, 1920.

INDEX

CHINESE DYNASTIES

Shang-Yin Dynasty	*? 1766-? 1122 B.C*
Chou Dynasty	*?1122-221*
Warring States	*c. 481-221*
Ch'in Dynasty	*221-206*
Former (Western) Han Dynasty . . .	*206-A.D. 25*
Later (Eastern) Han Dynasty . . .	*A.D. 25-220*
The Six Dynasties	*220-589*
The Three Kingdoms	*221-280*
Period of Northern and Southern Dynasties .	*386-589*
Sui Dynasty	*581-618*
T'ang Dynasty	*618-906*
The Five Dynasties	*907-960*
Northern Sung Dynasty	*960-1127*
Southern Sung Dynasty	*1127-1279*
Yüan Dynasty	*1279-1368*
Ming Dynasty	*1368-1644*
Ch'ing Dynasty	*1644-1912*

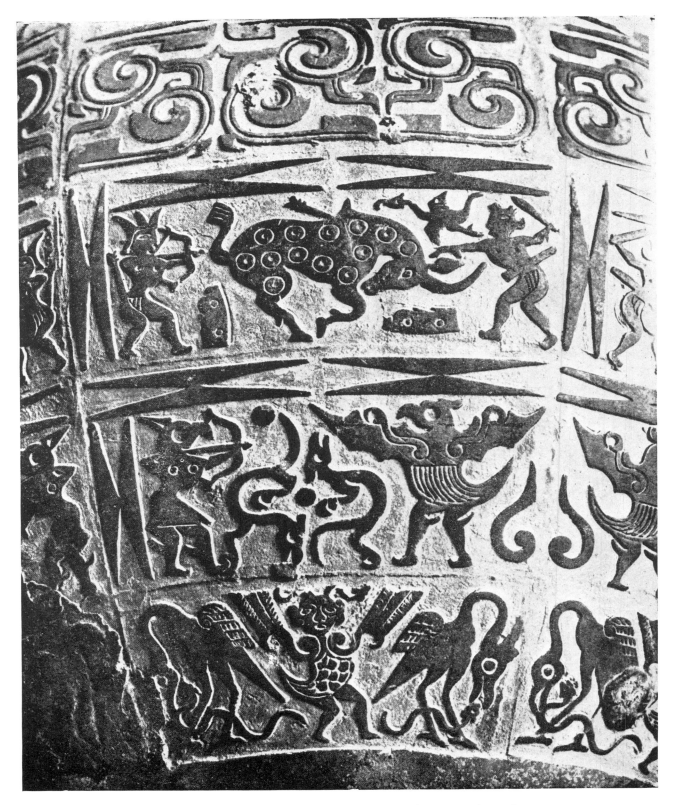

1. MAGIC HUNTING SCENES. Flat reliefs on a bronze vessel (Hu). Height of the Hu 38 cm.
5th-3rd century B.C. *Mr. C. T. Loo, New York.*

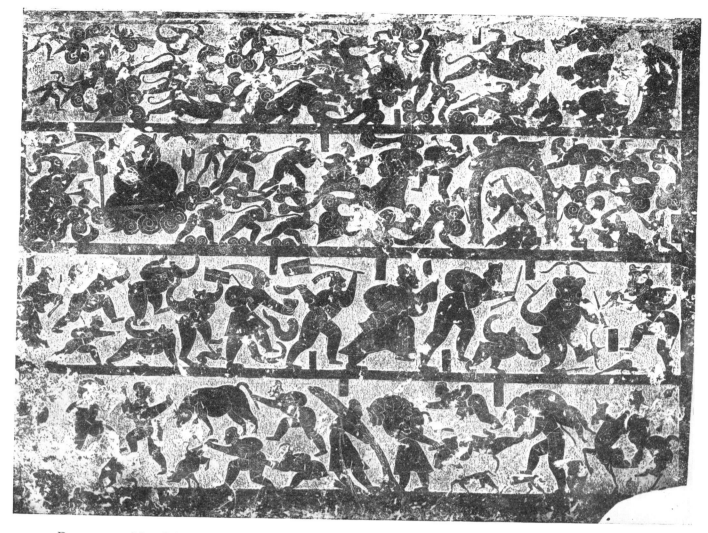

2. DEITIES AND MEN (MAGICIANS). Flat relief from a tomb-chamber of the Wu family. H.112 cm. W.141 cm. A.D. 147 to 167. *Wu-liang-tzʻŭ near Chia-hsiang-hsien (Shantung).*

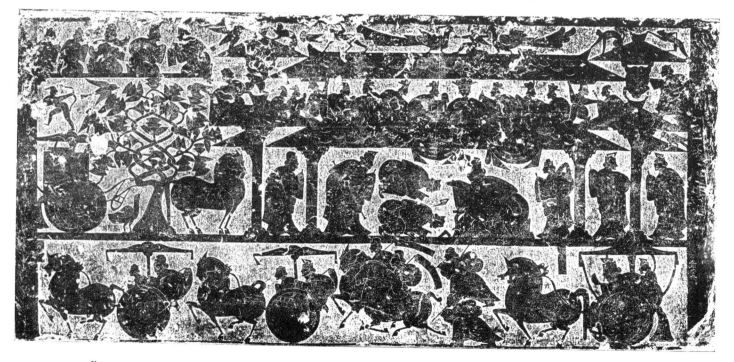

3. RECEPTION IN A HALL AND THE WONDER TREE. Flat relief from a tomb-chamber of the Wu family. H.70 cm. W.155 cm. A.D. 147 to 167. *Wu-liang-tzʻŭ near Chia-hsiang-hsien (Shantung).*

5

4-5. MALE FIGURES, perhaps SPECTATORS AT A FIGHT. Details of a painting in colour on hollow tiles.
H.19.5 cm. 2nd or 3rd century A.D. *Museum of Fine Arts, Boston.*

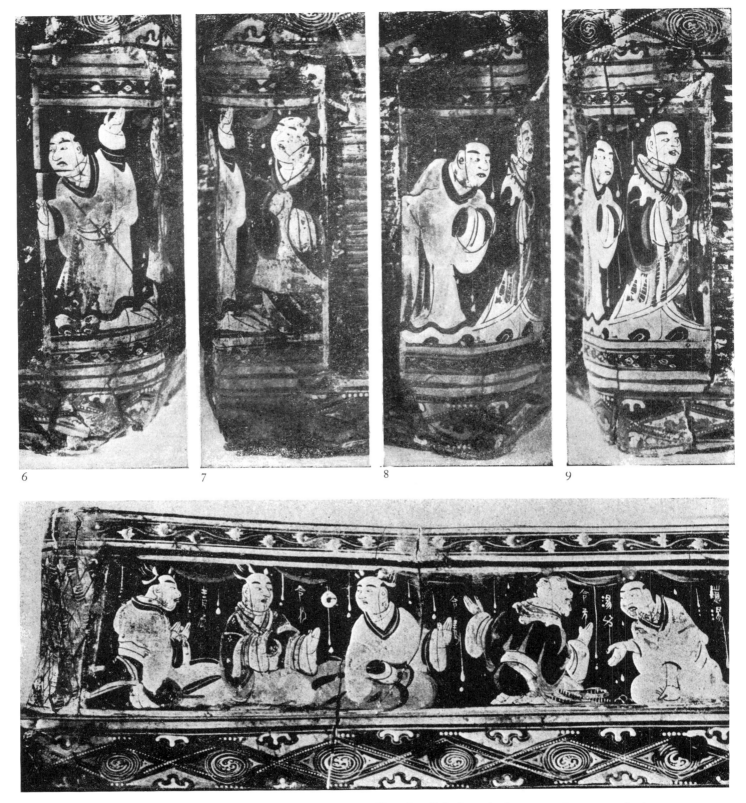

6-10. MALE FIGURES (PERSONS FAMOUS FOR FILIAL PIETY). Paintings in lacquer colour on a basket.
L. of the basket 39 cm. H. 22 cm. W. 18 cm. Unearthed in Korea. 2nd or 3rd century A.D. *Museum, Seoul.*

11

12

11-12. TWO OF THE ANIMALS OF THE FOUR CARDINAL POINTS: TORTOISE WITH SNAKE, DRAGON. Wall paintings from the tomb-chamber of Yang-wên (A.D. 545-559), *near Pyöng-yang* (*Korea*). Colour.

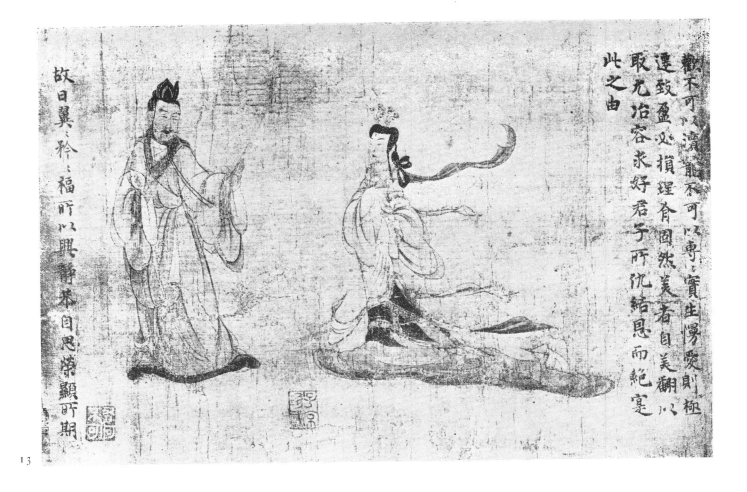

故曰翼翼矜矜福所以興靜恭未甞榮顯所期

歡不可以瀆寵不可以專實生慢愛則極遷致盈必損理有固然美者自美翻以取尤冶容求好君子所仇結恩而絕寔此之由

13

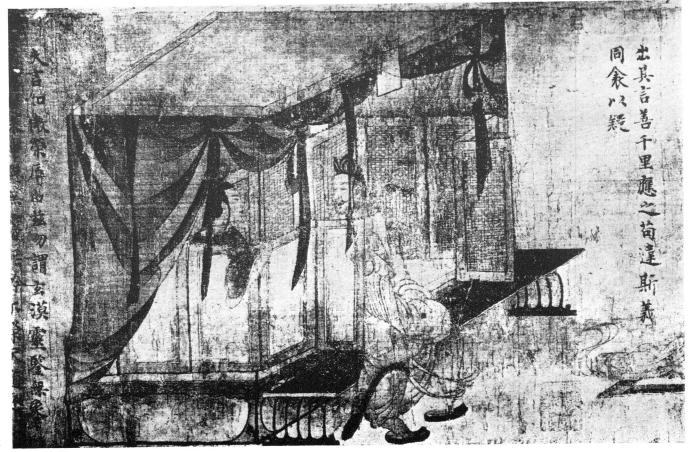

夫言如微榮辱尤甚勿謂玄漠靈監無象

出其言善千里應之苟違斯義同衾以疑

14

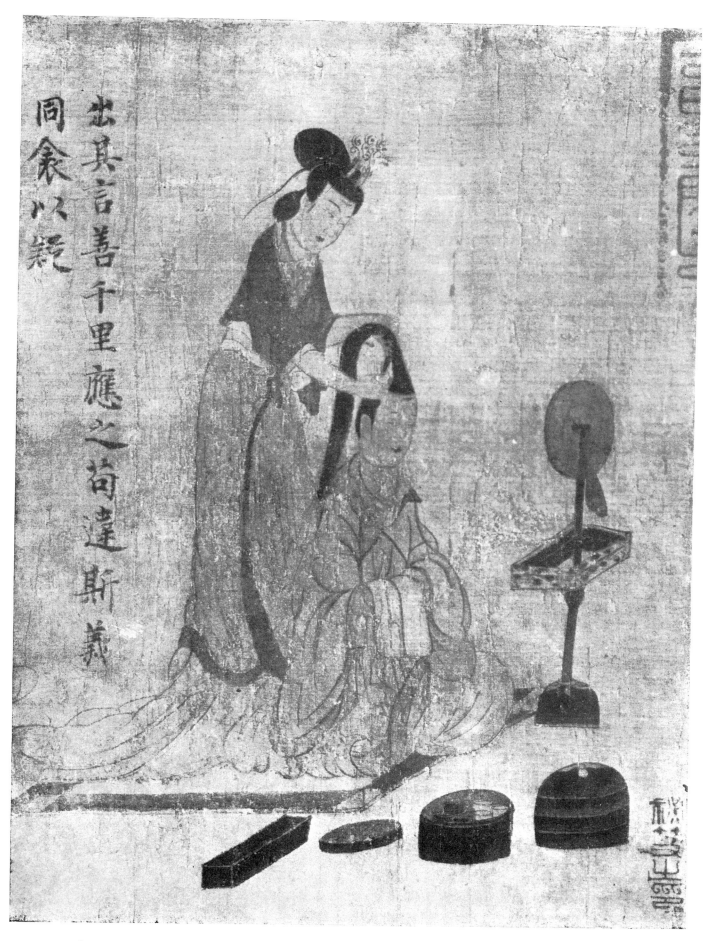

出其言善千里應之苟違斯義
同衾以疑

15

13-15. ATTRIBUTED TO KU K'AI-CHIH (4th century A.D.). THE ADMONITIONS OF THE IMPERIAL PRECEPTRESS.
Parts of a hand scroll (A LADY REPROACHED BY HER HUSBAND, BED-SCENE, TOILET-SCENE).
Ink and colour on silk. H.19.5 cm. L. 347 cm. *British Museum, London.*

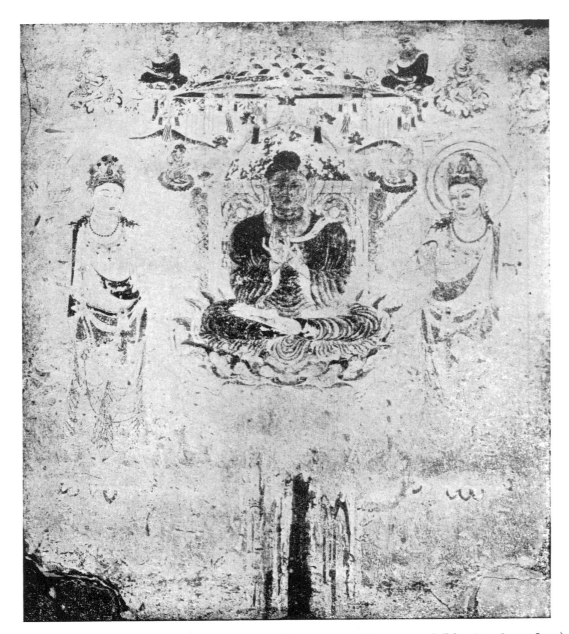

16. O-MI-T'O (AMITĀBHA) ACCOMPANIED BY THE BODHISATTVAS TA-SHIH-CHÊ (MAHĀSTHĀMAPRĀPTA) AND KUANYIN (AVALOKITESVARA). Wall painting in the Kondō of the Hōryūji (Japan). Colour. H.c.300 cm. 7th century A.D.

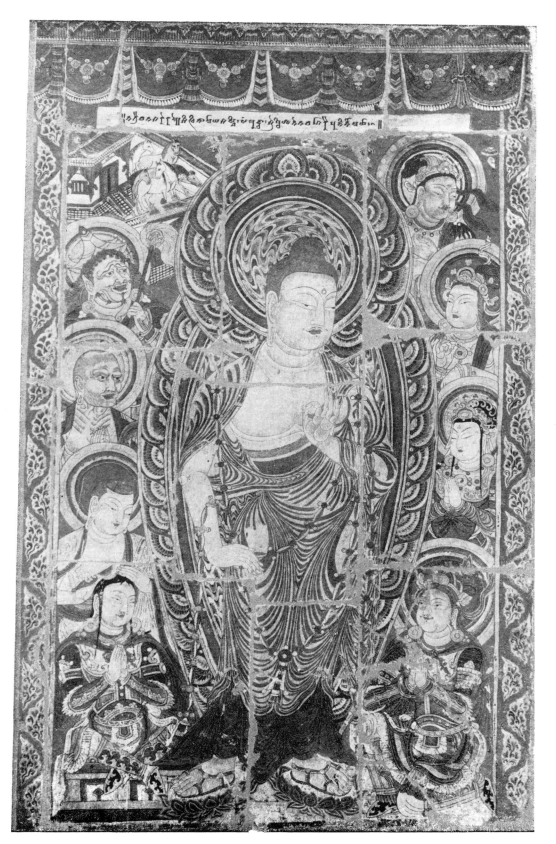

17. THE DĪPANKARA BUDDHA WITH EIGHT ATTENDANTS. Wall painting from a temple in Bäzäklik (Turfan, Central Asia). Colour. H.325 cm. W.200 cm. 8th or 9th century A.D. *Museum, Berlin.*

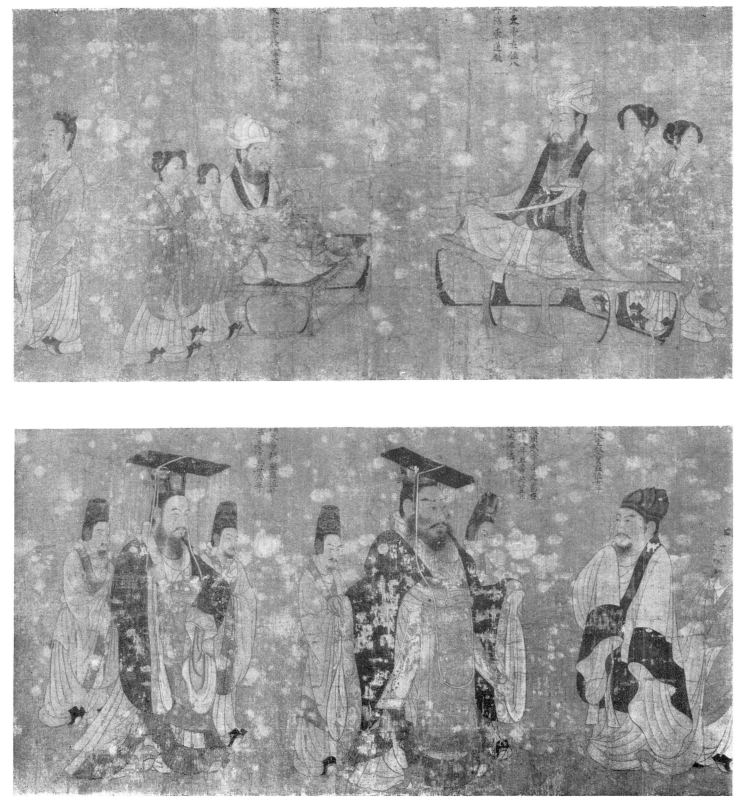

18

19

18-19. ATTRIBUTED TO YEN LI-PÊN (d. A.D. 673). PORTRAITS OF THE EMPERORS. Parts of a hand scroll.
Colour on silk. H.51 cm. L.531 cm. *Museum of Fine Arts, Boston.*

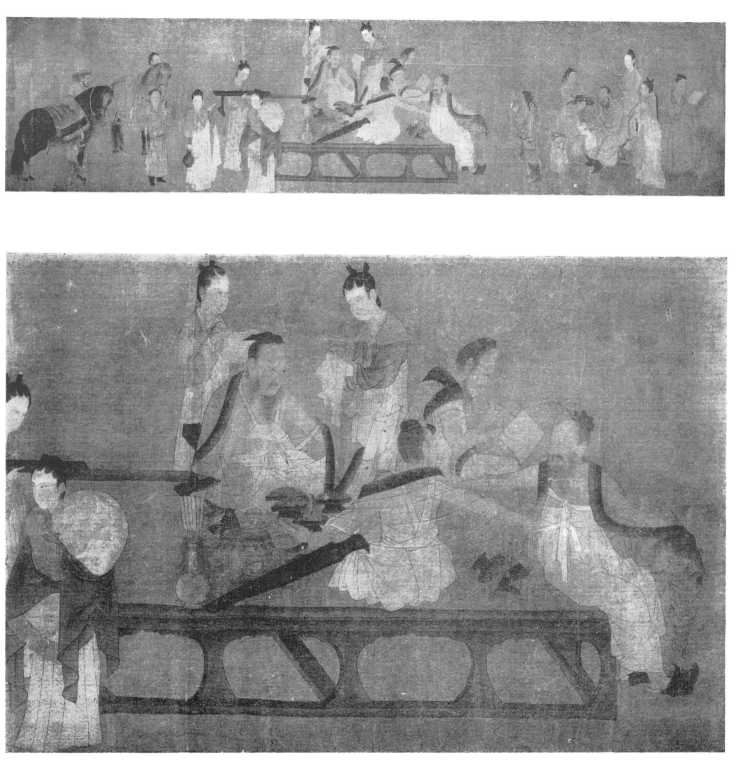

20-21. AFTER YEN LI-PÊN (d. A.D. 673). SCHOLARS OF THE NORTHERN CH'I DYNASTY COLLATING CLASSIC TEXTS.
Hand scroll. Ink and slight colour on silk. H.27 cm. L.114 cm. (21: Detail of 20)
Museum of Fine Arts, Boston.

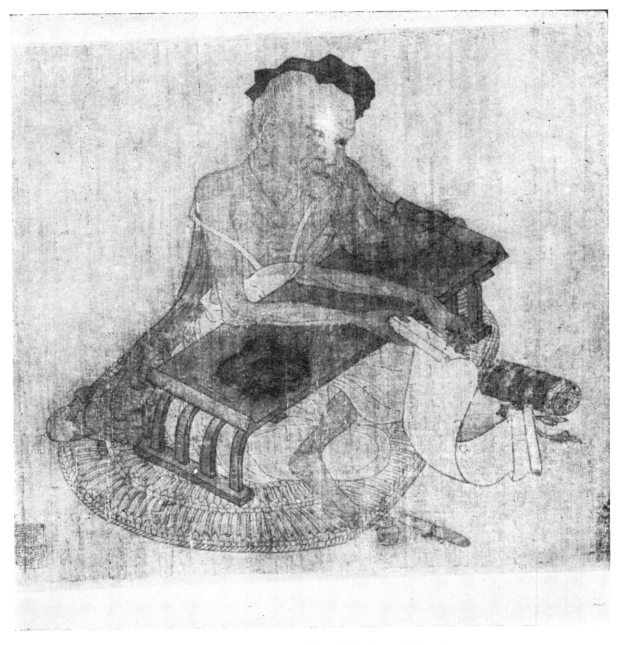

22. ATTRIBUTED TO WANG WEI (A.D. 698-759).
THE SCHOLAR FU SHÊNG (3rd century B.C.) ENGAGED IN RESTORING THE TEXT OF THE SHU CHING.
Ink and slight colour on silk. H.25 cm. W.44 cm. *Private Collection, Japan.*

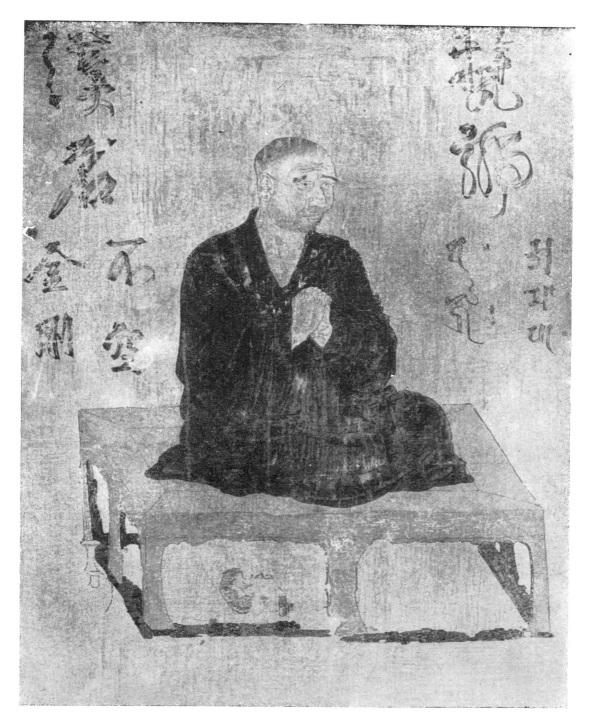

23. Li Chên (c. a.d. 800). The Indian Priest Pu-k'ung (Amoghavajra, d. a.d. 774).
Colour on silk. H.212 cm. W.152 cm. *Tōji, Kyōto.*

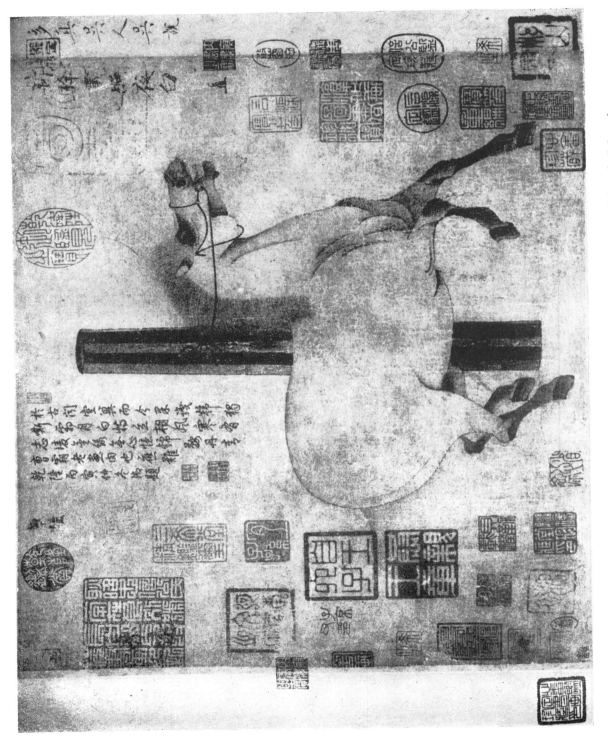

24.　ATTRIBUTED TO HAN KAN (c. A.D. 720–780).　HORSE BOUND TO A STAKE.　Ink and slight colour.
H.30 cm.　W.35 cm.　*Sir Percival David, Bt., London.*

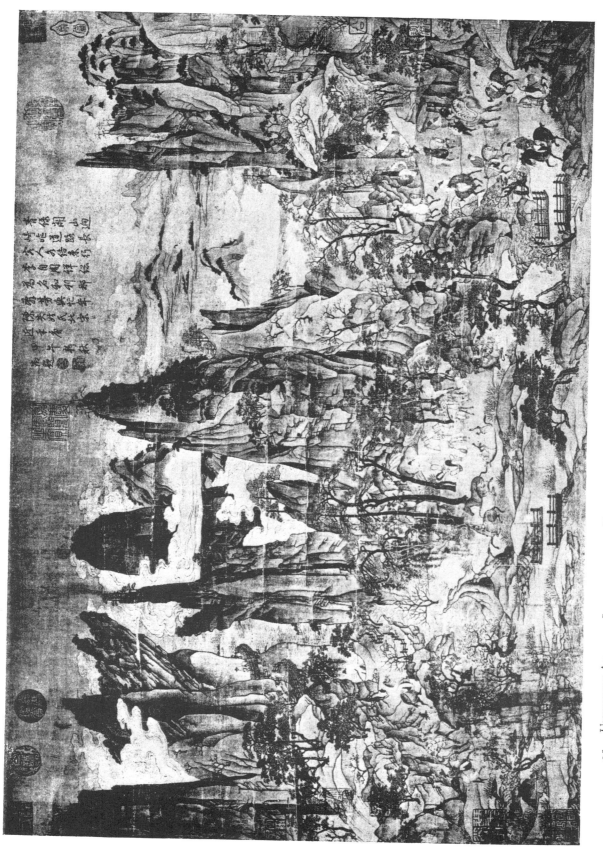

25. UNKNOWN ARTIST. LANDSCAPE WITH TRAVELLERS. Colour and ink on paper. 8th century A.D. *Chinese Government.*

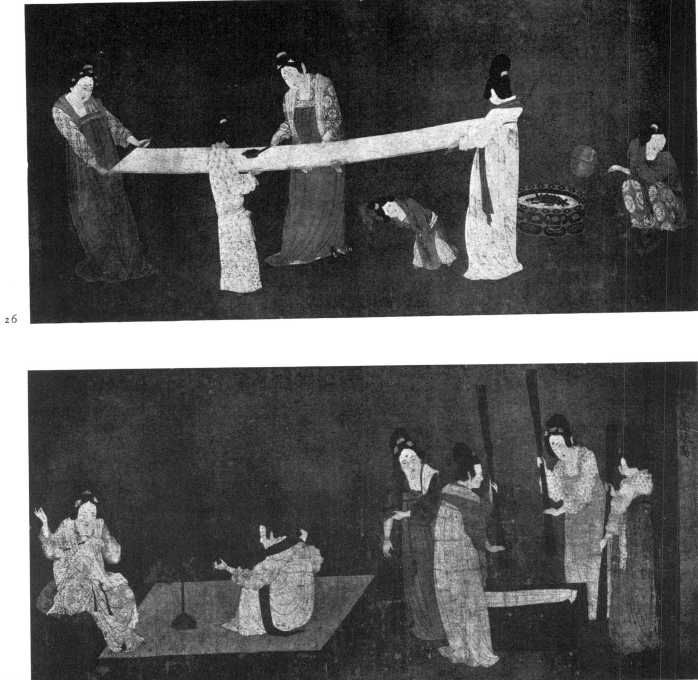

26

27

26-27. COPY POSSIBLY AFTER CHANG HSÜAN (active c. A.D. 713-742). Attributed to Emperor Hui Tsung (A.D. 1082-1135).
LADIES PREPARING NEWLY-WOVEN SILK. Hand scroll. Colour on silk. H.37 cm. L.145 cm.
Museum of Fine Arts, Boston.

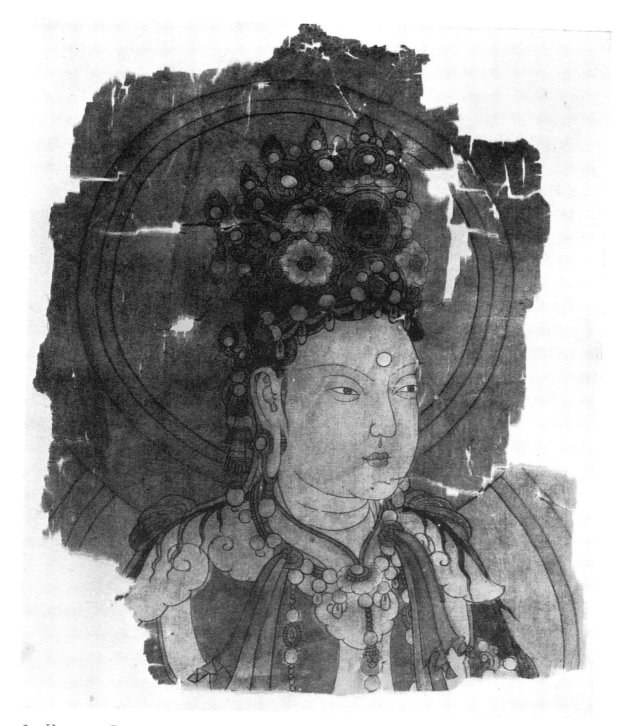

28. HEAD OF A BODHISATTVA. From Turfan (Central Asia). Colour on silk. H.30 cm. W.25 cm.
Fragment. 8th-9th century A.D. *Museum, Berlin.*

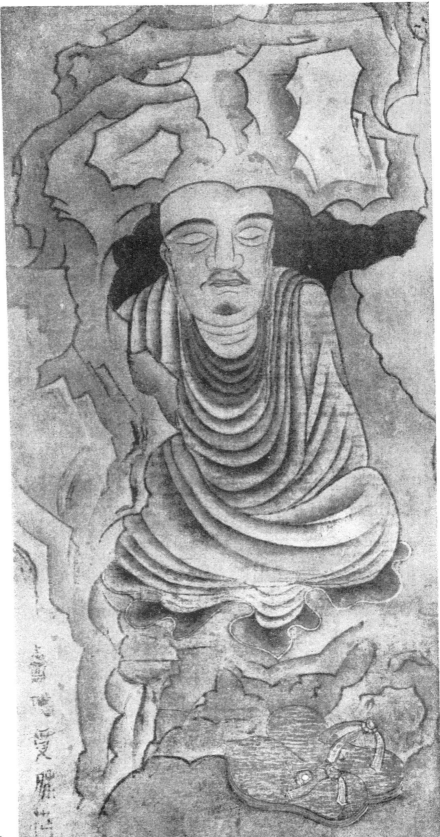

29

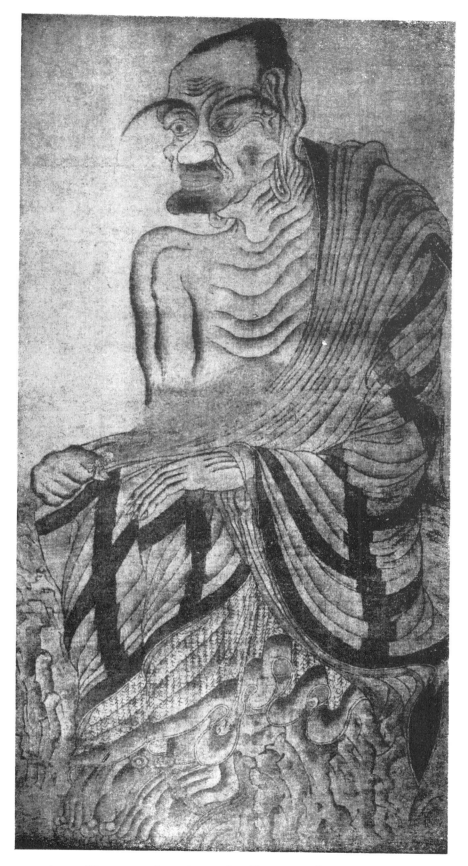

30

29-30. AFTER KUAN-HSIU (A.D. 832-912). TWO OF A SET OF SIXTEEN LOHANS.
Colour on silk. H.127 cm. W.67 cm. *Museum, Tōkyō.*

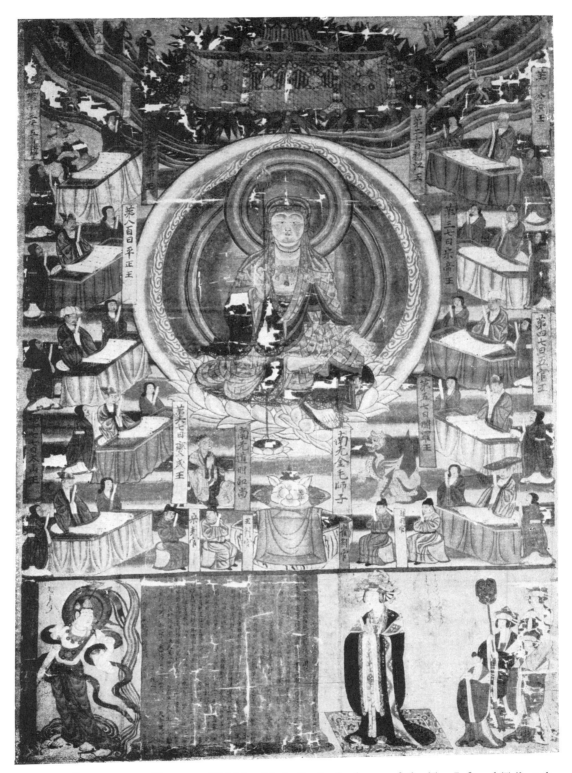

31. THE BODHISATTVA TI-TSANG (Kshitigarbha). In the background the Ten Infernal Tribunals.
Below Kuanyin and a noble Donor with Attendants. Colour on silk. H.228 cm. W.158 cm.
From Tun Huang. Dated A.D. 983 *Musée Guimet, Paris.*

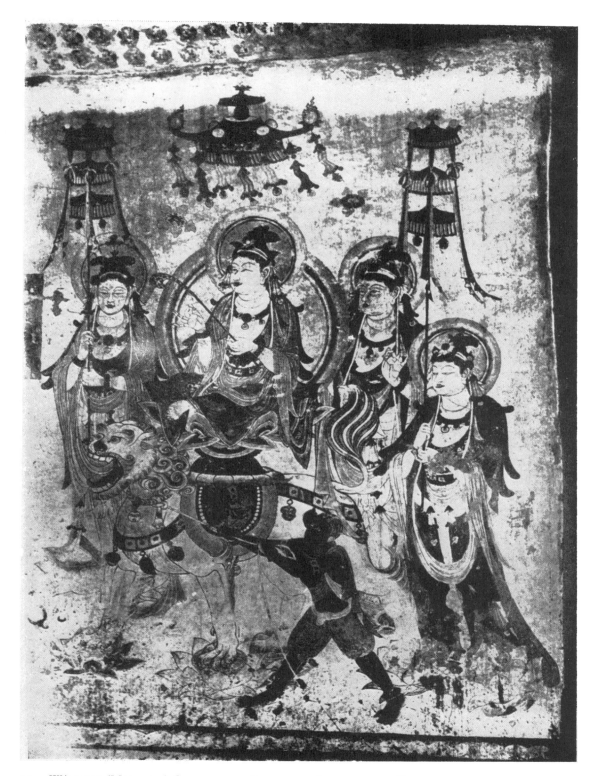

32. WÊN-SHU (MANJUSRI) SEATED ON A LION, AND ATTENDANTS. Fresco on the South Wall of the Main Chapel at Wan Fo-hsia near Tun Huang. Colour. H.300 cm. 9th century A.D.

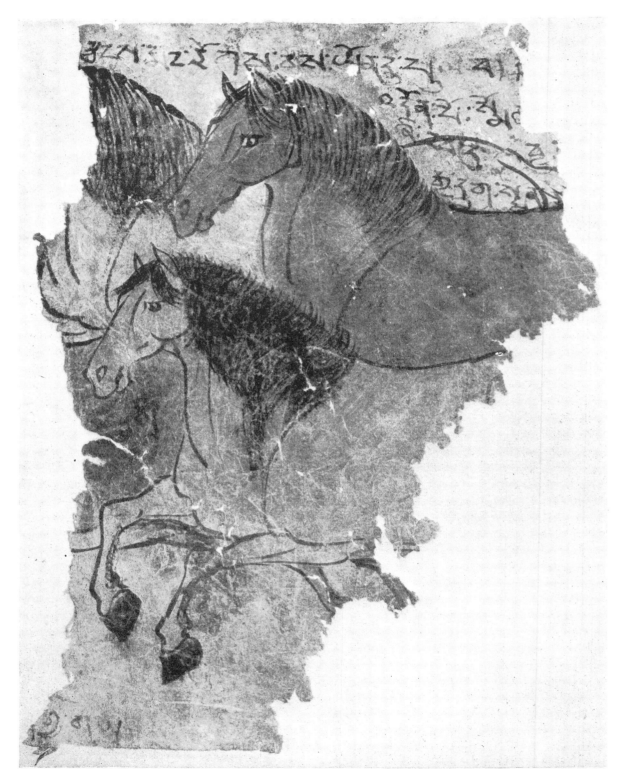

33. HORSES. Fragment from Tun Huang. Colour. H.28 cm. W.20 cm. 9th or 10th century A.D. *Government of India.*

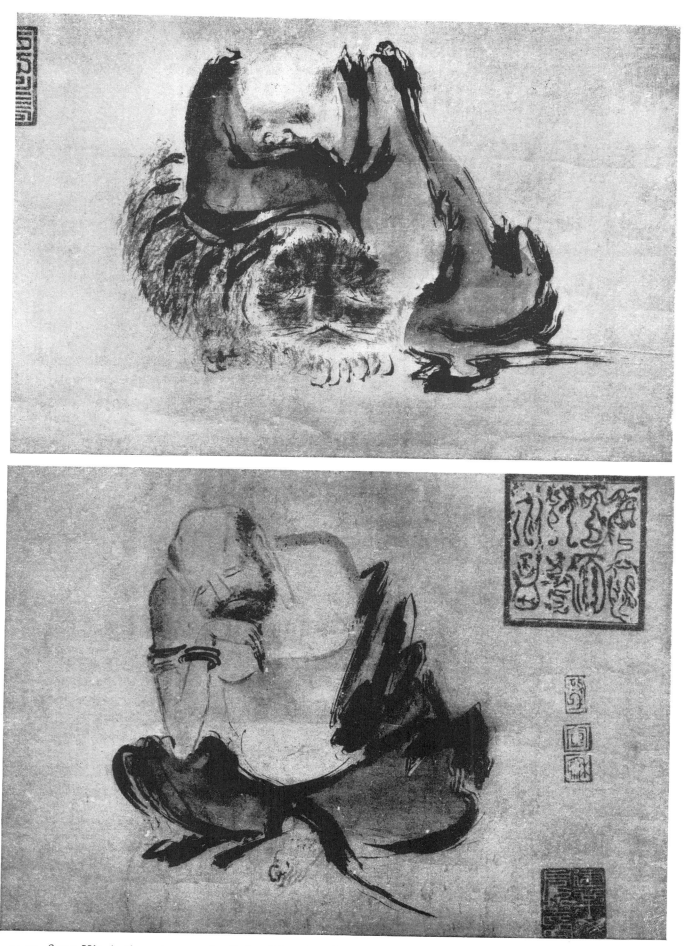

34

35

34-35. Shih K'o (10th century a.d.). Ch'an Monks in Meditation. Ink on paper. W.64 cm. *Shōhōji, Kyōto.*

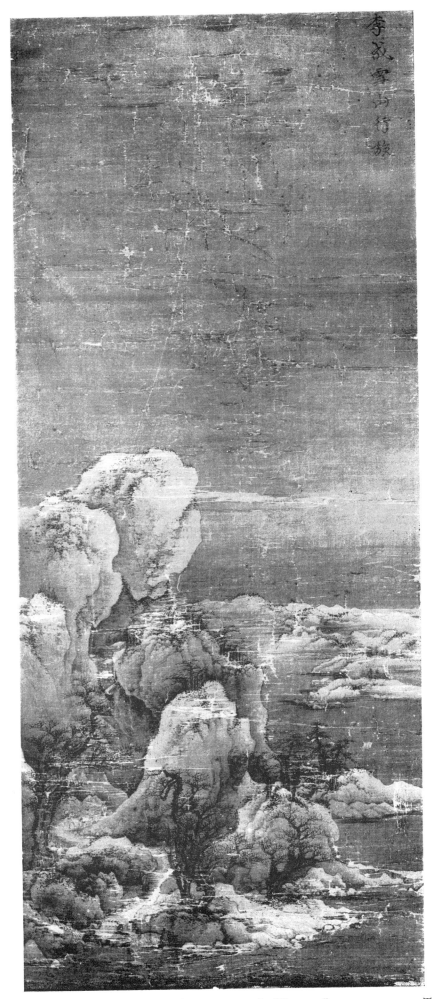

李成雪山行旅

36. ATTRIBUTED TO LI CH'ÊNG (late 10th century A.D.). WINTER LANDSCAPE WITH TRAVELLERS.
Ink and slight colour on silk. H.93 cm. W.37 cm. *Museum of Fine Arts, Boston.*

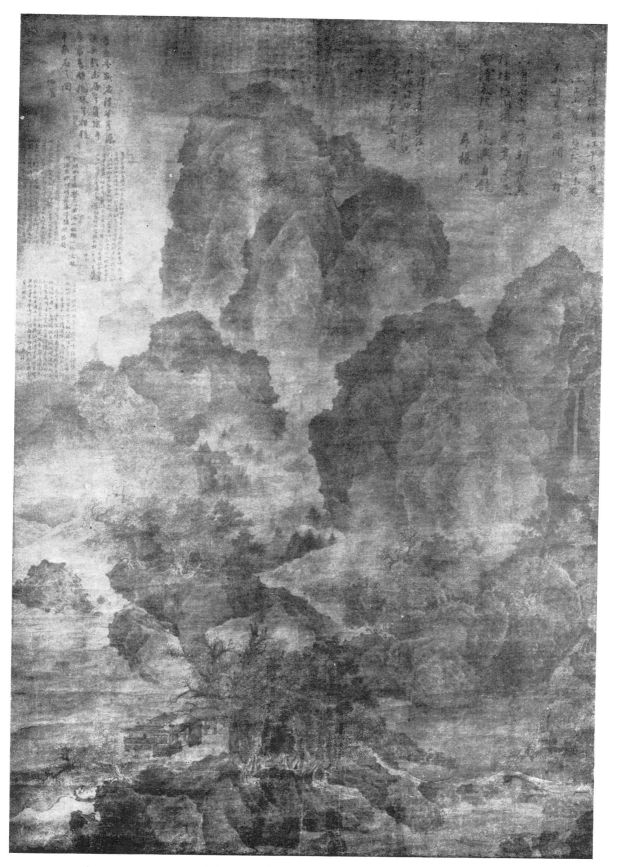

37. ATTRIBUTED TO FAN K'UAN (active c. A.D. 990-1030). LANDSCAPE. Ink on silk.
H.156 cm. W.106 cm. *Chinese Government.*

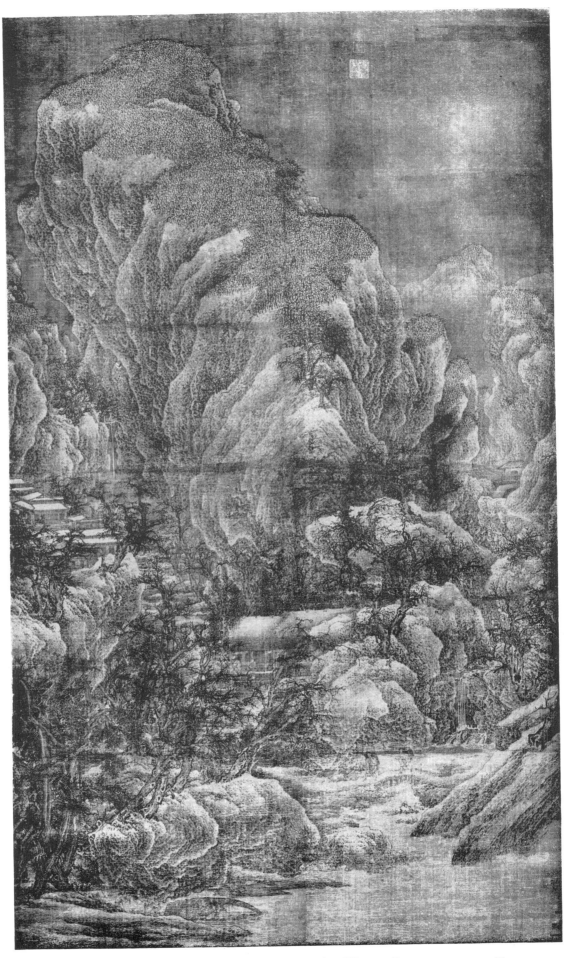

38.　ATTRIBUTED TO FAN K'UAN (active A.D. c.990-1030).　WINTER LANDSCAPE WITH TRAVELLERS.
Ink on silk.　H.182 cm.　W.103 cm.　*Museum of Fine Arts, Boston.*

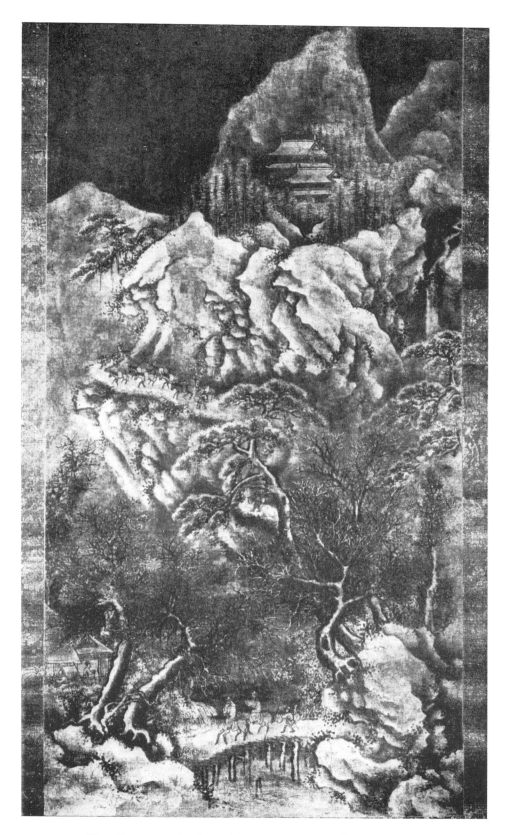

39. Hsü Tao-ning (early 11th century A.D.). Winter Landscape.
Ink on paper. H.165 cm. W.88 cm. *Private Collection, Japan.*

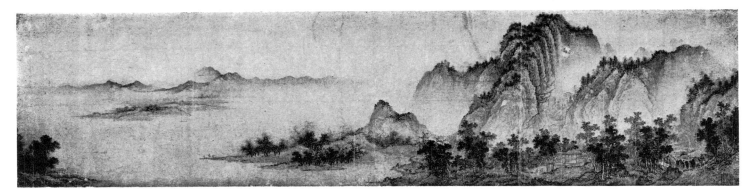

40. TUNG YÜAN (active c. A.D. 1000). RIVER LANDSCAPE. Part of a hand scroll. Ink and slight colour on paper.
H.37 cm. L.151 cm. *Museum of Fine Arts, Boston.*

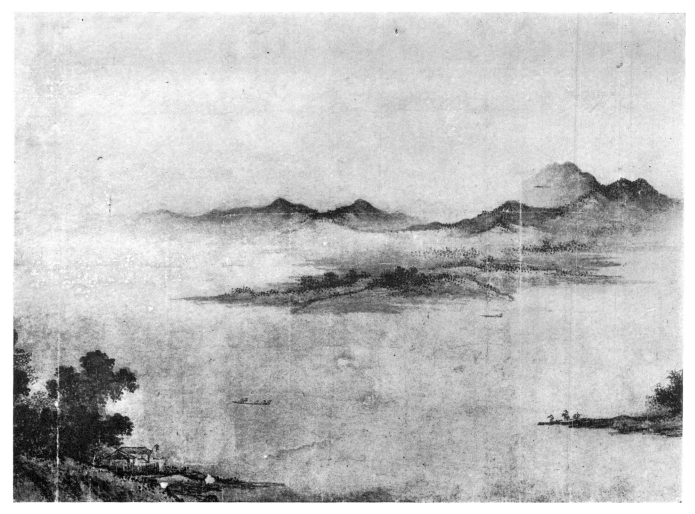

41. Detail of 40.

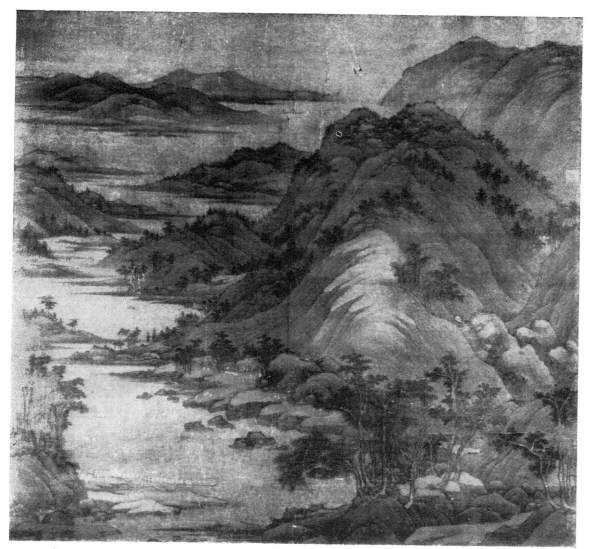

42. ATTRIBUTED TO TUNG YÜAN (active c. A.D. 1000). LANDSCAPE. Colour on silk. H. 156 cm. W.160 cm. *Chinese Government*.

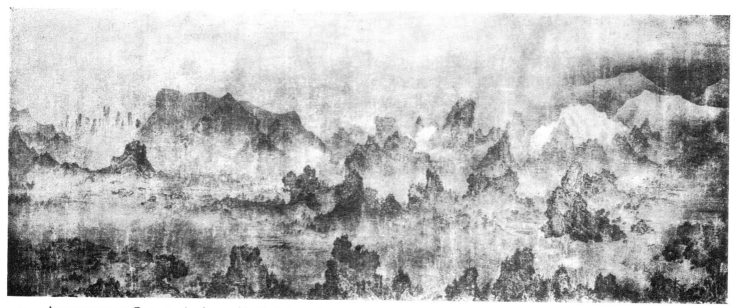

43. ATTRIBUTED TO CHÜ-JAN (active 2nd half of the 10th century A.D.). RIVER LANDSCAPE (YANGTZE). Part of a hand scroll. Ink on silk. H.43 cm. L.156 cm. *Freer Gallery, Washington*.

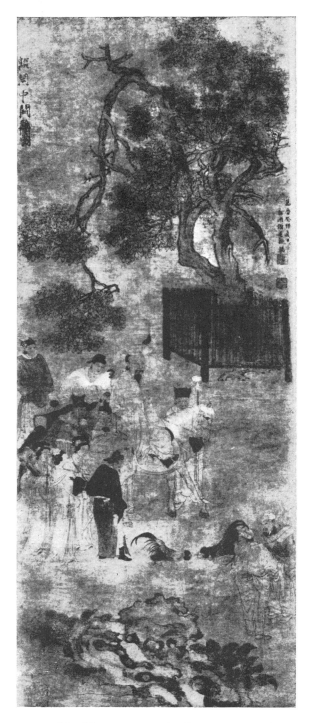

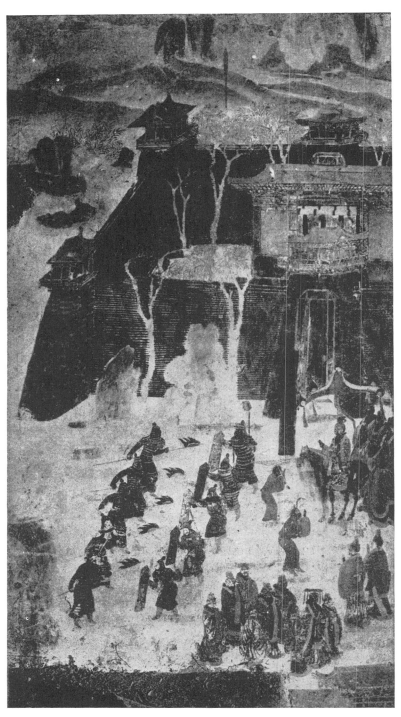

44. Ku Hung-chung (10th century A.D.).
Cock Fight. Colour on paper.
Private Collection, China.

45. Threatening Fight outside of Kusinagara.
Fresco in cave 70 of Tun Huang. Colour.
9th-10th century A.D.

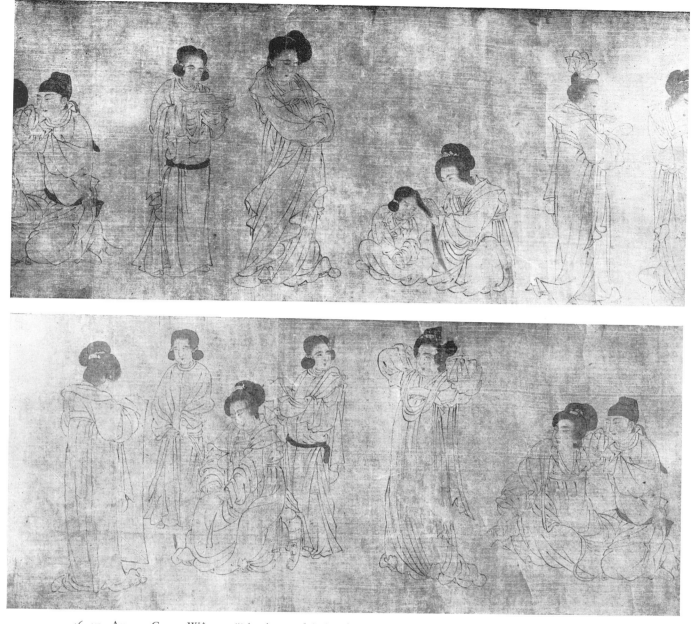

46-47. After Chou Wên-chü (active 2nd half of the 10th century A.D.). Ladies in the Palace.
Parts of a hand scroll. Ink and slight colour on silk. H.26 cm. L.167 cm. *Sir Percival David, Bt., London.*

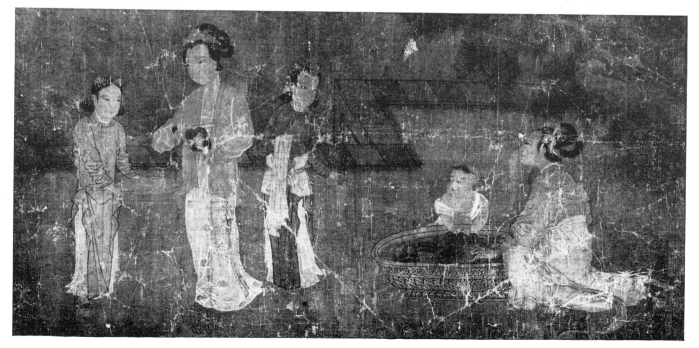

48. After Chou Wên-chü (active 2nd half of the 10th century A.D.). Ladies and Children on a Terrace.
Part of a hand scroll. Colour on silk. H.26 cm. *British Museum, London.*

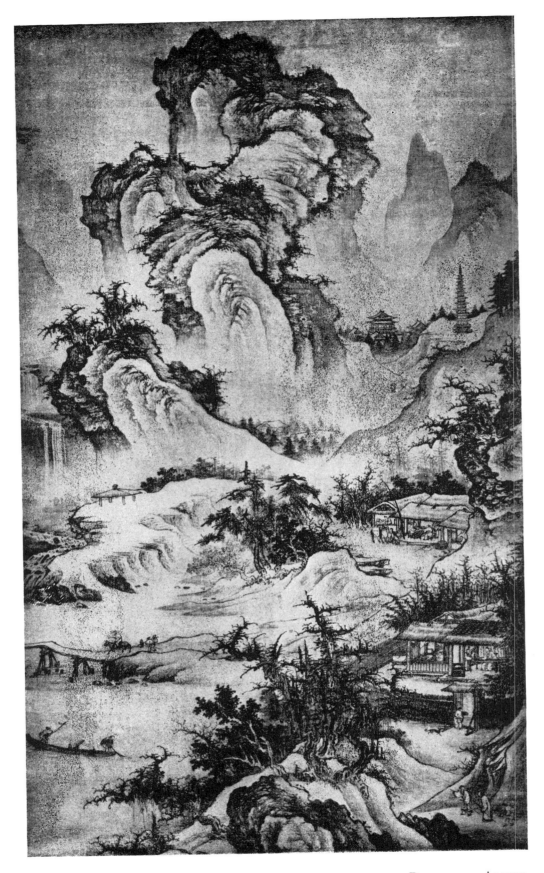

49. ATTRIBUTED TO KUO HSI (C. A.D. 1020-1090). LANDSCAPE WITH A PAGODA AND ABODES. Ink on silk. H.179 cm. W.51 cm. *Chinese Government*.

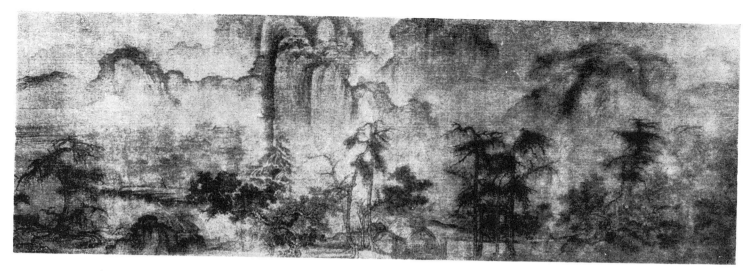

50. ATTRIBUTED TO KUO HSI (c. A.D. 1020-1090). RIVER LANDSCAPE (HUANG HO?). Part of a hand scroll.
Ink and slight colour on silk. H.26 cm. L. 206 cm. *Freer Gallery, Washington.*

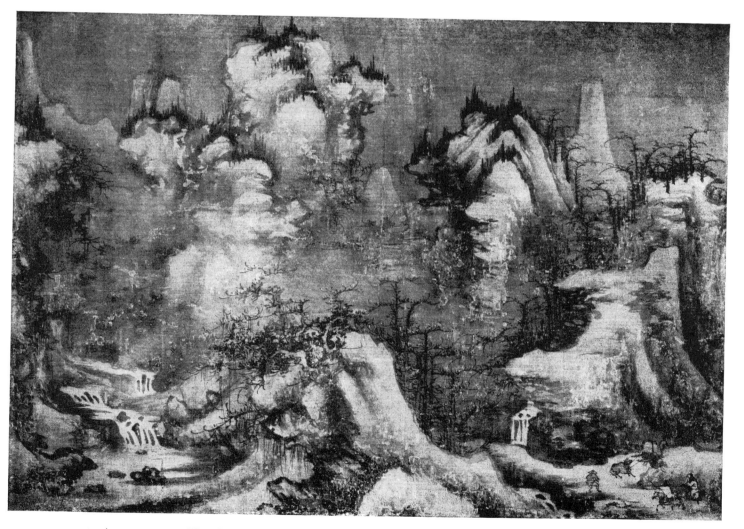

51. ATTRIBUTED TO KUO HSI (c. A.D. 1020-1090). WINTER LANDSCAPE. Part of a hand scroll. Ink on silk.
H.53 cm. L.475. cm. *Toledo Museum of Art, Toledo, Ohio.*

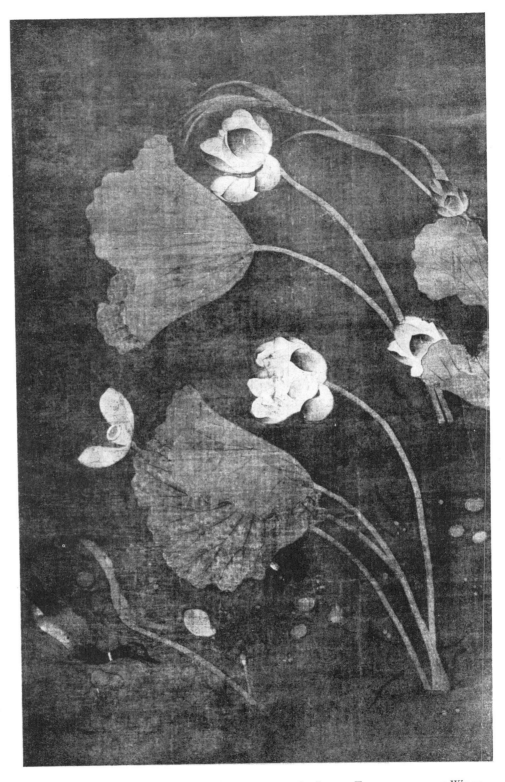

52. ATTRIBUTED TO HSÜ HSI (10th century A.D.). LOTUS FLOWERS IN THE WIND.
One of a pair of paintings. Colour on silk. H. c.100 cm. *Chionin, Kyōto.*

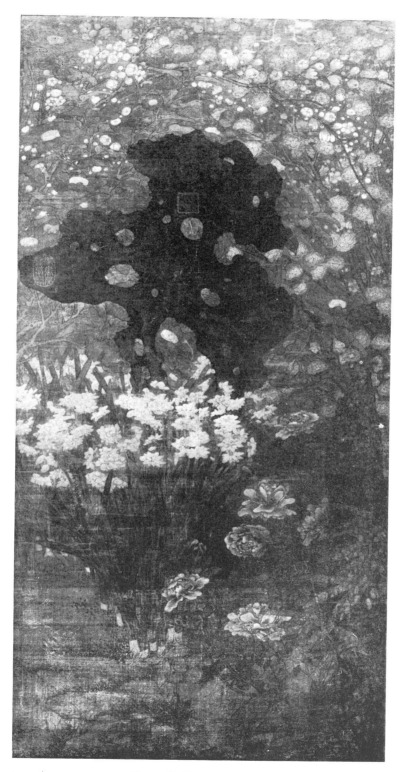

53. ATTRIBUTED TO CHAO CH'ANG (active c. A.D. 1000). FLOWERS.
Colour on silk. H.104 cm. W.51 cm. *Chinese Government*.

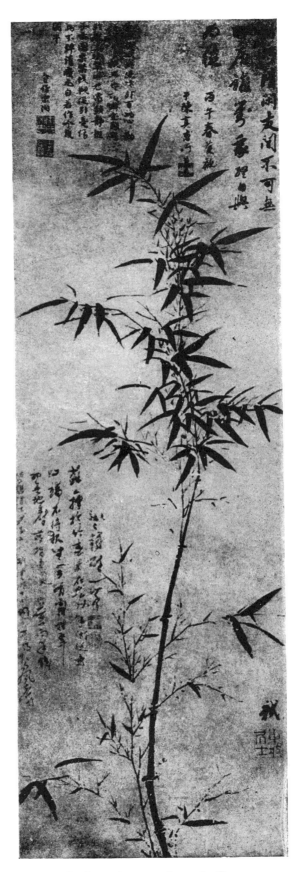

54. SU SHIH (A.D. 1036-1101). BAMBOO.
Ink on paper. *Private Collection, China.*

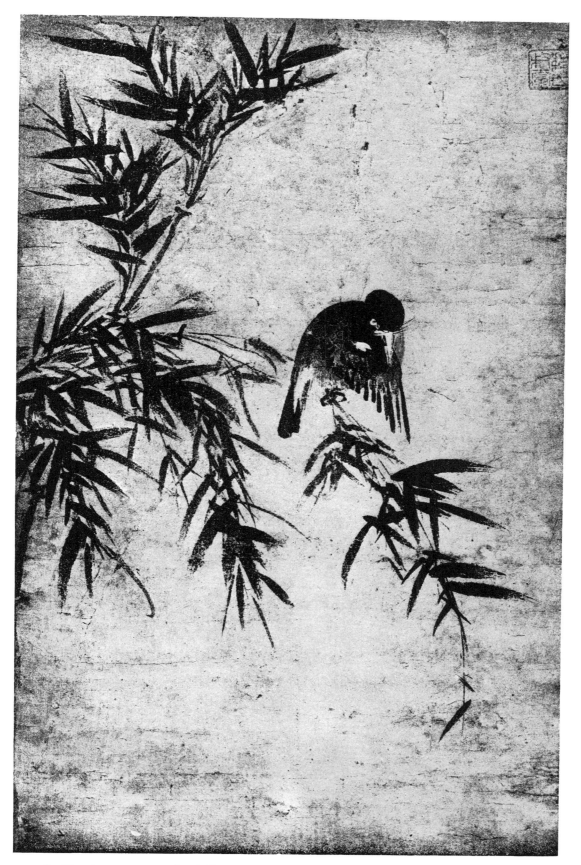

55. Su Kuo (A.D. 1072-1123). A Bird on a Bamboo Stalk. Ink on paper. H.47 cm. W.29 cm.
Private Collection, Japan.

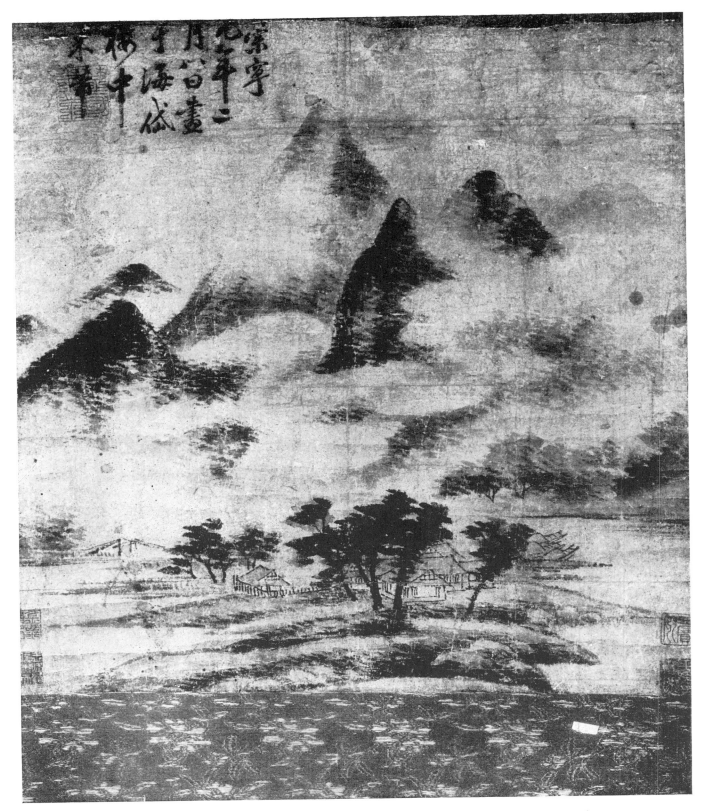

56. MI FEI (A.D. 1051-1107). LANDSCAPE. Ink on paper. H.51 cm. W.49 cm. Dated 1102.
Private Collection, Japan.

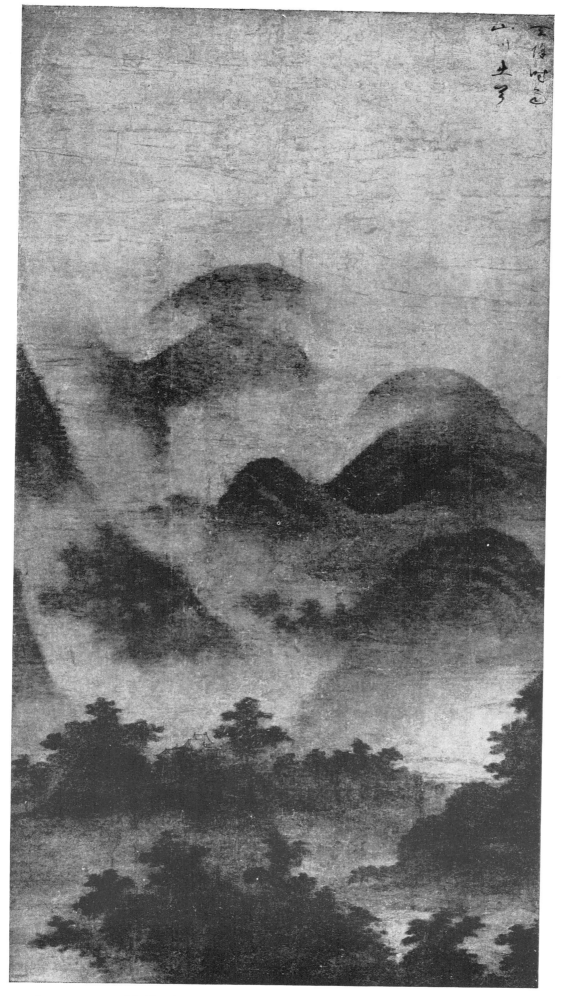

山川土了　雲傅嶺色

57. ATTRIBUTED TO MI FEI (A.D. 1051-1107). LANDSCAPE. Ink on silk. H.150 cm. W.78 cm.
Freer Gallery of Art, Washington.

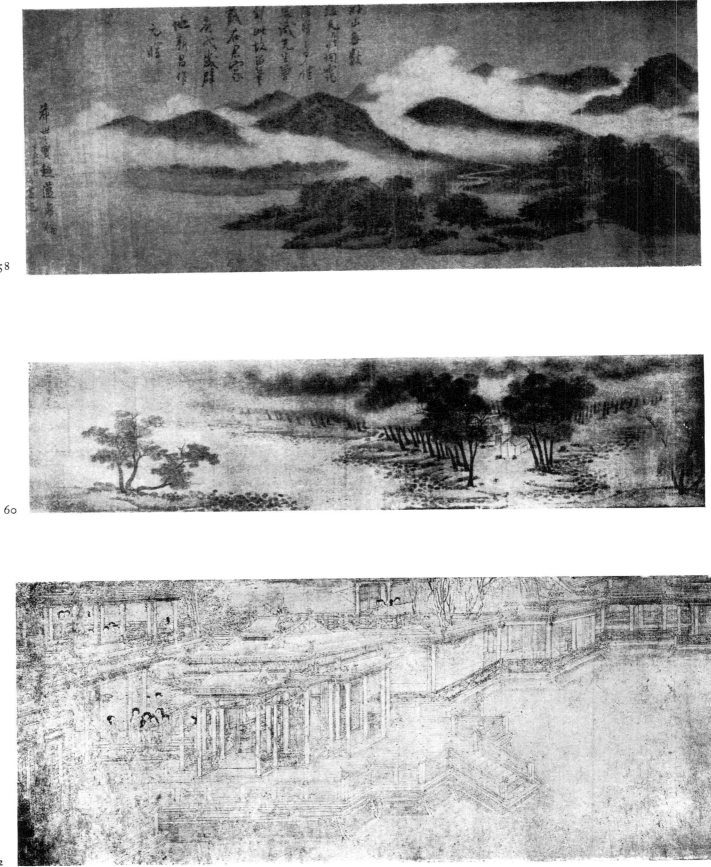

58

60

62

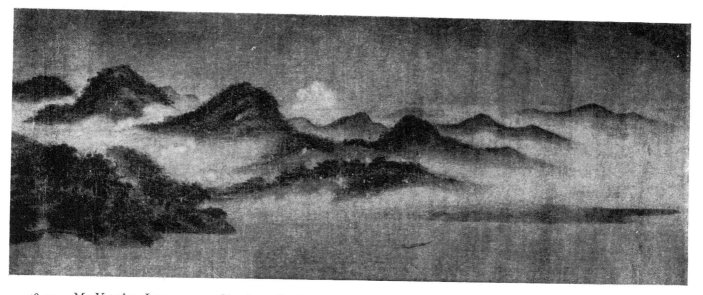

59

58-59. Mi Yu-jên. Landscape. Hand scroll. Ink and slight colour on silk. H.43 cm. L.192 cm. Dated 1130.
Cleveland Museum of Art, Cleveland.

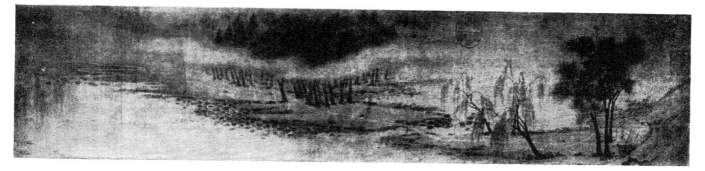

61

60-61. Chao Ta-nien (active c. a.d. 1080-1100). River Landscape. Hand scroll. Ink and slight colour on silk.
H.18 cm. L.165 cm. *Private Collection, China.*

63

62-63. Attributed to Li Lung-mien (c. a.d. 1040-1106). Imperial Summer Palace. Hand scroll. Ink on paper.
H.36 cm. L.146 cm. *Freer Gallery of Art, Washington.*

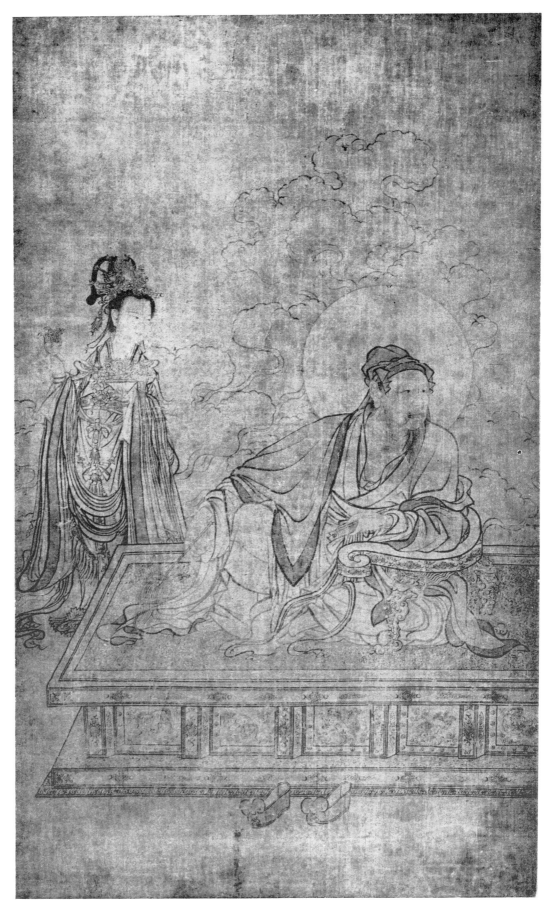

64. Attributed to Li Lung-mien (c. a.d. 1040-1106). Wei Mo-ch'i (Vimalakīrti) with Attendant. Ink on silk. H.100 cm. W.53 cm. *Private Collection, Japan.*

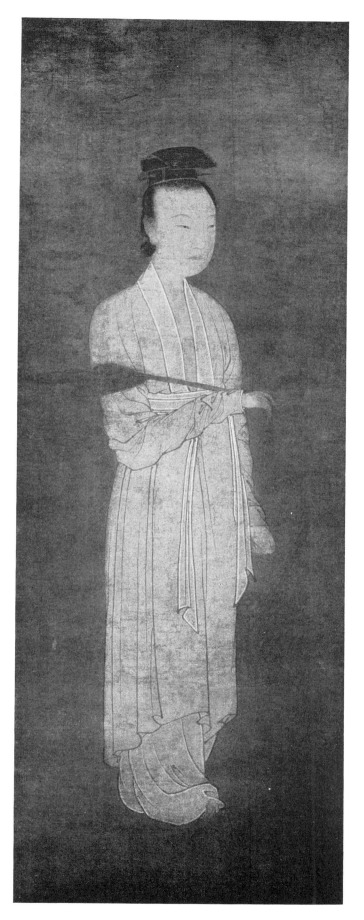

65. UNKNOWN ARTIST. WOMAN IN WHITE WITH BASKET (KUANYIN?).
Ink and colour on silk. H.93 cm. W.43 cm. 13th or 14th century A.D.
Freer Gallery of Art, Washington.

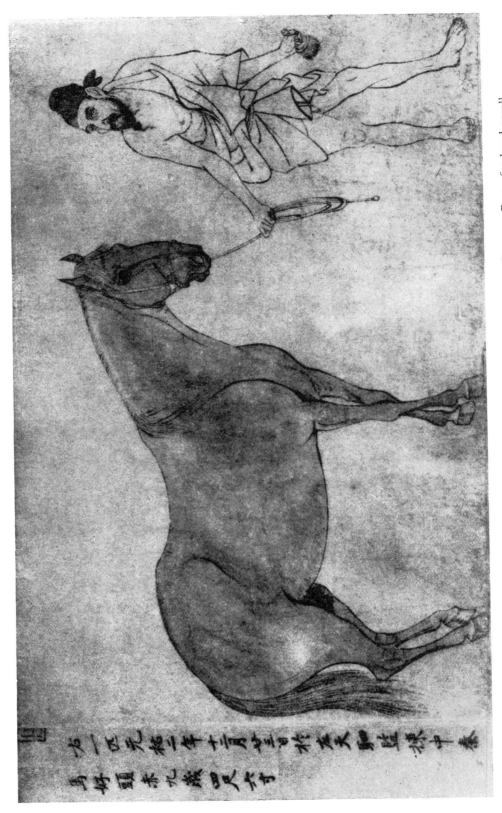

66. Li Lung-mien (c. a.d. 1040-1106). Five Tribute Horses from Khotan with Grooms. Part of a hand scroll. *Chinese Government.* One of the Horses with Groom. Ink and slight colour on paper. H.30 cm. L.182 cm.

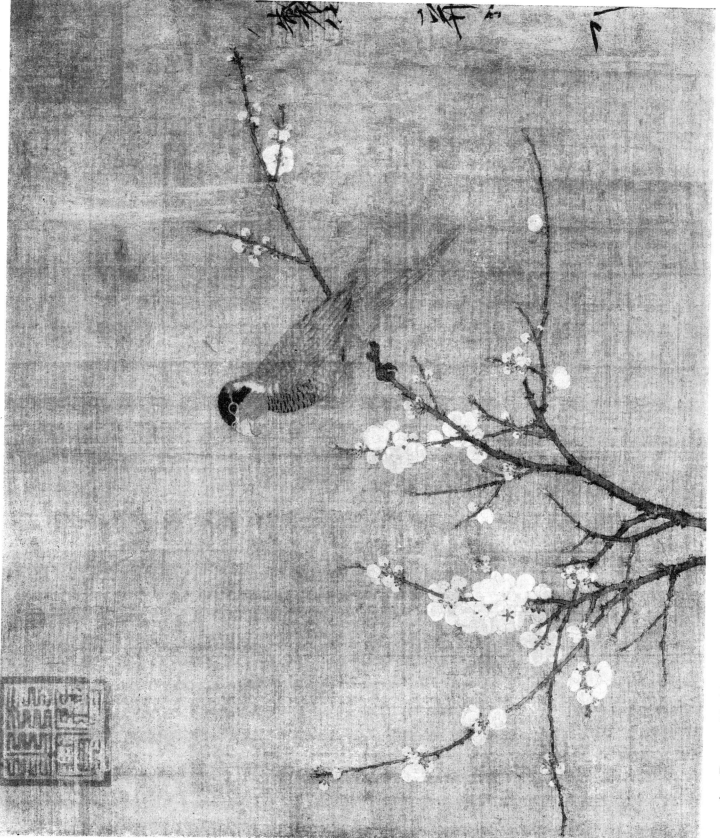

67. EMPEROR HUI TSUNG (A.D. 1082-1135). THE FIVE-COLOURED PARAKEET PERCHED ON AN APRICOT BRANCH. Hand scroll. Colour on silk.
H.53 cm. L.125 cm. *Museum of Fine Arts, Boston.*

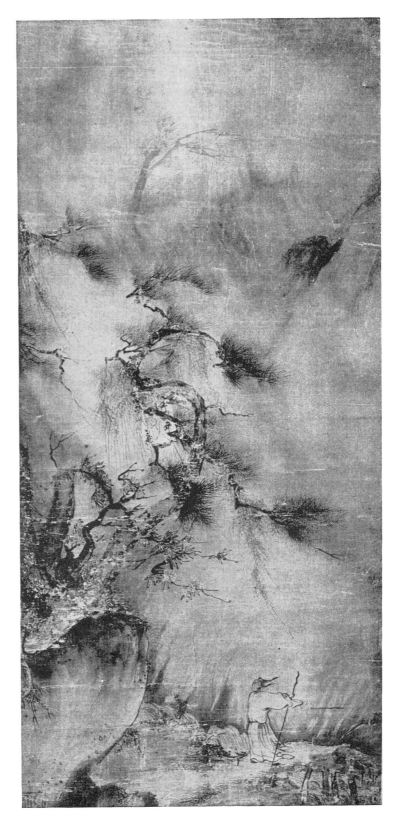

68. ATTRIBUTED TO EMPEROR HUI TSUNG (A.D. 1082-1135). LANDSCAPE IN STORM.
Ink and slight colour on silk. H.120 cm. W.50 cm. *Kuonji, Minobu, Japan.*

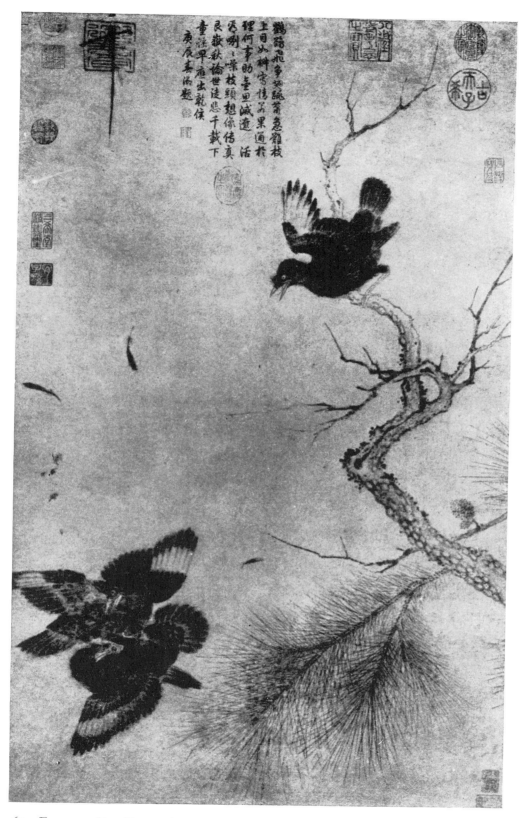

69. Emperor Hui Tsung (A.D. 1082-1135). Birds and Pine Tree. Ink on paper.
H.87 cm. W.52 cm. *Tonying & Co., New York.*

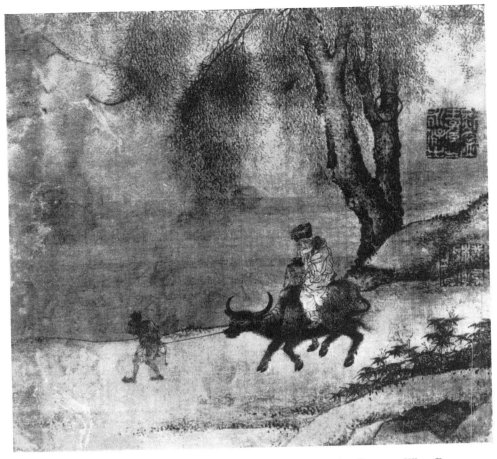

70. ATTRIBUTED TO LI T'ANG (active c. A.D. 1100-1130). ON THE WAY BACK.
Ink on paper. H.25 cm. W.27 cm. *Museum of Fine Arts, Boston.*

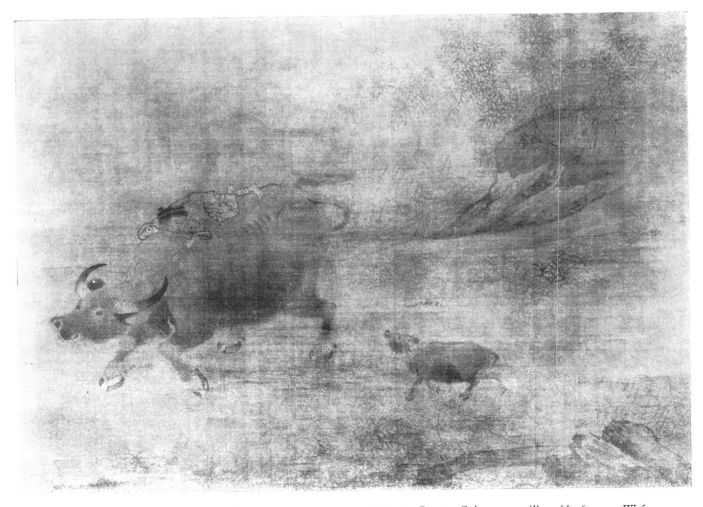

71. ATTRIBUTED TO LI T'ANG (active c. A.D. 1100-1130). MILCH COW. Colour on silk. H.46 cm. W.63 cm.
Chinese Government.

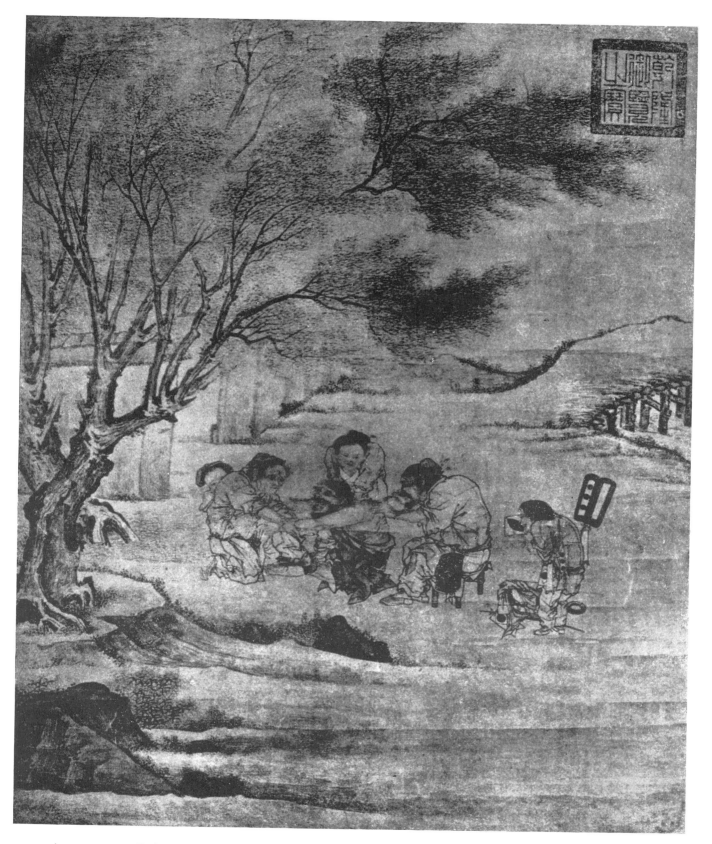

72. ATTRIBUTED TO LI T'ANG (active c. A.D. 1100-1130). THE VILLAGE DOCTOR. Ink on paper. *Chinese Government*.

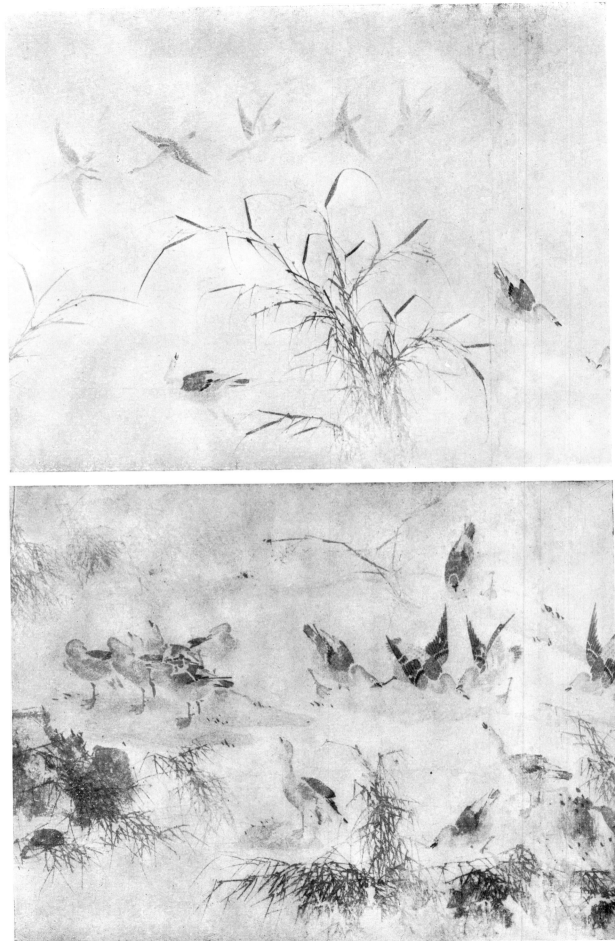

73

74

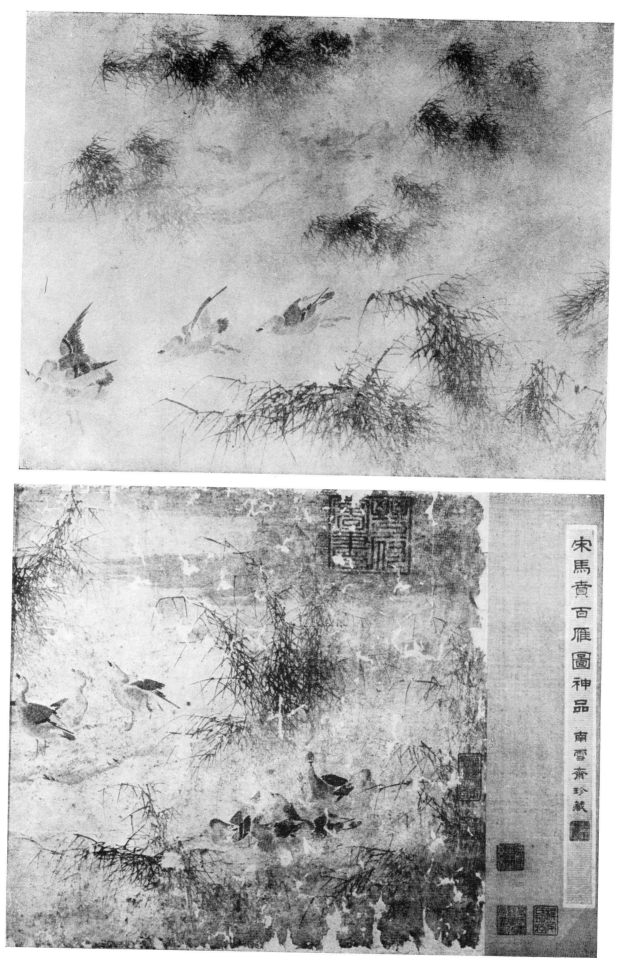

75

76

宋馬賁百雁圖神品 南雪齋珍藏

73-76. ATTRIBUTED TO MA FÈN (2nd half of the 11th century A.D.). THE HUNDRED GEESE.
Parts of a hand scroll. Ink on paper. H.34 cm. L.465 cm. *Honolulu Academy of Arts, Honolulu.*

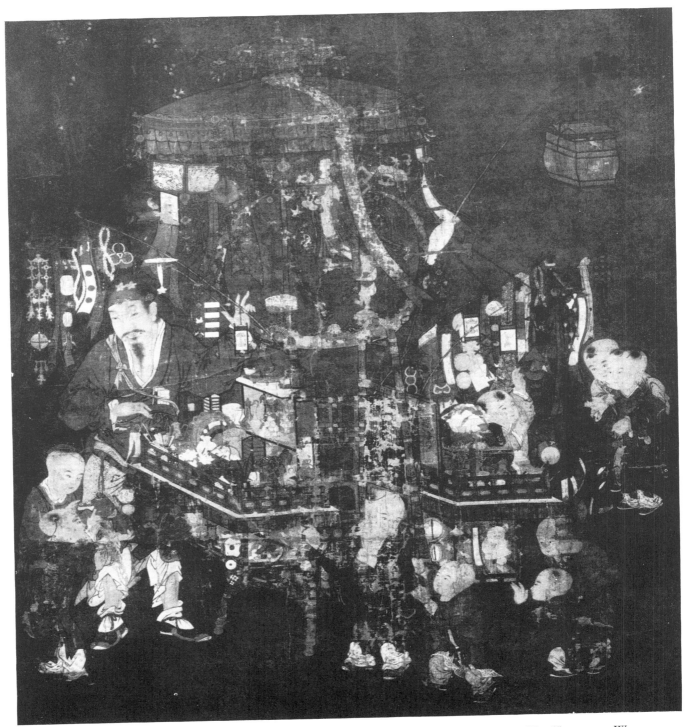

77. ATTRIBUTED TO SU HAN-CH'ÊN (C. A.D. 1115-1170). A PEDLAR OF TOYS. Colour on silk. H.159 cm. W.97 cm. *Chinese Government.*

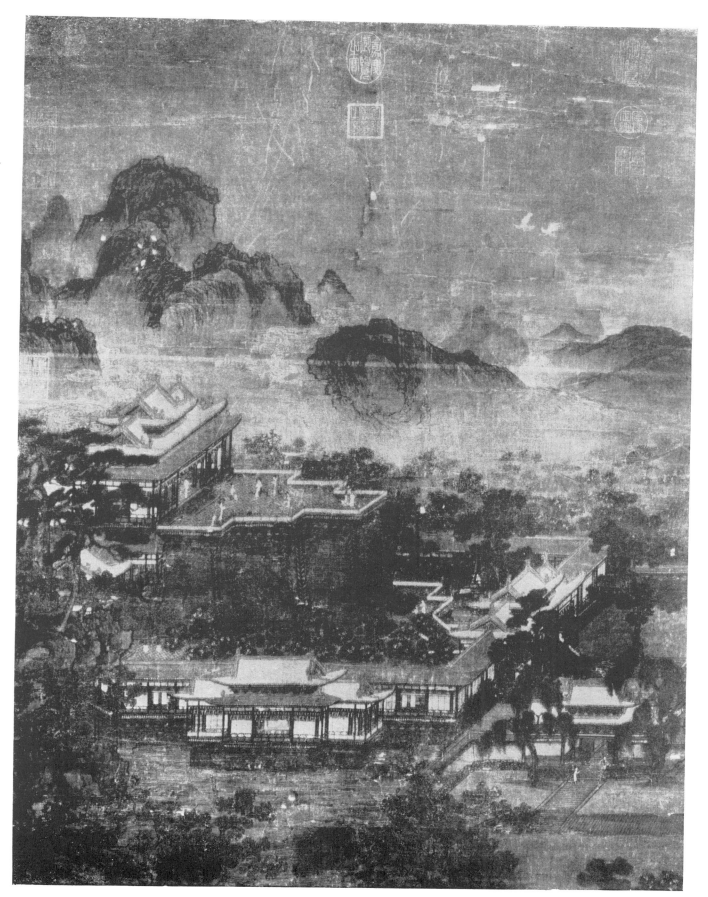

78. ATTRIBUTED TO CHAO PO-CHÜ (12th century A.D.). SUMMER PALACE. Colour on silk. H.73 cm. W.55 cm.
Chinese Government.

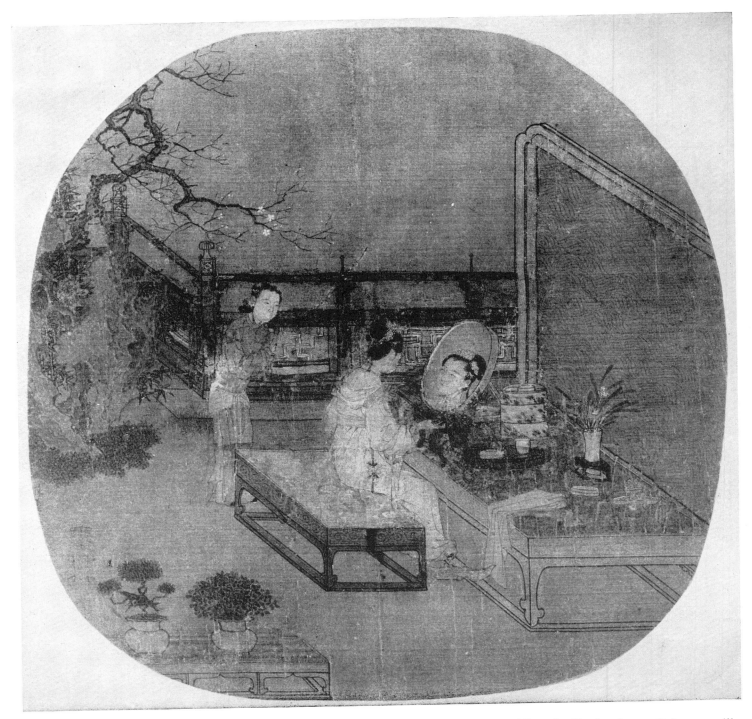

79.　Attributed to Su Han-ch'ên (c. a.d. 1115-1170).　Lady at a Dressing Table.　Album-leaf in fan shape.　Colour on silk.
H.25 cm.　W.26 cm.　*Museum of Fine Arts, Boston.*

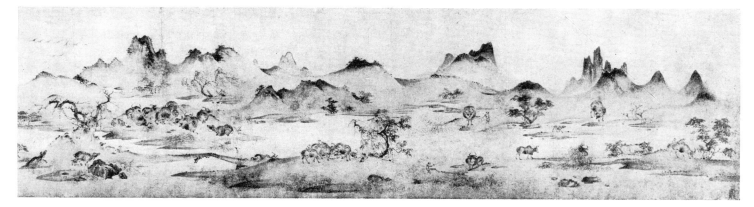

80. ATTRIBUTED TO CHIANG TS'AN (active middle of the 12th century A.D.). THE HUNDRED WATER-BUFFALOES. Part of a hand scroll. Ink on paper. H.31 cm. L.221 cm. *Metropolitan Museum, New York.*

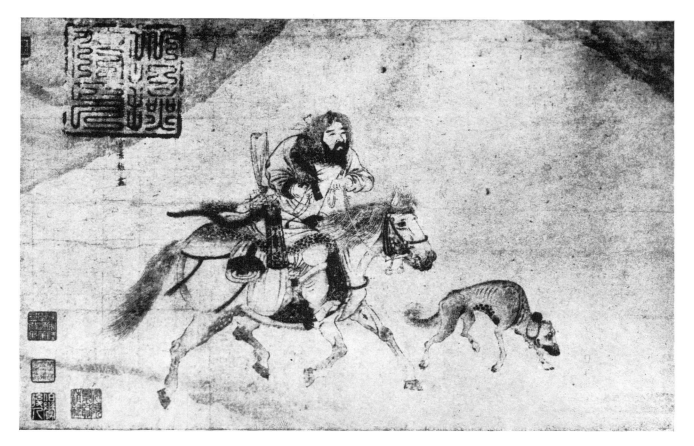

81. ATTRIBUTED TO KUNG SU-JAN (active c. A.D. 1100). NOMADS ON THE MARCH. Part of a hand scroll. Ink on paper. H.30 cm. L.180 cm. *Private Collection, Japan.*

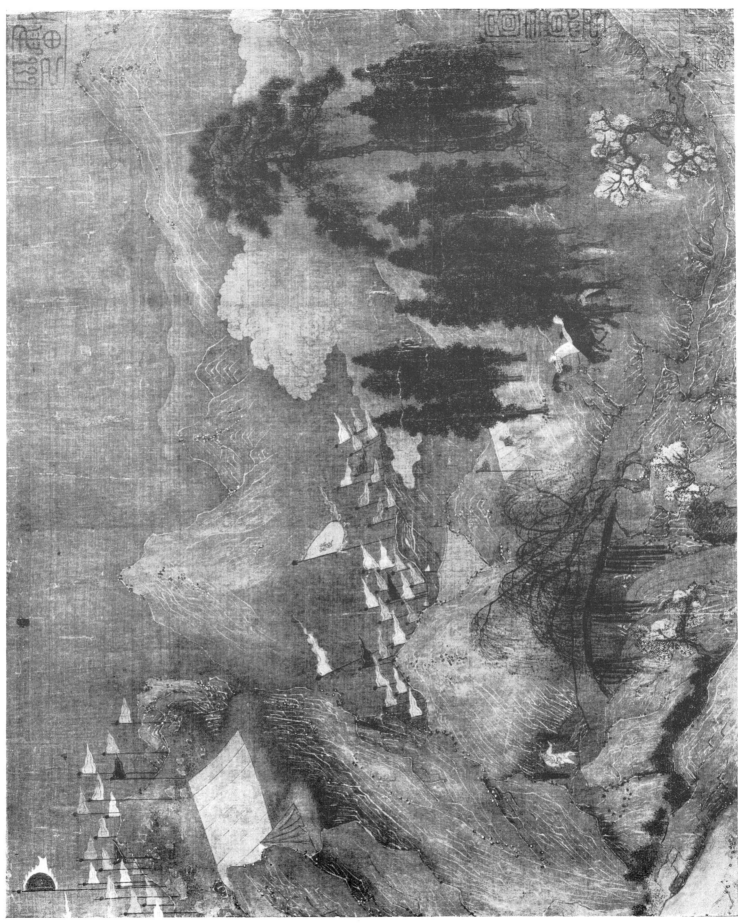

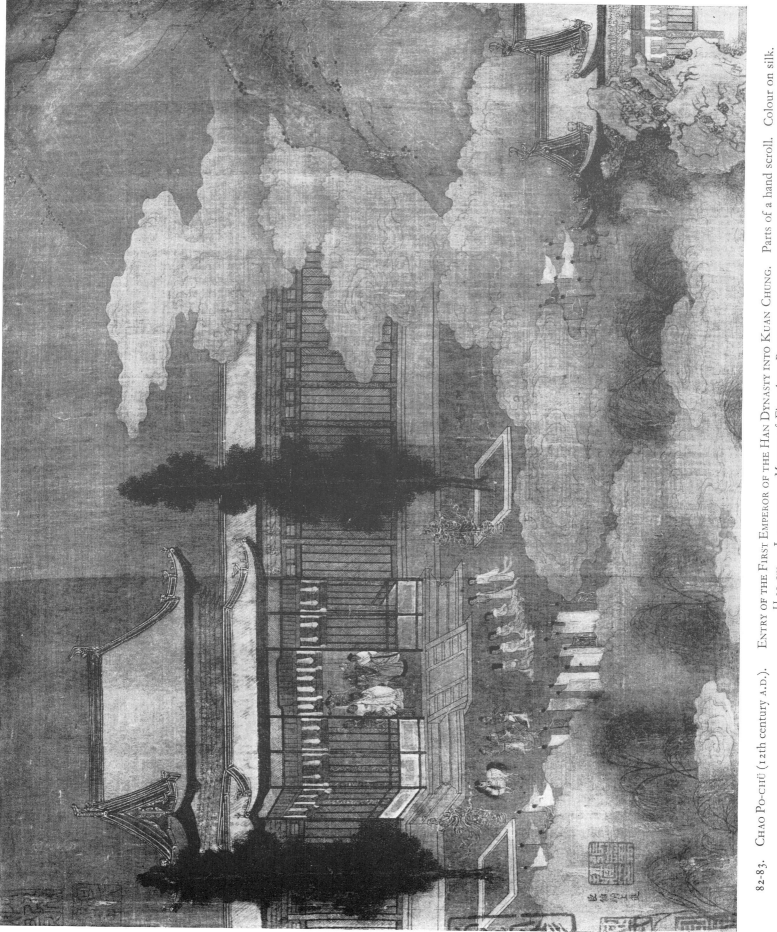

82-83. CHAO PO-CHÜ (12th century A.D.). ENTRY OF THE FIRST EMPEROR OF THE HAN DYNASTY INTO KUAN CHUNG. Parts of a hand scroll. Colour on silk. H.29 cm. L.312 cm. *Museum of Fine Arts, Boston.*

83

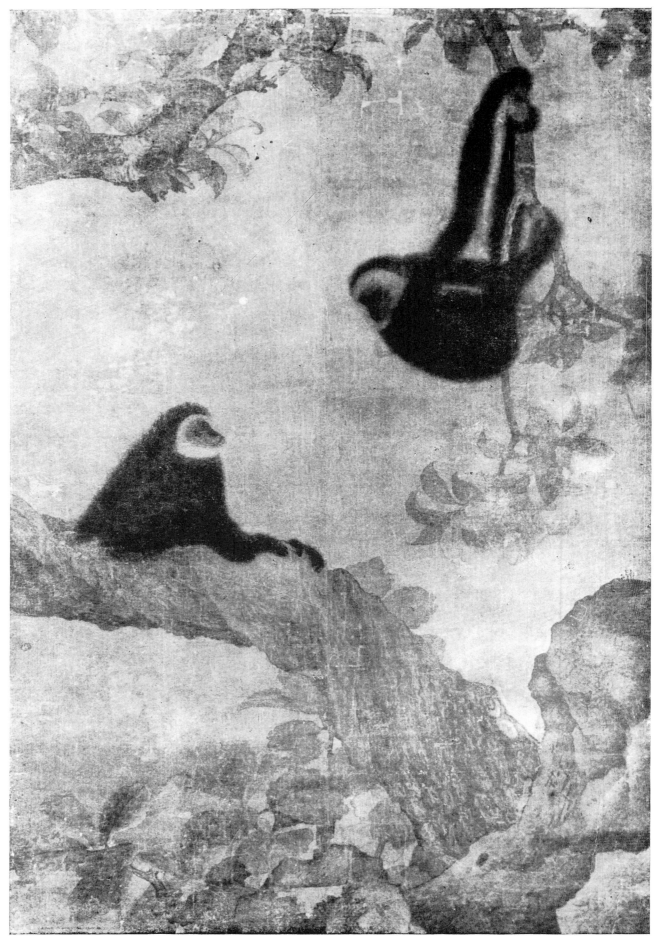

84. UNKNOWN ARTIST. MONKEYS AT PLAY ON A LOQUAT TREE. Ink and colour on silk. H.165 cm. W.107 cm.
13th century A.D. *Chinese Government*.

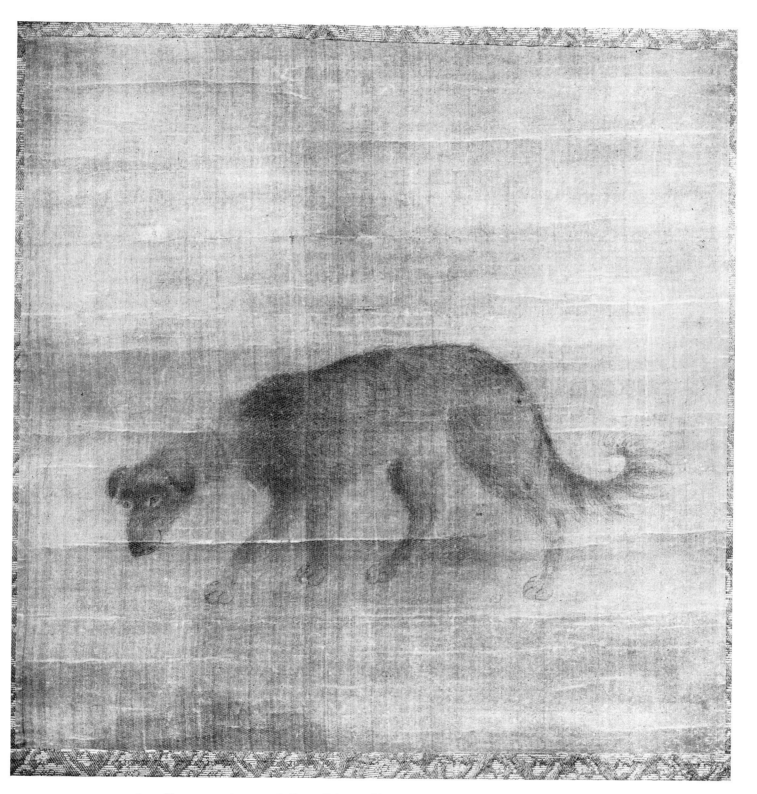

85. UNKNOWN ARTIST. A DOG. Ink on silk. H.28 cm. W.27 cm. 13th century A.D.
Museum of Fine Arts, Boston.

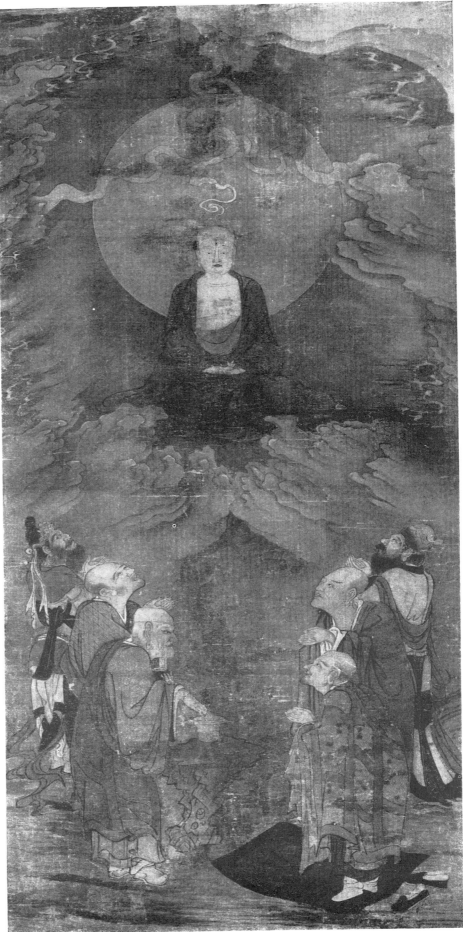

86

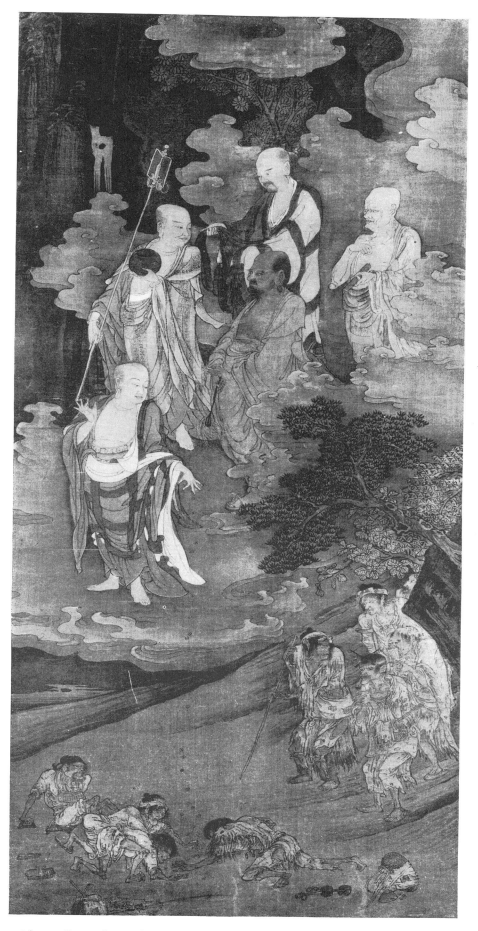

86-87. CHOU CHI-CH'ANG AND LIN T'ING-KUEI (active c. A.D. 1160-1180).
THE FIVE HUNDRED LOHANS. Two of a set of a hundred paintings.
Colour on silk. H.111 cm. W.53 cm. *Museum of Fine Arts, Boston.*

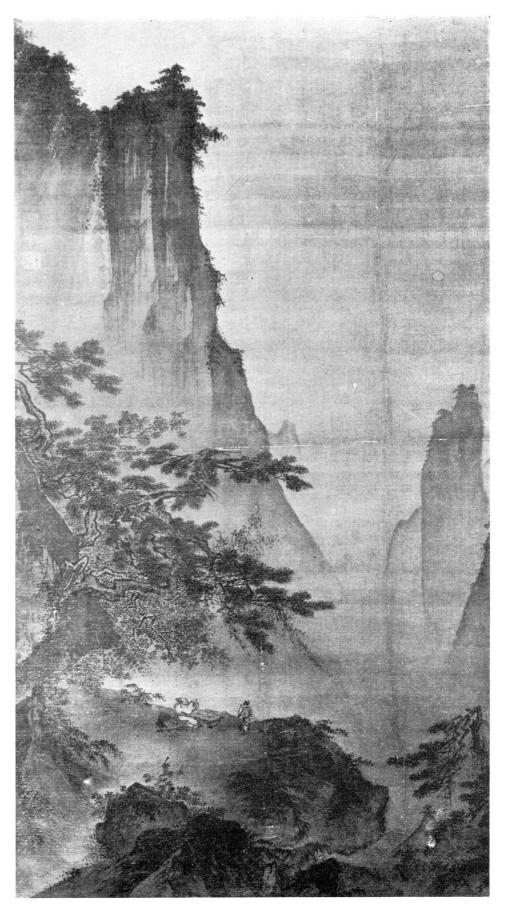

88. ATTRIBUTED TO MA YÜAN (active c. A.D. 1190-1224). LANDSCAPE IN MOONLIGHT.
Ink and slight colour on silk. H.150 cm. W.78 cm. *Chinese Government.*

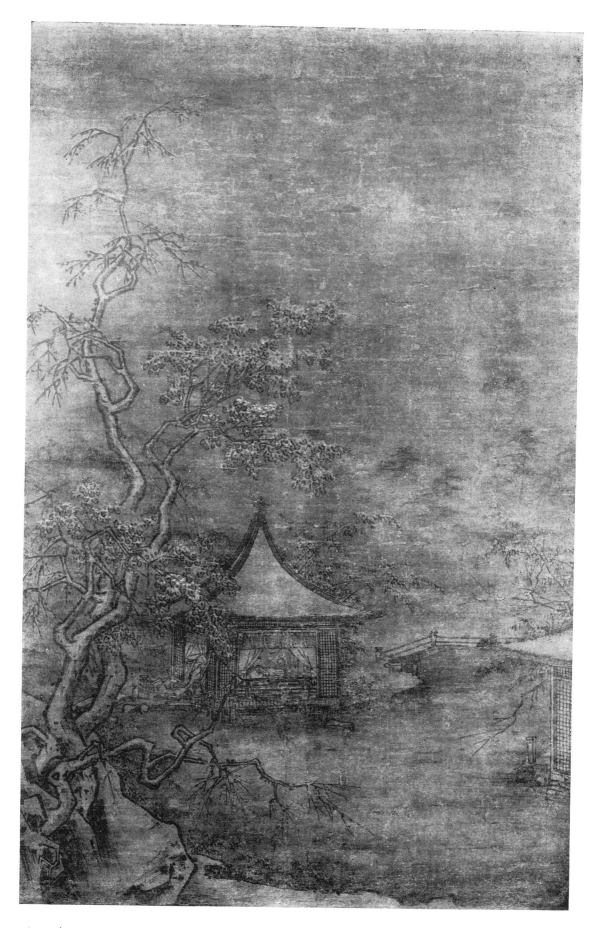

89. ATTRIBUTED TO MA YÜAN (active c. A.D. 1190-1224). WINTER LANDSCAPE WITH PAVILION ON A RIVER. Ink and slight colour on silk. H.91 cm. W.54 cm. *Museum of Fine Arts, Boston.*

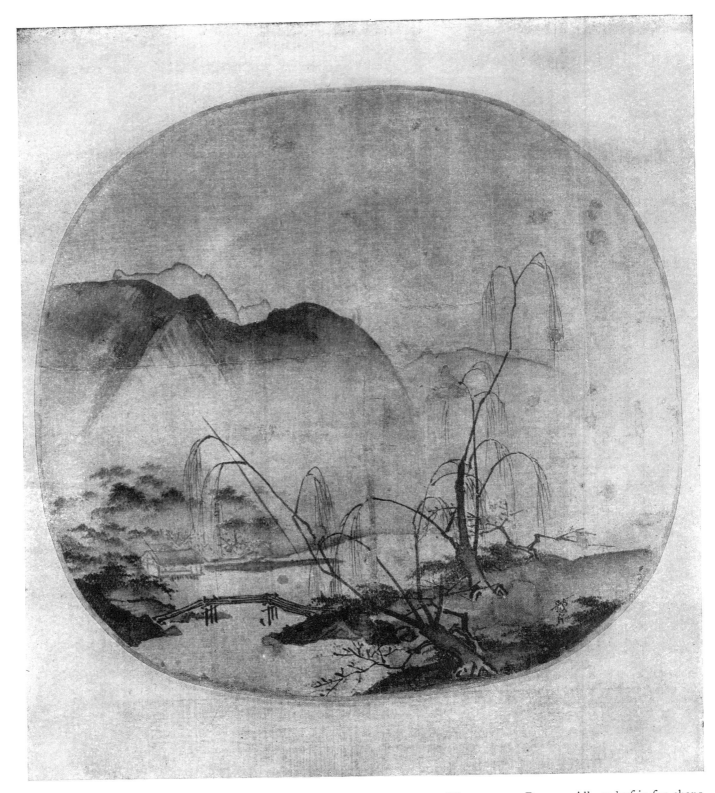

90. ATTRIBUTED TO MA YÜAN (active c. A.D. 1190-1224). LANDSCAPE WITH WILLOW AND BRIDGE. Album-leaf in fan shape. Ink and slight colour on silk. H.24 cm. W.24 cm. *Museum of Fine Arts, Boston.*

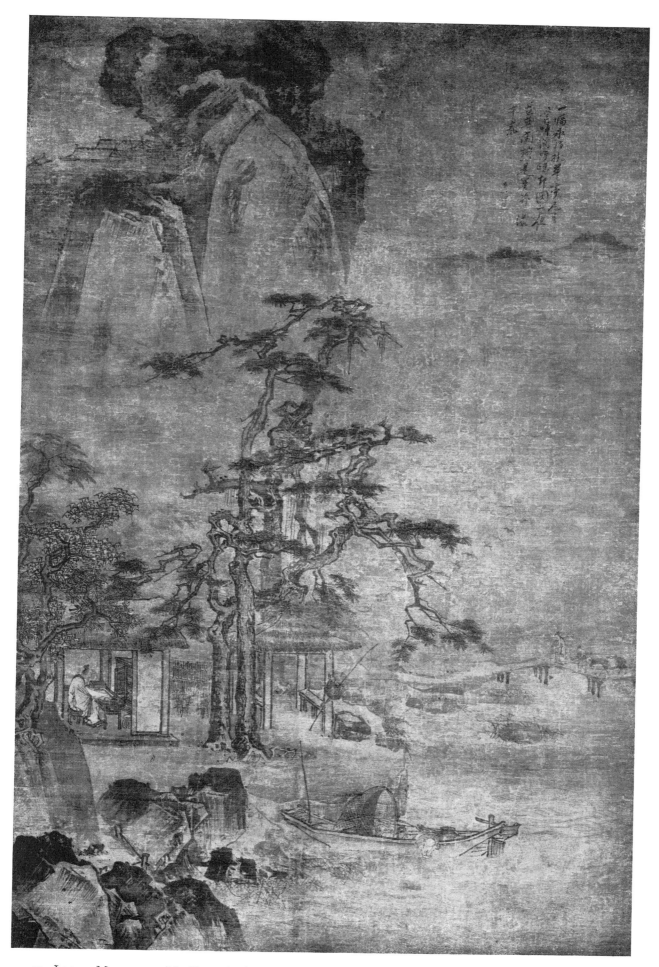

91. In the Manner of Ma Yüan (active c. A.D. 1190-1224). Landscape with the Retreat of a Sage. Ink and slight colour on silk. H.189 cm. W.122 cm. 13th century A.D. *Freer Gallery of Art, Washington.*

92. Attributed to Ma Yüan (active c. a.d. 1190-1224). Fisherman in a Boat. Colour on silk.
H.22 cm. W.48 cm. *Private Collection, Japan.*

93. ATTRIBUTED TO HSIA KUEI (active c. A.D. 1180-1230). SUMMER LANDSCAPE. Ink on silk. H.25 cm. W.33 cm. *Private Collection, Japan.*

94

95

94-96. ATTRIBUTED TO HSIA KUEI (active c. A.D. 1180-1230). A MYRIAD MILES OF THE YANGTZE. Parts of a hand scroll.
Ink on silk. H.27 cm. L.1114 cm. *Chinese Government*.

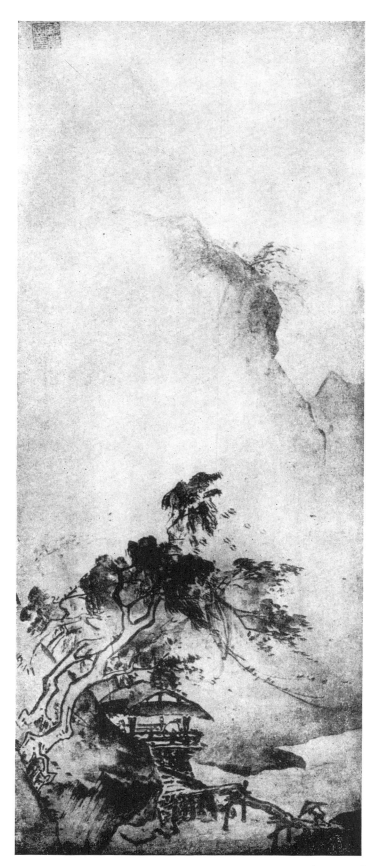

97. HSIA KUEI (active c. A.D. 1180-1230). LANDSCAPE IN AUTUMN STORM.
Ink on paper. H.91 cm. W.40 cm. *Private Collection, Japan.*

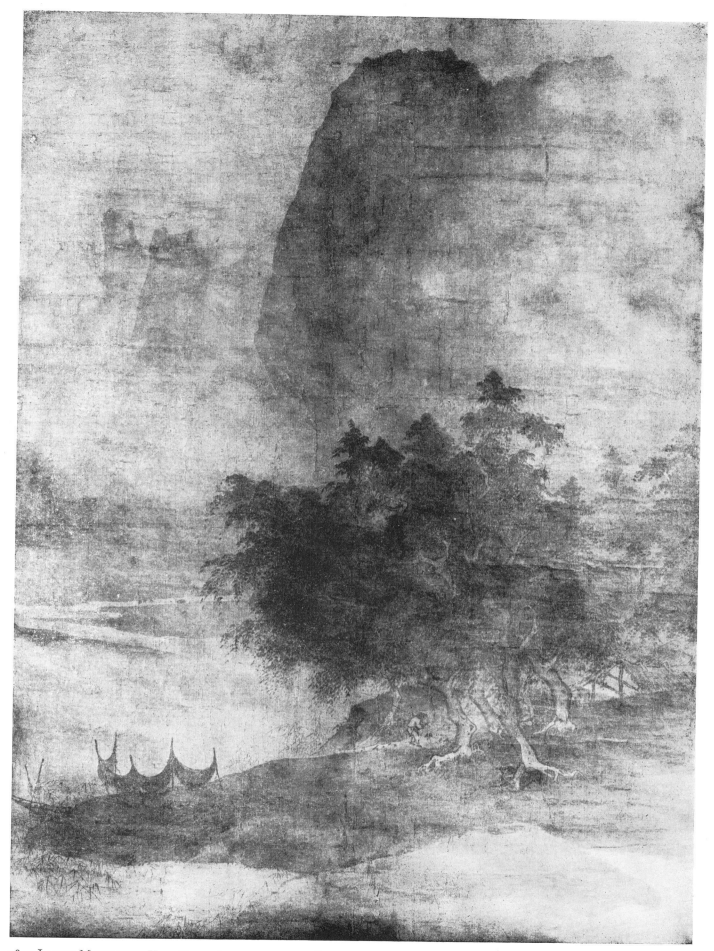

98. IN THE MANNER OF HSIA KUEI. LANDSCAPE WITH FISHING NETS. Ink and slight colour on silk. H.144 cm. W.100 cm.
13th century A.D. *Museum of Fine Arts, Boston.*

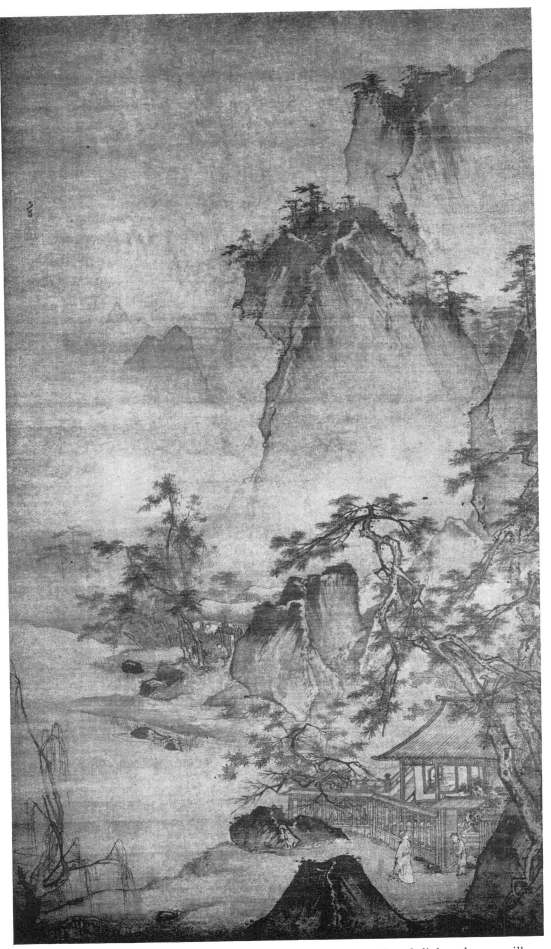

99. HSÜ SHIH-CHANG (12th-13th century A.D.). LANDSCAPE. Ink and slight colour on silk.
H.184 cm. W.101 cm. *Freer Gallery of Art, Washington.*

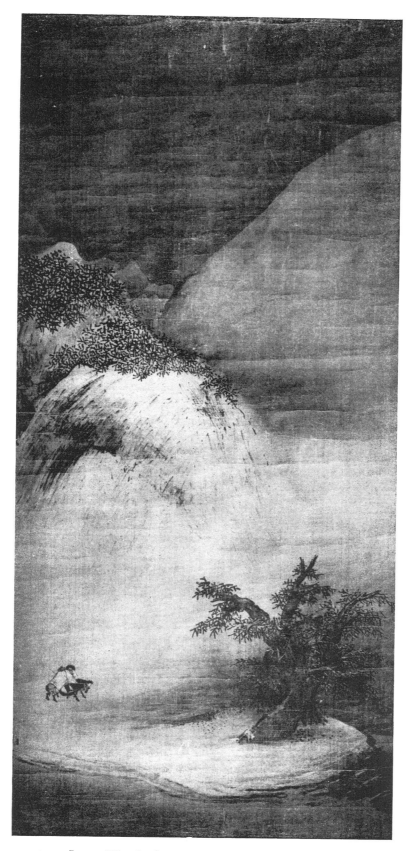

100. LIANG K'AI (active c. A.D. 1200). WINTER LANDSCAPE.
Ink and slight colour on paper. H.130 cm. W.48 cm.
Private Collection, Japan.

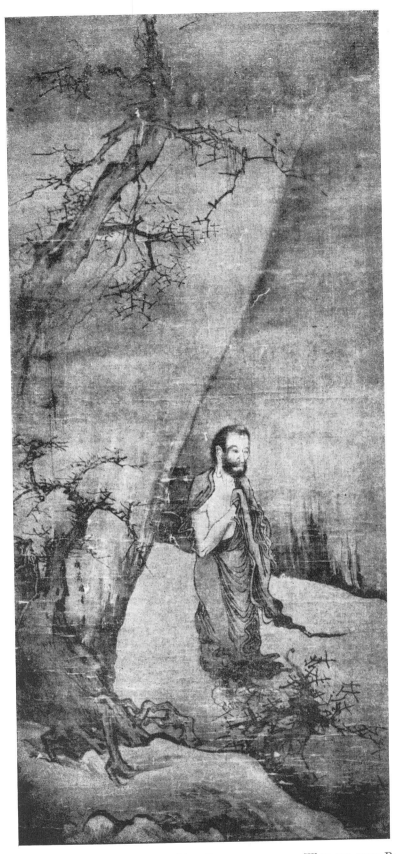

101. LIANG K'AI (active c. A.D. 1200). THE BUDDHA ON THE WAY TO THE BODHI TREE. Colour on silk. H. 117 cm. W. 51 cm. *Private Collection, Japan.*

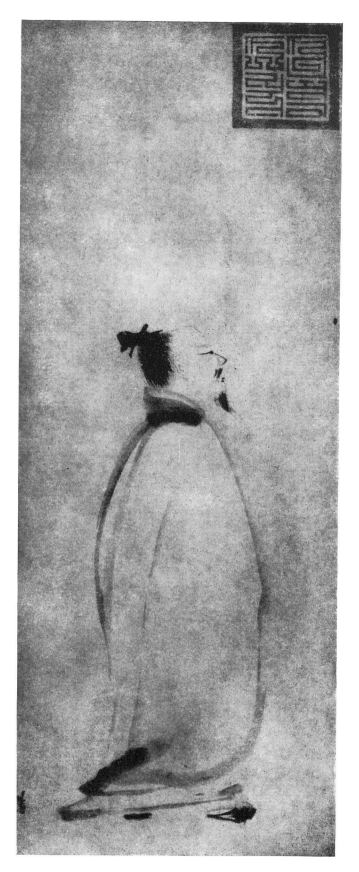

102. LIANG K'AI (active c. A.D. 1200). THE POET LI T'AI-PO (c. A.D. 700-762).
Ink on paper. H.79 cm. W.30 cm. *Private Collection, Japan.*

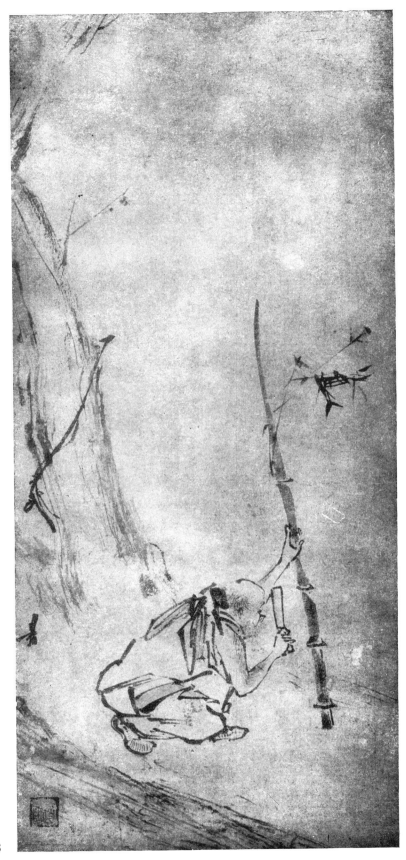

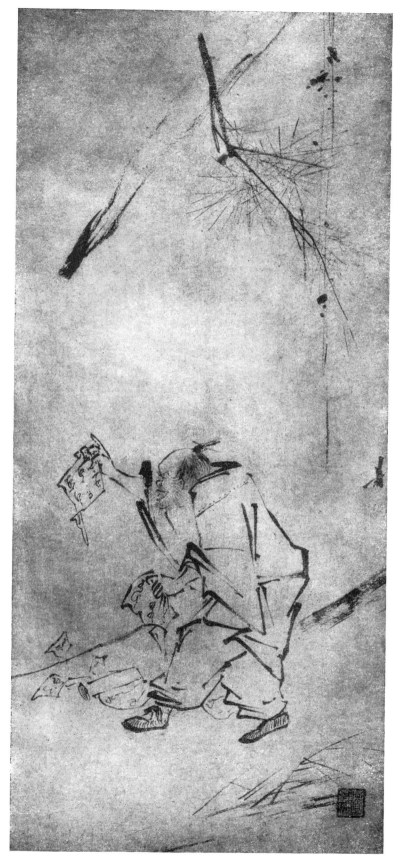

103-104. Liang K'ai (active c. A.D. 1200). Patriarchs of the Ch'an Sect.
Two paintings. Ink on paper. H.74 cm. W.30 cm. *Private Collection, Japan.*

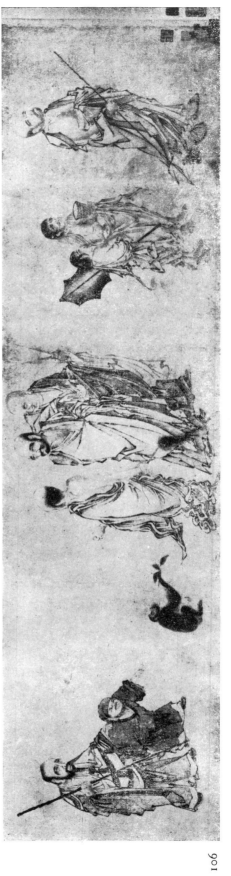

105-106. LIANG K'AI (active c. A.D. 1200). THE SIXTEEN LOHANS. Parts of a hand scroll. H.32 cm. L.573 cm. *Private Collection, Japan.*

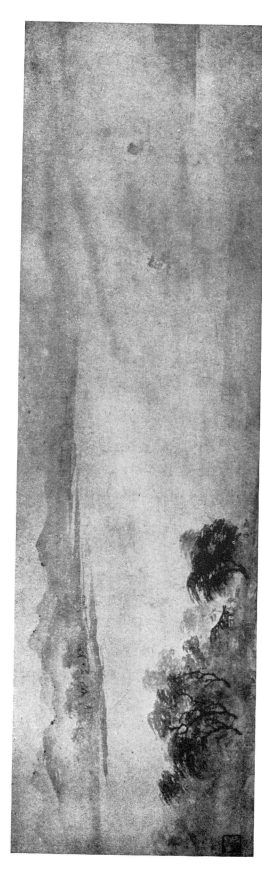

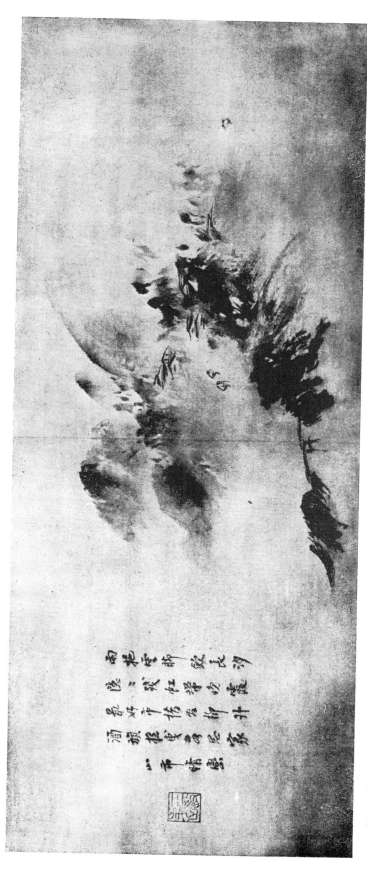

107. FA-CH'ANG (Mu-ch'i, c. A.D. 1181-1239). ONE OF THE EIGHT VIEWS OF THE TUNG-T'ING LAKE (RETURNING SAILS). Part of a hand scroll. Ink on paper. H.28 cm. L.130 cm. *Private Collection, Japan.*

108. YING YÜ-CHIEN (12th-13th century A.D.). ONE OF THE EIGHT VIEWS OF THE HSIAO HSIANG (HAZE DISPERSING FROM AROUND A MOUNTAIN TOWN). Part of a hand scroll. Ink on paper. H.31 cm. L.82 cm. *Private Collection, Japan.*

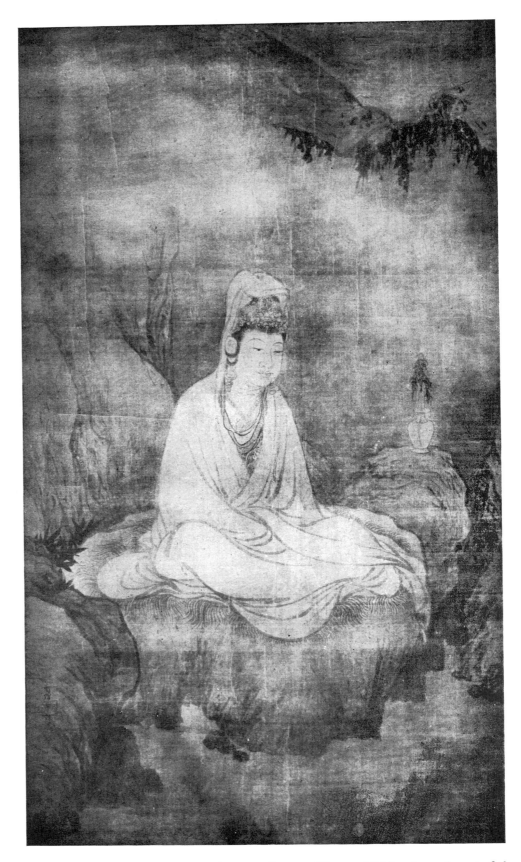

109. FA-CHʻANG (Mu-chʻi, c. A.D. 1181-1239). KUANYIN CLAD IN WHITE. Middle piece of a set of three paintings.
Ink on silk. H.142 cm. W.96 cm. *Daitokuji, Kyōto.*

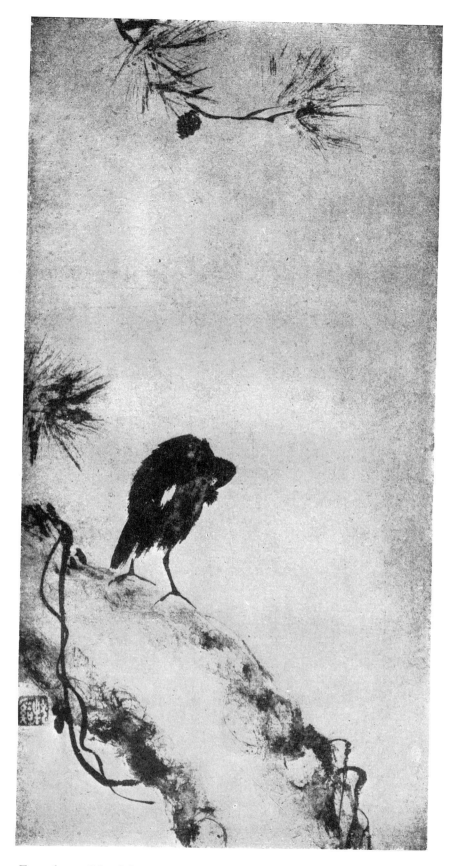

110. FA-CH'ANG (Mu-ch'i, c. A.D. 1181-1239). SHRIKE PERCHED ON A PINE TREE. Ink on paper. H.79 cm. W.32 cm. *Private Collection, Japan.*

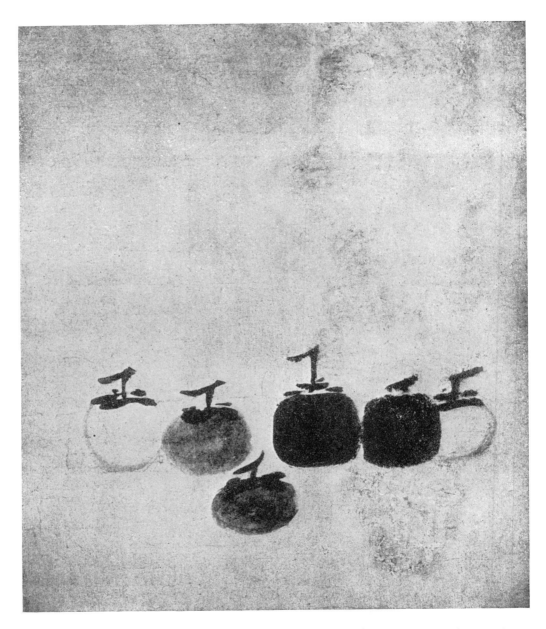

111. FA-CH'ANG (Mu-ch'i, c. A.D. 1181-1239). PERSIMMONS. Ink on paper. H.36 cm. W.38 cm. *Daitokuji, Kyōto.*

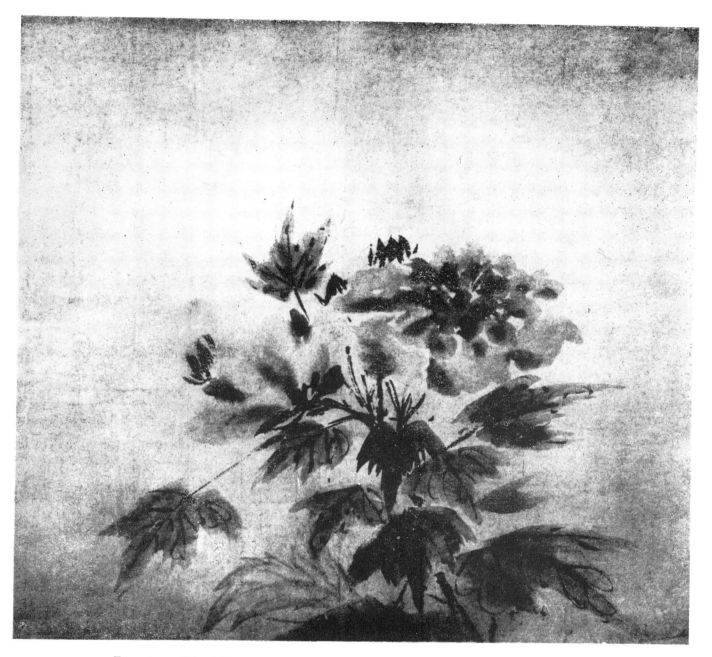

112. FA-CH'ANG (Mu-ch'i, c. A.D. 1181-1239). PEONIES. Ink on paper. H.36 cm. W.38 cm. *Daitokuji, Kyōto.*

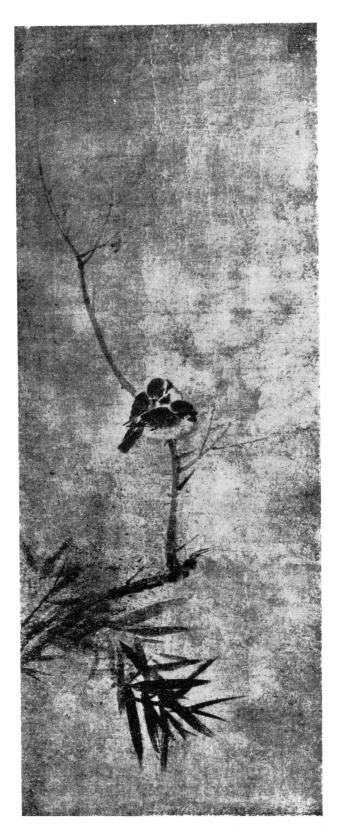

FA-CH'ANG (Mu-ch'i, c. A.D. 1181-1239). TWO SPARROWS ON A BAMBOO BRANCH.
Ink on paper. H.184 cm. W.45 cm. *Private Collection, Japan.*

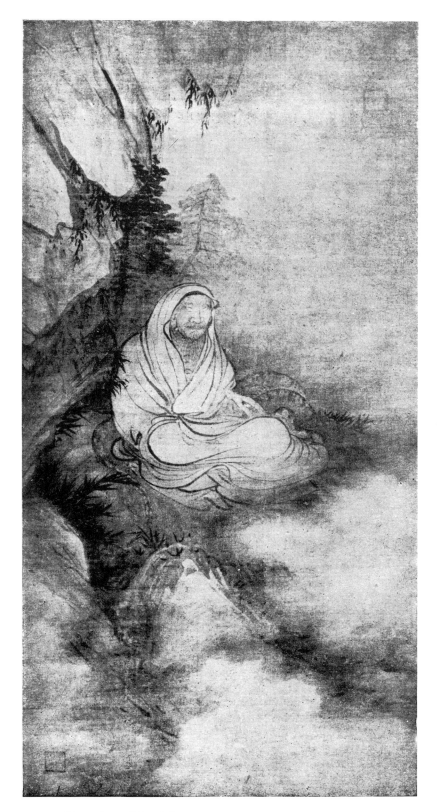

114. FA-CH'ANG (Mu-ch'i, c. A.D. 1181-1239). LOHAN. Ink on silk.
H.107 cm. W.45 cm. *Private Collection, Japan.*

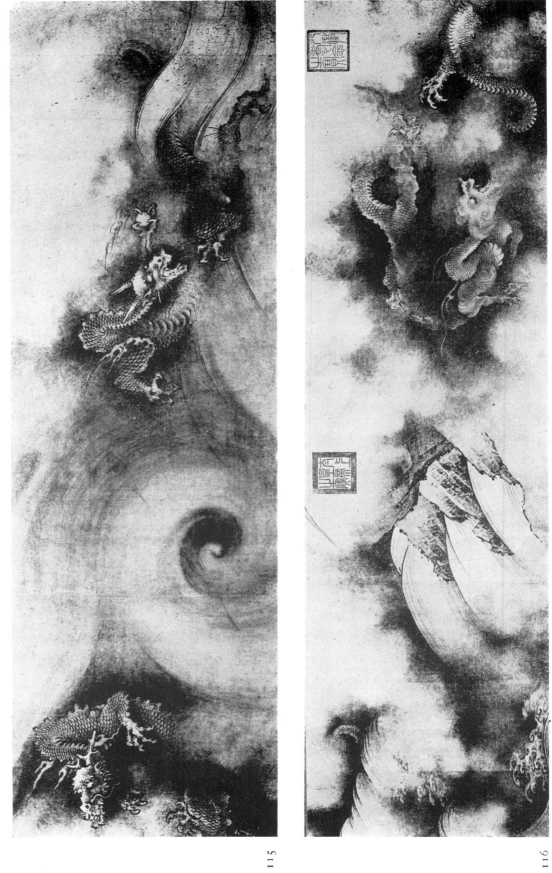

115

116

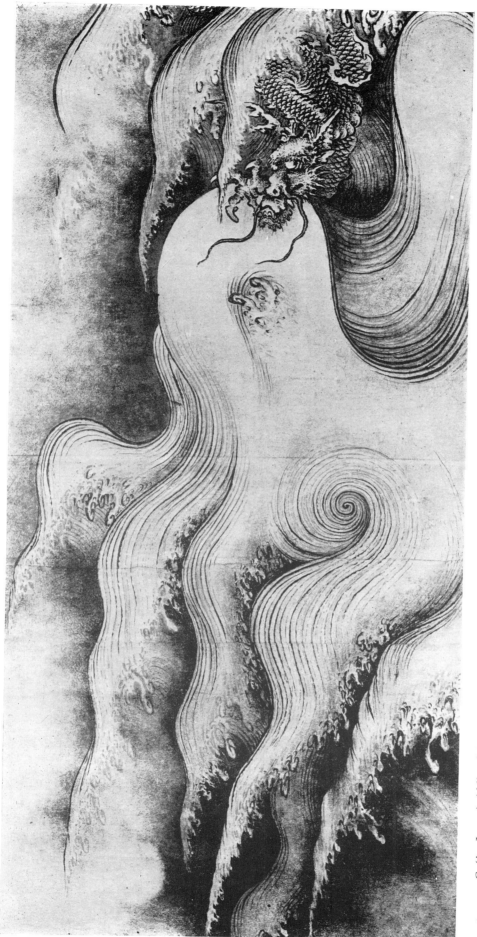

115–117. CH'ÊN JUNG (middle of the 13th century A.D.). DRAGONS AMONG CLOUDS AND WAVES. Parts of a hand scroll. Ink and slight colour on paper. H.46 cm. L.1096 cm. Dated 1244. *Museum of Fine Arts, Boston.*

117

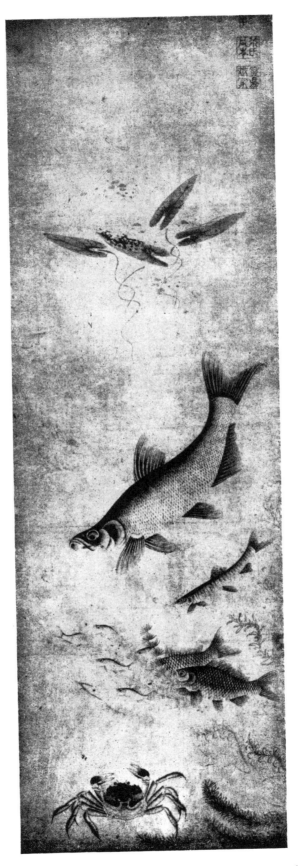

118. FAN AN-JÊN (middle of the 13th century A.D.).
CARPS, CRAB AND WATERPLANTS.
Ink on Paper. *Private Collection, Japan.*

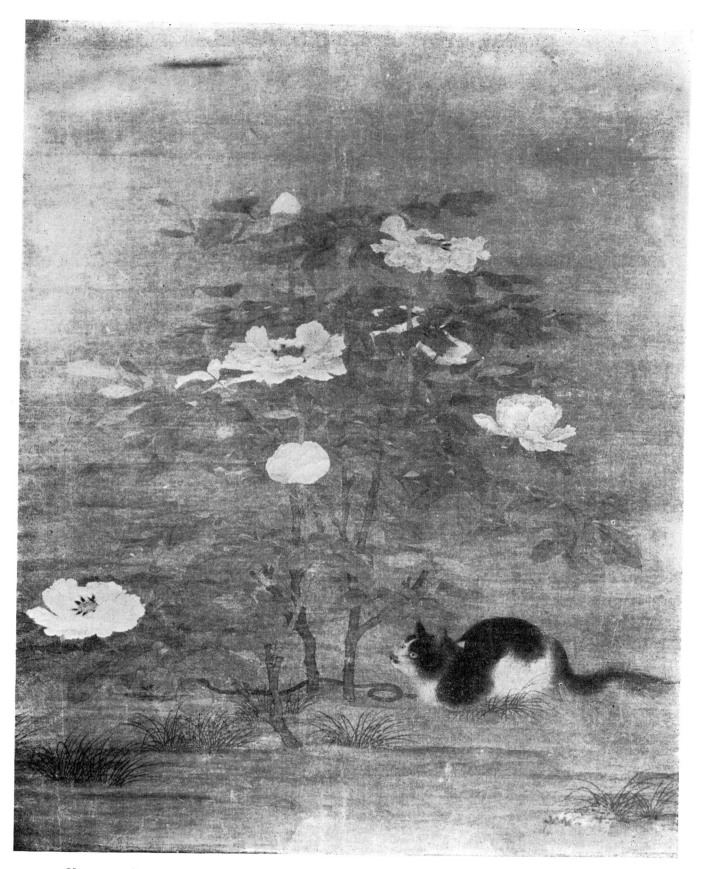

119. Unknown Artist. Peonies and a Cat. Colour on silk. H.141 cm. W.107 cm. 13th or 14th century A.D.
Chinese Government.

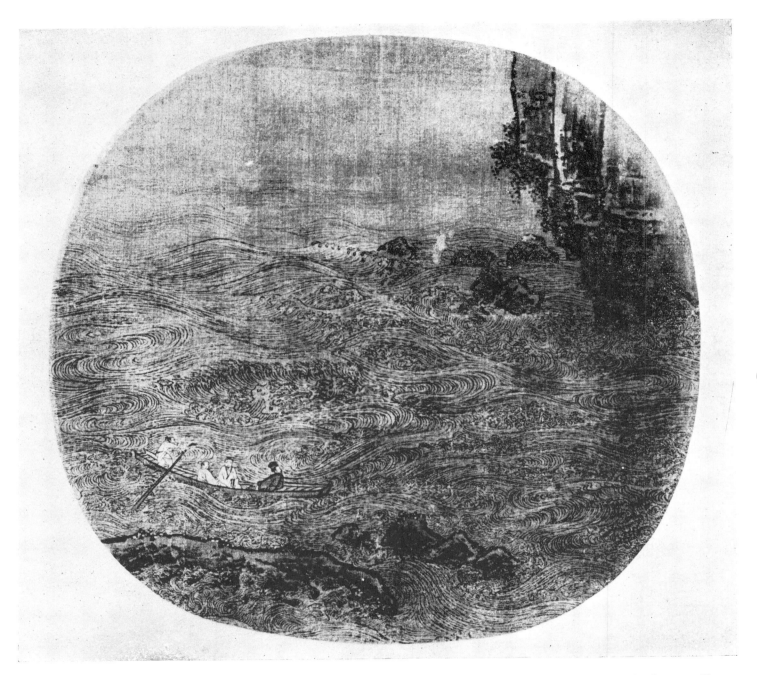

120. ATTRIBUTED TO LI SUNG (A.D. 1166-1243). IN A BOAT AT SEA. Album-leaf in fan shape. Ink and colour on silk.
H.c. 24 cm. W.c.24 cm. *Private Collection, Japan.*

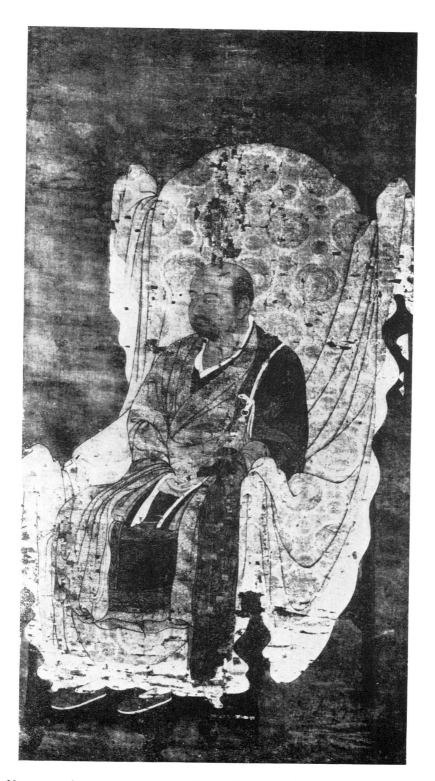

121. UNKNOWN ARTIST. THE INDIAN PRIEST PU-K'UNG (AMOGHAVAJRA, d. A.D. 774).
H.114 cm. W.102 cm. 12th or 13th century A.D. *Kōzanji, Kyōto.*

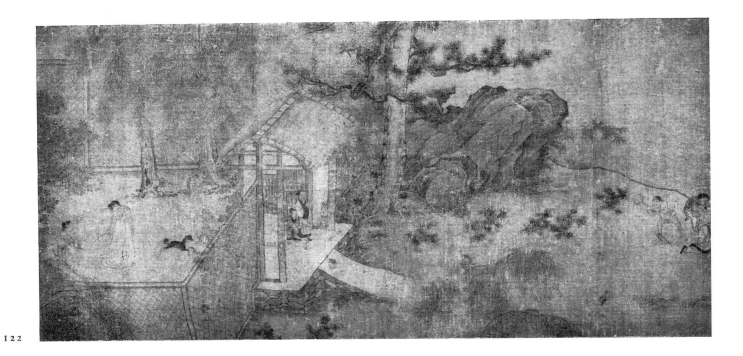

122

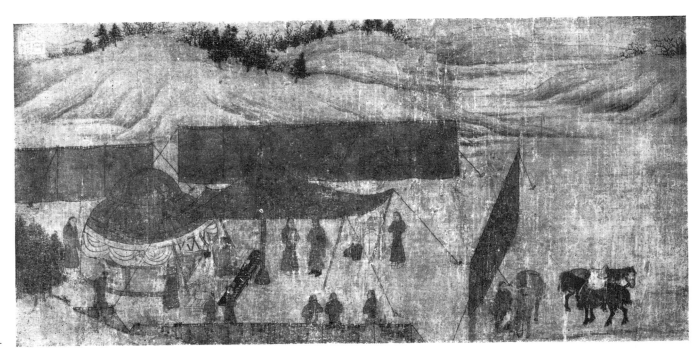

124

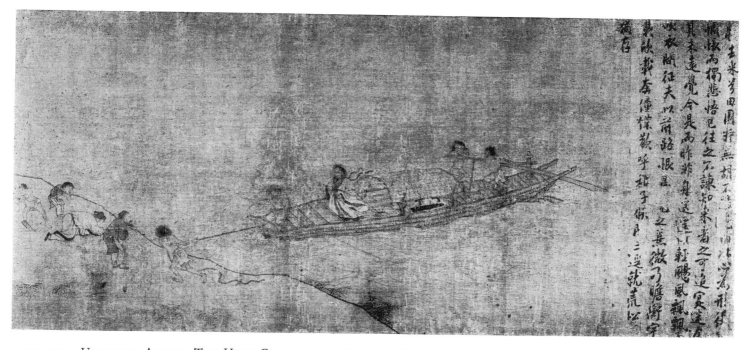

123

122-123. UNKNOWN ARTIST. THE HOME-COMING OF A RETIRING OFFICIAL. Parts of a hand scroll. Ink and colour on silk. H.37 cm. L.518 cm. 13th century A.D. *Freer Gallery of Art, Washington.*

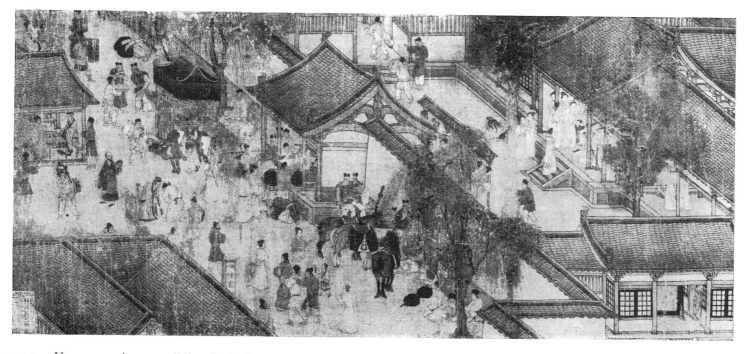

125

124-125. UNKNOWN ARTIST. WÊN CHI'S CAPTIVITY IN MONGOLIA AND HER RETURN TO CHINA (ENCAMPMENT IN THE DESERT; ARRIVAL AT THE CHINESE CITY). Two of four paintings. Colour on silk. H.24-25 cm. W.50-55 cm. 13th century A.D. *Museum of Fine Arts, Boston.*

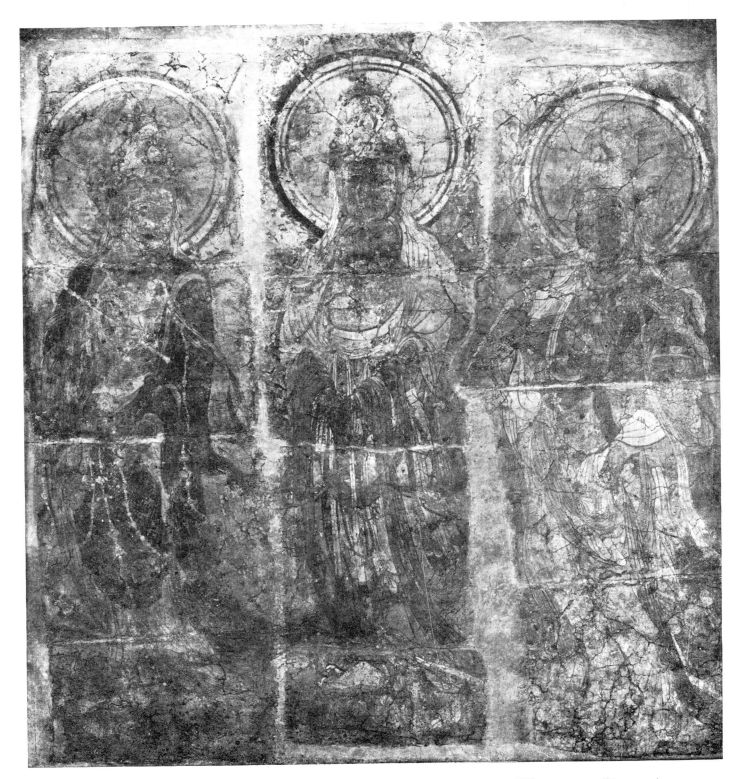

126. Unknown Artist. Three Bodhisattvas (Kuanyin accompanied by Wên-shu and P'u-hsien).
Wall painting. Colour. H.c.400 cm. W.c.370 cm. 13th century A.D. *British Museum, London.*

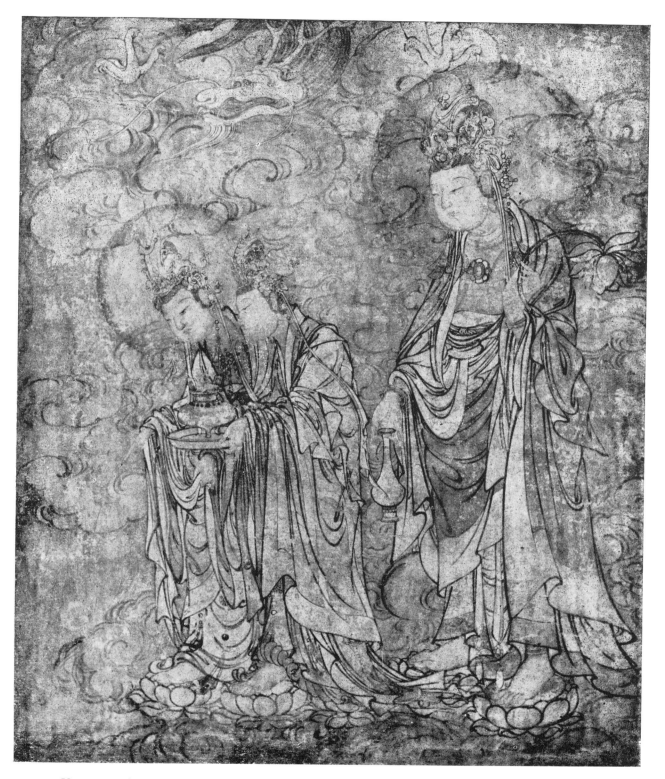

127. Unknown Artist. Kuanyin with Attendants in Clouds. Wall painting. Ink and slight colour.
H.107 cm. W.87 cm. 13th century A.D. *Berkeley Galleries, London.*

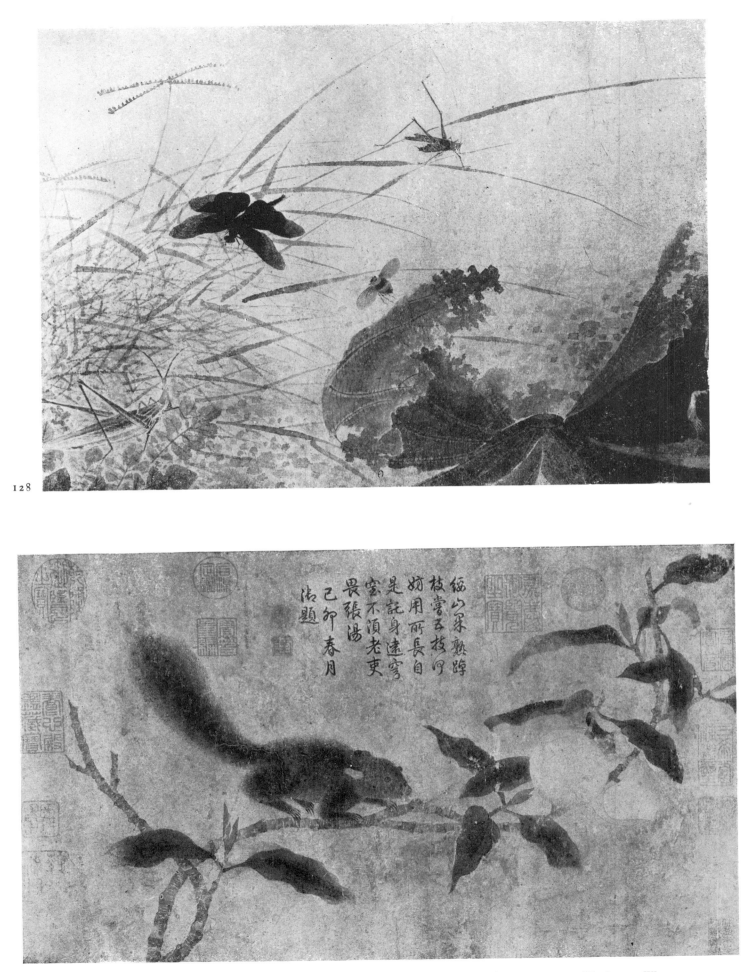

128

綵山采熟蹄
枝嘗玉技吅
妍用所長自
是託身速穹
宓不須老吏
晨張湯
己卯春月
僴題

130. CH'IEN HSÜAN (A.D. 1235–C. 1290). SQUIRREL ON A PEACH BOUGH. Colour on paper. H.26 cm. W.44 cm.
Chinese Government.

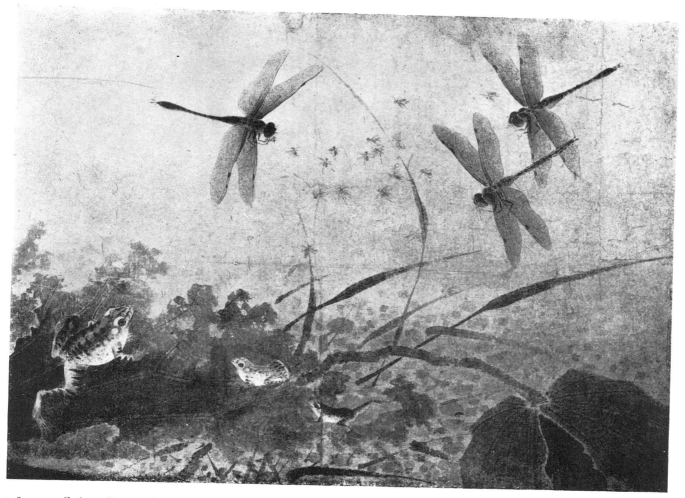

129

128-129. CH'IEN HSÜAN (A.D. 1235-C. 1290). INSECTS AND LOTUS. Parts of a hand scroll. Ink and colour on paper.
H.26 cm. L.120 cm. *Detroit Institute of Arts, Detroit.*

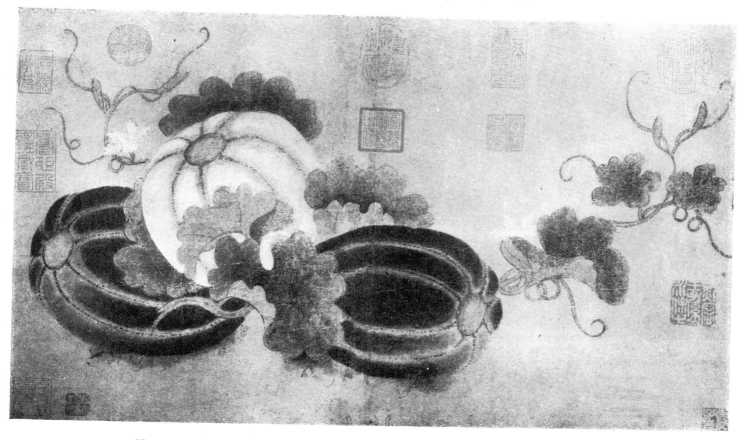

131. UNKNOWN ARTIST. MELONS. Colour on paper. H.27 cm. W.45 cm. 13th century A.D.
Chinese Government.

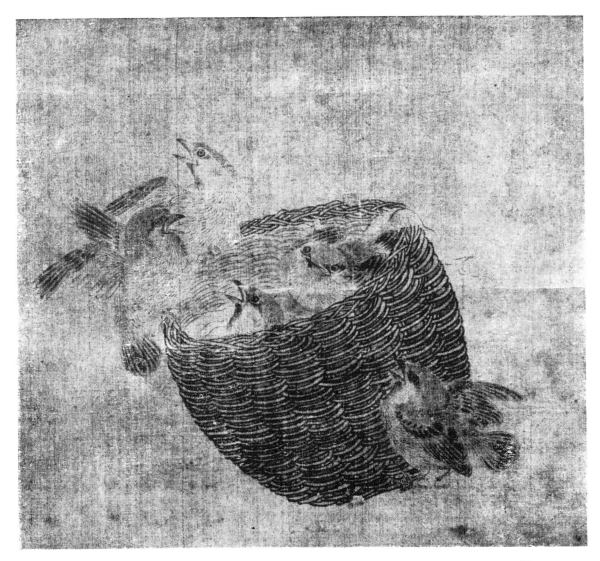

132. UNKNOWN ARTIST. YOUNG SPARROWS. Album-leaf. Colour on silk. H.c.24 cm. W.24 cm.
13th century A.D. *Private Collection, Japan.*

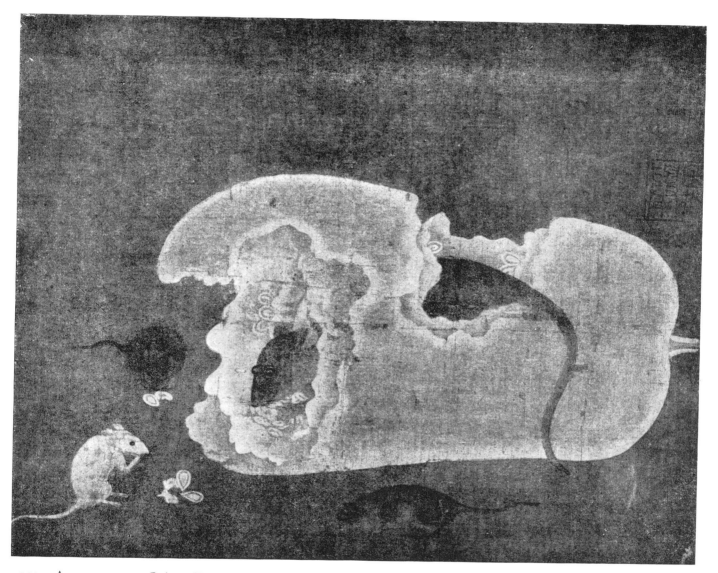

133. ATTRIBUTED TO CH'IEN HSÜAN (A.D. 1235-C. 1290). RATS FEEDING ON A MELON. Album-leaf. Colour on silk. H.c.22 cm. *Private Collection, Japan.*

134. Chao Mêng-fu (A.D. 1254-1322). Two Horses. Fragment of a hand scroll. Ink on silk. H.40 cm. W.65 cm. Dated 1301. *Mr. A. Stoclet, Brussels.*

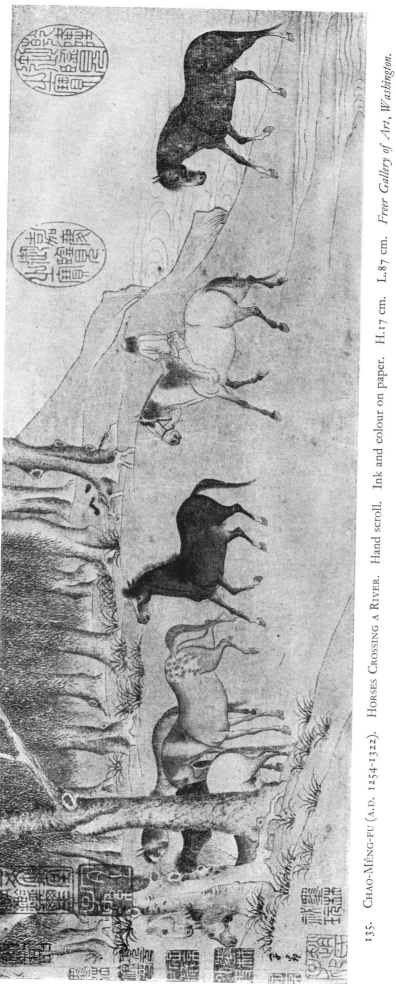

135. CHAO-MÊNG-FU (A.D. 1254–1322). HORSES CROSSING A RIVER. Hand scroll. Ink and colour on paper. H.17 cm. L.87 cm. *Freer Gallery of Art, Washington.*

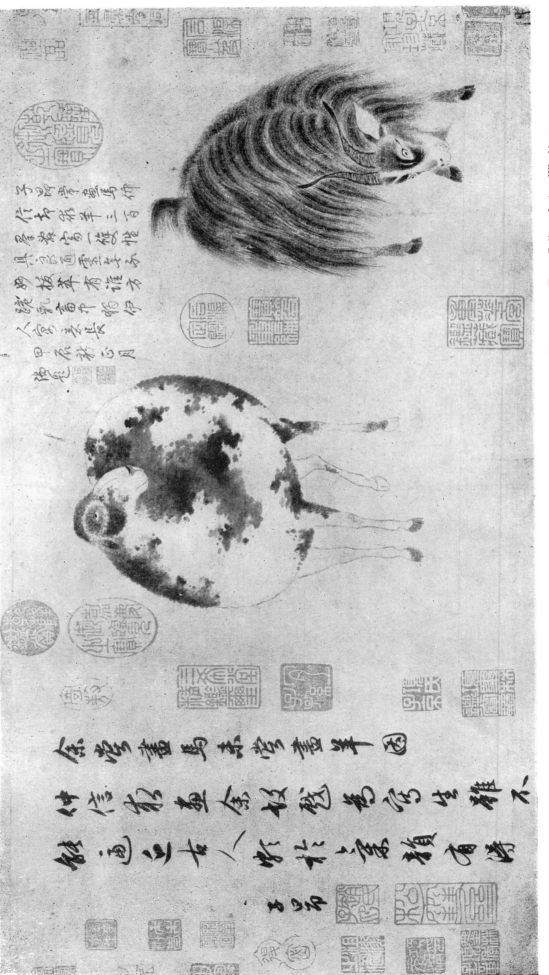

136. CHAO MÊNG-FU (A.D. 1254-1322). A GOAT AND A SHEEP. Ink on paper. H.25 cm. W.48 cm. *Freer Gallery of Art, Washington.*

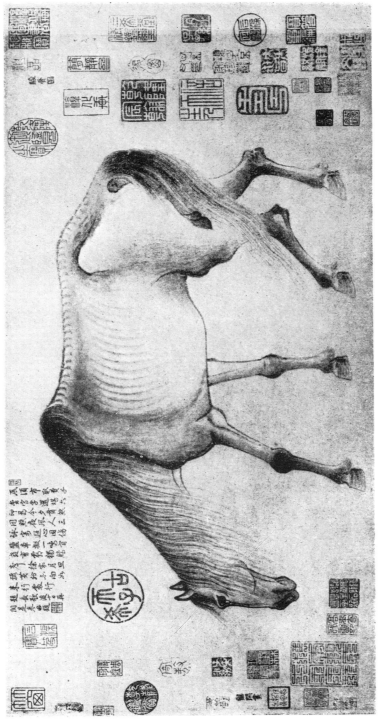

137. KUNG K'AI (late 13th century A.D.). THE EMACIATED HORSE. Ink on paper. H.30 cm. W.56 cm. *Private Collection, Japan.*

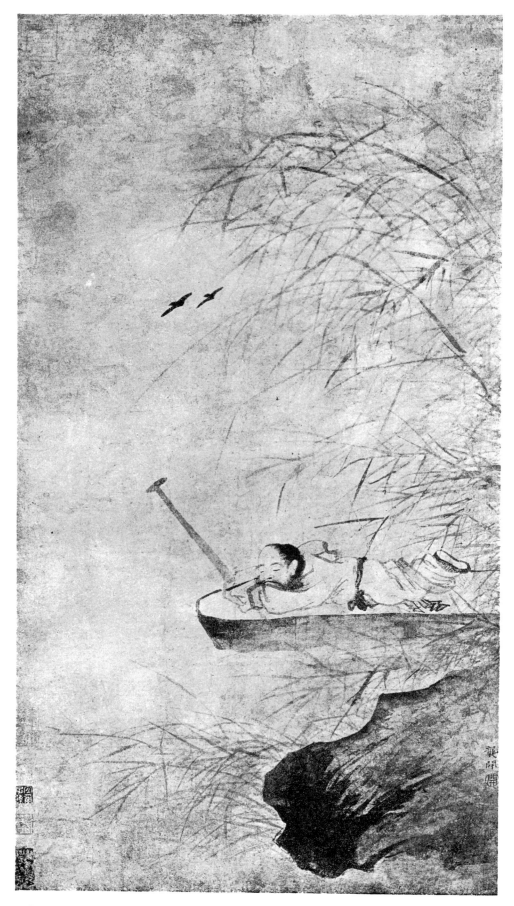

138. ATTRIBUTED TO KUNG K'AI (late 13th century A.D.). ASLEEP IN A BOAT NEAR THE SHORE. Ink on paper. H.104 cm. W.55 cm. *Freer Gallery of Art, Washington.*

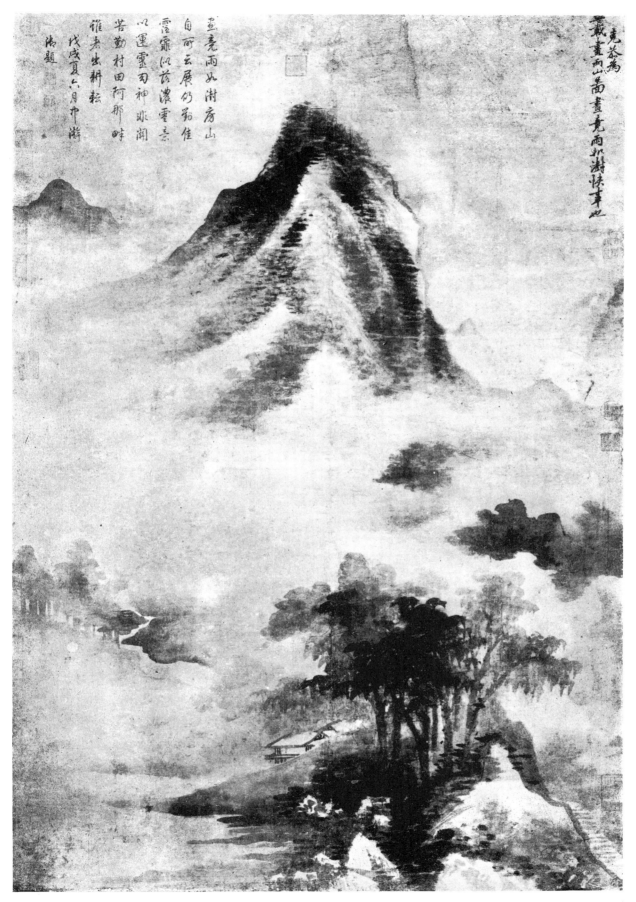

139. KAO K'O-KUNG (active 2nd half of the 13th century A.D.). LANDSCAPE AFTER RAIN. Ink on paper. H.122 cm. W.81 cm. *Chinese Government.*

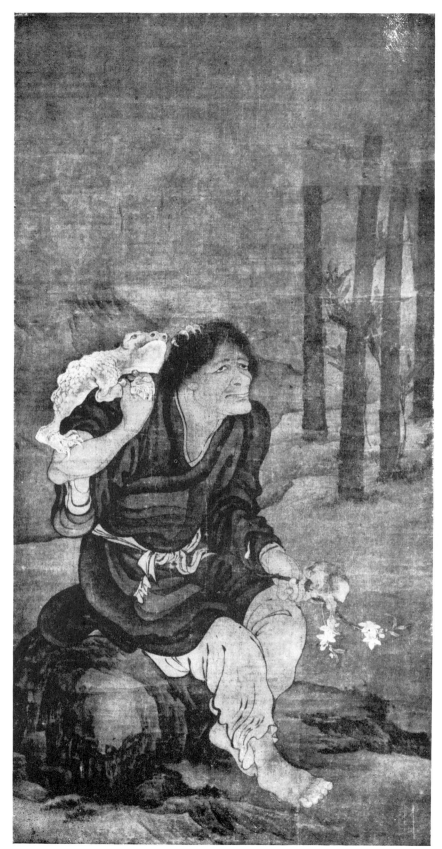

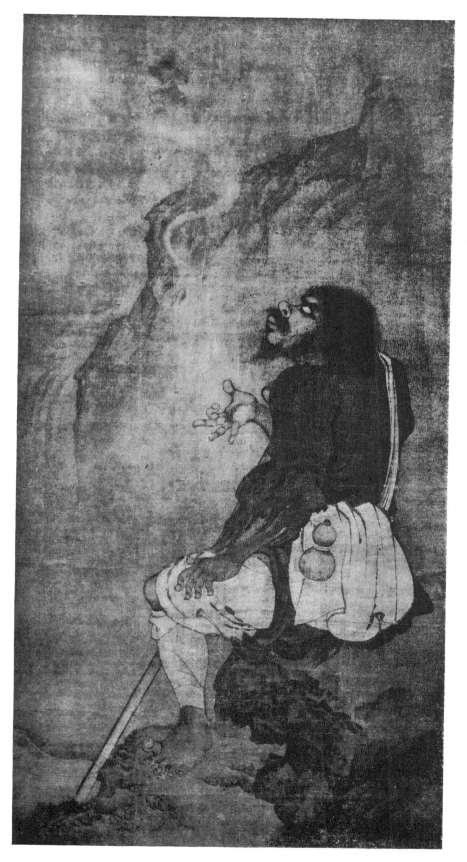

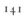

140-141. YEN HUI (14th century A.D.). THE TWO HERMITS HA-MA AND T'IEH-KUAI. A pair of paintings. Ink and colour on silk. H.160 cm. W.78 cm. *Chionji, Kyōto*.

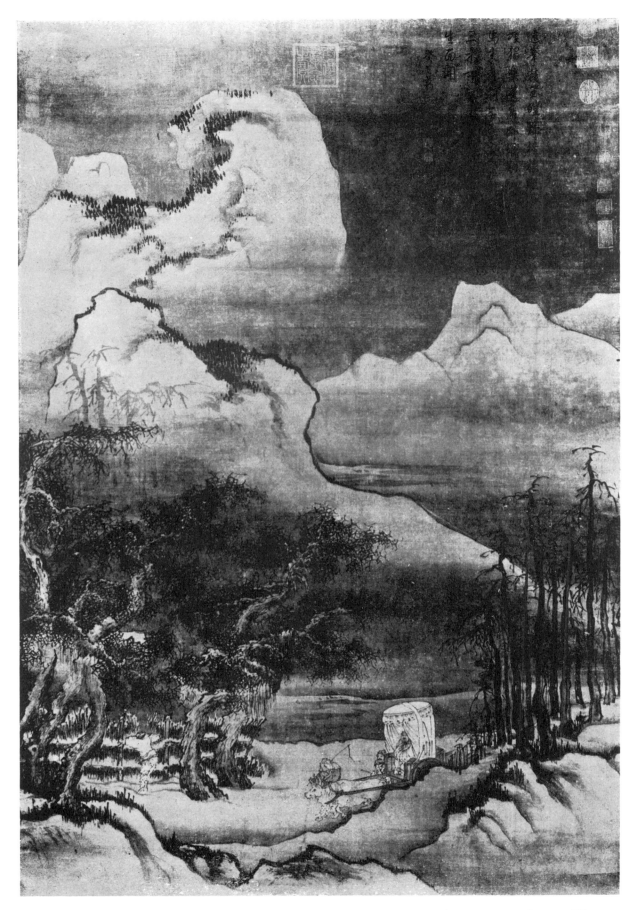

142. ATTRIBUTED TO YEN HUI (14th century A.D.). WINTER LANDSCAPE. Ink on silk. H.160 cm. W.105 cm.
Chinese Government.

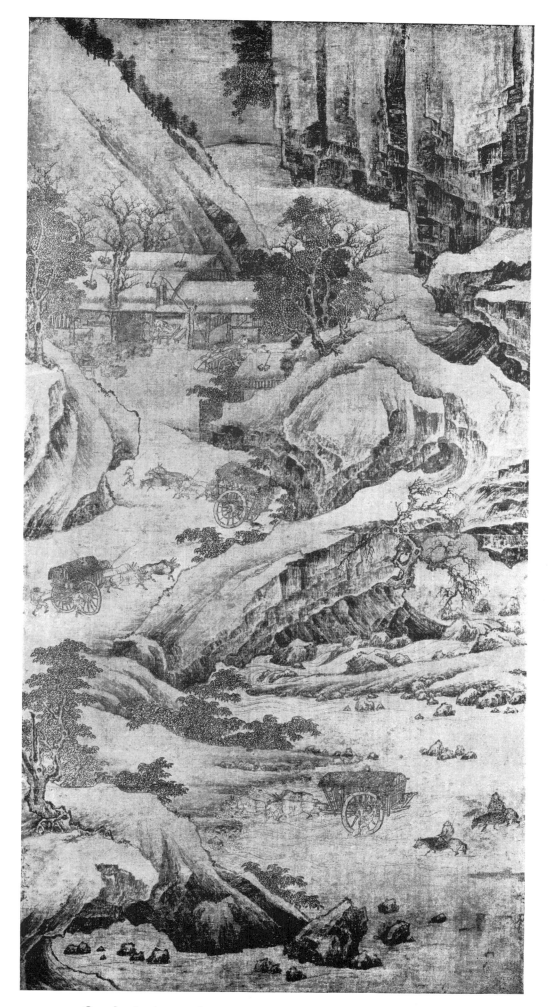

143. CHU JUI (13th or 14th century A.D.). BULLOCK CARTS IN THE MOUNTAINS.
Colour and ink on silk. H.104 cm. W.51 cm. *Museum of Fine Arts, Boston.*

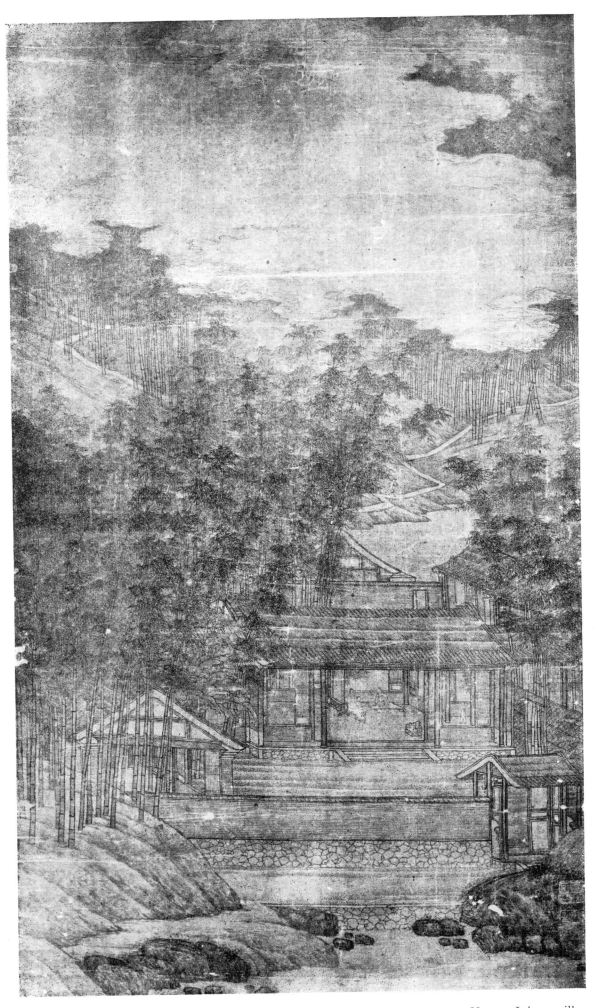

144. SIGNED LI WEI (11th century A.D.?). BAMBOO GROVE WITH SUMMER HOUSE. Ink on silk.
H.75 cm. W.41 cm. Probably 13th or 14th century A.D. *Museum of Fine Arts, Boston.*

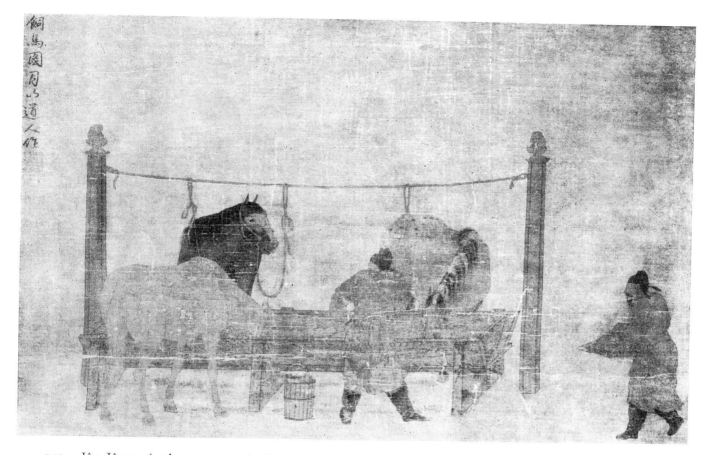

145. JÊN JÊN-FA (14th century A.D.). FEEDING HORSES. Ink and slight colour on silk. H.50 cm. W.75 cm.
Victoria and Albert Museum, London.

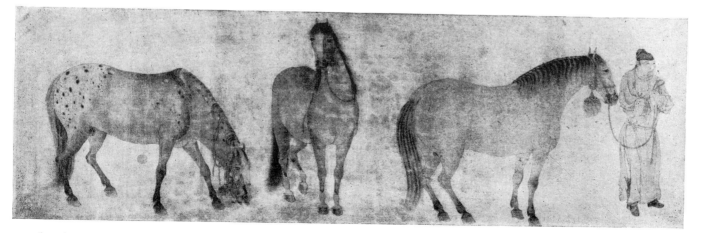

146. ATTRIBUTED TO JÊN JÊN-FA (14th century A.D.). HORSES WITH GROOMS. Part of a hand scroll. Dated 1314.
Colour on silk. H.28 cm. L.175 cm. *Fogg Art Museum, Cambridge (Mass.).*

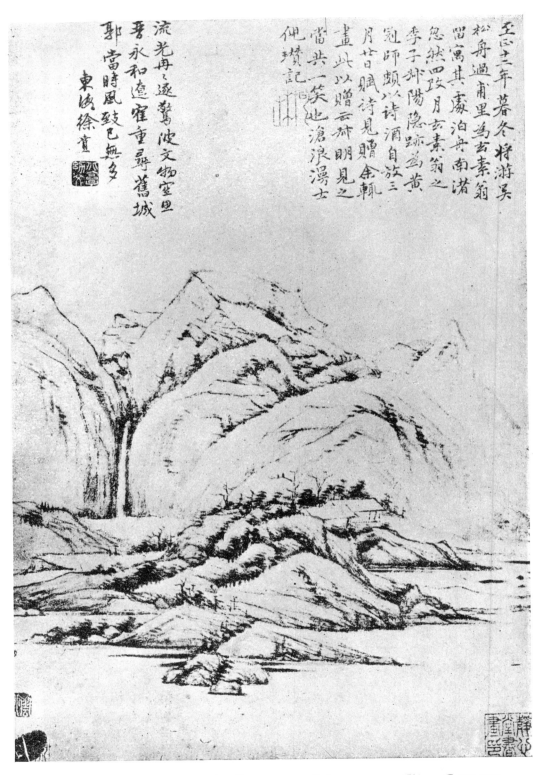

至正十二年暮冬將游吳
松舟過甫里為去素翁
留寓其霧泊舟南渚
忽然四玻月玄素翁之
季子邶陽隱跡為黃
冠師頓以詩酒自放三
月苦賦詩見贈余輒
畫此以贈云邶明見之
當共一笑也滄浪漫士
俾讚記

流光冉冉逐驚波文物空里
晉永和遙崔重尋舊城
郭當時風致已無多
東海徐賁

147. NI TSAN (A.D. 1301-1374). LANDSCAPE. Ink on paper. *Chinese Government*.

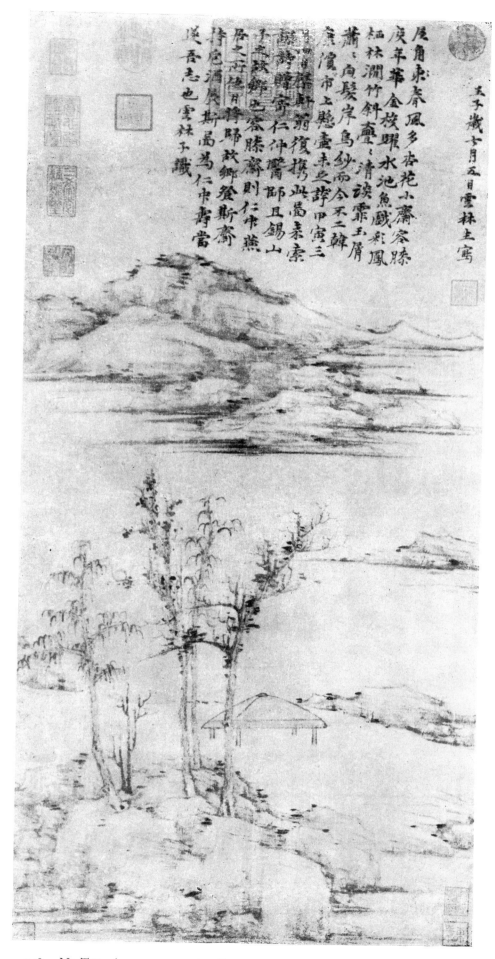

148. NI TSAN (A.D. 1301-1374). LANDSCAPE WITH PAVILION. Ink on paper.
H.73 cm. W.35 cm. *Chinese Government*.

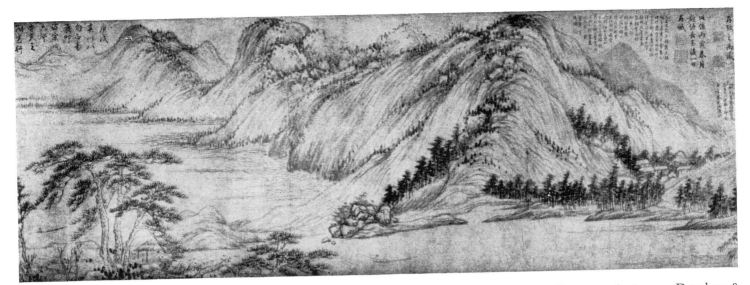

149. HUANG KUNG-WANG (A.D. 1269-1354). LANDSCAPE. Part of a hand scroll. Ink on paper. H.32 cm. L.589 cm. Dated 1338. *Chinese Government.*

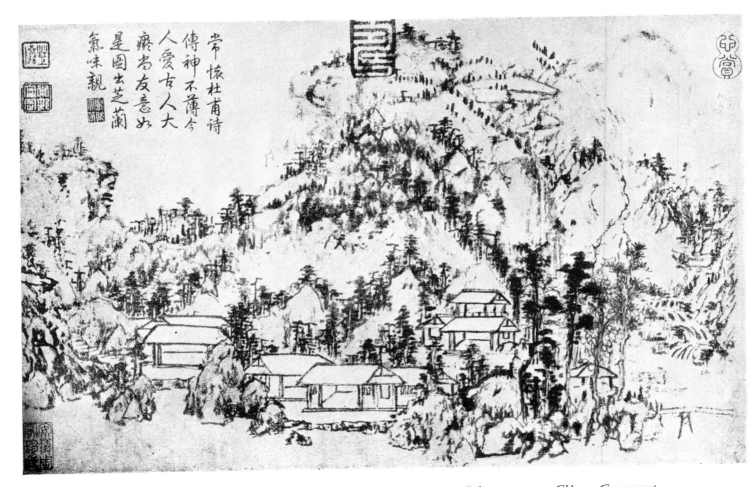

150. HUANG KUNG-WANG (A.D. 1269-1354). LANDSCAPE. Ink on paper. *Chinese Government.*

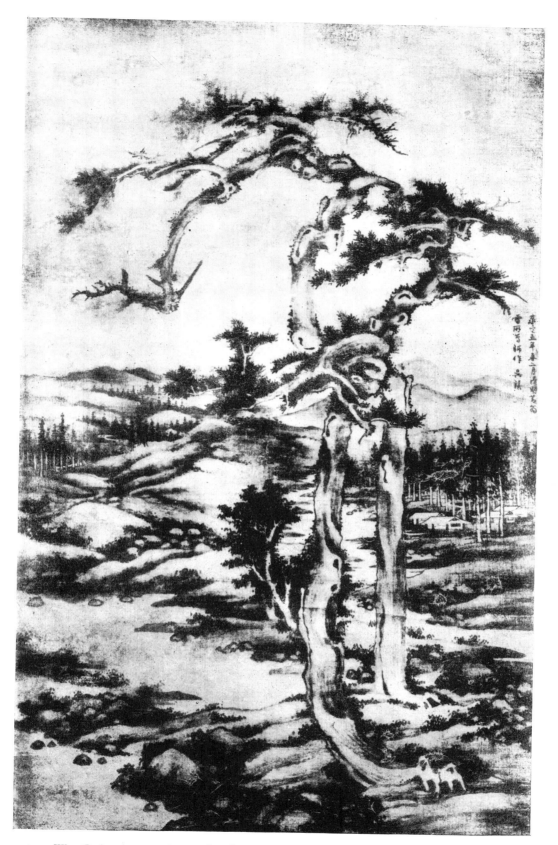

151. Wu Chên (a.d. 1280-1354). Landscape with two Pine Trees. Ink on paper. *Chinese Government.*

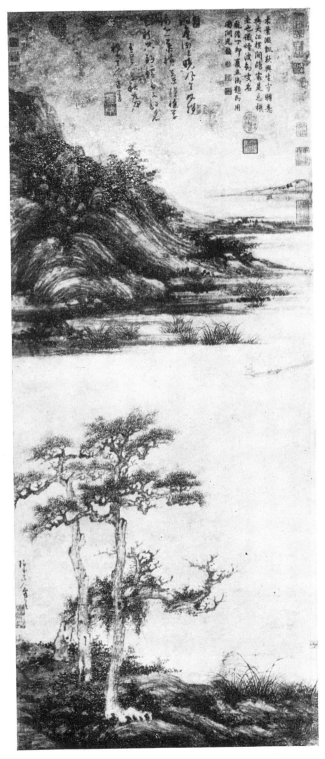

152. WU CHÊN (A.D. 1280-1354). LANDSCAPE. Ink on paper. H.145 cm. W.58 cm. *Chinese Government.*

153. WANG MÊNG (A.D. 1308-1385). LANDSCAPE WITH WATERFALL. Ink on paper. *Chinese Government.*

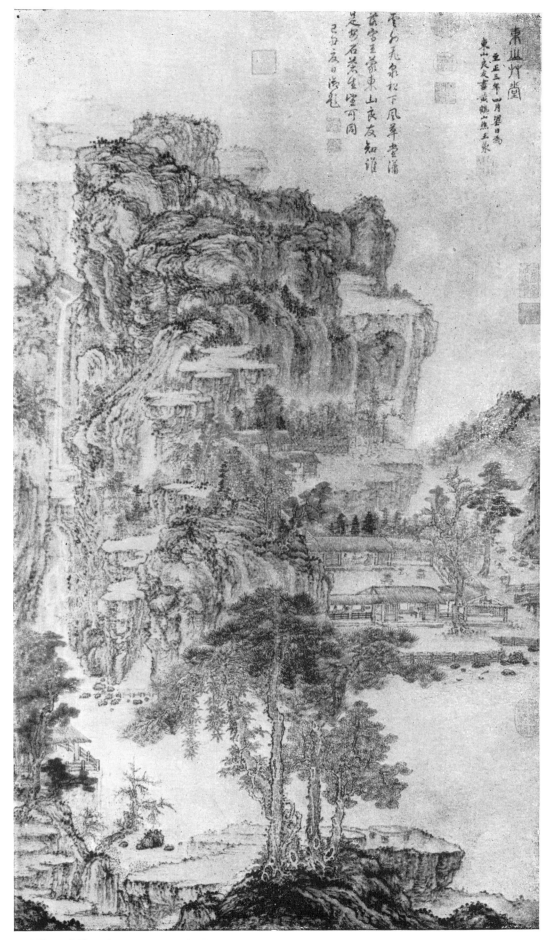

東山草堂

至正三年四月望日為
東山良友知誰

雲幻无象松下風華堂道
蒼雪圭華東山良友知誰
是鄉石崇坐堂可同
己己庚日涑花

154. WANG MÊNG (A.D. 1308-1385). LANDSCAPE WITH THATCHED SUMMER HOUSES. Colour on paper.
H.111 cm. W.60 cm. *Chinese Government.*

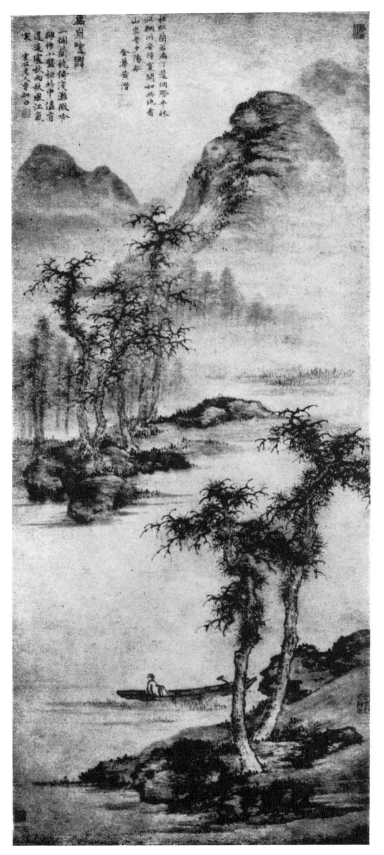

155. Ts‘ao Chih-pai (13th-14th century A.D.). River Landscape.
Ink on paper. *Private Collection, China.*

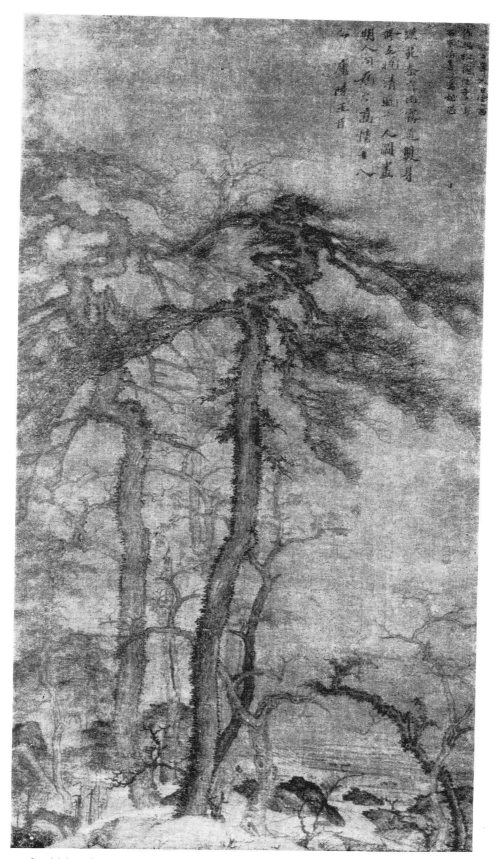

156. Ts‘ao Chih-pai (13th-14th century A.D.). Two Pine Trees. Ink on silk.
H.132 cm. W.57 cm. Dated 1329. *Chinese Government.*

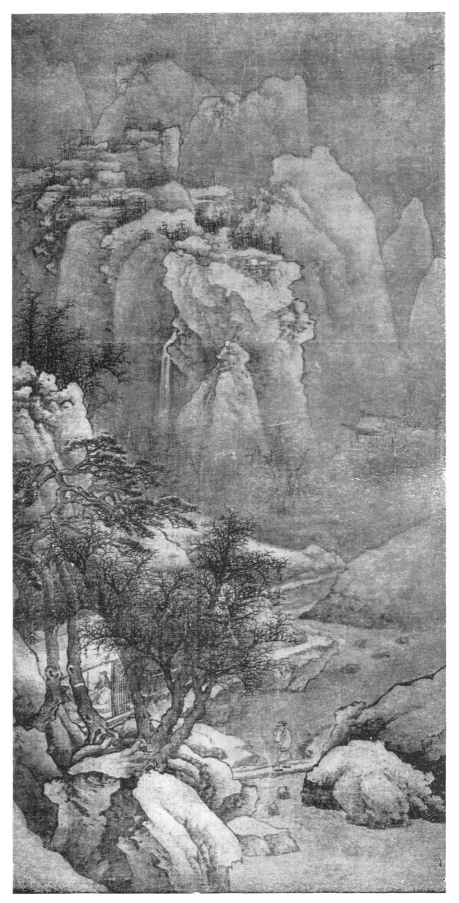

157. SHÊNG MOU (14th century A.D.). WINTER LANDSCAPE. Ink on silk.
H.106 cm. W.49 cm. *British Museum, London.*

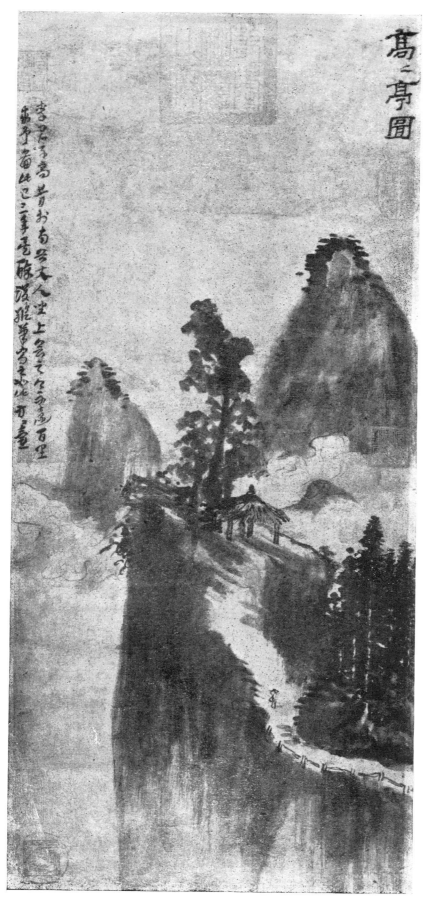

158. FANG TS'UNG-I (14th century A.D.). LANDSCAPE WITH PAVILION.
Ink on paper. H.62 cm. W.28 cm. *Chinese Government*.

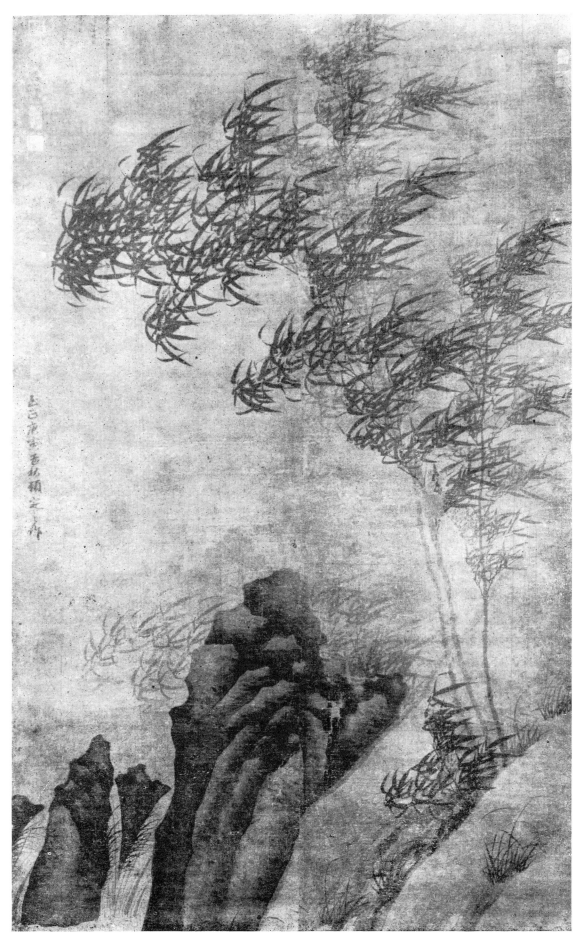

159. KU AN (14th century A.D.). BAMBOOS AND ROCKS. Ink on silk. H.187 cm. W.104 cm.
Dated 1350. *Chinese Government*.

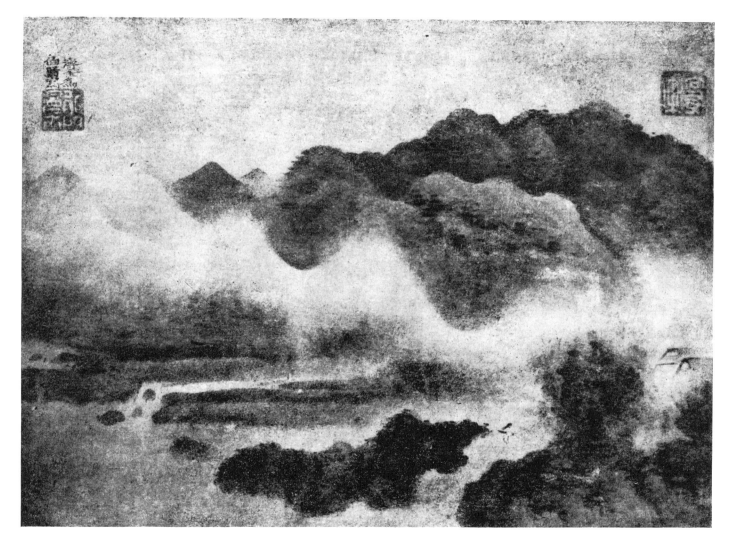

160.　Kao Jan-hui (13th-14th century a.d.).　Summer Haze.　Ink and slight colour on paper.
Private Collection, Japan.

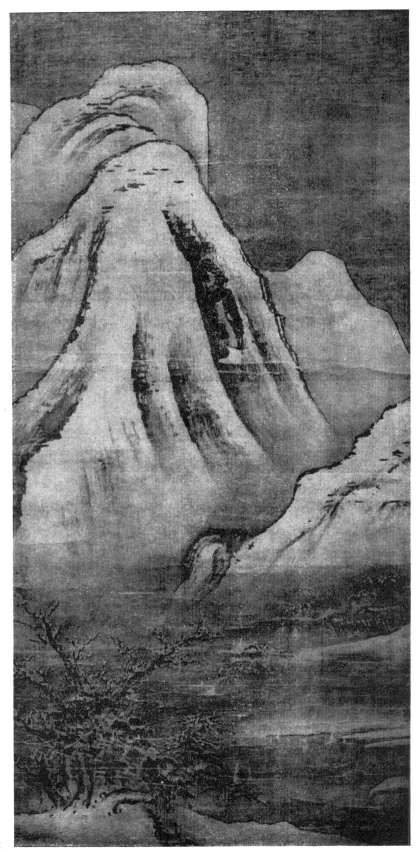

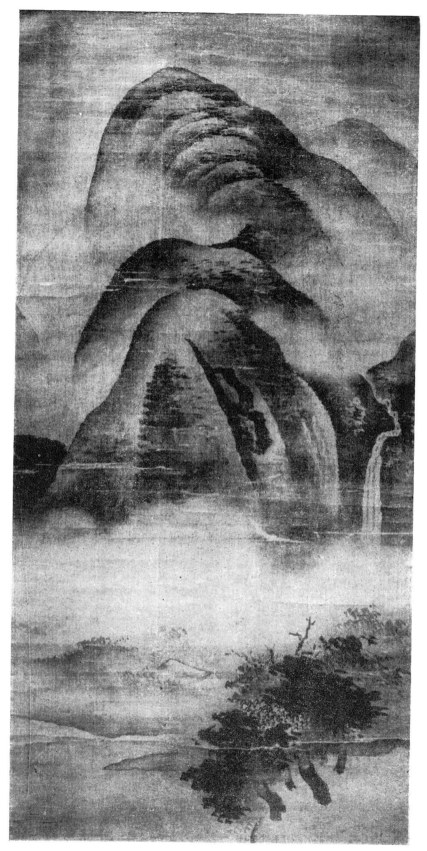

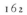 162

161-162. KAO JAN-HUI (13th-14th century A.D.). WINTER AND SUMMER LANDSCAPE.
A pair of paintings. Ink on silk. H.124 cm. W.60 cm. *Konchiin, Kyōto.*

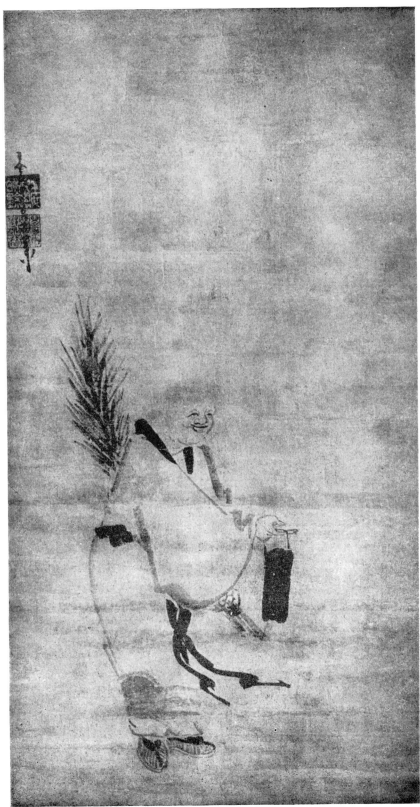

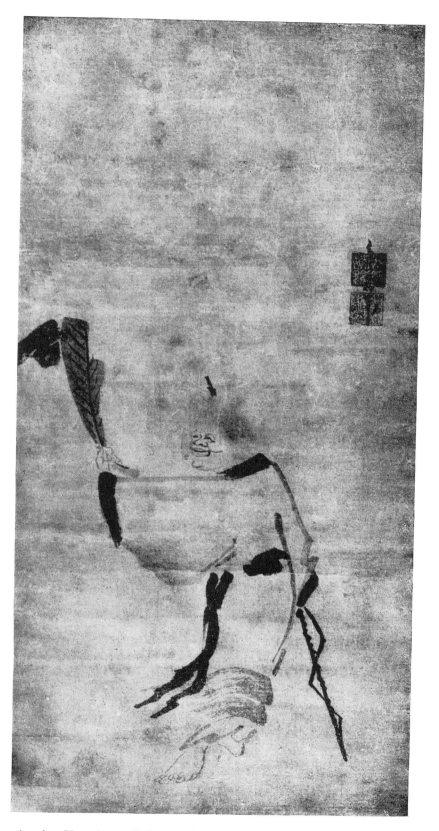

164

163-164. Yin-t'o-lo (Indara, 13th century A.D.). Han-shan and Shih-tê.
A pair of paintings. Ink on paper. *Private Collection, Japan.*

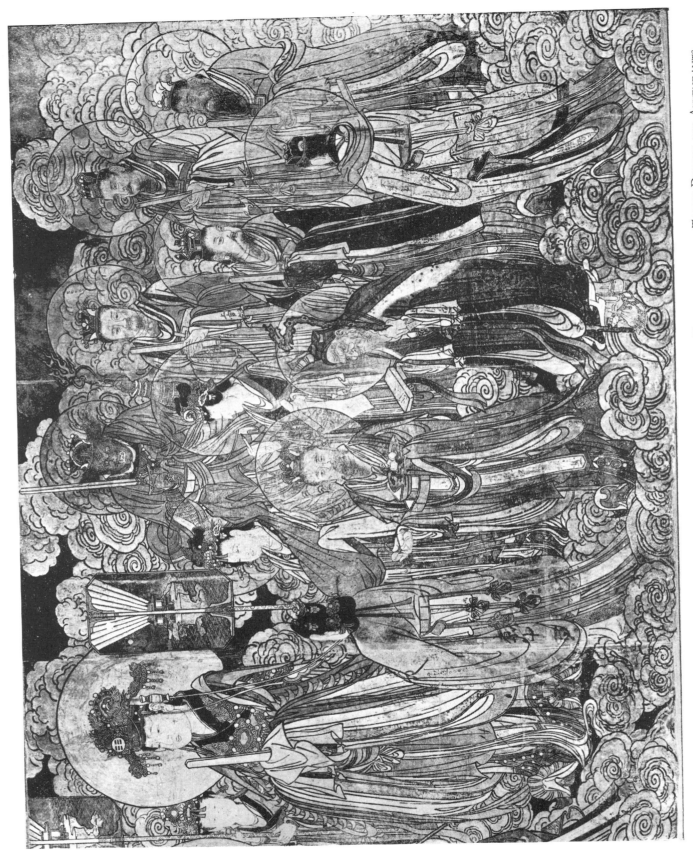

165. Chên Wu, the Prince of the North Pole, the Seven Deities of the Northern Dipper, and other Taoist Deities and Attendants. Part of a fresco. Colour. H.341 cm. 13th or 14th century A.D. *Royal Ontario Museum, Toronto.*

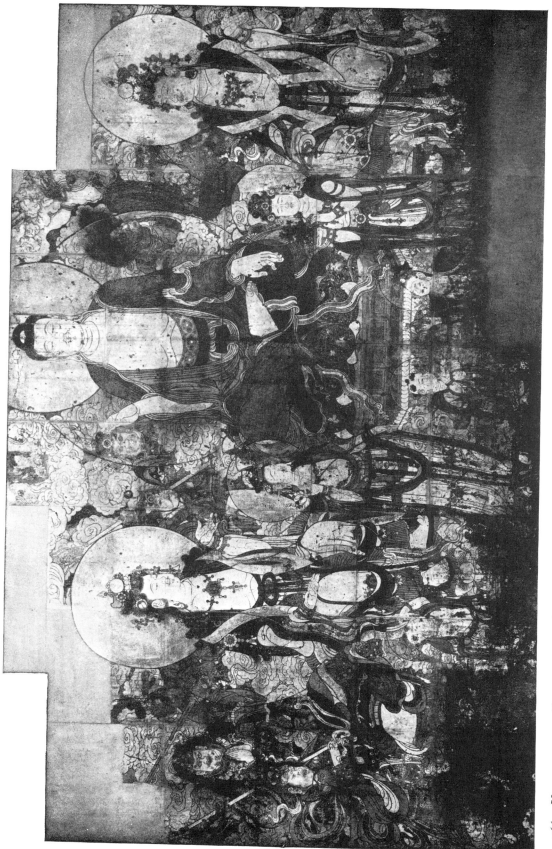

166. Yo-shih-wang (Bhaishajyaguru) accompanied by Jih Tʻien (Sun) and Yüeh Tʻien (Moon), the Twelve Generals and other Attendants. Fresco. Colour. H.c.550 cm. W.c. 1000 cm. 15th century A.D. From the Yüeh Shan Ssŭ (Honan). *University Museum, Philadelphia.*

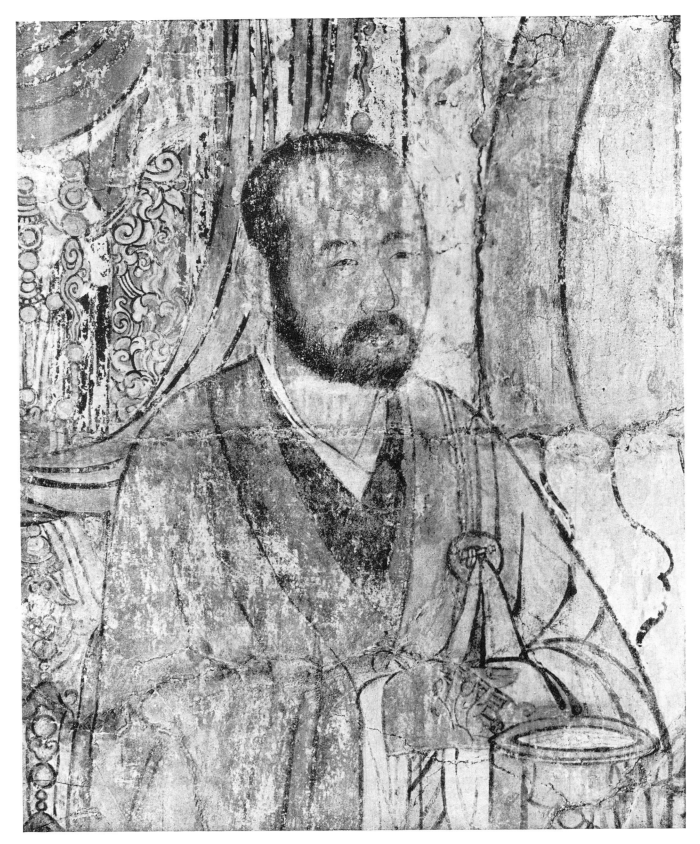

167. PORTRAIT OF A PRIEST. Fresco. Fragment. Colour. H.41 cm. W.30 cm. 13th or 14th century A.D.
British Museum, London.

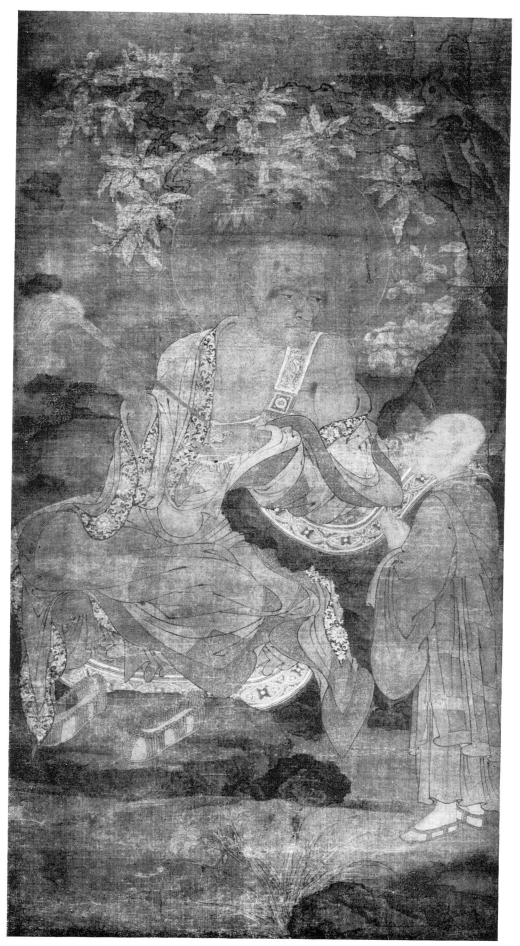

168. UNKNOWN ARTIST. LOHAN AND WORSHIPPING PRIEST. Colour on silk.
H.148 cm. W.76 cm. 14th or 15th century A.D. *Freer Gallery of Art, Washington.*

169

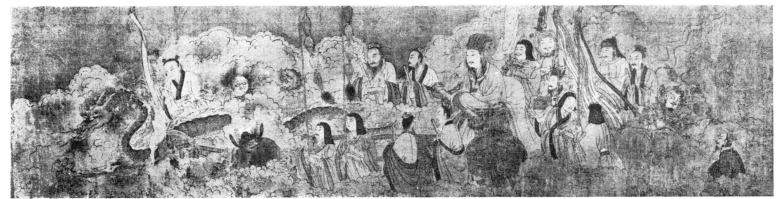

171

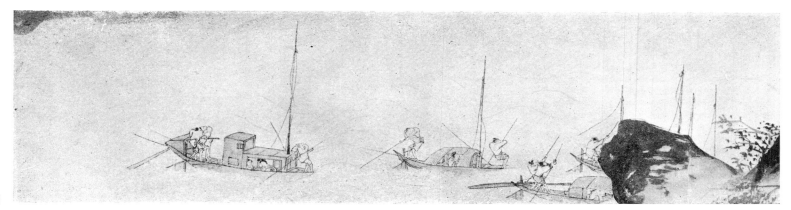

173

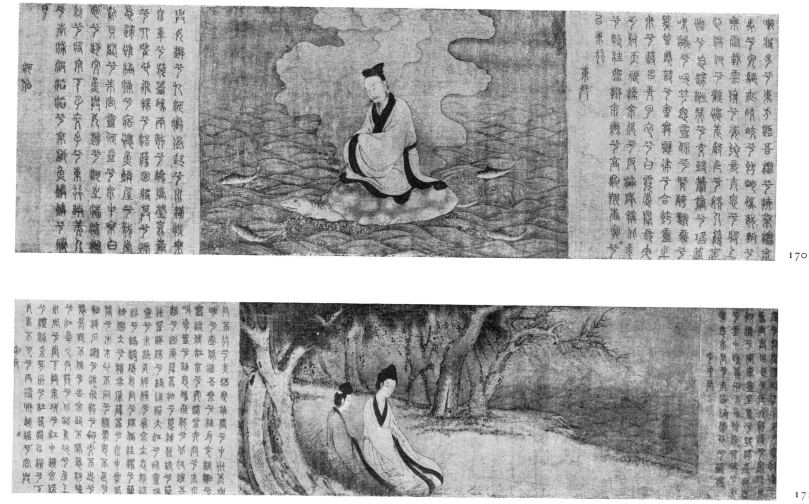

170

169-172. ATTRIBUTED TO CHANG WU (14th century A.D.). THE NINE SONGS OF CH'Ü YÜAN (3rd century B.C.). Parts of a hand scroll. Colour on silk. H.25 cm. L.608 cm. *Museum of Fine Arts, Boston.*

172

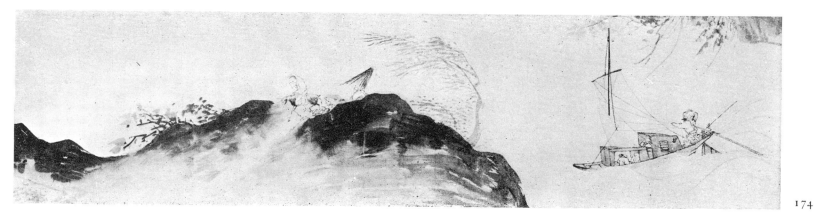

174

173-174. TAI CHIN (15th century A.D.). ON THE RIVER. Parts of a hand scroll. Ink on paper. H.29 cm. L.1112 cm. *Freer Gallery of Art, Washington.*

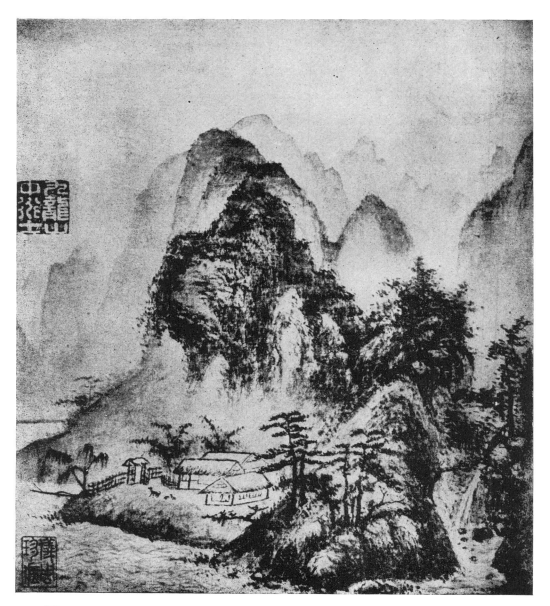

175. WANG FU (A.D. 1362-1416). LANDSCAPE WITH FARM. Ink on paper. *Chinese Government.*

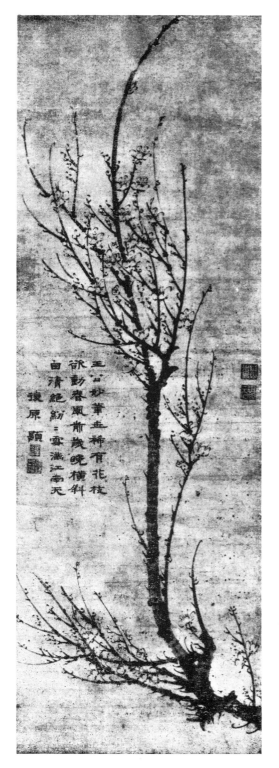

176. Wang Mien (a.d. 1335-1407). Plum-Blossom.
Ink on paper. *Private Collection, Japan.*

177

蓬居河雯雲壅田
分付寒蟾伴老梅
半縞烟消香窘冷
墨痕留影上窗來
最寒夲新秋

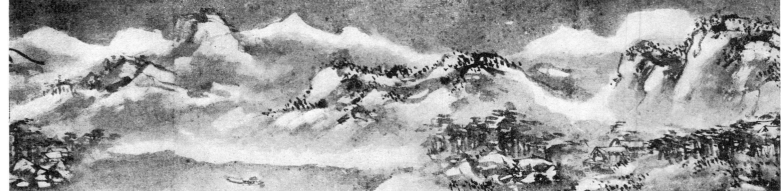

179

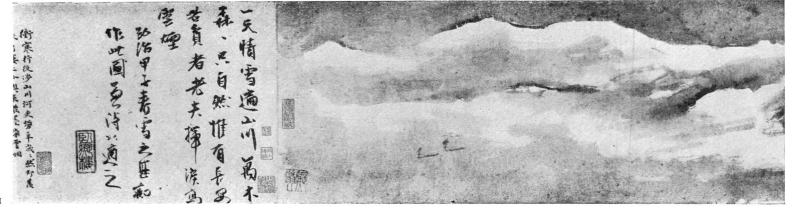

181

一天情雪遍山川萬木
森、只自然堆有長耶
若貫者老夫揮凍寫
雲煙
弘治甲子春雪之止和
作此圖ゑ時以遣之

衛寒仁得沙山川河大夢千戌怣然打老
仁一長二十生辰波老柴雲州

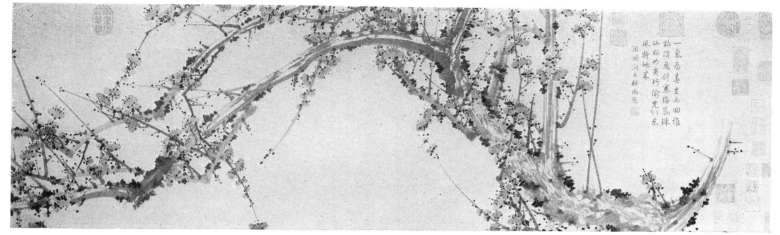

一氣惠士必回推
物消息付寒梅蕊珠
仙坼幼葵巧偷笔东
風持地来
閑閑閒元楨鸿题

178

177-178. TSOU FU-LEI (14th century A.D.). PLUM-BLOSSOM. Hand scroll. Ink on paper. H.34 cm. L.221 cm.
Freer Gallery of Art, Washington.

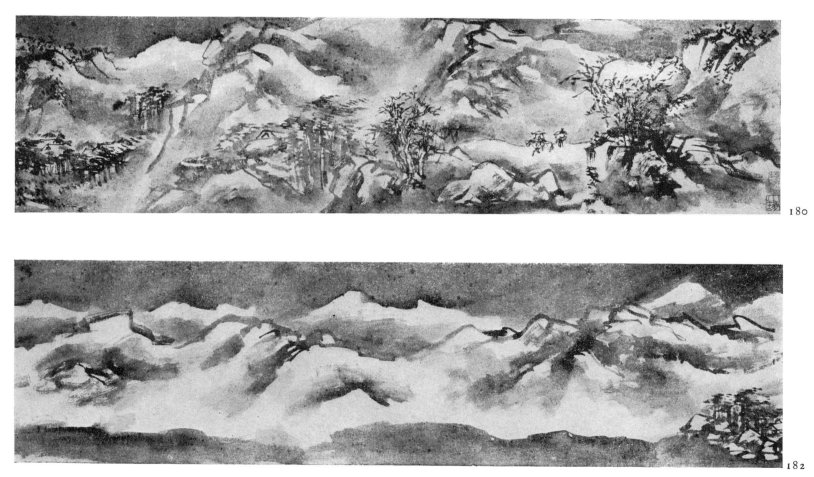

180

182

179-182. SHIH CHUNG (A.D. 1437-1517). WINTER LANDSCAPE. Hand scroll. Ink on paper. H.25 cm. L.319 cm. Dated 1504.
Museum of Fine Arts, Boston.

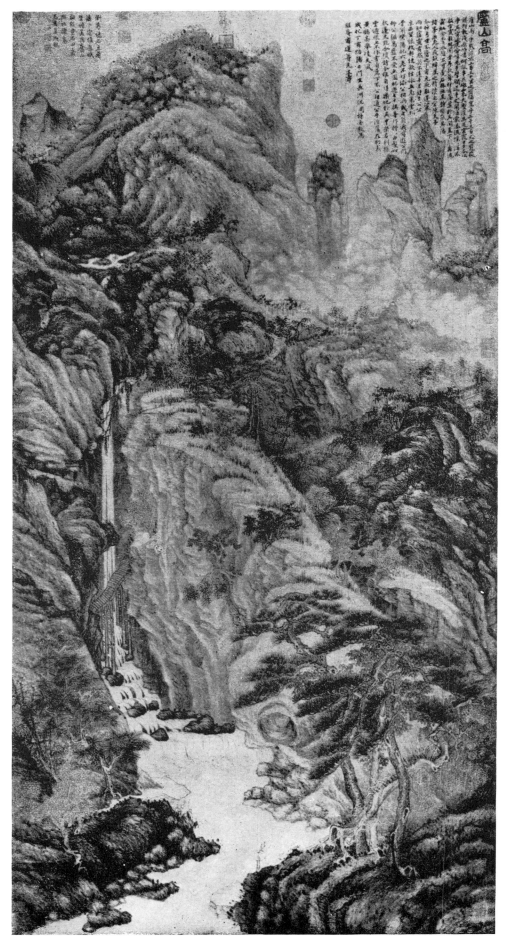

183. SHÊN CHOU (A.D. 1427-1509). LANDSCAPE WITH WATERFALL. Ink and slight colour on paper.
H.193 cm. W.98 cm. Dated 1467. *Chinese Government.*

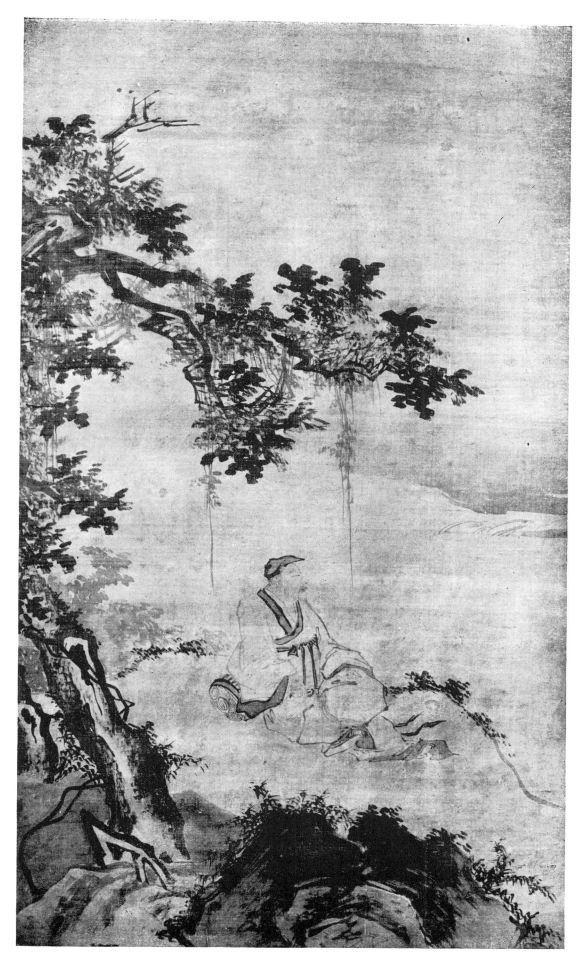

184. ATTRIBUTED TO WU WEI (A.D. 1458-1508). IN CONTEMPLATION OF NATURE. Ink and slight colour on silk. H.146 cm. W.82 cm. *Museum of Fine Arts, Boston.*

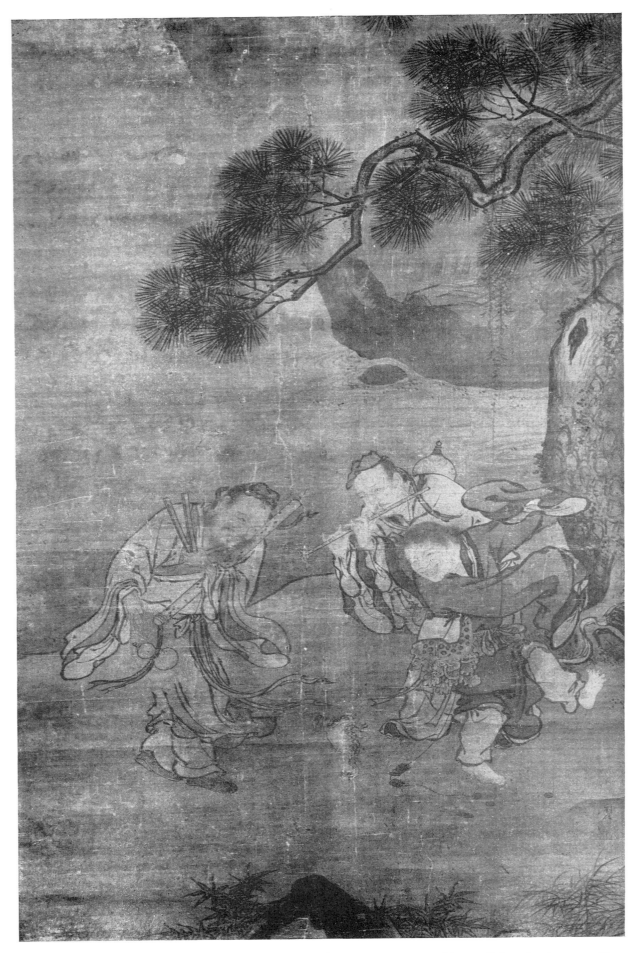

185. LIU CHÜN (15th century A.D.). THREE SENNIN DANCING AROUND A TOAD. Ink and colour on silk.
H.135 cm. W. 84 cm. *Museum of Fine Arts, Boston.*

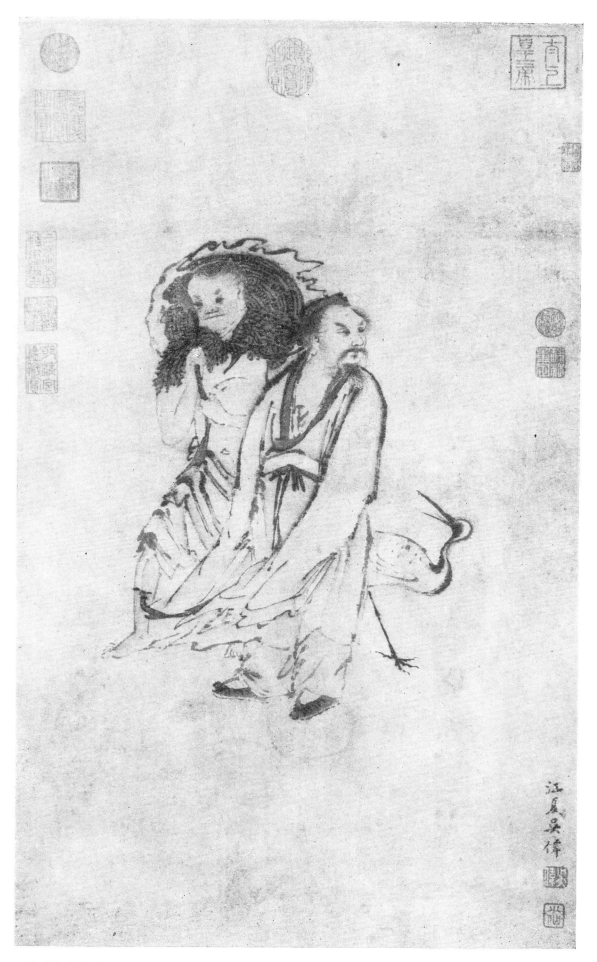

186. WU WEI (A.D. 1458-1508). TWO OF THE EIGHT IMMORTALS. Ink on paper. H.69 cm. W.39 cm.
Chinese Government.

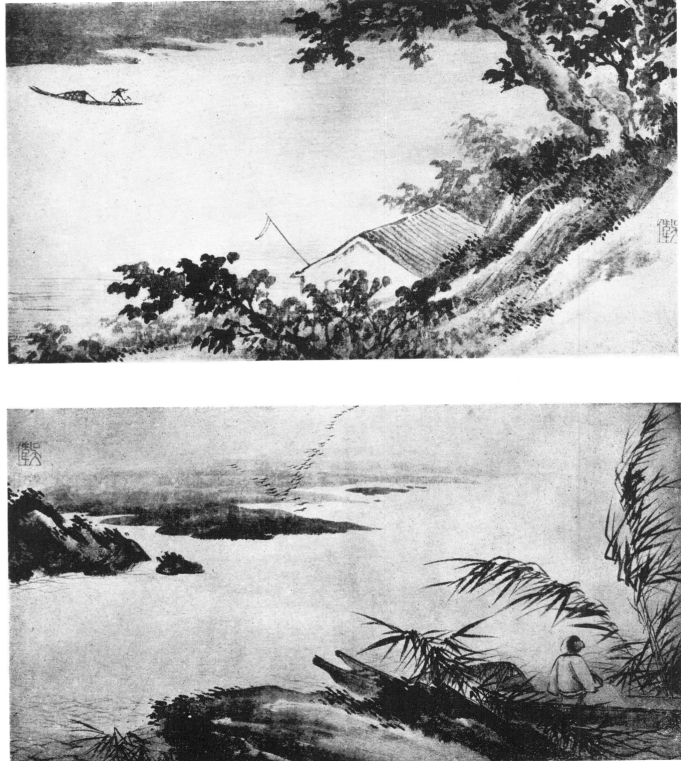

187

188

187-188. Wu Wei (A.D. 1458-1508). River Landscapes. Album-leaves. Ink on paper. H.37 cm. W.69 cm.
National Museum, Stockholm.

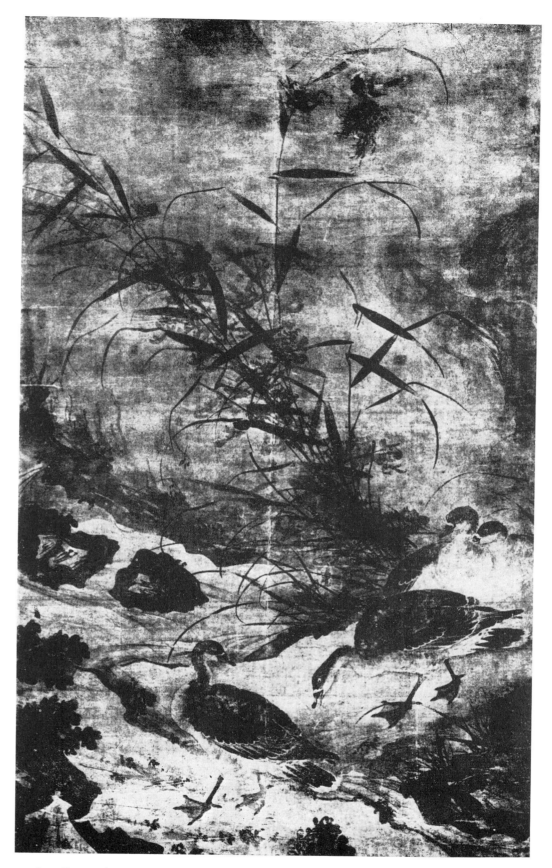

189. LIN LIANG (C. A.D. 1500). WILD GEESE AND BUSHES. Ink on silk. H.188 cm. W.99 cm.
British Museum, London.

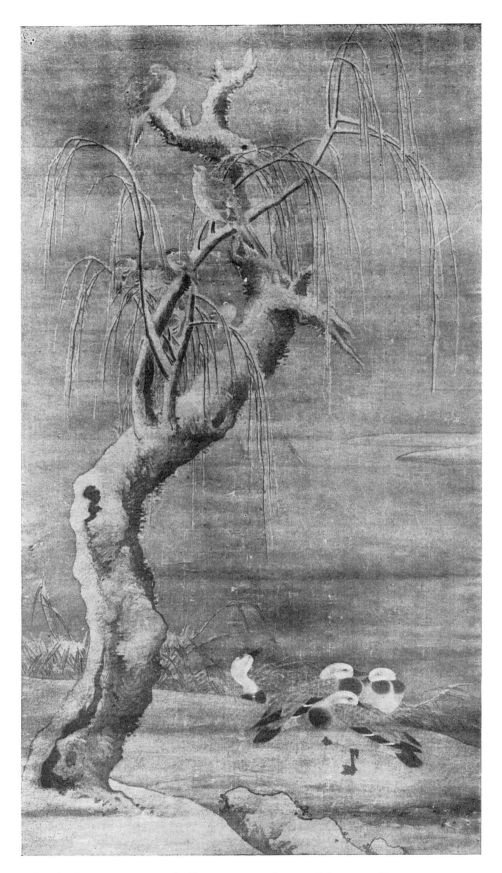

190. Lü Chi (active A.D. 1488-1506). Ducks in the Snow. Colour on silk. H.170 cm. W.91 cm.
Chinese Government.

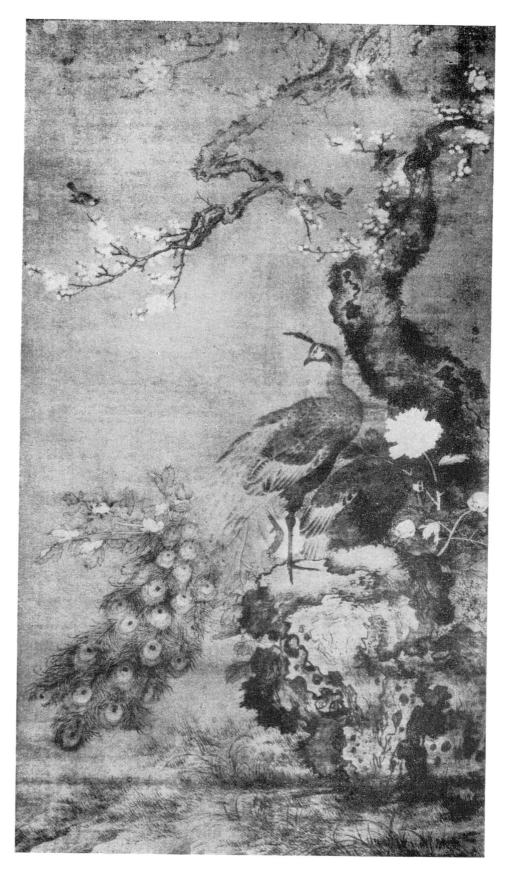

191. LÜ CHI (active A.D. 1488-1506). PEACOCK UNDER A PLUM TREE AND PEONIES. Colour on silk. *Chinese Government.*

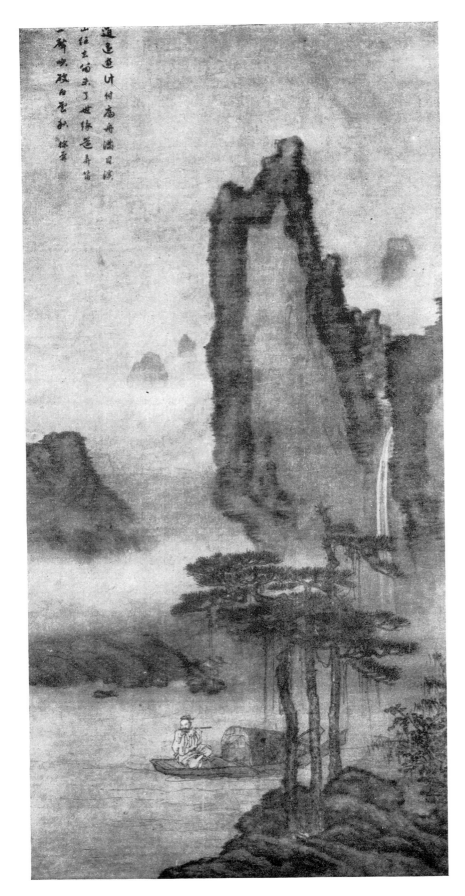

192.　Hsü Lin (early 16th century A.D.).　Landscape with a Man Playing the Flute in a Boat.
Ink and colour.

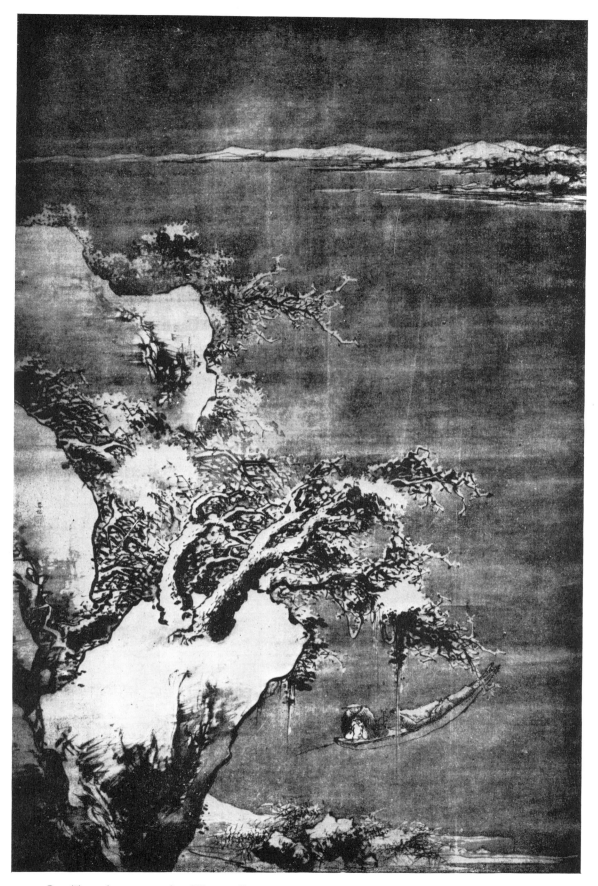

193.　Chu Tuan (c. a.d. 1500).　Winter Landscape with Angler in a Boat.　Ink and colour on silk.
H.80 cm.　W.120 cm.　*Manjuin, Kyōto.*

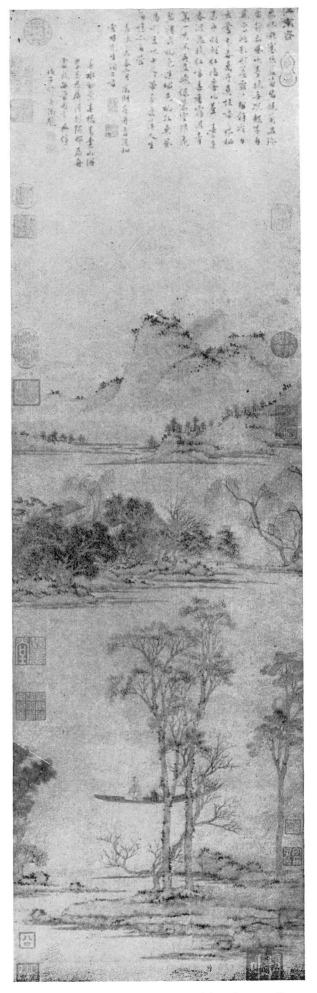

194. WÊN CHÊNG-MING (A.D. 1470-1567). SPRING LANDSCAPE.
Ink and slight colour on paper. H.106 cm. W.30 cm. Dated 1547.
Chinese Government.

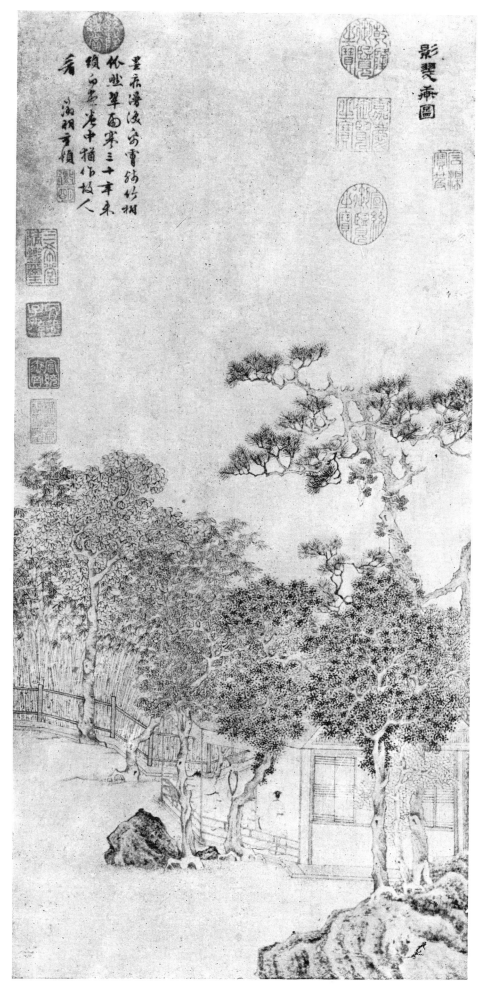

195. WÊN CHÊNG-MING (A.D. 1470-1567). SUMMER HOUSE UNDER TREES. Colour on paper.
H.67 cm. W.31 cm. *Chinese Government.*

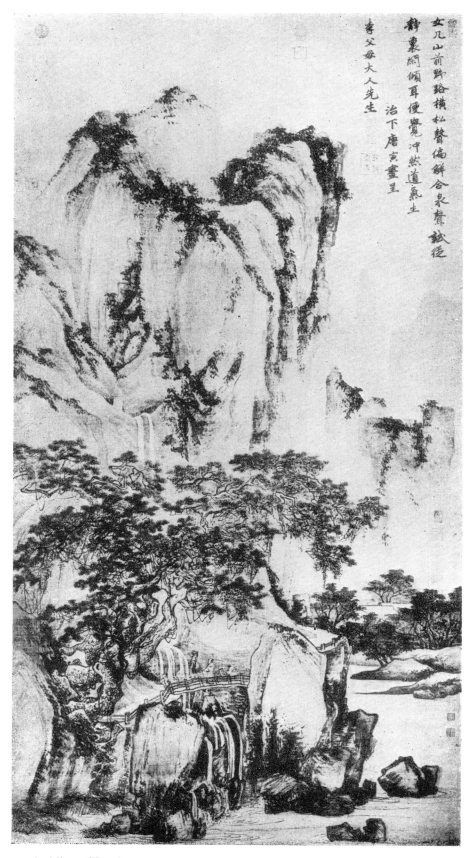

女几山前野路横松聲偏稱合泉聲　試從

靜裏閑傾耳便覺冲然道氣生

治下唐寅畫呈

喜父母大人先生

196. T'ANG YIN (A.D. 1470-1523). LANDSCAPE WITH WATERFALL AND BRIDGE.
Ink on paper. *Chinese Government*.

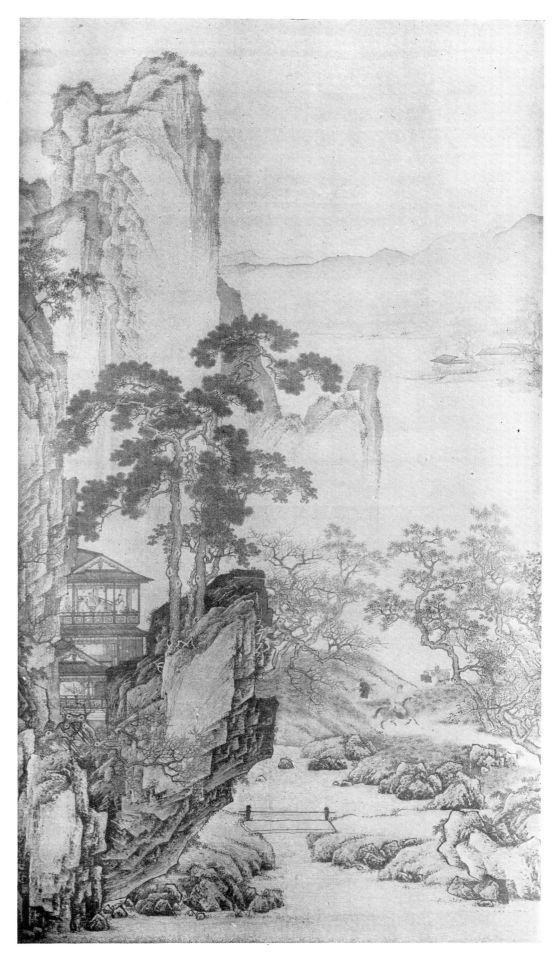

197. CHOU CH'ÊN (active c. A.D. 1500). LANDSCAPE. Ink and colour on silk. H.195 cm. W.107 cm.

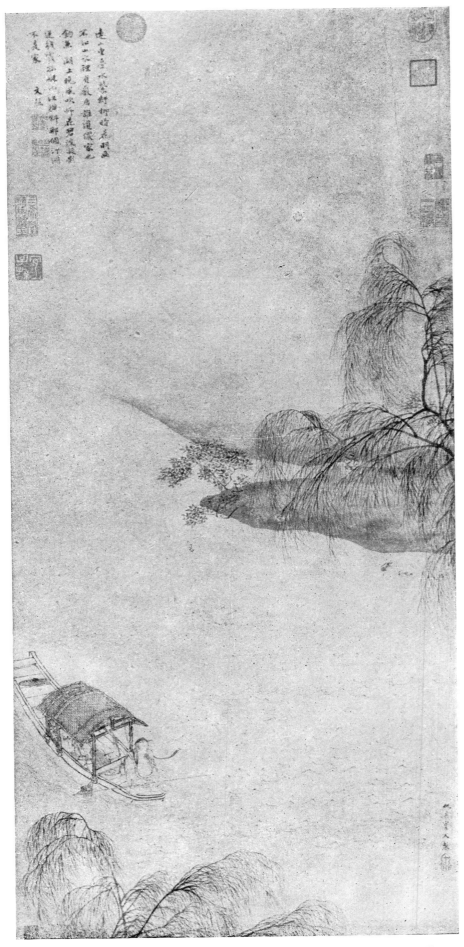

198. CH'IU YING (active c. A.D. 1522-1560). A FISHING BOAT AMONG WILLOWS.
Ink on paper. H.97 cm. W.48 cm. *Chinese Government*.

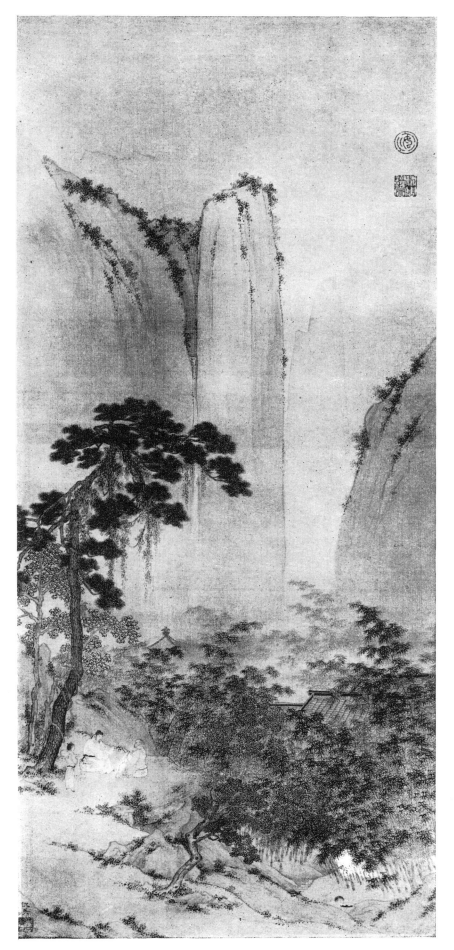

199. CHʻIU YING (active c. A.D. 1522-1560). LANDSCAPE WITH HOUSES IN A BAMBOO GROVE. Ink and colour on silk. H.43 cm. W.31 cm. *Museum of Fine Arts, Boston.*

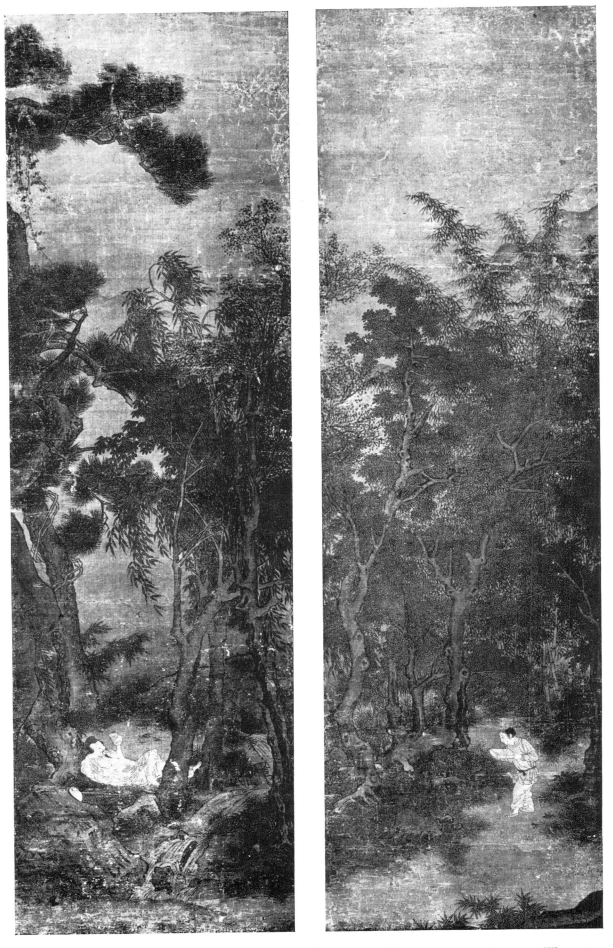

200-201. UNKNOWN ARTIST. IN A FOREST. A pair of paintings. Colour on paper. H.99 cm. W.29 cm.
16th or 17th century A.D. *British Museum, London.*

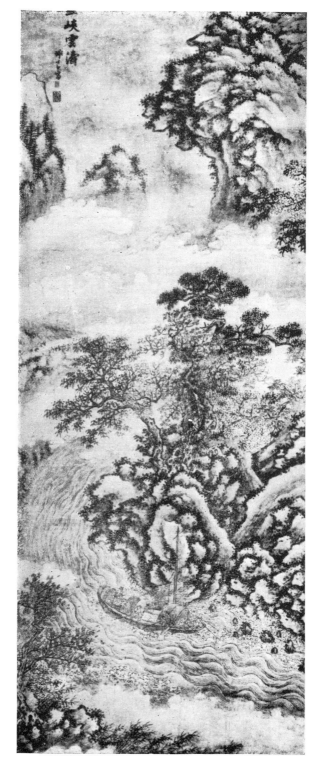

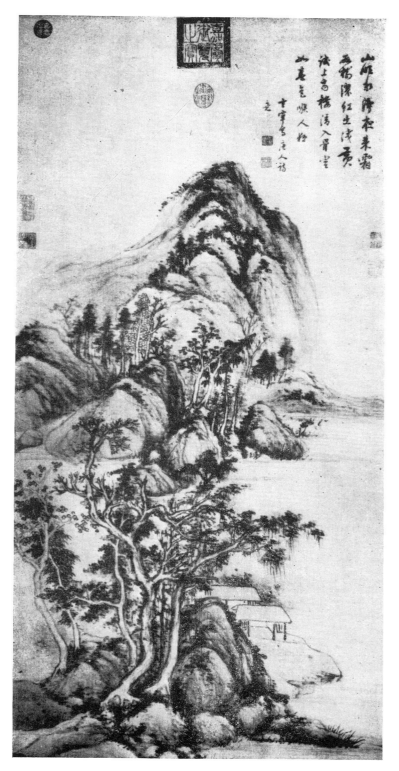

202. HSIEH SHIH-CH'ÊN (A.D. 1488-1547).
IN THE GORGE. Ink on paper.

203. TUNG CH'I-CH'ANG (A.D. 1555-1636). LANDSCAPE.
Ink on paper. *Chinese Government.*

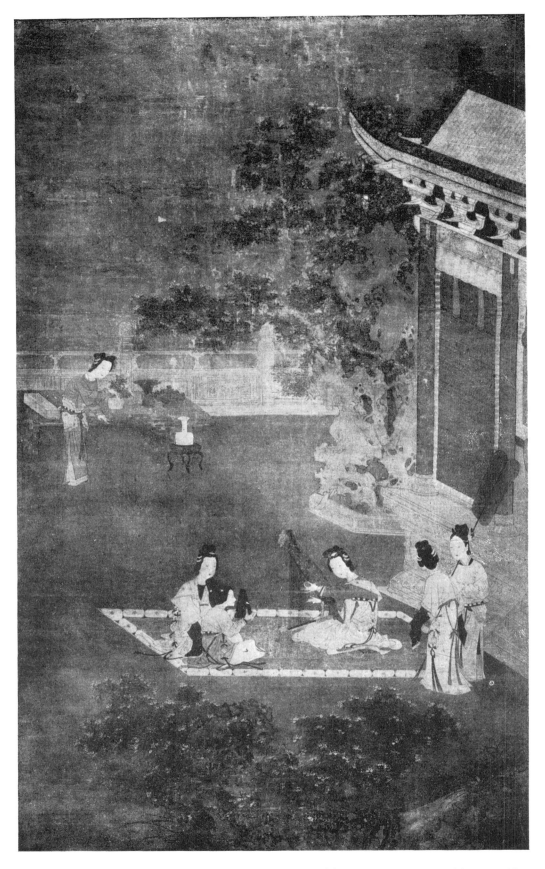

204. ATTRIBUTED TO CH'IU YING (active c. A.D. 1522-1560) OR HIS DAUGHTER TU-LING NEI-SHIH.
MUSIC IN THE GARDEN. Colour on silk. *Private Collection, China.*

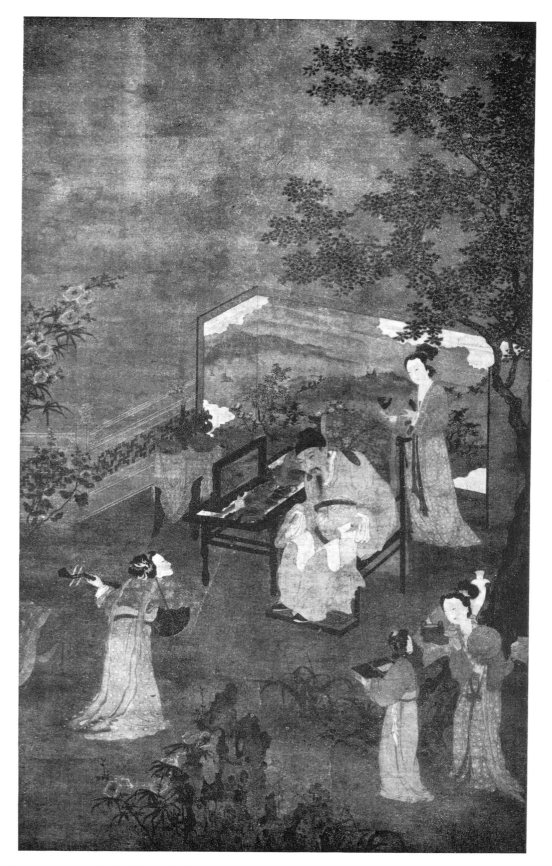

205. ATTRIBUTED TO CH'IU YING (active c. A.D. 1522-1560). THE EMPEROR CH'ÊN SHU-PAO (A.D. 582-604)
LISTENING TO THE MUSIC OF HIS CONCUBINE. Colour on silk. H.170 cm. W.103 cm. *British Museum, London.*

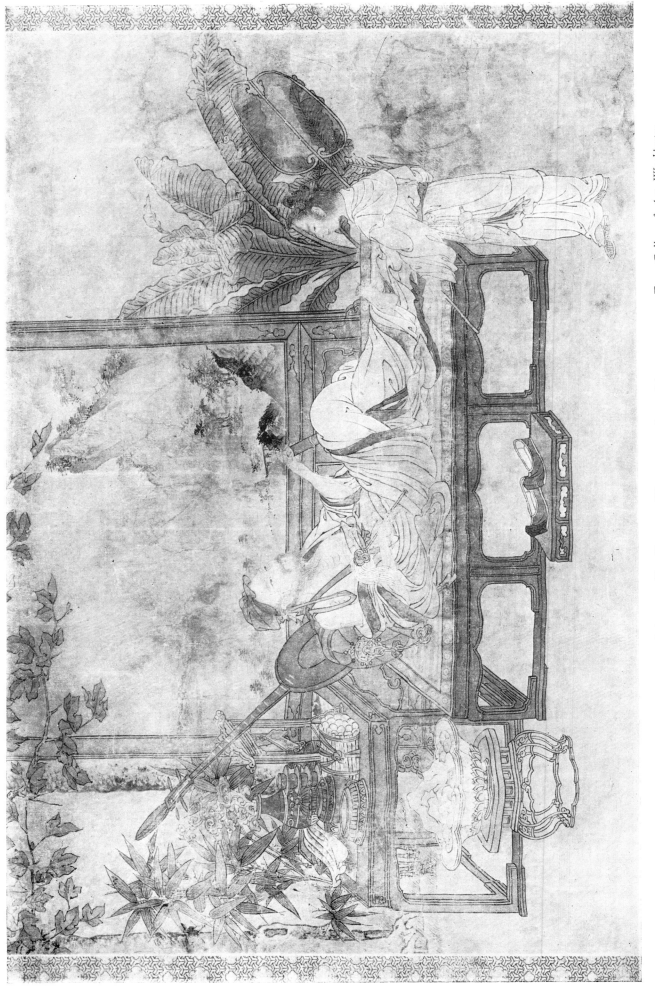

206. Unknown Artist. Poet at Ease. Colour on silk. H.34 cm. W.52 cm. 15th or 16th century A.D. *Freer Gallery of Art, Washington.*

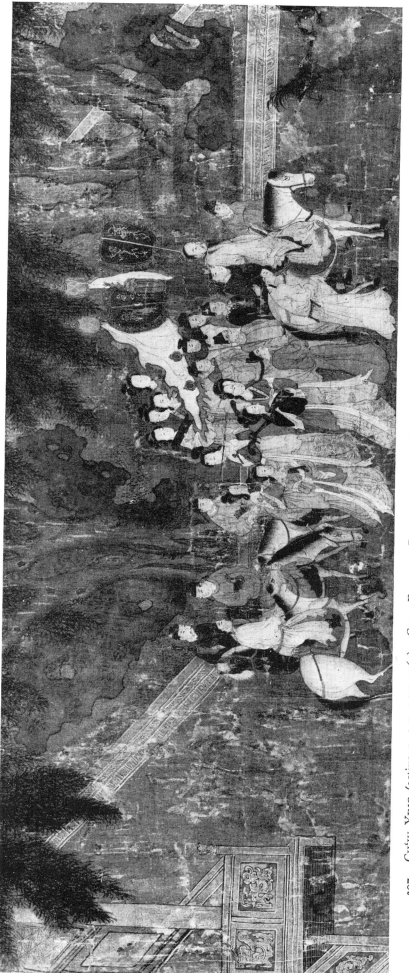

207. CH'IU YING (active c. A.D. 1522-1560). COCK FIGHT IN PRESENCE OF THE EMPEROR. Hand scroll. Colour on silk. H.26 cm. L.192 cm.
Museum of Fine Arts, Boston.

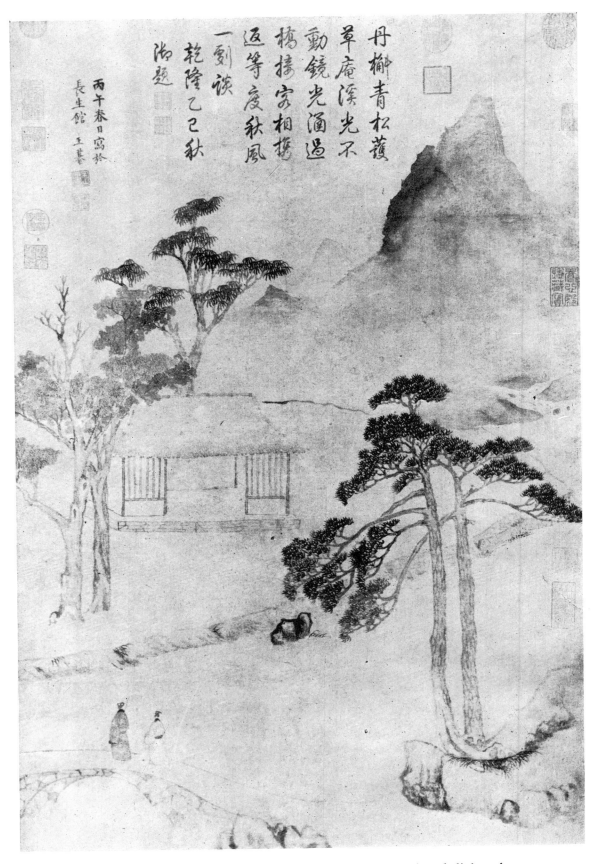

丹榊青松護
草庵溪光不
動鏡光溜過
橋擣衣相楚
返筝度秋風
一刻談
乾隆乙巳秋
御題

丙午春日寫於
長生館
王綦

208. WANG CH'I (early 17th century A.D.). TREES BY A BRIDGE. Ink and slight colour on paper.
H.88 cm. W.58 cm. Dated 1606. *Chinese Government.*

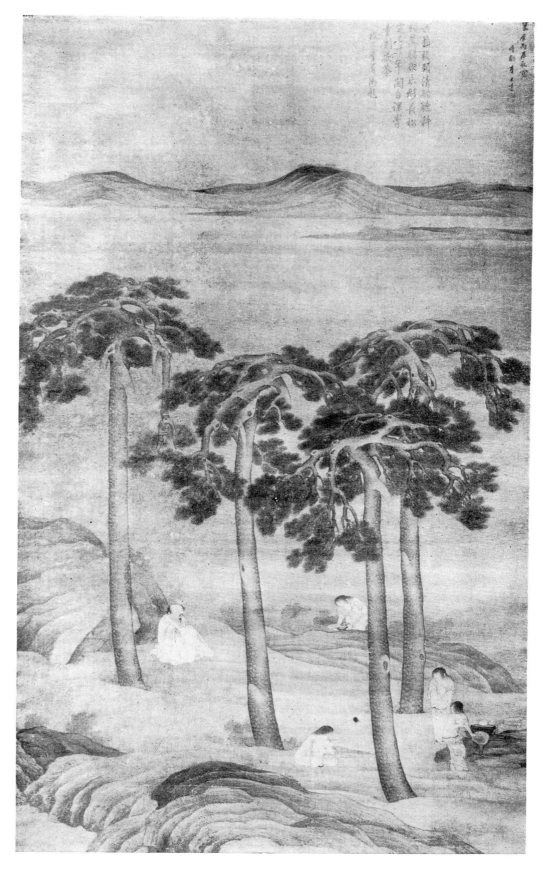

209. LI SHIH-TA (C. A.D. 1556-1620). THE WIND AMONG THE PINES. Colour on silk.
H.167 cm. W.100 cm. Dated 1616. *Chinese Government*.

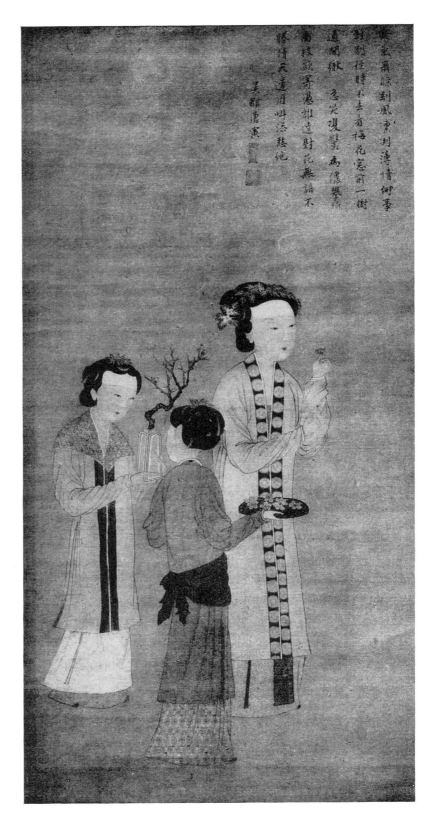

210. T'ANG YIN (A.D. 1470-1523). LADIES WITH FLOWERS. Colour on silk.

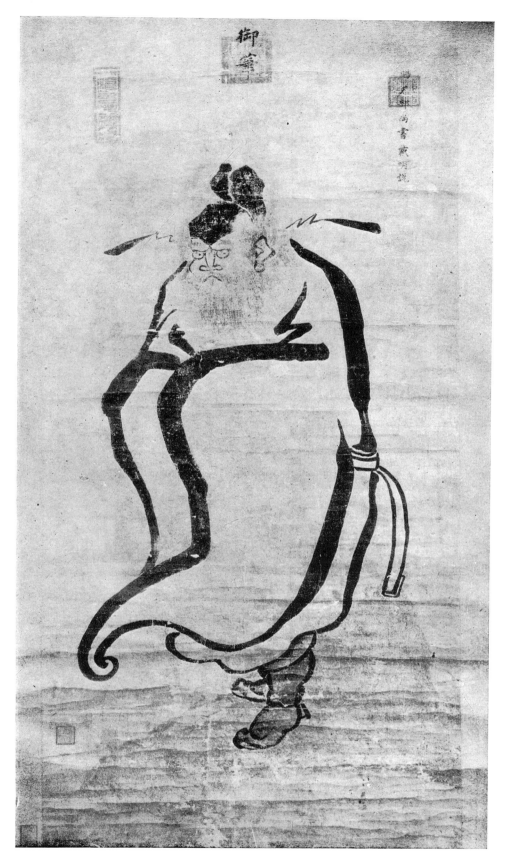

211. THE EMPEROR SHUN CHIH (reigned A.D. 1644-1662). CHUNG KUEI, THE DEMON EXORCISER.
Ink on paper. H.132 cm. W.64 cm. *Chinese Government.*

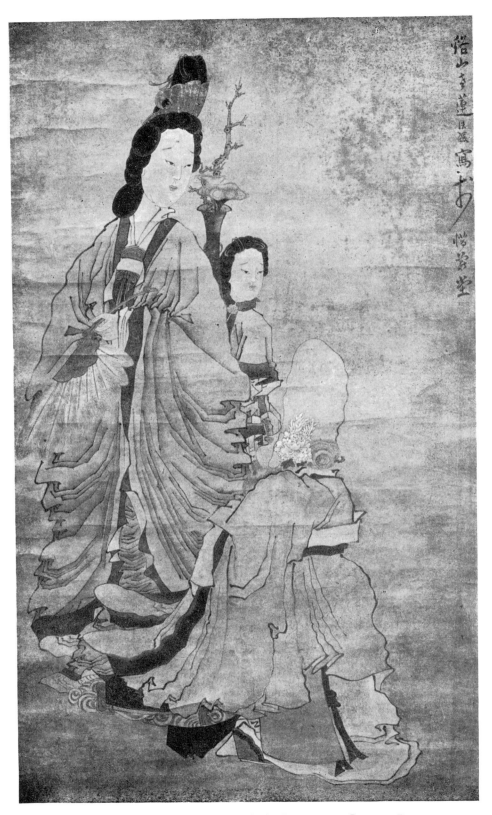

212. CH'ÊN HUNG-SHOU (A.D. 1599-1652). LADY AND GOD OF LONGEVITY.
Ink and slight colour on paper. H.285 cm. W.103 cm. *British Museum, London.*

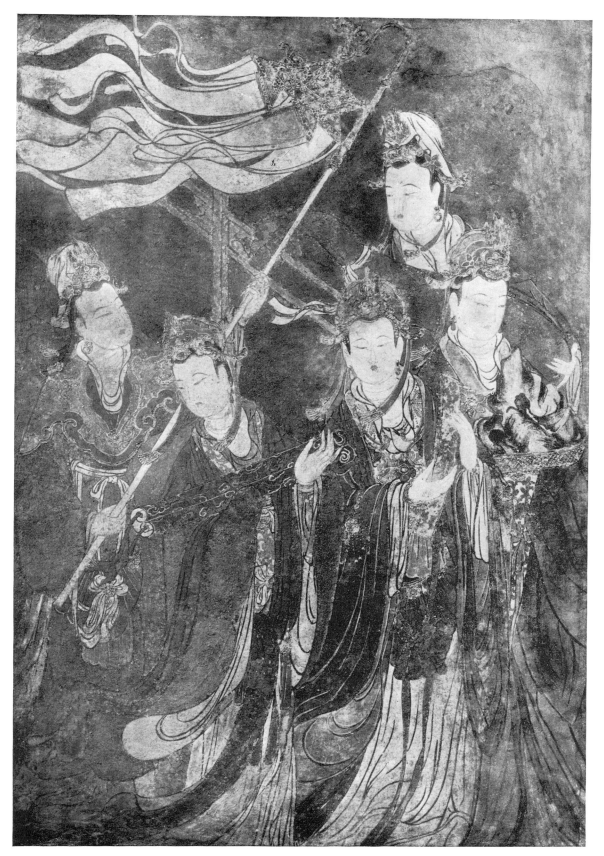

213. TAOIST DEITIES. Fresco. Colour. Fragment. H.165 cm. W. 117 cm. 16th or 17th century A.D.
Sir Frederick Whyte, London.

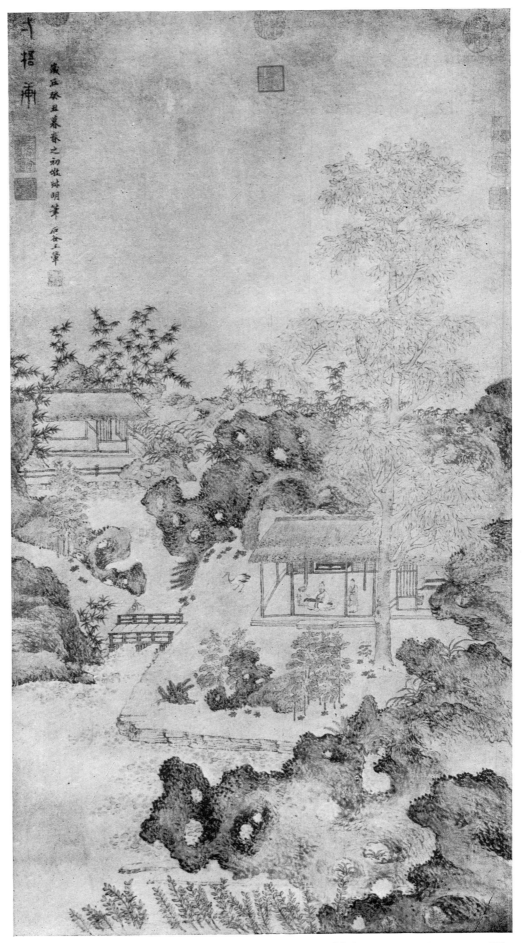

214. WANG HUI (A.D. 1632-1720). SUMMER HOUSES. Colour and ink on paper. H.104 cm. W.54 cm.
Chinese Government.

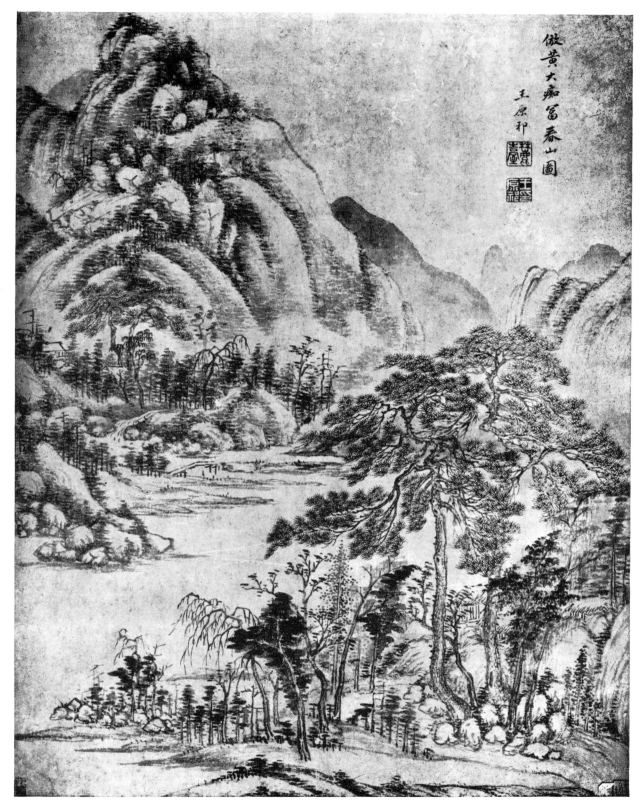

傚黃大癡富春山圖
王原祁

215. WANG YÜAN-CH'I (A.D. 1642-1715). LANDSCAPE. Ink on paper. H.56 cm. W.43 cm.
British Museum, London.

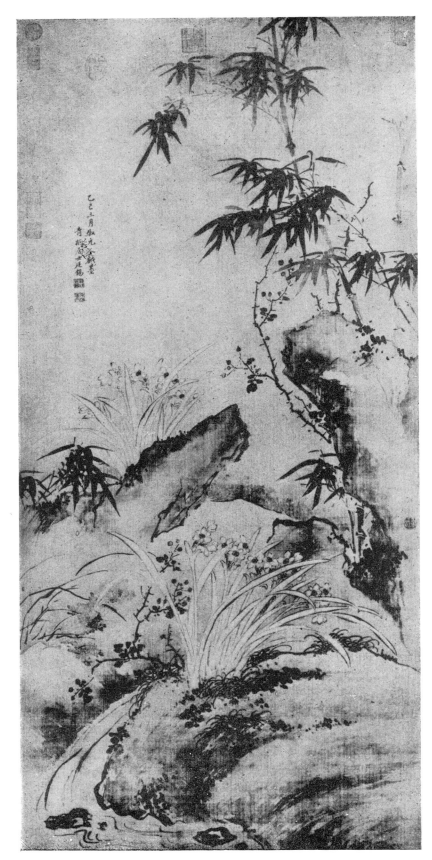

216. CHIANG T'ING-HSI (A.D. 1669-1732). NARCISSI, ROCKS, AND BAMBOOS.
Colour on silk. H.145 cm. W.62 cm. *Chinese Government.*

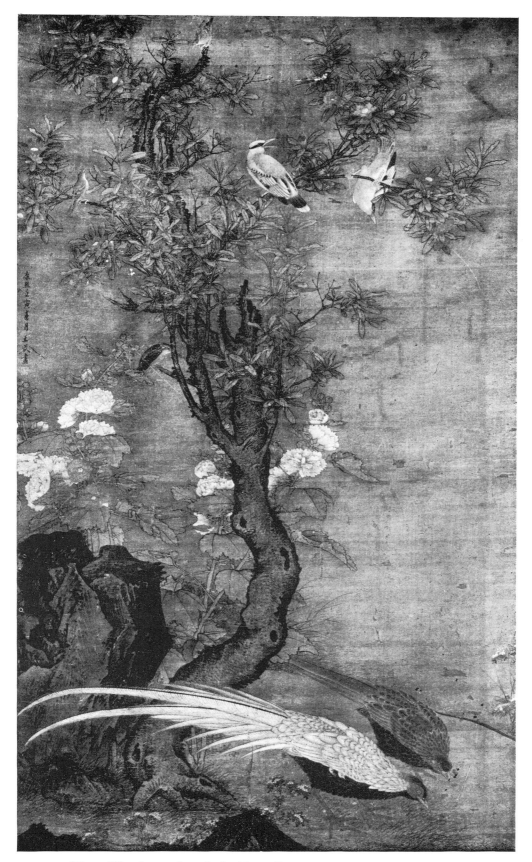

217. WANG WU (A.D. 1632-1690). TREE, PEONY AND PHEASANTS. Colour on silk.
H.176 cm. W.102 cm. Dated 1662. *British Museum, London.*

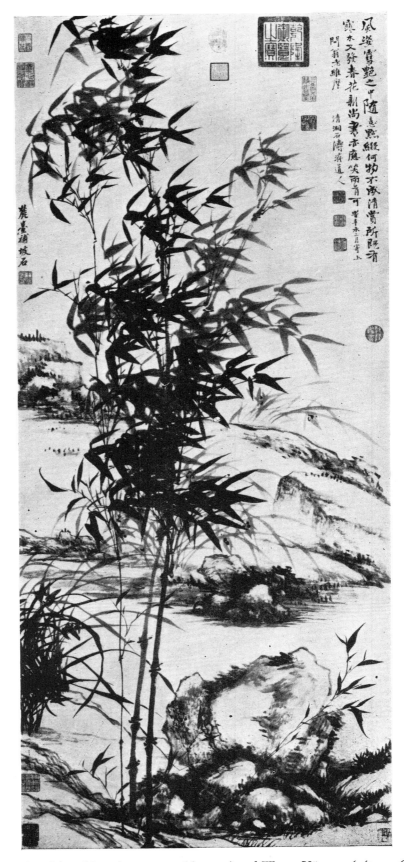

218. SHIH-T'AO (Tao-chi, active c. A.D. 1660-1710) and WANG YÜAN-CH'I (A.D. 1642-1715).
ORCHIDS AND BAMBOOS. Ink on paper. H.134 cm. W.58 cm. *Chinese Government.*

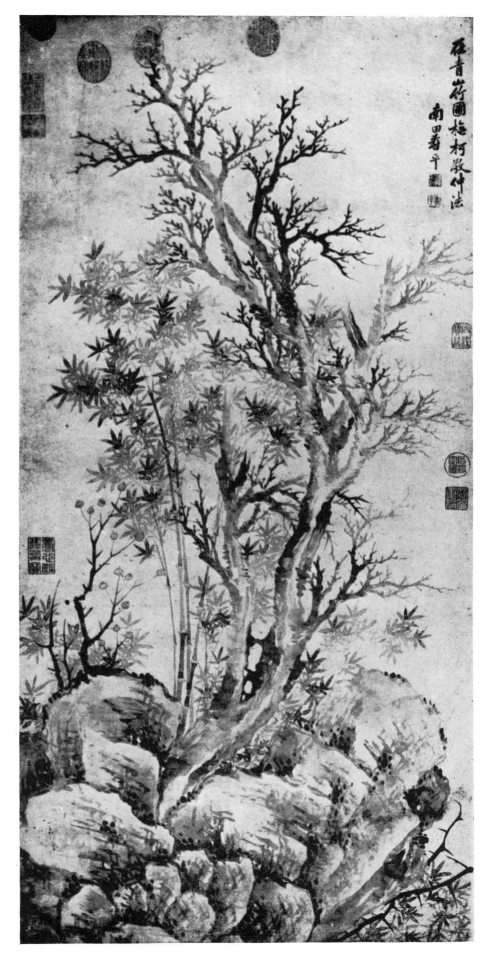

219. YÜN SHOU-P'ING (A.D. 1633-1690). BAMBOOS AND A WITHERED TREE.
Colour and ink on paper. H.101 cm. W.48 cm. *Chinese Government.*

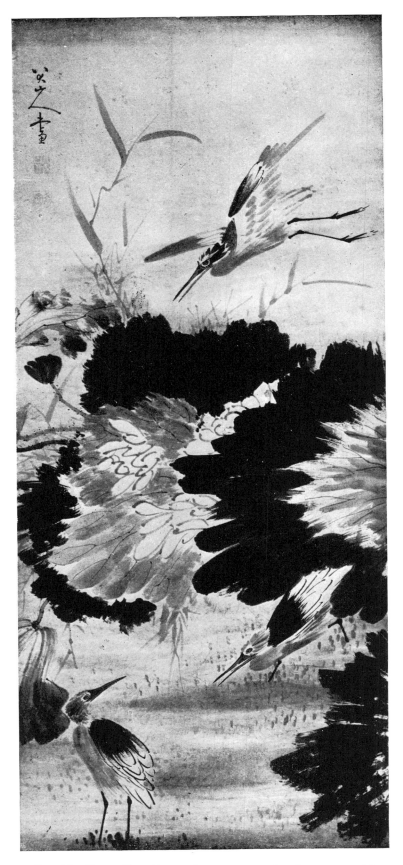

220. CHU TA (Pa-ta Shan-jên, 17th century A.D.). LOTUS AND HERONS.
Ink on paper. H.161 cm. W.69 cm. *National Museum, Stockholm.*

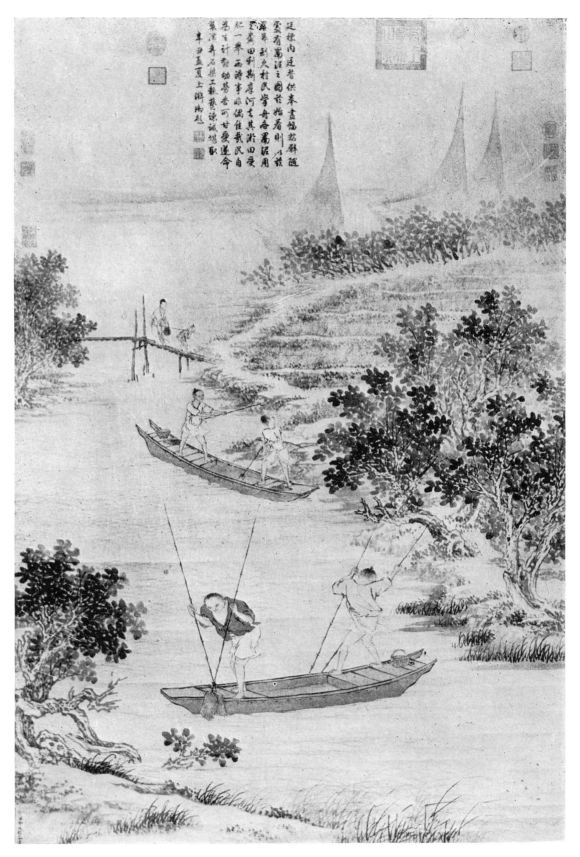

221.　CHING T'ING-PIAO (18th century A.D.).　DREDGING MUD.　Ink and slight colour on paper.
H.142 cm.　W.89 cm.　*Chinese Government*.

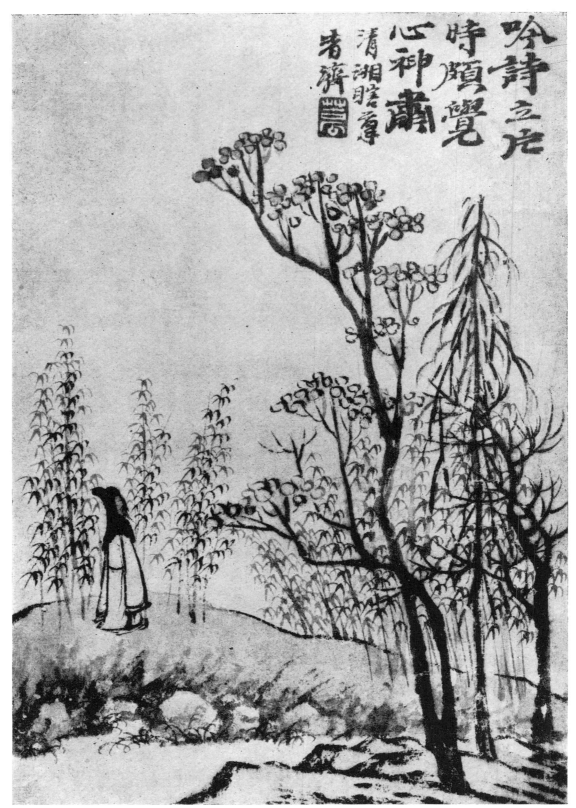

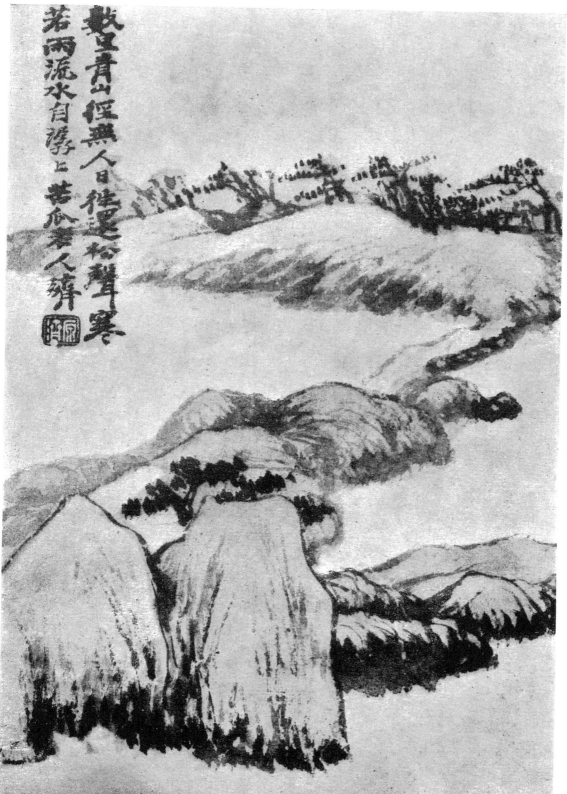

数里青山径无人日徙连松声寒
若两流水自浮上若瓜薯人辫

223

222-223. SHIH-T'AO (Tao-chi, active c. A.D. 1660-1710). LANDSCAPES. Album leaves. Ink on paper.

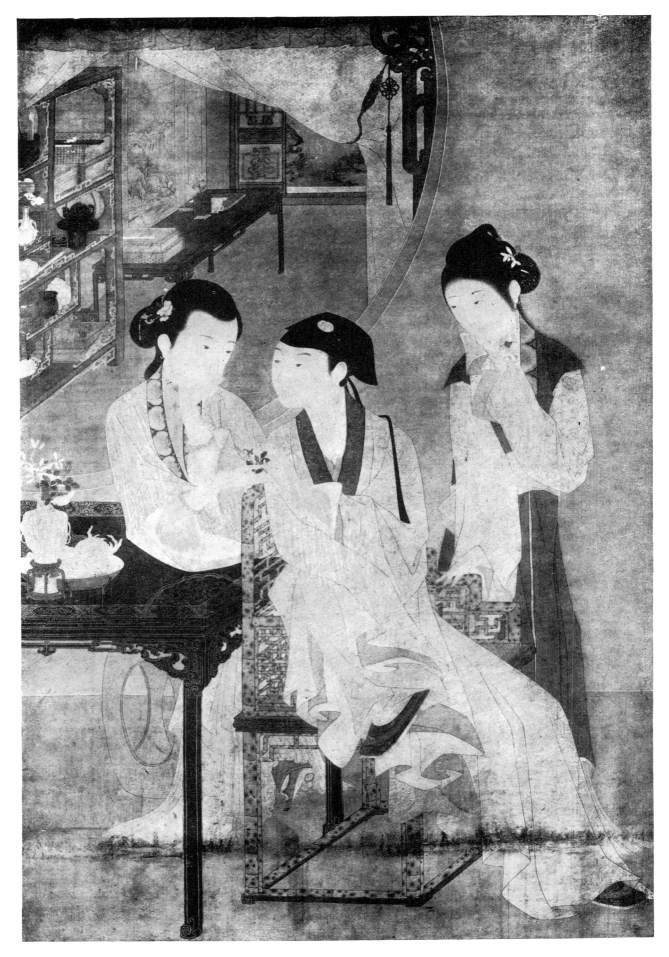

224. Unknown Artist. Young Man between Two Rivals. Colour on silk. H.198 cm. W.130 cm. 18th century A.D. *Freer Gallery of Art, Washington.*

LIST OF PLATES

AND

INDEX OF COLLECTIONS

LIST OF PLATES

PLATE 50
Attributed to Kuo Hsi (c. A.D. 1020-1090). River Landscape (Huang Ho ?). Part of a hand scroll. Ink and slight colour on silk. H.26 cm. L.206 cm. *Freer Gallery of Art, Washington.*

PLATE 51
Attributed to Kuo Hsi (c. A.D. 1020-1090). Winter Landscape. Part of a hand scroll. Ink on silk. H.53 cm. L.475 cm. *Toledo Museum of Art, Toledo, Ohio.*

PLATE 52
Attributed to Hsü Hsi (10th century A.D.). Lotus Flowers in the Wind. One of a pair of paintings. Colour on silk. H.c.100 cm. *Chionin, Kyōto.*

PLATE 53
Attributed to Chao Ch'ang (active c. A.D. 1000). Flowers. Colour on silk. H.104 cm. W.51 cm. *Chinese Government.*

PLATE 54
Su Shih (A.D. 1036-1101). Bamboo. Ink on paper. *Private Collection, China.*

PLATE 55
Su Kuo (A.D. 1072-1123). A Bird on a Bamboo Stalk. Ink on paper. H.47 cm. W.29 cm. *Private Collection, Japan.*

PLATE 56
Mi Fei (A.D. 1051-1107). Landscape. Ink on paper. H.51 cm. W.49 cm. Dated 1102. *Private Collection, Japan.*

PLATE 57
Attributed to Mi Fei (A.D. 1051-1107). Landscape. Ink on silk. H.150 cm. W.78 cm. *Freer Gallery of Art, Washington.*

PLATES 58—59
Mi Yu-jên. Landscape. Hand scroll. Ink and slight colour on silk. H.43 cm. L.192 cm. Dated 1130. *Cleveland Museum of Art, Cleveland.*

PLATES 60—61
Chao Ta-nien (active c. A.D. 1080-1100). River Landscape. Hand scroll. Ink and slight colour on silk. H.18 cm. L.165 cm. *Private Collection, China.*

PLATES 62—63
Attributed to Li Lung-mien (c. A.D. 1040-1106). Imperial Summer Palace. Hand scroll. Ink on paper. H.36 cm. L.146 cm. *Freer Gallery of Art, Washington.*

PLATE 64
Attributed to Li Lung-mien (c. A.D. 1040-1106). Wei Mo-ch'i (Vimalakīrti) with Attendant. Ink on silk. H.100 cm. W.53 cm. *Private Collection, Japan.*

PLATE 65
Unknown Artist. Woman in White with Basket (Kuanyin?). Ink and colour on silk. H.93 cm. W.43 cm. 13th or 14th century A.D. *Freer Gallery of Art, Washington.*

PLATE 66
Li Lung-mien (c. A.D. 1040-1106). Five Tribute Horses from Khotan with Grooms. Part of a hand scroll. One of the Horses with Groom. Ink and slight colour on paper. H.30 cm. L.182 cm. *Chinese Government.*

PLATE 67
Emperor Hui Tsung (A.D. 1082-1135). The Five-Coloured Parakeet perched on an Apricot Branch. Hand scroll. Colour on silk. H.53 cm. L.125 cm. *Museum of Fine Arts, Boston.*

PLATE 68
Attributed to Emperor Hui Tsung (A.D. 1082-1135). Landscape in Storm. Ink and slight colour on silk. H.120 cm. W.50 cm. *Kuonji, Minobu, Japan.*

PLATE 69
Emperor Hui Tsung (A.D. 1082-1135). Birds and Pine Tree. Ink on paper. H.87 cm. W.52 cm. *Tonying & Co., New York.*

PLATE 70
Attributed to Li T'ang (active c. A.D. 1100-1130). On the Way Back. Ink on paper. H.25 cm. W.27 cm. *Museum of Fine Arts, Boston.*

PLATE 71
Attributed to Li T'ang (active c. A.D. 1100-1130). Milch Cow. Colour on silk. H.46 cm. W.63 cm. *Chinese Government.*

PLATE 98
In the manner of Hsia Kuei. Landscape with Fishing Nets. Ink and slight colour on silk. H.144 cm. W.100 cm. 13th century A.D. *Museum of Fine Arts, Boston.*

PLATE 99
Hsü Shih-chang (12th-13th century A.D.). Landscape. Ink and slight colour on silk. H.184 cm. W.101 cm. *Freer Gallery of Art, Washington.*

PLATE 100
Liang K'ai (active c. A.D. 1200). Winter Landscape. Ink and slight colour on paper. H.130 cm. W.48 cm. *Private Collection, Japan.*

PLATE 101
Liang K'ai (active c. A.D. 1200). The Buddha on the Way to the Bodhi Tree. Colour on silk. H.117 cm. W.51 cm. *Private Collection, Japan.*

PLATE 102
Liang K'ai (active c. A.D. 1200). The Poet Li T'ai-po (c. A.D. 700-762). Ink on paper. H.79 cm. W.30 cm. *Private Collection, Japan.*

PLATES 103—104
Liang K'ai (active c. A.D. 1200). Patriarchs of the Ch'an Sect. Two paintings. Ink on paper. H.74 cm. W.30 cm. *Private Collection, Japan.*

PLATES 105—106
Liang K'ai (active c. A.D. 1200). The Sixteen Lohans. Parts of a hand scroll. H.32 cm. L.573 cm. *Private Collection, Japan.*

PLATE 107
Fa-ch'ang (Mu-ch'i, c. A.D. 1181-1239). One of the Eight Views of the Tung-t'ing Lake (Returning Sails). Part of a hand scroll. Ink on paper. H.28 cm. L.130 cm. *Private Collection, Japan.*

PLATE 108
Ying Yü-chien (12th-13th century A.D.). One of the Eight Views of the Hsiao Hsiang. (Haze dispersing from around a Mountain Town.) Part of a hand scroll. Ink on paper. H.31 cm. L.82 cm. *Private Collection, Japan.*

PLATE 109
Fa-ch'ang (Mu-ch'i, c. A.D. 1181-1239). Kuanyin Clad in White. Middle piece of a set of three paintings. Ink on silk. H.142 cm. W.96 cm. *Daitokuji, Kyōto.*

PLATE 110
Fa-ch'ang (Mu-ch'i, c. A.D. 1181-1239). Shrike perched on a Pine Tree. Ink on paper. H.79 cm. W.32 cm. *Private Collection, Japan.*

PLATE 111
Fa-ch'ang (Mu-ch'i, c. A.D. 1181-1239). Persimmons. Ink on paper. H.36 cm. W.38 cm. *Daitokuji, Kyōto.*

PLATE 112
Fa-ch'ang (Mu-ch'i, c. A.D. 1181-1239). Peonies. Ink on paper. H.36 cm. W.38 cm. *Daitokuji, Kyōto.*

PLATE 113
Fa-ch'ang (Mu-ch'i, c. A.D. 1181-1239). Two Sparrows on a Bamboo Branch. Ink on paper. H.184 cm. W.45 cm. *Private Collection, Japan.*

PLATE 114
Fa-ch'ang (Mu-ch'i, c. A.D. 1181-1239). Lohan. Ink on silk. H.107 cm. W.45 cm. *Private Collection, Japan.*

PLATES 115—117
Ch'ên Jung (middle of the 13th century A.D.). Dragons among Clouds and Waves. Parts of a hand scroll. Ink and slight colour on paper. H.46 cm. L.1096 cm. Dated 1244. *Museum of Fine Arts, Boston.*

PLATE 118
Fan An-jên (middle of the 13th century A.D.). Carps, Crab and Water plants. Ink on paper. *Private Collection, Japan.*

PLATE 119
Unknown Artist. Peonies and a Cat. Colour on silk. H.141 cm. W.107 cm. 13th or 14th century A.D. *Chinese Government.*

PLATE 142
Attributed to Yen Hui (14th century A.D.). Winter Landscape. Ink on silk. H.160 cm. W.105 cm. *Chinese Government.*

PLATE 143
Chu Jui (13th or 14th century A.D.?). Bullock Carts in the Mountains. Colour and ink on silk. H.104 cm. W.51 cm. *Museum of Fine Arts, Boston.*

PLATE 144
Signed Li Wei (11th century A.D.?). Bamboo Grove with Summer House. Ink on silk. H.75 cm. W.41 cm. Probably 13th or 14th century A.D. *Museum of Fine Arts, Boston.*

PLATE 145
Jên Jên-fa (14th century A.D.). Feeding Horses. Ink and slight colour on silk. H.50 cm. W.75 cm. *Victoria and Albert Museum, London.*

PLATE 146
Attributed to Jên Jên-fa (14th century A.D.). Horses with Grooms. Part of a hand scroll. Colour on silk. H.28 cm. L.175 cm. Dated 1314. *Fogg Art Museum, Cambridge (Mass.).*

PLATE 147
Ni Tsan (A.D. 1301-1374). Landscape. Ink on paper. *Chinese Government.*

PLATE 148
Ni Tsan (A.D. 1301-1374). Landscape with Pavilion. Ink on paper. H.73 cm. W.35 cm. *Chinese Government.*

PLATE 149
Huang Kung-wang (A.D. 1269-1354). Landscape. Part of a hand scroll. Ink on paper. H.32 cm. L.589 cm. Dated 1338. *Chinese Government.*

PLATE 150
Huang Kung-wang (A.D. 1269-1354). Landscape. Ink on paper. *Chinese Government.*

PLATE 151
Wu Chên (A.D. 1280-1354). Landscape with two Pine Trees. Ink on paper. *Chinese Government.*

PLATE 152
Wu Chên (A.D. 1280-1354). Landscape. Ink on paper. H.145 cm. W.58 cm. *Chinese Government.*

PLATE 153
Wang Mêng (A.D. 1308-1385). Landscape with Waterfall. Ink on paper. *Chinese Government.*

PLATE 154
Wang Mêng (A.D. 1308-1385). Landscape with thatched Summer Houses. Colour on paper. H.111 cm. W.60 cm. *Chinese Government.*

PLATE 155
Ts'ao Chih-pai (13th-14th century A.D.). River Landscape. Ink on paper. *Private Collection, China.*

PLATE 156
Ts'ao Chih-pai (13th-14th century A.D.). Two Pine Trees. Ink on silk. H.132 cm. W.57 cm. Dated 1329. *Chinese Government.*

PLATE 157
Shêng Mou (14th century A.D.). Winter Landscape. Ink on silk. H.106 cm. W.49 cm. *British Museum, London.*

PLATE 158
Fang Ts'ung-i (14th century A.D.). Landscape with Pavilion. Ink on paper. H.62 cm. W.28 cm. *Chinese Government.*

PLATE 159
Ku An (14th century A.D.). Bamboos and Rocks. Ink on silk. H.187 cm. W.104 cm. Dated 1350. *Chinese Government.*

PLATE 160
Kao Jan-hui (13th-14th century A.D.). Summer Haze. Ink and slight colour on paper. *Private Collection, Japan.*

PLATES 161—162
Kao Jan-hui (13th-14th century A.D.). Winter and Summer Landscape. A pair of paintings. Ink on silk. H.124 cm. W.60 cm. *Konchiin, Kyōto.*

INDEX OF COLLECTIONS